HADASSAH

THE LITTMAN LIBRARY OF
JEWISH CIVILIZATION

Dedicated to the memory of
LOUIS THOMAS SIDNEY LITTMAN
*who founded the Littman Library for the love of God
and as an act of charity in memory of his father*
JOSEPH AARON LITTMAN
יהא זכרם ברוך

*'Get wisdom, get understanding:
Forsake her not and she shall preserve thee'*
PROV. 4:5

HADASSAH

American Women Zionists and the Rebirth of Israel

MIRA KATZBURG-YUNGMAN

Translated from the Hebrew by
TAMMY BERKOWITZ

Oxford · Portland, Oregon
The Littman Library of Jewish Civilization

The Littman Library of Jewish Civilization

Chief Executive Officer: Ludo Craddock
Managing Editor: Connie Webber

PO Box 645, Oxford OX2 0UJ, UK
www.littman.co.uk

———

Published in the United States and Canada by
The Littman Library of Jewish Civilization
c/o ISBS, 920 NE 58th Avenue, Suite 300
Portland, Oregon 97213-3786

First published 2012
First published in paperback 2014
First digital on-demand edition 2014

A catalogue record for this book is available from the British Library

The Library of Congress catalogued the hardback edition as follows:

Katsburg-Yungman, Mirah.
[Nashim tsiyoniyot ba-Amerikah. English]
Hadassah : American women Zionists and the rebirth of Israel /
Mira Katzburg-Yungman ; translated from the Hebrew by Tammy Berkowitz.
p. cm. Includes bibliographical references and index.
ISBN 978-1-874774-83-9
1. Hadassah, the Women's Zionist Organization of America—History.
2. Zionism—United States—History—20th century.
3. Jewish women—United States—Societies and clubs—History—20th century.
4. Jewish women—Political activity—United States—History—20th century.
5. Israel—Social conditions—20th century.
I. Berkowitz, Tammy. II. Title.
DS150.H4K3813 2011 320.54095694082'0973–dc22 2010031579

ISBN 978-1-906764-59-3

Publishing co-ordinator: Janet Moth
Copy-editing: Gillian Somerscales
Designed and typeset by Pete Russell, Faringdon, Oxon.
Printed in Great Britain by Lightning Source UK, Milton Keynes,
in the United States by Lightning Source US, La Vergne, Tennessee,
and in Australia by Lightning Source Australia, Scoresby, Victoria.

This book has been printed digitally and produced in a
standard specification in order to ensure its continuing availability.

Publication of this book was supported financially by the Open University Research Fund (nos. 4405, 4422, 33205) and the Koret Foundation, and by the Dushkin Foundation through the Institute of Contemporary Jewry at the Hebrew University of Jerusalem

Preface and Acknowledgements

THIS BOOK deals with the largest and strongest Zionist organization in the Jewish world. I have attempted here to comprehend the essence of this organization and to relate portions of its complex narrative, which spreads out over a hundred years and spans two continents divided by a great geographical and cultural distance.

The book is the culmination of a research project that continued over many years, starting with a doctoral dissertation written at the Institute of Contemporary Jewry at the Hebrew University in Jerusalem. After completing the dissertation, I substantially expanded the scope of the research and updated it to take account of further developments. In consequence, the current volume is almost double the length of the original text, and also rather different from it. It is also rather different from the book I published in 2008 under the title *Nashim tsiyoniot be'amerikah: hadassah utekumat yisra'el* (American Women Zionists: Hadassah and the Rebirth of Israel). Although both books originated from the same Hebrew text, the current volume has been extensively adapted for an English-speaking readership and in some areas ranges more widely than the Hebrew book.

A book cannot be written alone. Accompanying the author on her voyage are many 'contributors' to whom she owes much, from both a personal and an academic perspective. The publication of this book offers the best opportunity to thank those who have participated in my journey.

In one respect this book is the result of the curiosity about and interest in American Jewry that I began to feel many years before I started my academic research into the subject. The first American Jews of whom I was aware were members of my own family. My late grandmother Regina (Rivka) Katzburg, née Miller, had two brothers who emigrated from Hungary to the United States and practised medicine there. In 1905 the older brother came to the United States and established himself as a dentist. Because of his American citizenship he was able, at a time when very few Jews were being admitted to the United States, to guarantee entry for his younger brother, a young physician who had completed his medical education in Switzerland. At about the same time my grandmother, who did not want to live in the United States, moved from Hungary to Palestine. From then on, every week for the sixty years until her brothers died, she received a letter in Hungarian whose secrets I never understood, though apparently they described in great detail the lives of her brothers' sons and daughters. Later, after I had already

started my academic studies on American Jewry at the Hebrew University, a letter
written in English arrived for my parents. It came from the daughter of one of those
brothers, lamenting the death of my grandmother, the last of the generation of
immigrants that built the two branches of our family, in Israel and in the United
States. The American branch, so the letter related, knew from my grandmother's
letters every detail of its parallel branch in Israel. This letter was for me an illumin-
ation of the deep connection between the American side of the family, created by
the two brothers' settling in America, and the Israeli side created by my grand-
mother's settling in Palestine, and retrospectively explains the roots of my great
interest in American Jewry.

Another prompt to set out on the adventure of researching Hadassah was my
close acquaintance with the centre of Hadassah's medical activity in Israel, through
which it made its greatest contribution to the Zionist enterprise: its medical centre
in Jerusalem. The Rothschild-Hadassah University Hospital, more commonly
known simply as the Hadassah Hospital, was the site of several of my most intense
experiences. There my uncle died while still in his prime, and there also three of my
four children were born. Despite its central position in the life of Jerusalem,
however, only a few know of the origins of this hospital, of its distinctiveness, and
above all of the enormous contribution to its establishment and development made
by the women's organization from which it took its name. Few, too, know of the
wonderful collaboration between people in Israel and those Jewish American
women without which Hadassah would not have been capable of making its
unique contribution to medicine in Israel. My wish to make more people aware of
this history and its continuing relevance was the principal justification for writing
this book.

In talking about the history of the State of Israel, the history of the Zionist
movement, and the link between the two, one is bound also to talk about Jews going
to live in Israel. In Hebrew the term used for this movement is *aliyah*, which
literally means 'ascent'. This has been throughout the ages the traditional Jewish
word for the movement of Jews living outside the 'Land of Israel' to live in the
country. From the beginnings of political Zionism it was used to connote the
emigration of Jews, and only Jews, from their homeland in the Diaspora and their
immigration to the Jewish homeland Erets Yisra'el, the biblical 'Land of Israel'. It
does not mean 'immigration' per se, but since the Hebrew term *aliyah* may be
foreign to many readers of this book, the terms 'emigration' and 'immigration', as
appropriate in context, are generally used instead. These terms are to some extent
inadequate because they lack the ideological overtones of the Hebrew, but it is to be

hoped that this brief airing of the problem will compensate to some degree for what is lost in translation.

Each of my supervisors in my doctoral work, Professor Allon Gal and Professor Gideon Shimoni, made a substantial contribution in his specialist field to the research and the book born from it. It is a pleasant duty to thank them for their dedicated help. Special thanks are due to Professor Gal for suggesting Hadassah as a research topic, and for encouraging me to expand that project into a book.

It is a further pleasant duty to thank the Open University of Israel, my academic home, which allowed me to spend the time necessary on this research, funded most of it, and contributed to meeting the costs of publication. I would also like to thank those who found me worthy of a 'Friends of Herzl' stipend, and the Institute of Contemporary Jewry at the Hebrew University in Jerusalem, Hadassah, and the Open University of Israel for jointly bearing the costs of my first research trip to the United States.

Hadassah's veteran leaders gave time to me at the beginning of the research, and the interviews I held with them—most in New York, a few in Jerusalem— opened up the gates of the organization to me and taught me a great deal about it. I would especially like to thank the former presidents Carmela Kalmanson, the late Charlotte Jacobson, and Marlene Post, who devoted many hours of their time to me. I would also like to offer profound thanks to Jane Zolot, who gave up a great deal of time to me at the beginning of my research and taught me a lot about Hadassah. I also derived great benefit from the conversations I had with two former directors general of the Hadassah-Hebrew University Medical Center, the late Professor Eli Davis and the late Professor Kalman Mann, with many doctors, and with a few of the central figures in Israeli nursing, including Yehudith Steiner Freud, Dr Leah Zvanger, and scholar of the history of nursing in the Yishuv, Dr Nira Bartal. I would also like to thank Dr Amnon Grushka for his help with medical terminology. The daughters of several of Hadassah's leaders in the 1950s, in New York and in Israel, contributed a valuable human dimension to the research.

I would like to express my enormous gratitude to Susan Woodland, the director of the Hadassah Archives in New York, whose great assistance at the later stages of the work on the book contributed to my learning about many subjects. There are numerous issues that could not have been tackled without her help. I would also like to express my profound thanks to the book's copy-editor Gillian Somerscales, who contributed greatly to its final version, and of course to Connie Webber, the managing editor of the Littman Library of Jewish Civilization, for her confidence in

the book and for the work and care she put into it; and to Janet Moth, who shepherded it through to completion. I owe special thanks also to Tammy Berkowitz, who dedicated several years to completing the translation, and who was a joy to work with throughout.

I would also like to thank the staff of the Ben-Gurion Archives at Sede Boqer and the Central Zionist Archives in Jerusalem, and the staff and director of the Israel State Archives. I am also grateful to Daniel S. Gross, my assistant in the final stages.

I extend my deep gratitude to my whole family, who stood by my side over all the years of the book's preparation: my husband Rami, whose love and patience have accompanied me all the way since my master's degree, through all the years of writing as I worked on my doctorate and the book, and who gave me the mental serenity necessary for such an endeavour; my four children, all of whom missed a great many mother-hours because of this book—Carmit, who accompanied the research from its inception and also helped to complete it as my assistant; Matan and Assaf, who taught me the secrets of the computer and its advantages; and Roni, who revealed great patience at the decisive time of completing the writing; and my sisters Mali, who accompanied me the whole way and also provided professional advice from her own sphere, and Yael, who always listened to me amiably and intelligently. Special thanks also to my mother-in-law Bluma, who took care of my three elder children, the third one a baby of only six months, during my trip to the United States to collect the material for the research. Without her help the whole project would have been impossible, and I will never forget how much I owe her for that.

And finally, thank you to all of my close and long-standing friends and colleagues, who always knew how to combine intelligent professional advice with words of encouragement, at the right times, and helped to diminish the solitude that is the fate of the working historian: Professor Judy Baumel-Schwartz, Dr Eleonora Lapin, Dr Aviva Weingarten, Dr Hagit Cohen, Dr Nelly Las, and Dr Ilan Kaiser (who also stood in for me at the Open University for several months so that I could finish my work). I also would like to thank Peri Rosenfeld and her husband Stu for opening their home in New York to me and giving me a taste of home on my research travels.

I cannot at this time thank my beloved mother, who passed away before she could see this book. I find a small comfort in the fact that she knew whole portions of it by heart from the manuscript and previous publications of mine. I am very grateful that my late father lived to see the publication of the Hebrew edition; it is to his memory that the present edition is dedicated.

December 2011 / Kislev 5772 MKY

Contents

PART V
HADASSAH IN CONTEXT

APPENDICES

Plates

between pages 112 and 113, and 240 and 241

1. A Hadassah logo from the 1940s
2. Henrietta Szold
3. Doctors, sanitarians, and administrators of the American Zionist Medical Unit, photographed in New York before sailing to Palestine in 1918
4. Motor truck donated by the Detroit chapter of Hadassah for the American Zionist Medical Unit, 1918
5. The handover of Rothschild Hospital to Hadassah on 3 November 1918
6. A laboratory in the Hospital of the American Zionist Medical Unit in Jaffa, 1919
7. Hadassah staff of the Rothschild (Hadassah) Hospital in the 1920s
8. The pharmacy of the Rothschild (Hadassah) Hospital, 1920s
9. Patients waiting in the outpatient clinic of the Rothschild (Hadassah) Hospital, 1920s
10. Women's ward in the Rothschild (Hadassah) Hospital, 1920s
11. Hadassah hospital in Tel Aviv, 1926
12. Shulamit Cantor
13. Rummage sale organized by Hadassah members in Des Moines, Iowa, 1934
14. Hadassah National Board meeting, 1942
15. Members of the Hadassah National Board with David Ben-Gurion at the Waldorf Astoria Hotel, New York City, 1946
16. Rose Halprin
17. Rose Jacobs
18. Etta Rosensohn
19. Judith Epstein
20. Young Judaea logo, 1950s
21. Tel Yehudah campers carrying the American flag alongside members of the Hebrew Tsofim carrying the Israeli flag, 1958
22. President Truman receives the Henrietta Szold Citation and Award for Distinguished Humanitarian Service, 1951
23. Members of the Minneapolis chapter of Hadassah selling war bonds, 1944
24. Hadassah members, dressed in American army uniform, selling war bonds at the Paris department store in San Francisco in 1944

Note on Transliteration

THE transliteration of Hebrew in this book reflects consideration of the type of book it is, in terms of its content, purpose, and readership. The system adopted therefore reflects a broad approach to transcription, rather than the narrower approaches found in the *Encyclopaedia Judaica* or other systems developed for text-based or linguistic studies. The aim has been to reflect the pronunciation prescribed for modern Hebrew, rather than the spelling or Hebrew word structure, and to do so using conventions that are generally familiar to the English-speaking reader.

In accordance with this approach, no attempt is made to indicate the distinctions between *alef* and *ayin*, *tet* and *taf*, *kaf* and *kuf*, *sin* and *samekh*, since these are not relevant to pronunciation; likewise, the *dagesh* is not indicated except where it affects pronunciation. Following the principle of using conventions familiar to the majority of readers, however, transcriptions that are well established have been retained even when they are not fully consistent with the transliteration system adopted. On similar grounds, the *tsadi* is rendered by 'tz' in such familiar words as *barmitzvah*, *mitzvot*, and so on. Likewise, the distinction between *ḥet* and *khaf* has been retained, using *ḥ* for the former and *kh* for the latter; the associated forms are generally familiar to readers, even if the distinction is not actually borne out in pronunciation, and for the same reason the final *heh* is indicated too. As in Hebrew, no capital letters are used, except that an initial capital has been retained in transliterating titles of published works (for example, *Shulḥan arukh*).

Since no distinction is made between *alef* and *ayin*, they are indicated by an apostrophe only in intervocalic positions where a failure to do so could lead an English-speaking reader to pronounce the vowel-cluster as a diphthong—as, for example, in *ha'ir*—or otherwise mispronounce the word.

The *sheva na* is indicated by an *e*—*perikat ol, reshut*—except, again, when established convention dictates otherwise.

The *yod* is represented by *i* when it occurs as a vowel (*bereshit*), by *y* when it occurs as a consonant (*yesodot*), and by *yi* when it occurs as both (*yisra'el*).

Names have generally been left in their familiar forms, even when this is inconsistent with the overall system.

Prologue

Dream great dreams, and take practical steps to make them a reality.
Henrietta Szold

O N S A T U R D A Y N I G H T, 24 February 1912, at the Temple Emmanuel Reform synagogue in New York City, thirty-eight American Jewish women gathered, led by Henrietta Szold—a woman who personified a rare combination of spirit, vision, idealism, and an extraordinary organizational and practical ability. On the basis of a profound understanding of the nature and dilemmas of American Jewry and the feminist views of that time on 'woman's nature' and her needs, these women founded Hadassah, the Women's Zionist Organization of America, which in time became the largest Zionist organization in the Diaspora, a pillar of the entire Zionist movement, the largest women's organization in the United States, and possibly even the largest and most active women's organization in Jewish history.

The study group that became Hadassah's founding core was one of those groups of Zionist women—albeit different in its social make-up from other such groups— which developed in the United States even before the First Zionist Congress to study the ideas of the first Zionist thinkers. It took its name from the beautiful Jewish woman in the biblical book of Esther who saved her people, named there as 'Hadassah, that is, Esther' (Esther 2: 7). The choice of name was unanimously approved at the organization's first annual convention, as a symbolic expression of several of its ideological fundamentals: it was an organization of Jewish women; it had a profound bond with Jewish tradition and Jewish history; and it was dedicated to saving Jews. The focus of Hadassah's activity from its inception was to serve the needs of Palestine, and right up to the present day its work in Israel has been in the sphere of health; to reflect this, the organization's motto since its foundation has been *arukhat bat ami*, 'the health of the daughter of my people', from the verse 'Is there no balm in Gilead? Is there no physician there? Why then is not the health of the daughter of my people recovered?' (Jer. 8: 22).[1]

Henrietta Szold, who was both the spiritual and the organizational progenitor of Hadassah, envisioned it as a way to harness the unique capabilities of American

[1] Dash, *Summoned to Jerusalem*, 107.

Jewish women to the Zionist enterprise in Palestine. She saw its contribution as importing the 'American healing art',[2] providing 'help for the sick', and developing 'public, preventive health institutions for the people at large'.[3] All this was to be done, in Szold's view, 'in a form dictated by modern science'.[4] These principles have underpinned Hadassah's activity from its inception to the present day, although their expression and development have altered in accordance with the changing times.

It is worth mentioning that the path forged by Hadassah ran largely in parallel to that of the Zionist Organization of America (ZOA), an organization that played a central role in the political and diplomatic struggle for the establishment of the State of Israel. Led by men although its membership included women, the ZOA was explicitly political in nature, and engaged primarily in political activity (in both the international and American scenes as well as in the American Jewish and Zionist arenas), in lobbying and in fundraising. It was also involved for many years in Jewish education, but success in this field eluded it. Because of its political orientation, the ZOA was unstable from the outset, flourishing only when the Jewish people faced a grave crisis or substantial political challenge. When the crisis was over or the challenge had passed, its activity waned, and its membership fell away.

Hadassah has always been involved in two geographical arenas: in the United States, where it was active in Jewish education, and in the Jewish homeland, first in the Yishuv, as the pre-state Jewish community in Palestine was called, and later in Israel, where it helped develop medical and welfare services. Because it was not essentially a political organization, Hadassah's sense of purpose did not diminish when crises were resolved. It always remained stable, and in that sense was very different from the ZOA: although the challenges confronting the Jewish world naturally affected it, it did not depend on them for its ability to thrive.

The history of Hadassah is part of the history of American Jewry, with its dual heritage of Jewish tradition and American culture. It is an inseparable part of the history of the Yishuv and of the State of Israel, and an important element in the relationship between American Jewry and the Jewish homeland. It is also part of the history of Jewish women in the United States and in the modern world more broadly.

[2] Speech by Henrietta Szold at the annual convention of the Zionist Organization of America, Boston, 28 June 1915, as quoted in Miller, 'A History of Hadassah', 52.

[3] Statement prepared by Henrietta Szold entitled 'Palestine Hospitals Building Fund', 23 Mar. 1926, quoted in Miller, 'A History of Hadassah', 265. [4] Ibid.

There is no comprehensive history of Hadassah, but two doctoral dissertations, by Donald Miller and Carol Kutscher, although written a generation ago, provide some insights into the first decades in the life of the organization.[5] Several works have set out to illuminate particular aspects of Hadassah. Among these, Erica Simmons focused on the organization's activity on behalf of children and teen-agers (including the Youth Aliyah enterprise), mainly in the period of the British Mandate, and sheds light on the progressive foundations of this activity.[6] Zippora Shehory-Rubin and Shifra Shvarts's book covers some of the same ground, but primarily from the perspective of the Yishuv.[7] Other works deal mainly with gender issues, and several research papers on Henrietta Szold provide additional infor-mation on the organization up to Szold's death in 1945.[8] Nira Bartal's book (in Hebrew) about the establishment of the nursing profession in Palestine sheds much light on the position and contribution of Hadassah in this context and in-cidentally also on other aspects of Hadassah's health-related activity in Israel during the Mandate period.[9] Hadassah as a whole was also discussed briefly in the major works of research on American Zionism.[10] Allon Gal's research on David Ben-Gurion and American Jewry sheds light on the relationship between Ben-Gurion and Hadassah up to 1943, and several of his articles discuss various aspects of the thought and beliefs underpinning Hadassah, mainly from the American viewpoint.[11] Several studies devoted to the history of medicine in Palestine provide some information on Hadassah's contribution in this field during the period of the British Mandate.[12]

[5] The works are: Miller, 'A History of Hadassah', and Kutscher, 'The Early Years of Hadassah'.

[6] Simmons, *Hadassah and the Zionist Project*.

[7] Shehory-Rubin and Shvarts, *Hadassah for the Health of the People* (Heb.).

[8] Three works that focus on gender issues have been published: Antler, *The Journey Home*; McCune, 'Social Workers in the Muskeljudentum'; ead., *'The Whole Wide World'*. The major researches dealing with Szold that are relevant to Hadassah as well are: Dash, *Summoned to Jerusalem*; Fineman, *Woman of Valor*; Goldstein, 'The Practical'; Brown, 'Henrietta Szold's Progressive American Vision'.

[9] Bartal, *Compassion and Competence* (Heb.).

[10] Particularly the two books by Urofsky, *American Zionism* and *We Are One*. Other research works that discuss Hadassah in different American Zionist contexts include Cohen, *American Jews and the Zionist Idea*; Halperin, *The Political World of American Zionism*; and Shapiro, *Leadership of the American Zionist Organ-ization*.

[11] Gal, *David Ben-Gurion* (Heb.), id., *David Ben-Gurion and the American Alignment*, id., 'Hadassah and the American Jewish Political Tradition', and id., 'Hadassah's Ideal Image of the State of Israel' (Heb.) deal with Hadassah's political orientation, commitment to liberal democratic principles, and vision of the Jewish state.

[12] Levy, *Chapters in the History of Medicine* (Heb.); Shvarts, *Clalit Health Fund* (Heb.); Niederland, 'The Influence of the German Immigrant Doctors, 1933–1939' (Heb.); id., 'The History of the Medical School' (Heb.); Niederland and Kaplan, 'The Medical School' (Heb.).

Up until now, then, no attempt has been made to study the organization as a whole, including all its origins—Jewish, Zionist, and feminist—in the context of the circumstances prevailing both in the United States and in the Yishuv and Israel. Nor has any comprehensive discussion yet taken place about the organization's ideology and its place in the World Zionist Organization. Similarly, there has never been a study of the role of those who partnered Hadassah in its health-related work—the doctors, nurses, and others within the organization—and its Zionist enterprise, or in its educational work, whether in the United States, in the Yishuv, or in Israel; or indeed of Hadassah's relationship with the State of Israel. Most of the research that has been done, moreover, focuses on the period of the British Mandate, and in particular on the first decades of the organization's existence; far less attention has been paid to the later history.

This book does not tell the story of Hadassah in its entirety, but it does cover many parts of its history. Highlighting both the ideology of the organization and its practical expression, it explores the nature of the organization and its network of ties with the various countries and cultures it has straddled: the American Jewish community, the Yishuv, the State of Israel, and the world Zionist movement. Successive chapters analyse the organization's ideas and trace their Jewish, American, and feminist origins, describe its activities, and elucidate the significance of both ideas and activities within these various contexts.

An important aspect of the book is the attempt to analyse Hadassah both from the American Jewish perspective and from that of the Yishuv and Israel, which have been in turn not only the focus of its activity for a hundred years, but also the pillar on which the organization in the United States was and still is founded. Hadassah always worked in full co-operation with the leadership of the Yishuv and later of Israel, and always employed local people to manage and implement its projects there. Hadassah not only brought the professions of nursing and public health to the Yishuv, but also developed alongside them the paramedical professions of occupational therapy, nutrition, and nutrition education—all of which were considered predominantly women's professions in the United States. Special attention is paid to Hadassah's role in introducing modern medical services, research, and education, and in shaping the medical profession in Israel. The history of Hadassah also illuminates important issues in the history of general education in Israel, and in the fields of vocational guidance (later known as career counselling) and health education, including work with immigrant youngsters in the first decade after the foundation of the state. Similarly, it sheds light on Hadassah's role in Youth Aliyah (the organization responsible for the immigration of

young Jews from the Diaspora, known in Hebrew as Aliyat Hano'ar, liteally 'youth immigration'), which was also, among other things, an educational enterprise.

Within the American context, the discussion focuses mainly, although not exclusively, on the Hadassah leadership, the key group in understanding the organization. Less attention is devoted to the local Hadassah groups and the 'chapters' in which they were organized (although they do feature in the discussions of specific issues). The documentation that has survived is of little historical value for such a study, and oral history can no longer significantly fill the gaps since former members are either no longer alive or very elderly.

A central assumption underpinning the study was that in order to reach sound general conclusions about the nature of Hadassah it was essential to examine the organization in all its aspects: its ideology, its Jewish and American origins, and the totality of its activities in the United States, the Yishuv, and Israel. I therefore decided not to confine the study to particular themes or areas of activity (for example, its enterprises in the Yishuv and Israel, its contribution to the American Jewish community, or specifically gender-related questions). However, given the organization's longevity and vast scope of activity, a study of its entire history would be beyond the scope of a single researcher, requiring the efforts of a team. Consequently, in order to preserve the necessary breadth of analysis, the option of an in-depth probe of one period in Hadassah's history was chosen as an instructive case study.

This approach is reflected in the structure of the book. Part I is a broad review of the history of Hadassah from its establishment in 1912 up to the end of 1947, when Israel's War of Independence began. Part II explores Hadassah in its American context, looking at the founding ideas and values that shaped its path, their Jewish and American origins, and the organization's principal *modus operandi*. Part III moves the discussion to Hadassah's role in the World Zionist Organization, after the establishment of the State of Israel. In Part IV the emphasis shifts to Hadassah's projects and activities in Israel in its formative years, from 1948 to 1956, and in fact till Hadassah moved to its new medical centre in Ein Kerem in 1961. These were important years in the history of the Jewish people—an era of development and consolidation in Israel, a time of crisis in American Zionism, and a point of departure for the reformulation of American Jewry's relations with independent Israel—and they provide an excellent context in which to explore the nature of Hadassah, embedded as it was in all three environments. The War of Independence, mass immigration and the concomitant problems, and the need to adjust to the new situation created by Israeli statehood form the backdrop to an account of

Hadassah's extensive activities during this time, through which it becomes pos-sible to trace the patterns of action that reflect the essence of the organization.

These years also witnessed a massive growth in Hadassah's membership to more than 250,000 women, turning it into a mass movement and enhancing its strength and influence at a time when other Zionist organizations, unable to redefine their goals and motivate their members after the establishment of Israel, declined. Hadassah's flourishing in this era of transition poses an additional chal-lenge for the research and exploration of the organization.

The last part of the book, Part V, deals with topics that enrich our understanding of Hadassah in additional dimensions, such as some gender issues; comparisons of Hadassah with other Zionist organizations; and the importance of people in the Yishuv, and later of Israelis, in Hadassah's activities. Finally, an Epilogue considers developments to 2005. It sets out to assess whether the conclusions reached with regard to Hadassah as an organization remain valid. This question is addressed by considering various developments within Hadassah in the 1970s and the sub-sequent quarter of a century, years when the organization was affected by sig-nificant changes within the wider American Jewish community—specifically, the enormous increase in intermarriage with non-Jews and the impact of the so-called 'second wave' of feminism.

As noted above, Hadassah is, so far as can be ascertained, the largest women's organization in Jewish history. In view of the heightened interest in women and gender in recent and current historical research, it seems appropriate to devote a few words here to the discussion of these issues. A major subject of this book is the collective contribution of American Jewish women to the Jewish collective in Israel; a contribution perhaps unprecedented in Jewish history in terms of scope, content, and duration. The narrative describes an undertaking pursued by women rooted in the two cultural worlds of Jewish women in America—Jewish tradition and Amer-ican civilization—and examines the combination of factors that enabled this activity to thrive both in America and in Israel. I have tried to describe Hadassah's contribution not only as a Zionist effort, but also as essentially a women's effort. Therefore, particular attention is paid in the book to the life stories of the individual women—both those in America and those in the Yishuv and Israel—who played key roles in Hadassah and its projects in the 1940s and 1950s, and also earlier.

Even though this volume does not fall into the category of gender studies, it does consider several gender-related issues that have not yet been studied: among others, a gender analysis of Hadassah as compared with the ZOA, and the org-anization's Zionist ideas in relation to gender as they developed over the years, as

well as the impact on Hadassah of the 'second wave' of feminism, as noted above. The book also sheds light on the contribution of the women of the Yishuv and Israel in their capacity as nurses, nutritionists, and occupational therapists.

The book is based on extensive documentation in various American and Israeli archives. I also took pains to assemble a vast quantity of oral recollections and documentation, interviewing former leaders of Hadassah as well as various personalities who were associated with its activities in Israel. Using this mass of primary source material, I aim to present an extensive, diverse, and balanced historical picture of Hadassah in the two arenas of its activity—the land that is now Israel, and the United States.

PART I

CONTEXTS AND CHALLENGES

Hadassah, 1912–1933: Finding a Role

THE AMERICAN SETTING

ZIONIST WOMEN'S SOCIETIES appeared in Europe and the United States even before the First Zionist Congress of 1897, and between 1907 and 1912 national Zionist women's groups emerged in Germany, eastern Europe, Russia, and Britain. By 1914 the German Zionist women's organization, Verband Jüdischer Frauen für Kulturarbeit in Palästina (Society of Jewish Women for Cultural Work in Palestine), which had been founded in 1907 during the Eighth Zionist Congress, had approximately 6,500 members, both men and women, in various branches in Germany, in most of the other countries of western Europe, and also in Romania and Canada. Among its activities in Palestine were the establishment of the Girls' Farm at Kinneret in 1911 for the agricultural training of girls, aid to the Sha'ar Zion hospital in Jaffa, and the establishment of lace-making schools for young women in various locations in Palestine. Attempts that had begun in 1903 to establish a broad regional organization in the Austro-Hungarian province of Galicia were finally realized in 1910 when the Zionist Women's Society of Galicia was formed in Lwów. In Britain, a Zionist women's organization was established in 1912 known as the Federation of Women Zionists of Great Britain and Ireland, out of which the Women's International Zionist Organization (WIZO) developed a decade later.[1]

The establishment of a separate Zionist organization for women in the United States and its mode of operation are directly related to the nature of the American Jewish women's arena, as well as to the Zionist ideas that had penetrated the United States along with Jewish immigrants from eastern Europe. Hadassah emerged

[1] On the Verband Jüdischer Frauen für Kulturarbeit in Palästina, see Esther Carmel-Hakim, 'Agricultural–Vocational Training for Women in the Yishuv' (Heb.), 54–5; Berkowitz, 'Transcending Tzimmes and Sweetness'. On the Zionist Women's Society of Galicia, see Gelber, *The History of the Zionist Movement in Galicia* (Heb.), ii. 805–12. On the British organization, see Gassman-Sherr, *Story of the Federation of Women Zionists of Great Britain and Ireland*. Research on all of these organizations is still in its infancy and in the future it may become clear that such attempts were also made in other places in Europe.

against the background of the development of women's organizations both in American society at large and in the German Jewish community that was already established in the United States.

Women's organizations themselves were not, of course, unique to the United States. There were numerous such groups in nineteenth- and twentieth-century Germany and Britain, developing for the most part in line with the predominant views about gender roles and identities, and the proper realms of involvement for women and men respectively: public life for men and home life for women.[2] In the United States, the development of such groups was fostered and accelerated by the impulse towards voluntary and philanthropic activity that has characterized the American way of life.[3] In the 1870s and 1880s, and especially in the 1890s, a period of intensive industrialization in the United States, there was a significant increase in the number of philanthropic organizations and women's organizations, most of them established within religious and ethnic frameworks.[4] The women's organizations dealt mainly with cultural and literary matters or charitable work; many undertook practical projects for the benefit of the public, such as establishing public libraries or even hospitals.[5] Involvement in these bodies was considered an acceptable activity for middle-class women, many of whom found themselves with more free time as a result of urbanization, technological developments (such as sewing and washing machines, electricity, home heating, and ready-made clothing), and the availability of cheap household labour as a result of mass immigration.[6]

Most of the American women's organizations in existence at the beginning of the twentieth century embraced what was later called 'social feminism': a feminist outlook based on the assumption that men and women have different traits and skills, and that women's intellectual characteristics and sense of morality enable them to contribute to social reform. Social feminism directed women primarily into the fields of nursing, child welfare, health, and various social reform activities —all areas to which women were at that time deemed particularly well suited by their innate characteristics.[7]

[2] Kuzmack, *Woman's Cause*, 9–10.

[3] On voluntarism, see Lipset, *Continental Divide*, 75; on philanthropic tradition, see Curti, 'American Philanthropy', 421, 422, 427.

[4] On women's organizations, see O'Neill, *Feminism in America*, 149; on religious and ethnic frameworks, see Toll, 'Quiet Revolution', 7; Kutscher, 'The Early Years of Hadassah', 25.

[5] Dash, *Summoned to Jerusalem*, 154.

[6] Lerner, *Woman in American History*, 614; O'Neill, *Feminism in America*, 150.

[7] On 'social feminism' and its fields of activity, see Woloch, *Women and the American Experience*, 326–7; Black, *Social Feminism*, 53–62.

Hand in hand with these developments in the United States came the greater accessibility of higher education for women, including a few Jewish women.[8] This in turn facilitated the emergence of professional women, and of 'women's professions': nursing, social work, and teaching.[9] Within nursing, an area of particularly strong development was public health. This was an aspect of social activity accorded high priority in the so-called Progressive era (between 1890 and 1920), and one to which women were considered very well suited, both as professionals and as volunteers.[10]

As women's organizations developed across American society, so Jewish women's groups emerged in parallel to those of their non-Jewish compatriots. This phenomenon was part of a twin process of Jews integrating into American society and women breaking into the world of Jewish philanthropy. A contributory factor here—in the absence both of a wealthy philanthropic Jewish elite, such as that embodied by the Rothschild and Montefiore families in England, and of a Jewish community anchored in the laws of the state, as was customary in central Europe— was the gathering momentum of community-wide Jewish organizations that were being created outside the synagogues. In this context, the women's associations also provided their members with a way of expressing and indeed defining their Jewish identity. Through their participation in these groups they assimilated fundamentals from the Jewish tradition alongside ideas and modes of organizing drawn from American society.[11]

This trend was fuelled by the large-scale immigration of Jews from eastern Europe into the United States during the late nineteenth and especially the early twentieth century. Women of German Jewish origin volunteered for philanthropic activity to help the immigrants and developed a network of charities intended to support them and facilitate their acculturation in America. These groups played a significant role in the extensive philanthropic activity undertaken by German Jews in America for the benefit of new arrivals.[12]

Among the plethora of women's groups in turn-of-the-century America were several nationwide organizations that provided models for the founders of

[8] On the development of higher education among women in the US, see Woloch, *Women and the American Experience*, 283–327; see also the figures in Graham, 'Expansion and Exclusion', 764–5; on Jewish women in the colleges, see Turk, 'College Students'.

[9] On the appearance of professional women, see Woloch, *Women and the American Experience*, 283; on the development of nursing and social work as women's professions, see O'Neill, *Feminism in America*, 142; Rothman, *Woman's Proper Place*, 154–6. [10] Brown, *The Israeli–American Connection*, 145.

[11] Toll, 'Club Movement', 234–5; Nadell and Sarna, *Women and American Judaism*, 4; Sarna, *American Judaism*, 50. [12] Kuzmack, *Woman's Cause*, 12.

Hadassah. One such was the General Federation of American Women's Clubs—a non-religious, mass-orientated women's organization, founded in Chicago in 1890. Starting with a few thousand members, the federation grew rapidly, reaching a membership of over a million in 1910.[13] Another was the American Red Cross, which was involved in health-related philanthropic work, and was noted for its size, efficiency, practical outlook, and high standards of 'businesslike' management.[14]

There was a Jewish model as well. Hadassah was influenced by the first nation-wide Jewish women's organization in the United States, the National Council of Jewish Women (NCJW). Founded in Chicago in 1893 by a group of women of German Jewish origin, the NCJW developed a rich programme of Jewish education, alongside extensive immigrant aid work. In the nationwide format it developed, with a central office and branches all over the country, it followed the example of non-religious social feminist groups that set up women's clubs of the kind characteristic of the late nineteenth century, devoted to social reform. The NCJW worked against 'white slavery', extended aid to immigrant women, and was involved in the work of the settlement house movement. The 'settlement houses' were households set up by communities of workers among the poor, where they devoted their energies to combating the social and physical causes of illness. The practice of living among the poor was based on the idea that, in order to help remove the social and physical causes of disease, it was necessary for those helping them to live among them in the impoverished neighbourhoods. The settlement house movement had begun in England; in its American version, many of the activists were women. It was very active in poor areas of the large US cities, where it provided residents (mostly immigrants) with health, social, and educational services.[15] One of the most renowned of these communities was Lillian Wald's Henry Street Settlement House, founded in New York City in 1893.[16] In all, the movement established settlement houses for immigrants in at least twelve cities.

The NCJW developed an effective social network, based on the unique life experience of American Jewish women. At the same time it was part of the broader American movement for social reform and acculturation, and combined Americanism, Judaism, and feminism as well as practical work (philanthropy and social

[13] O'Neill, *Feminism in America*, 84–5.

[14] Kutscher, 'The Early Years of Hadassah', 17.

[15] The history of the National Council of Jewish Women in this period and its activity in the field of immigrant aid and development of Jewish education for members of the organization are discussed in detail in Rogow, *Gone to Another Meeting*, 130–66, and in Dash, *Summoned to Jerusalem*, 37; on the settlement house movement, see Woloch, *Women and the American Experience*, 253.

[16] Morawska, 'Assimilation of Nineteenth-Century Jewish Women', 89–90.

services) and Jewish women's education (by means of study circles that offered Jewish women a unique opportunity to study their heritage).[17] The NCJW's national framework, as well as some of its basic principles and areas of activity, served as a model for Hadassah, which eventually developed along similar lines, pursuing philanthropic aid alongside a cultural programme with Jewish content adapted to the needs of a Zionist organization.

HEALTH SERVICES IN EARLY
TWENTIETH-CENTURY PALESTINE

Alongside developments in America, the health-care needs of Jews living in Palestine at the beginning of the second decade of the twentieth century were an additional factor in the establishment of a Zionist women's organization in the United States and in the direction its Zionist work took. Modern health and medical institutions in Palestine were first established in the second half of the nineteenth century and the early years of the twentieth, all of them by religious and philanthropic organizations based outside Palestine. Reflecting the view, both Christian and Jewish, of Palestine as the Holy Land, such institutions were set up in places that were considered especially sacred.

In 1854 the Rothschild family founded Palestine's first modern hospital, in response to an appeal to Baron James Jacob de Rothschild to help the Yishuv, which suffered great difficulties during the Crimean War from the severing of its communications with the Jews of Russia, and the concomitant loss of their financial support.[18] One of many humanitarian institutions founded by the Rothschilds in Palestine, the hospital was named after the founder of the dynasty, Mayer Amschel Rothschild. Its main area of treatment was infectious disease, especially malaria and eye diseases, and patients were admitted free of charge. In 1877 the Rothschild family bought a 6-dunam plot of land (1.5 acres) adjacent to the Russian Compound in Jerusalem, and the hospital was moved to this location. The large,

[17] Rogow, *Gone to Another Meeting*, 1–8.

[18] Baron James Jacob de Rothschild (1792–1868), the son of Mayer Amschel Rothschild, the dynasty's founder, and himself the founder of the French branch of the Rothschild family. He served as economic adviser to two French kings, and after the Napoleonic Wars, which he helped to finance, his business affairs played a prominent role in the transformation of France into an industrial empire, by funding the infrastructure and establishment of the railways and quarry sites for mining. The fortune he accumulated in the course of his business transactions granted him a place of honour on the list of the richest people in the world at that time. In 1822 James de Rothschild, together with three of his brothers, received the title of baron from Francis I of Austria.

modern building that the family had built there remains a strikingly handsome feature of the city to this day, and was certainly one of the largest and most impressive buildings in Palestine at the time.[19]

In 1904 Alliance Israélite Universelle took over the management of the hospital, which became famous for its excellent physicians and specialist facilities, including wards for paediatrics and ophthalmology. Shortly before the First World War it had fifty beds, but when the war broke out it expanded its activities, almost doubling this total. It operated until spring 1915, but was then closed by order of the Turkish authorities, apparently because it was connected with a French Jewish organization and sponsored by the Rothschild family of Paris and London. About a year later the hospital resumed operations; but in April 1917, after the United States joined the war against Germany, it was closed for the second time, again because of its association with the enemy. It remained closed until the British occupation.[20] On 3 November 1918 its management was transferred to Hadassah—under a temporary agreement which was never cancelled—and it became the centre of the organization's activity in Palestine.

By the time the First World War broke out, four other Jewish hospitals had been established in Jerusalem: Bikur Holim (founded in 1860), Ezrat Nashim (founded in 1895), Misgav Ladakh (1899, in the old city), and Sha'arei Tsedek (1902).[21] Other clinics and hospitals were established in Jaffa (Sha'ar Zion, 1891), Tiberias (1897), and Safed (1912). At the same time, various missions founded health institutions in Jerusalem and Nazareth to serve the non-Jewish residents and many Christian pilgrims in Palestine.[22]

Taken together, however, these health institutions fell far short of meeting the needs of the Jewish population. Health conditions and sanitation in Palestine in the early twentieth century were extremely poor. Many regions were infected by malaria, intestinal typhoid, and dysentery; tuberculosis and trachoma, a severe eye disease which can cause blindness, were also very common; and hygiene conditions in the cities were far from adequate.[23] Mortality rates were therefore high, especially among infants. Malaria was the most common of the endemic diseases. In the Ottoman period which preceded the British Mandate there was nowhere

[19] Levy, *Chapters in the History of Medicine* (Heb.), 59.
[20] Shiloni, 'The Medical Service and Hospitals' (Heb.), 72–4.
[21] Shvarts, *Clalit Health Fund* (Heb.), 7–8; 'Erets Yisrael', *Encylopedia Hebraica* (Heb.), vii. 716; on the hospitals in Jerusalem, see Ben-Arieh, *A City in the Context of the Period* (Heb.), index; Gat, 'First Medical Institutions' (Heb.). [22] Shvarts, *Clalit Health Fund* (Heb.), 7.
[23] Tulchinsky, *Health in Israel*, 5; see also Shvarts, *Clalit Health Fund* (Heb.), 5.

in Palestine that was not affected by this disease, and in some villages entire populations were wiped out owing to the lack of health and medical services. Again, the impact on children was particularly severe. It was almost 1900 before intensive efforts to drain the swamps began. This activity was initiated by Dr Hillel Yaffe, one of the first Jewish physicians in Palestine and a pioneer in the extermination of malaria, and financed by Baron Edmond de Rothschild. In the course of this campaign to prevent or reduce the spread of the disease, eucalyptus trees were planted, the swamps were sprayed with kerosene, and quinine was systematically distributed among the residents of the moshavot (agricultural settlements composed of private farms).[24]

THE FOUNDING OF HADASSAH

As noted above, Zionist women's societies were established in the United States even before the First Zionist Congress in 1897, and others followed within the framework of the Federation of American Zionists (which in 1918 became the Zionist Organization of America, ZOA). Most adopted the name Daughters of Zion; some added the name of a famous woman from Jewish history, such as Rebecca, Deborah, or Hadassah. Their activity revolved around discussions of issues related to Jewish history, Palestine, and, after the First Zionist Congress, the Zionist movement. In Harlem, New York, the Hadassah study group was founded as early as 1899; its members read and debated the ideas of the Zionist thinkers Theodor Herzl, Judah Leib Pinsker, and Ahad Ha'am.[25]

In 1907 this group was joined by Henrietta Szold (1860–1945), the daughter of Benjamin Szold (1829–1902), a scholar and rabbi of the German Jewish Reform congregation Oheb Shalom in Baltimore. Under her guidance the group broadened its programme of study to include Jewish current events and Jewish history, as well as Zionism; yet Szold herself felt that it lacked direction.[26] Two years after she joined the group, she found that direction on a visit to Palestine. There, the lack of health services, the poor sanitary conditions, the grim economic situation, and the general misery of the inhabitants made a deep impression on her, and she resolved to use her study group as the basis for an organization dedicated to improving the situation. When she returned to the United States in 1910 Szold presented the members of the Hadassah study group with her impressions of the tour, and

[24] Shvarts, *Clalit Health Fund* (Heb.), 9. [25] Friesel, *The Zionist Movement* (Heb.), 175.
[26] Antler, *The Journey Home*, 104.

exhorted them to found a national Zionist women's organization to help promote health services in Palestine.[27]

To this end, Szold and six other women published a flyer calling upon the Jewish women of America to found a large Zionist organization, with the twin aims of disseminating Zionism in the United States and setting up health and welfare services for women and children in Palestine. In response to this appeal, thirty-eight women gathered at Temple Emanuel in New York on 24 February 1912.

The social composition of this original group was different from that of most Zionist societies of the time. These were young women born or raised and educated in the United States, who had a higher social status than that of the majority of members of the Zionist movement at that period. These women also had the free time to devote to working for the Zionist cause.[28] Among those who attended the founding meeting were Emma Leon Gottheil, wife of the Zionist leader Richard Gottheil; Rosalie Solomons Phillips (the wife of N. Taylor Phillips), a wealthy and respected member of New York City's oldest Sephardi congregation who already belonged to various Jewish and non-Jewish societies, and was a descendant of Revolutionary War hero Haym Solomons; and Lotta Levensohn, a graduate of the Teachers' Institute of the Jewish Theological Seminary of America and secretary to Rabbi Judah Magnes.[29] Of the thirty-eight founder members, twenty were elected at this inaugural meeting to hold portfolios as officers or directors, and thus became Hadassah's first leadership.[30]

The new organization adopted the name Hadassah Chapter of the Daughters of Zion, after the study group that formed its core; and the women agreed, following Szold, that it should be devoted to meeting the pressing need for better health services in Palestine.[31] Even though other ideas were also raised—all connected with women's and children's welfare: a maternity hospital, the establishment of a day nursery, supervising midwives, vocational training, employing girls in lace-making or the pearl industry—it was agreed at the first meeting that the organization would undertake a nursing project for women and children in Palestine.[32] Thus the main field of activity that Hadassah chose to enter was one already considered suitable for women in the United States, professionals and volunteers alike.

[27] For Szold's impressions of the conditions in Palestine, see Antler, *The Journey Home*, 104; Miller, 'A History of Hadassah', 44. For a detailed description of the journey, see Dash, *Summoned to Jerusalem*, 79–91; Jacobs, 'Beginnings', 232–3. On her presentation of these impressions to the members and encouragement to found a Zionist women's organization, see Dash, *Summoned to Jerusalem*, 45–6, 144.

[28] Friesel, *The Zionist Movement* (Heb.), 175. [29] Hyman and Moore, *Jewish Women*, i. 571–2.

[30] Kutscher, 'The Early Years of Hadassah', 64. [31] Antler, *The Journey Home*, 105. [32] Ibid.

Later that same month, the group founded a national organization with the twofold aim 'to promote Jewish institutions and enterprises in Palestine and to foster Zionist ideals in America'. The name of the organization—Hadassah, the Women's Zionist Organization of America—was officially approved at its first annual national convention, held in Rochester, New York, in June 1914.[33]

The Founders

Henrietta Szold was not only the chief founder of Hadassah but also became its icon. Both as 'founding president, organizer, and visionary' and, no less, as a myth, she played a determining role in shaping the organizational and ideological character of Hadassah.[34] Her own attributes and attitudes were influenced inter alia by a combination of the westernized Judaism of her Hungarian-born, German-educated father (see below) and the fundamental elements of American progressivism—a belief in science and social pluralism, as well as the attachment of supreme importance to activity in health, medicine, and education. All these factors in turn influenced the character of the organization that she founded.[35] She never married, though at a mature age she experienced a difficult and painful emotional involvement with the renowned scholar Professor Louis Ginzberg. She dedicated her life to Jewish public activity in the United States and, later, to work on behalf of the Yishuv.

Henrietta's father Rabbi Szold was a well-known figure among the American Jewish community of the later nineteenth century. Born in Hungary, he had studied at the University of Breslau and at the newly founded rabbinical seminary there and immigrated to the United States following an invitation from the Oheb Shalom congregation in Baltimore to serve as its rabbi. Rabbi Szold gave his daughter a broad Jewish education (which was highly unusual for Jewish girls at the time) and trained her to assist him in his scholarly work. Henrietta Szold spent her childhood and adolescence in the German Jewish community in Baltimore; after finishing high school, she worked as a teacher at an English and French school for girls and taught Hebrew at her father's Oheb Shalom congregation. Among other activities, she founded and directed a school for Jewish immigrants, which in 1898 was transferred to the authority of the City of Baltimore and became a model school

[33] On the establishment of the national organization, see Miller, 'A History of Hadassah', 47; Report of the First Annual Convention of the Daughters of Zion held in Rochester, New York, HA; for the quotation, see 'Report of the Proceedings of the First Annual Convention of the Daughters of Zion, held in Rochester, New York, June 29 and 30', *The Maccabean*, 25/1 (July 1914), 12, 51; on the name of the organization, see ibid.
[34] Brown, *The Israeli–American Connection*, 133. [35] Ibid. 134, 137.

for immigrant naturalization. She was also an active participant in the Botany Club for Women and the Women's Literary Club of Baltimore.

For many years Henrietta Szold was deeply involved in public and literary Jewish activity, notably as a translator and editor. She was held in great esteem among the German Jewish elite in the United States, and was the only woman invited to take part in the founding of the Jewish Publication Society of America. She served the society as secretary of the editorial board, editor, and translator for over twenty years, during which she worked on the society's major projects such as *The Jewish Encyclopedia* and *The American Jewish Yearbook*.[36]

Although she found many outlets for her intellectual abilities, Henrietta Szold deeply regretted her lack of a college education. (At this time, very few of the leading colleges in America, and none in Baltimore, admitted women.[37]) Accordingly, it was with great enthusiasm that in her forties she became the first woman to attend the Jewish Theological Seminary of America.[38] Indeed, it was as the result of a traumatic development in her personal life while studying at the seminary that she made the visit to Palestine that was to ignite her mission. She had fallen in love with Louis Ginzberg, a prominent member of the seminary faculty; but Ginzberg, who was many years her junior, rejected her and married a younger woman. It was after this, in 1909, that Henrietta set off with her mother on a trip to Europe and Palestine.

Henrietta Szold and her father Benjamin were already sympathizers with the Zionist idea before the First Zionist Congress. In 1900 they both joined the first Zionist association in Baltimore, one of the earliest to be established in the United States. Later, in 1909–10, Henrietta was secretary of the Federation of American Zionists, and later still she held positions on its committees and its executive board. She was also active in American women's organizations, belonging to several in her home town of Baltimore, and was a popular speaker to women's groups both within and beyond the city. She was one of the four Jewish women who spoke at the 1893 International Women's Congress held at the Chicago World's Columbia Exposition (the World's Fair).[39]

[36] Dash, *Summoned to Jerusalem*, 5–7; Kutscher, 'The Early Years of Hadassah', 65–6; Friesel, *The Zionist Movement*, 123. [37] Antler, *The Journey Home*.

[38] Kutscher, 'The Early Years of Hadassah', 56, 110; Szold's years of study at the JTS are discussed extensively in Dash, *Summoned to Jerusalem*, 47–8.

[39] On Szold and her father being advocates of Zionism prior to the First Zionist Congress and their joining the Zionist Association, see Friesel, *The Zionist Movement*, 28. On Szold's positions in the Zionist Organization of America, see ibid. 123–4, 144. On her activity in the women's arena, see Dash, *Summoned to Jerusalem*, 37. On her speech at the international women's congress, see Kutscher, 'The Early Years of Hadassah', 66; Kuzmack, *Woman's Cause*, 100.

In the early 1920s, when she was over 60 years old, Hadassah sent Henrietta to Palestine. After three years she returned briefly to the United States, but in 1925 went back to Palestine, where she lived until her death in 1945. There she served as a mediator between the Yishuv and various American Jewish organizations, and as a point of contact with the wealthy American Jewish individuals who sponsored Hadassah's work. She directed wide-ranging activity in the fields of health and medicine, social work, and education, and became a well-regarded figure in the Yishuv, particularly in its women's circles. However, in her thinking and the work ethic that she tried to bring to Palestine, she remained an 'apostle of Americanism'.[40] She dedicated the last twenty-five years of her life to strengthening the Yishuv and gave it the best she could give: American connections, American technology, and American ideas, which were considered at the time to be the most advanced in the spheres of medicine, education, and welfare.[41]

Henrietta Szold was deeply involved in the development of all aspects of Hadassah's activity in Palestine. Among other things, she aspired to develop professions that did not yet exist in the Yishuv, many of them considered 'women's professions' in the United States, such as nursing, nutrition, and social work. She tried to recruit members of these professions in the United States for work in Palestine, and sent people from the Yishuv to study the professions in the United States. In this way, for example, she established the profession of nutrition and home economics in Palestine, as described below.

'The mother of social work in Israel' began to display an interest in social work in Palestine as early as 1913, at which time she wanted to devise a programme for organizing this sphere. In 1931, after the Va'ad Leumi (the governing body of the Yishuv) decided to establish its own department of social work, she was invited to join the its executive board and head the new department. Envisioning a modern, professional social service system, she faced strong opposition from the Yishuv and its leaders. Nevertheless, she set about acquiring knowledge of the methods employed in the field of social work both in Europe and in America, consulting with professionals and volunteers from Germany, the Netherlands, and the United States, and learning from the experience of the social services in the United States, Germany, and Austria. Later in 1931 she submitted to the Va'ad Leumi her plan for setting up a department following the principles of family consultation—an American field of specialization that was known in some European countries but not in Palestine. The method was based on professional work and organized training, and therefore she felt it was necessary to establish a school for social

[40] See Brown, *The Israeli–American Connection*, 134.
[41] Brown, 'Henrietta Szold's Progressive American Vision', 80.

workers. To this end she invited the social worker Siddy (Sidonie) Wronsky, who had taught in a school of social work in Berlin, to emigrate to Palestine and establish the Va'ad Leumi's school of social work. The school was set up and run by Wronsky, whose professional background lay in Germany, but it was greatly influenced by developments in the field of social work in the United States.[42]

The department Henrietta Szold founded, and headed for several years during the 1930s, was intended to organize official social services across the Yishuv and to direct the multi-faceted social work and volunteer activity that was carried out in the community. She also headed Youth Aliyah, the movement founded to rescue Jewish children and youngsters from hardship, persecution, or deprivation, and give them care and education in Palestine, from 1935 until she died in 1945. She took a particular interest in the problems of immigrant youth in the Yishuv, which was the central focus of social work in the community in that period, and tried to raise awareness among women and the public in general of the problems faced by these youngsters. She also invented and implemented the idea of annual social work conferences, which were held in the Yishuv every year from 1932, to discuss current social problems. These meetings were intended to draw the general public's attention to social questions and increase awareness of the idea of social work.[43]

The other founders of Hadassah also came from the German Jewish community in the United States. Most of them were born in the last three decades of the nineteenth century into well-established middle-class homes; some were members of wealthy, influential families.[44] Almost all of them were college graduates; some were social workers, others were teachers. Education and writing were their main fields of interest.[45] As noted above, this combination of professional backgrounds, which was common among professional women in early twentieth-century America, fitted well with Hadassah's two major fields of involvement—health services in Palestine and Jewish education in the United States—and it is possible that it influenced their choice of direction for the new organization.

Gendered Zionism

The founders of Hadassah wanted to launch a concrete project immediately. They sought to serve several aims: to fulfil women's nature and needs, as they under-

[42] Deutsch, 'The Development of Social Work' (Heb.), 142–3, 417; Dash, *Summoned to Jerusalem*, 225–8; Lotan, 'Henrietta Szold as a Guide' (Heb.), 207–8; Gelber, *A New Homeland* (Heb.), 450; Weiss et al., 'Development of the Social Work Profession' (Heb.), 137.

[43] Deutsch, 'The Development of Social Work' (Heb.), 170, 173, 189; Dash, *Summoned to Jerusalem*, 226.

[44] For biographies of the founding leadership, see Kutscher, 'The Early Years of Hadassah', 77–113.

[45] Ibid.

stood them, following feminist (especially social feminist) thought of the time; to respond to the need for health services in Palestine; and to create a distinct role for women in the Federation of American Zionists (FAZ). It was considered inappropriate for the Daughters of Zion women's societies (which were then part of the FAZ) to participate in the federation's main sphere of activity, that of politics and ideology. The women were not even asked to pay dues—the so-called 'Zionist shekel'—and therefore were not members of the World Zionist Organization (WZO).[46] Far from contesting this exclusion, the founder leadership of Hadassah sought an alternative path in accordance with contemporary social feminist views, among them the belief that women are more suited to engagement in practical matters than to debate on ideas and ideology. Applying this distinction within the context of Zionism, the founders felt that Hadassah should avoid 'wasting energy on arguments' and political debates, and concentrate on concrete tasks.[47] Specifically, men were considered more suited to dealing with the political aspects of nation-building, women to dealing with daily educational and medical work, especially with children. Within the Zionist context, a key concept was that women had special abilities and fields of interest that enabled them to contribute to the cause in equal degree to men, but in different fields.[48]

Until the mid-1920s the leaders of Hadassah disseminated these ideas on the gender-based division of responsibilities both among the members of the organization and outside it. The notion of distinct roles for men and women struck a chord with many Jewish women in this period. Mary McCune claims that the promulgation of these gender-orientated ideas made it possible for Hadassah to recruit non-Zionist women to its ranks, and was among the factors that made Hadassah an important element of the American Zionist movement during the 1920s. Even in this early period of their activity, the leaders of Hadassah saw their medical work as the exclusive, special contribution of American Jewish women to the Zionist movement.[49] These views of the founders were imprinted upon the organization for generations to come. In particular, their decision to deal only with activity that was perceived as practical, and as far as possible to avoid political involvement, remained the official policy of Hadassah until the early 1940s, when the organization made a late entrance into Zionist political activity as a result of the

[46] McCune, 'Social Workers in the Muskeljudentum', 137.

[47] For the quotation, see Kutscher, 'The Early Years of Hadassah', 330. On the common views regarding the physical and psychological bases of differences between men and women, see Rosenberg, *Beyond Separate Spheres*, 76; on perceptions about cognitive differences between men and women, see O'Neill, *Feminism in America*, 70. [48] McCune, 'Social Workers in the Muskeljudentum', 159.

[49] McCune, 'The Whole Wide World', 91, 96.

special circumstances of the Jewish people during the late 1930s and 1940s. Even at that time, however, politics formed only a part of the organization's work.

Another central idea in the overall philosophy developed by Hadassah's leaders, and one which served as a metaphor bonding together all the organization's enterprises in Palestine, was the idea of Hadassah taking care of the Yishuv like a mother raising her children by providing for the health, education, and welfare of its people in general and of its children specifically.[50]

This idea also drew its inspiration from the American feminist sphere. The historian Molly Ladd-Taylor claims that motherhood was a unifying factor for extensive public activity by women during the nineteenth and twentieth centuries, and during the Progressive period it even had a political dimension. 'Maternalistic reformers' in the United States came primarily from among educated middle-class women volunteers, and among them were also the initiators of the settlement house movement. According to the historian Erica Simmons, Hadassah actually was doing in Palestine what non-Jewish American women (and, as mentioned above, some Jewish American women too) did in America.[51]

A further strand in the appraisal mentioned above was an emphasis on the practicality and realism of women in general, and of Hadassah in particular, in comparison with men. These characteristics are what made 'getting things done' one of the principal hallmarks of all the generations of Hadassah.

Another principle that made its mark on Hadassah's policy until the early 1940s was pacifism, which was very widespread among members of women's organizations in the United States in the first two decades of the twentieth century. Some of the founders of Hadassah, Henrietta Szold among them, were pacifists.[52] This tendency gained force as, over time, the ideology of social feminism was extended to the realm of relationships between peoples. The militant branch of that movement urged that women, as the givers of life and the educators of young children, must work to increase harmony in the world in order to ensure the future happiness and security of those children. Accordingly, the political orientation of social feminism included the rejection of militaristic policies and chauvinism, and the embrace of peace and international solidarity.[53]

In keeping with these ideas, Hadassah was involved during the 1920s and early 1930s mainly with health and welfare activity in Palestine, and with Jewish education in the United States.

[50] Simmons, *Hadassah and the Zionist Project*, 51. [51] Ibid. 49–50.

[52] On pacifism, see Degen, *Peace Party*, 16; on the pacifist founders of Hadassah, see Shapiro, *Leadership*, 112.

[53] Gal, 'Hadassah and the American Jewish Political Tradition', 90.

HADASSAH'S FIRST HEALTH PROJECTS
IN PALESTINE

A Modest Beginning: Two Public Health Nurses

Hadassah's first involvement in health work in Palestine—which began under its previous name, Daughters of Zion—was in the field of public health. The public health movement in the United States, in which many women, both Jews and non-Jews, were involved, recorded notable achievements in the decade that preceded the establishment of Hadassah, particularly in the areas of mother and child health care. Those first years of the twentieth century saw several ground-breaking developments in this field: in 1902 the Jewish registered nurse Lillian Wald founded a health centre in the Lower East Side of Manhattan, renowned as the Henry Street Settlement House. This centre was operated according to the district nursing system, and was a model for many other such centres around the world. It was financed by Jacob Schiff, owner of one of the most powerful private investment banking houses in America and among the country's foremost Jewish leaders. In 1906 health inspections (for physical hygiene, lice, and the like) were made compulsory in every public school in Massachusetts; in 1909 the New York City government established the first child hygiene division in the United States; and in 1912 a federal department for children was founded. These innovations, in which many women were involved, among them Jewish women, helped prepare the way for Hadassah's first activities in Palestine.[54]

In early 1913, less than a year after the foundation of the organization and a year before its first convention, at which the definitive form of its name was chosen, the leadership decided that a health project should be undertaken for the benefit of women and children in Palestine. To put it into practice, the Daughters of Zion employed two Jewish public health nurses who had been trained in nursing schools in the United States: Rose Kaplan (1867–1917) of New York and Rae (Rachel) Landy (1885–1952) of Cleveland.[55]

Rose Kaplan had been born in Petrograd and had emigrated to the United States in 1892; after completing her training at the Mount Sinai Training School for Nurses in New York, she had served as a nurse in the Spanish–American War of 1898. Rae Landy, the daughter of a family of rabbis, had been born in Lithuania and

[54] Waserman, 'For Mother and Child', 253.
[55] Antler, *The Journey Home*, 105; Dash, *Summoned to Jerusalem*, 112; *The Maccabean*, 23/2 (Feb. 1913), 59, cited in Miller, 'A History of Hadassah', 86; see also Shvarts, *Clalit Health Fund* (Heb.), 49.

emigrated with her family to the United States. She studied in the first nursing class at the Jewish Hospital in Cleveland (later known as Mount Sinai Hospital) and graduated in 1911, after which she went to work in a hospital in Harlem, New York.[56]

The task with which these two women were charged was to go to Palestine and, beginning in Jerusalem, set up a network of health centres that would apply the visiting district nursing method. Henrietta Szold, the driving force behind the project, wanted to set up for the Yishuv a network of community centres, each of which would supply all the services required to ensure the welfare of a healthy community: health services in the schools; preventative medicine to safeguard against tuberculosis; infant and child well-being; and education about preventative medicine in general.[57] The model for these centres was the visiting district nursing system, as applied at the Henry Street Settlement House founded by Lillian Wald.[58] According to this method (based on the English model and adapted to local needs), the nurses resident in the settlement house covered a certain area within the city: going from house to house, attending exclusively to the poor, their job was not only to treat the sick but also to identify those who were needy and at risk. The main aim was to treat pregnant women and small infants and to prevent infectious diseases, but health education and social work were also important aspects of the nurses' task. Although Szold was also influenced by the Hull House community model established by Jane Addams in Chicago, she urged Kaplan and Landy to visit the Henry Street Settlement House in order to learn its methods in preparation for their journey to Palestine.[59] The nurses were instructed to 'devote themselves primarily to the needs of women and children', and, with this aim in mind, 'to organize the work of the midwives along the lines laid down by the State Legislature of New York and made effective through the activity of the Nurses' Settlement [Henry Street Settlement House]'.[60]

The project was funded by the American Jewish businessman and philanthropist Nathan Straus (1848–1931). The sole owner of Macy's department store

[56] For the details about the nurses, see Hyman and Moore, *Jewish Women*, i. 721, 791.

[57] Antler, *The Journey Home*, 105.

[58] For a description of the method as it was implemented at the Henry Street Settlement, see Eastabrooks, 'Larina Lloyd', 284–6.

[59] Rosen, *A History of Public Health*, 349–70; Adams, 'The Creation of Community Nursing' (Heb.), 86. On the two nurses' visit to this centre, see Antler, *The Journey Home*, 105; Bartal, *Compassion and Competence* (Heb.), 52; Simmons, *Hadassah and the Zionist Project*, 53.

[60] *The Maccabean*, 23/2 (Feb. 1913), 59, quoted in Miller, 'A History of Hadassah', 86; Shvarts, 'The Women's Federation for Mothers' (Heb.), 65.

in New York from 1887, he took a lifelong interest in public health, both in the United States and later in Palestine. It is estimated that he spent two-thirds of his fortune on various public health projects in Palestine.[61] In 1893 he had begun to establish a network for the distribution of pasteurized milk to mothers in New York, and at the time Hadassah was founded he was already engaged in philanthropic activity in Palestine. On a visit in 1912 he established in Jerusalem a soup kitchen and a health centre with three departments: for hygiene education, for eye diseases, and for bacteriology—the last of these to fight the plagues of typhus through immunization and biological pest control.[62] The next year Nathan Straus and his wife, Lina, were back in Palestine, accompanying Rose Kaplan and Rae Landy.[63]

In accordance with the settlement house tradition, upon their arrival in Palestine the two nurses found a place to live among the poor, in a small house in the Me'ah She'arim neighbourhood of Jerusalem. They hung a sign on the door that read 'American Daughters of Zion, Nurses' Settlement, Hadassah'. Beginning work in March 1913 and following the pattern established in the New York settlement houses, the nurses used their house both as a residence and as a clinic to serve the needy. Shortly after their arrival, Jane Addams paid them a visit, providing further evidence of their ties with the settlement house movement.[64]

In Jerusalem, the nurses worked in co-operation with several health agencies already present in the city, including the Rothschild Hospital, the Pasteur Institute, and the hospital for eye diseases run by the Czech-born Jewish ophthalmologist Dr Albert Ticho. Their centre concentrated on the organization of midwifery, education about health and hygiene, first aid, home visits to poor families, and checking students in the schools, particularly for early signs of trachoma.[65] Since the main problem affecting the women of Jerusalem was hunger, the centre provided food as well as medication. The medical care was administered by Dr Segal of Rothschild Hospital, and those suffering from eye diseases were treated by Dr Ticho.[66]

With the outbreak of the First World War in the late summer of 1914, the two nurses' activities were seriously disrupted. The Ottoman authorities were hostile to American citizens, despite the neutral position of the United States, and it became increasingly difficult for the nurses to continue their work. Rose Kaplan returned to the United States in January 1915 for a combination of family reasons and illness (probably breast cancer).[67] Rae Landy stayed in Jerusalem and continued to work

[61] Cohen et al., 'Straus'.

[62] Shvarts and Shehory-Rubin, 'Women's Federations for Mothers and Children' (Heb.), 52.

[63] Antler, *The Journey Home*, 105; Dash, *Summoned to Jerusalem*, 112; Shvarts, *Clalit Health Fund* (Heb.), 94.

[64] Antler, *The Journey Home*, 105. [65] Shvarts, 'The Women's Federation for Mothers' (Heb.), 65.

[66] Ibid. [67] Levy, *Chapters in the History of Medicine* (Heb.), 192.

with Dr Helena Kagan (1889–1978), a Turkestan-born Jewish doctor and pioneer of paediatric medicine in the Yishuv who had studied medicine in Switzerland and come to Jerusalem before the war. Only in September 1916, when conditions finally made it impossible for her to continue, did she close the centre and return to the United States.[68]

The American Zionist Medical Unit

In 1914, when the war broke out, there were sixteen hospitals in Palestine (ten of them Jewish), of which ten were in Jerusalem (five of them Jewish). There were two contributory regional workers' health funds (*kupot ḥolim*), one in Judea and one in Galilee, together employing dozens of physicians and pharmacists. Most of the funding for these services came from various foreign sources. With the outbreak of war and subsequent deterioration in contact between the Yishuv and its sources of support abroad there was a steady deterioration in health care, as in all areas of economic and social life. Medicine suffered acutely, with the Jewish community in Jerusalem hit hardest. Most of the hospitals and stores of medications were expropriated by the Turkish military government, and almost all of the doctors were recruited into the army. In the second half of 1916 an epidemic of typhus broke out in Palestine. It spread very rapidly, mainly among the Jewish population centres in Jerusalem, Jaffa, and Safed. Thousands died from the infection and many others of starvation and for lack of proper health care.[69]

In July 1916 the Zionist Executive (the executive committee of the World Zionist Organization) appealed to the Federation of American Zionists to organize urgent medical aid for the Yishuv. The request was referred to Hadassah, as it was known to have had some experience in health work in Palestine.[70] Hadassah began to organize a delegation, but was forced to call a halt when the United States entered the war in April 1917 and American citizens were prohibited from entering Palestine. Only in December 1917, shortly after the British had occupied Jerusalem, did Hadassah make its initial contact with the British government, in the effort to obtain permission for an American medical delegation to enter Palestine; and it was March 1918 before British approval was received.[71]

Under the auspices (but not the control) of Hadassah, and funded by the Joint Distribution Committee (known in the US as the JDC, but in Europe as 'the Joint') based in New York, a large group of health workers, the American Zionist Medical

[68] Antler, *The Journey Home*, 105; Levy, *Chapters in the History of Medicine* (Heb.), 176, 192.
[69] Shvarts, 'Who Will Treat the People of Palestine?' (Heb.), 326–7. [70] Ibid. [71] Ibid.

Unit (referred to hereafter as the Medical Unit) arrived in Palestine in the summer of 1918. Its forty-four professionals included specialist physicians (dermatologists, ophthalmologists, orthopaedists, pathologists, paediatricians, and others), dentists, twenty-two nurses, a pharmacist, a hospital orderly, a sanitation engineer/supervisor, and administrative staff. They brought with them thousands of boxes packed with over $25,000-worth of medical equipment and medications, also financed by the JDC, which allocated a budget of $400,000—a huge sum at the time—for the unit's operation.[72]

The Medical Unit was led by Dr Isaac Max Rubinow, who had been born in Russia but had acquired his medical training at New York University, and was an advocate for the promotion of social insurance in the United States. Dr Rubinow aside, all the members of the unit were young people (the oldest nurse was aged 25). Most had never been outside the United States and, though highly motivated, were not at all ready for the kind of mission that awaited them in Palestine.[73]

By these last months of the war the Yishuv was exhausted, in every sense. Of a community of 85,000 Jews before the war, only 57,000 were left after the expulsions, disease, epidemics, and hunger of the past four years, and their physical and mental condition was very poor.[74] From the moment it arrived in Palestine, then, the unit had to take urgent action. As well as providing immediate treatment where it was needed, towards the end of the year it spent time establishing hospitals in the central urban Jewish communities. In Jerusalem the Medical Unit revived the Rothschild Hospital as its central hospital in Palestine; in Jaffa it reopened the Sha'arei Zion community hospital, which had been closed the previous month at the end of the war. It also set up hospitals in Tiberias and Haifa, and a specialist hospital for tuberculosis patients in Safed. Clinics and laboratories were constructed as part of each hospital.[75]

When the Medical Unit reached Palestine, there was no nursing profession, in the contemporary sense, in the Yishuv. Nursing was practised by people trained in various ways: as European-trained *Feldschers*—paramedical practitioners—midwives, first aiders, and others. Such training as was given by physicians was very limited: they taught local women of low socio-economic status certain basic

[72] *Twenty Years of Medical Service in Palestine* (Heb.), 11–12; Shvarts, 'Who Will Treat the People of Palestine?' (Heb.), 322; id., *Clalit Health Fund* (Heb.), 50; Bartal, *Compassion and Competence* (Heb.), 27.

[73] Shvarts, 'Who Will Treat the People of Palestine?' (Heb.), 329.

[74] Shvarts, *Clalit Health Fund* (Heb.), 48.

[75] Shvarts, 'Who Will Treat the People of Palestine?' (Heb.), 330; *Twenty Years of Medical Service in Palestine* (Heb.), 12.

tasks. Thus there was no suitable nursing force for the needs of the unit, and as early as November 1918 it set up a school to produce registered nurses according to contemporary US practice.[76]

In addition to the hospitals, the Medical Unit set up public health projects: a department for health inspection and supervision, and infant welfare centres to monitor pregnant women and their newborn babies and educate mothers in child care according to currently accepted US norms. Later these centres became known as health welfare stations—a network of facilities known in Hebrew as Tipat Halav (literally, 'a drop of milk'). The unit also established nurses' training schools in Safed and Tiberias.[77]

Notwithstanding all the Medical Unit's efforts to address the health-care needs of the population, its relations with the Yishuv were not uniformly harmonious. Its American views, lack of understanding of the Yishuv's situation, and lack of knowledge of Hebrew all gave rise to problems in communication.

Initially, the Yishuv and its organizations welcomed the Medical Unit and its activities. The workers' health funds and the Jewish Medical Federation in Palestine (founded in 1912) hastened to form links with the unit in order to let it know what was happening in the health field in the Yishuv, and to put co-operation between them on a formal footing. However, the attempt to co-ordinate the activities of the Medical Unit with those of the health organizations of the Yishuv, and particularly to promote co-operation between the veteran doctors in Palestine and the members of the unit, was unsuccessful.

Dr Hillel Yaffe, at this time director of the hospital in Zikhron Yaakov and one of the leaders of the Hebrew Medical Federation in Palestine, who undertook to help the members of the unit integrate in Palestine, noted that the unit's doctors belittled his and his colleagues' vast practical experience, refused to include local doctors in their medical work, were patronizing with regard to medical skill, and rejected everything that had been done in the field of health in Palestine until then. The unit and the local physicians also clashed over the issue of Dr Rubinow's demand for adherence to American professional standards.[78] For their part, the members of the unit claimed that their attitude towards the Yishuv's doctors was based on their desire to uphold the medical standards and professional knowledge that they had brought from the United States, which were considered at the time to

[76] *Twenty Years of Medical Service in Palestine* (Heb.), 18; Zwanger, 'Foreign Prepared Jewish Nurses', 115; Bartal, *Compassion and Competence* (Heb.), 39; telephone interview, Nira Bartal, 24 Oct. 2001.

[77] Shvarts, 'Who Will Treat the People of Palestine?' (Heb.), 333–4; Bartal, *Compassion and Competence* (Heb.), 38. [78] Shvarts, 'Who Will Treat the People of Palestine?' (Heb.), 334.

be much higher than those prevailing in the Yishuv. In the face of this clash of attitudes, the relationship between the two medical communities remained formal but not practical, and no effective co-operation was achieved.[79]

A short while after the arrival of the Medical Unit in Palestine, the workers' parties of the Yishuv appealed to it with requests for help and assistance. However, the unit's doctors, headed by Dr Rubinow, responded to this by presenting force-ful demands—including an insistence on total submission, tantamount to self-denunciation—which were perceived as humiliating. The fact that because the members of the Medical Unit did not speak Hebrew the exchanges had to be held in Yiddish or by means of an interpreter exacerbated the tension. It quickly became clear that the workers of the Yishuv would not accept the medical help proffered by the unit, despite their severe medical problems, and that they preferred to develop independent health services that would meet their needs.

There was friction not only between the unit and the local doctors and workers' organizations, but also between the doctors and administrators within the unit. Tensions also arose concerning the work arrangements and salary framework as formulated by the director, and about whether the unit's doctors should be permitted also to work in private practice.[80]

The Hadassah Medical Organization

In 1920 British military rule of Palestine was replaced by British civilian govern-ment under the mandate granted to Britain at the Paris peace conference. This change in the form of governance called for a change in the form of the Medical Unit. From 1918 to 1920 the unit had operated as a temporary relief organization, with the aim of administering urgent medical assistance and providing treatment for pressing health problems. With the introduction of the British Mandate, the unit was asked to help establish a permanent health system for the Yishuv. This task, which by definition could not be carried out by a temporary organization, reinforced an earlier demand by the members of the unit that it be transformed into a permanent, autonomous institution. In September 1921, after a full year of dis-cussions, the Twelfth Zionist Congress, which convened in Carlsbad, decided to transform the Medical Unit into a body that would operate in Palestine as an in-dependent medical organization, directly under Hadassah: the Hadassah Medical Organization.[81] It remains to this day the umbrella organization which unifies all Hadassah medical services in Israel.

[79] Ibid.; Shvarts, *Clalit Health Fund* (Heb.), 110–25.
[80] Shvarts, 'Who Will Treat the People of Palestine?' (Heb.), 334.
[81] Ibid. 343; Shvarts, *Clalit Health Fund* (Heb.), 117; *Twenty Years of Medical Service in Palestine* (Heb.), 17.

The Mandate government adopted a policy of not interfering with the development of health services for the Yishuv. This policy was based on the assumption that Jews and Arabs alike should have access to a similar level of health care. The Jewish population had access to the services of the health funds, the Hadassah Medical Organization, financial aid from foreign organizations, and payments from the Yishuv itself, while the Arabs lacked all these. Consequently, the Mandate government considered itself obliged to concentrate its service provision on the Arab community and to limit its support of the Jews to encouragement in principle, on the assumption that they would continue to make provision for themselves. As a result of this policy, the growing Yishuv was forced to rely solely on its own means. The Mandate Ministry of Health focused its efforts on fighting malaria, while public health services in the Yishuv were handled almost entirely by the volunteer organizations that dominated this field from its emergence until the end of the Mandate. These were Hadassah and the health fund of the Histadrut, the General Federation of Labour, established in December 1920 on a basis put in place within the framework of the various workers' parties from 1912.[82]

The Hadassah Medical Organization also set up a network of clinics that provided medical care and preventative medicine, as well as infant welfare stations on an American model (discussed further below).[83] Working alongside Hadassah, the Histadrut Health Fund also began opening clinics, and in 1930, with help from Hadassah, it founded its first hospital in the Jezreel Valley, thus breaking Hadassah's monopoly in the field of hospital services. In 1930 building work began on Beilinson Hospital near Petah Tikva; it opened in 1936 and eventually became one of the major medical centres in Palestine.[84] Nevertheless, in the years immediately following the First World War and the establishment of the British Mandate, the Medical Unit and its successor, the Hadassah Medical Organization, constituted the only effective countrywide medical organization in Palestine, and made a vast contribution to the development of medicine and public health.[85]

Up to the beginning of the 1930s, Hadassah was responsible both for the hospital services of the Yishuv and for the majority of its public medical services. In the course of this work Hadassah introduced a more extensive use of modern medical equipment, such as the stethoscope and microscope, and the routine use

[82] Eliav, *The Jewish Community* (Heb.), 224; Gross, 'Economic Policy' (Heb.), 135–68; Kanivsky, *Social Insurance* (Heb.), 338, 344; see also Shvarts, *Clalit Health Fund* (Heb.), 53.

[83] *Twenty Years of Medical Service in Palestine* (Heb.), 17–19.

[84] Shvarts, *Clalit Health Fund* (Heb.), 91. [85] Levy, *Chapters in the History of Medicine* (Heb.), 183.

of bacteriological laboratories. It also established an X-ray institute for diagnosis and treatment, considered to be the best in the entire Middle East.[86]

Alongside the Histadrut Health Fund, new small health funds also began to emerge, such as the Popular (Amamit) Health Fund (1931) and the National (Leumit) Workers' Health Fund (1933).[87] The activities of all these health funds were restricted to medical remedial work; they did not offer preventative medicine, which remained the monopoly of Hadassah for the duration of the Mandate.[88] The Histadrut Health Fund saw Hadassah exclusively as a source of financial aid; Hadassah saw the health fund as a disorganized body that was incapable of operating effectively without its financial and organizational assistance. The jaundiced perceptions on both sides were an obstacle to their joint work, and a focus of much conflict.[89]

One particularly significant aspect of Hadassah's work at this time was providing medical care to new immigrants in Palestine. As early as 1920 and 1921 Hadassah undertook the treatment of the new arrivals from the moment they disembarked and throughout their first year in the country. A Hadassah physician checked the immigrants and assessed the condition of their health; special inspectors oversaw the sanitation and hygiene conditions in the camps set up to accommodate them before they dispersed around the country. Hadassah also financed the hospitalization of immigrants in government hospitals.[90]

[86] Bartal, *Compassion and Competence* (Heb.), 28–9.

[87] On the Popular Health Fund, see Shvarts, *Clalit Health Fund* (Heb.), 168; on the National Health Fund, see ibid. 172. [88] Ibid. 172. [89] Ibid. 117. [90] Levy, *Chapters in the History of Medicine* (Heb.), 181.

Hadassah, 1933–1947: Responding to Crisis

NAZISM, THE SECOND WORLD WAR, AND THE ZIONIST STRUGGLE

Hadassah Expands in Scale and Scope

The rise of Hitler to power in 1933, and the consequent challenge of coping with the problem of the Jewish refugees from Germany, led to an expansion both of Hadassah's activity and of the organization itself. In 1935 Hadassah became the US patron of Youth Aliyah, which had been founded in Germany in 1932 with the aim of facilitating the emigration of Jewish children and teenagers to Palestine.[1] Hadassah's decision to take on this responsibility was based not only on the pressing humanitarian need, but also on its own wish to find additional projects besides its health-care work in Palestine. The early 1930s saw a steep decline in the membership of Hadassah, as in that of other American Jewish organizations, as a result of the Great Depression, and its leaders reached the conclusion that its health projects in Palestine were not attracting enough members. In order to increase the size of the membership, they believed, it was necessary to take on another enterprise. This view gained support when the problem of German Jewish refugees arose: many women joined Hadassah because of this development and raised the question, which was also being put by some veteran members, whether good hospital care in Palestine was the most urgent priority on their agenda as Jewish women at this time.[2]

Among the leading figures in Hadassah in favour of taking on Youth Aliyah was Rose Gell Jacobs. One of Hadassah's founders, and its national president in 1930–2 and again in 1934–7, she was considered the organization's most important leader after Henrietta Szold. Rose Jacobs thought that Youth Aliyah would link Hadassah with the problems of world Jewry, and create a link between America, Europe, and

[1] Levin, *Balm in Gilead*, 124; Miller, 'A History of Hadassah', 318; Berman, *Nazism*, 35.
[2] Berman, *Nazism*, 35; Levin, *Balm in Gilead*, 121.

Palestine. Moreover, the work of Youth Aliyah was consistent with the first mission that Hadassah had adopted when it was founded: namely, practical and concrete work in Palestine for women and children.[3]

Hadassah's adoption of Youth Aliyah provoked a considerable response. Vast sums of money were rapidly donated, and in just two years from 1935 to 1937 Hadassah raised $250,000 for the project.[4] However, Hadassah's new role as fundraiser for Youth Aliyah in the United States met fierce opposition from the Zionist Organization of America. In the summer of 1935, during the Nineteenth Zionist Congress in Lucerne, an agreement was reached between the leaders of Hadassah, Rose Jacobs and Tamar de Sola Pool, and George Landauer, director of the Jewish Agency's Central Bureau for the Settlement of German Jews (of which the Youth Aliyah office was a part), that Hadassah would temporarily cover the living expenses of 100 children. When the leaders of the ZOA learned about this, some of them, led by Louis Lipsky, denounced the agreement. They argued that if Hadassah raised money independently on behalf of Youth Aliyah it would interfere with the work for the United Palestine Appeal, which the same year intended to have its own fundraising campaign, separate from the Joint Distribution Committee. Lipsky also alleged that the agreement breached a decision taken by the Zionist Congress that forbade Zionist organizations from engaging in separate fundraising appeals.

The Zionist Executive demanded that Hadassah cancel its agreement with Youth Aliyah, but the women leading Hadassah stood firm against the male Zionist establishment. They countered that the president of the Zionist Organization of America had seen the agreement previously and that two leaders of the organization, Nelson Ruthenberg and Lipsky himself, had known about the negotiations being held in Lucerne. Henrietta Szold supported Hadassah's position.[5] In the end, the agreement was signed, and was enthusiastically endorsed at Hadassah's annual convention at the end of 1935.[6]

The following years saw Hadassah grow into a mass organization, its membership swelling in response to a succession of revelations and events: the information that began to arrive in 1942 about the systematic murder of the Jews of Europe; the problem of displaced Jews at the end of the war; and the activities of the Zionist organizations in the United States to promote the establishment of a Jewish state. The number of members grew almost fivefold, from 54,200 in 1938 to nearly

[3] Antler, *The Journey Home*, 210. [4] Levin, *Balm in Gilead*, 124; Berman, *Nazism*, 36.
[5] Berman, *Nazism*, 35–6; Kadosh, 'Ideology vs Reality', 45. [6] Antler, *The Journey Home*, 210.

243,000 in 1948—a period that also saw a steep rise in the membership of the Zionist Organization of America. Until 1945, Hadassah was the largest Zionist organization in the United States: only in 1946–8 did the ZOA overtake it.[7] The growth in membership was also accompanied by a tremendous increase in contributions raised, a trend mirrored by all the Zionist and non-Zionist organizations in the United States at the time.[8]

Hadassah Enters Politics

From 1937 a gradual shift took place in Hadassah's policy that saw it beginning to engage in political activity. A significant contribution was made to this change by David Ben-Gurion, the Zionist workers' leader who would later be considered the architect of the Jewish state. Ben-Gurion served from 1935 until the establishment of the State of Israel as chairman of the executive of the Jewish Agency of Palestine and assumed an increasingly important role in shaping the policies of the Yishuv and of the Zionist movement. Aware that Hadassah was already not only the largest American Zionist organization but the one with the widest mass appeal, he worked for its 'political education' as part of his efforts to transform all American Zionists into a source of political power. By 1937, Ben-Gurion (who had lived in America during the First World War, after being expelled from Palestine by the Ottoman authorities) had already developed a close relationship with some of Hadassah's leaders, and it was to them that he first presented the plan to establish a sovereign Jewish state in Palestine.[9]

In the autumn of 1939, on the brink of the Second World War, a special emergency committee was set up in the United States by authorization of the World Zionist Organization. This Emergency Committee for Zionist Affairs (referred to hereafter as the Emergency Committee) was to draw together all the American Zionist organizations and had two main purposes: to ensure the existence in the neutral United States of a body that would assume the authority and functions of the WZO, which was located in London, in the event of its being unable to function

[7] Here the reference is to 'mass' as opposed to elitist. On the steep increase (from 43,000 to 250,000) in the membership of the ZOA between 1940 and 1948, see Halperin, *The Political World of American Zionism*, 212. For data, see ibid. 327. The data regarding Hadassah in Halperin are identical to those in the Hadassah Archives.

[8] See financial data for the years 1932–48 in Hadassah Biennial Report, 1949–51; on the increase in contributions raised by the other organizations, Zionist and non-Zionist, see the financial data in Halperin, *The Political World of American Zionism*, 212.

[9] On the entry into political activity, see Gal, *David Ben-Gurion* (Heb.), 83; on the factors contributing to the change of views, ibid. 83; on the presentation of the plan to establish a Jewish state, ibid. 107.

in war conditions; and to bring to the attention of the American public and political leaders the needs of Jews as a people and the role of Palestine in their future.

Hadassah joined the Emergency Committee immediately upon its establishment. About a year later, the Committee for Political Education and Public Relations was added to Hadassah's other National Board committees. However, despite these moves towards alignment with the Zionist establishment, within Hadassah's leadership it was a common view, owing much to the pacifist views of the founders, that the executive of the Jewish Agency—the political representative to negotiations on behalf of the Yishuv—was not doing enough to improve relations between Jews and Arabs. Hadassah energetically urged the Emergency Committee to address this issue.[10]

American Zionists as a whole attached great importance to Jewish–Arab relations in Palestine and, from the 1920s onwards, various different groups addressed this issue. However, of all the Zionist organizations in the United States, it was Hadassah that accorded the question most significance. The pacifist elements that had been present in Hadassah from the beginning continued to make their presence felt. In the 1930s a group of Hadassah leaders whose views were close to those of Judah Leon Magnes, then president of the Hebrew University, and of B'rith Shalom (the Peace Alliance), were prominent in the organization.[11] The most forceful Hadassah leader in B'rith Shalom was Rose Jacobs,[12] who as early as 1933 initiated Hadassah's establishment of a committee to study Jewish–Arab relations in Palestine. However, the Zionist Executive opposed the move and prevented further research. Rose Jacobs frequently confronted David Ben-Gurion on the subject of Palestinian Arabs.[13]

Another leading figure in Hadassah who focused on the problem of Jewish–Arab relations was Tamar de Sola Pool, Hadassah's president in the late 1930s and early 1940s. In 1940, under her leadership, Hadassah re-established a committee to investigate Jewish–Arab relations, called the Emergency Committee for Hadassah Projects. Chaired by Rose Jacobs, its original driving force, it also included among its active members Judah Leon Magnes and Professors Salo W. Baron, Oscar Janowsky, and Abraham Neuman, all of them very closely associated with Hadassah. The purpose of the committee was to crystallize Zionist policy on this

[10] Antler, *The Journey Home*, 205–15; Gal, *David Ben-Gurion* (Heb.), 84.
[11] Brit Shalom was an intellectual Zionist group which drew its members mostly from central Europe, with a few representatives from the English-speaking world.
[12] Shapiro, *From Philanthropy to Activism* (Heb.), 162; on Jacobs, see Antler, *The Journey Home*, 204–14.
[13] Shapiro, *From Philanthropy to Activism* (Heb.), 162.

key question by designing a compromise for Palestine that would allow the build-
ing of the Jewish national home to proceed but with the Arab population's consent.
The activities of the committee received much publicity after Mordecai Bentov of
the socialist Zionist youth movement Hashomer Hatzair (and later a member of
the Israeli government) published a study on constitutional developments in
Palestine. The report was distributed in America with the goal of promoting the
notion of a bi-national (Jewish–Arab) state in Palestine.[14]

In early 1941 Hadassah's work continued to reflect its established, moderate
political position: that is, it supported the political subordination of Zionism to
Britain's war against international fascism; strove for a compromise between the
Arabs and the Zionists; and was reluctant to call for an American Jewish contri-
bution to a Jewish army and to demand Jewish sovereignty in Palestine. However,
from this point onwards those who supported this position gradually found them-
selves outweighed,[15] and in November 1941 the change of course became explicit
when Hadassah, under the influence of Ben-Gurion and the militant faction of the
Zionist Organization of America, publicly declared its support for the establish-
ment of a Jewish commonwealth in Palestine.[16]

A few months later Hadassah, as one of the four largest Zionist organizations,
participated in the Extraordinary Zionist Conference of May 1942 held at the
Biltmore Hotel in New York after the extent of Nazi atrocities against the Jews of
Europe had become apparent. Here the split in the Hadassah leadership came into
the open. Rose Jacobs called for the delegates to refrain from making any explicit
resolution on the future of Palestine, thus setting herself in direct opposition to
both Chaim Weizmann and David Ben-Gurion. However, most of the participants
in the conference accepted Ben-Gurion's position, and officially Hadassah sup-
ported all eight clauses of the so-called Biltmore Programme that was accepted at
the conference. This included clear-cut political demands: the establishment of a
Jewish commonwealth in Palestine; annulment of the White Paper of 1939; and the
creation of a military force, in the form of Jewish units in the British army under a
Jewish flag, to fight the Nazis.[17] In the American Zionist arena, Hadassah's support
for the Biltmore Programme was understood as a turning point in its approach and
the point of departure from its traditional policy.[18]

[14] Shapiro, *From Philanthropy to Activism* (Heb.), 162. [15] Gal, *David Ben-Gurion* (Heb.), 120.
[16] Ibid. 196. The wording of the declaration is given in *Hadassah Newsletter*, 22/3 (Dec. 1942–Jan. 1943),
20, under the headline 'A Declaration of Principles Adopted by the Twenty-Seventh Annual Convention of
Hadassah'.
[17] On Hadassah's participation in the Biltmore Convention and its support for the Biltmore platform, see
Halperin, *The Political World of American Zionism*, 221. [18] Ibid. 223.

At this stage, the Hadassah leadership formed two groups, representing two generations: one, under the chairmanship of Rose Jacobs, which supported a bi-national state in Palestine, and the other, headed by Rose Halprin and Judith Epstein, which supported the Biltmore Programme. The summer of 1942 saw the beginning of the change of guard. Subsequently, the group that supported the Biltmore Programme and Ben-Gurion became dominant, and would lead Hadassah's policy in the years of the struggle for the establishment of the State of Israel.[19]

On the other side of the debate, the adoption of the Biltmore Programme brought together those who supported the bi-national solution in Palestine.[20] A short time after the Biltmore Conference, in August 1942, a body called Ihud was established in the Yishuv to promote this outcome: chaired by Judah Leon Magnes, it included Ernst Simon, Martin Buber, and Henrietta Szold among its members. Hadassah's Twenty-Eighth Annual Convention, held later in 1942, reaffirmed the support for the Biltmore Programme with a substantial majority and issued a statement against Ihud.[21] Both these decisions warrant special attention in the light of the fact that two of the leading figures in Ihud—Henrietta Szold and Judah Leon Magnes—were very closely associated with Hadassah

In the summer of 1943 the American Zionist leader and Reform rabbi Abba Hillel Silver took office as co-chair of the Emergency Committee, alongside Stephen Wise (also a Reform rabbi), and in the following years became the leading figure in the struggle of American Zionists to establish a Jewish state.[22] From that point on, Hadassah played an active role in the efforts of American Zionist organizations in this cause. Though Hadassah was not a leading party in the struggle, the effectiveness of the Emergency Committee under Silver in disseminating information was clearly reflected in its bulletin, the *Hadassah Newsletter*.[23] In 1944 a column that reviewed events on the Zionist political front began to appear regularly. From 1945 on, the newsletter devoted more space to the struggle for a Jewish state, and published reviews and extensive explanations of the political aims of American Zionism.[24] In November that year, the *Hadassah Newsletter* set out explicitly three

[19] Shapiro, *From Philanthropy to Activism* (Heb.), 172. [20] Ibid. 173.
[21] 'Hadassah in Convention', *Hadassah Newsletter*, 22/3 (Dec. 1942–Jan. 1943), 12; Dash, *Summoned to Jerusalem*, 298. [22] On the appointment of Silver, see Raphael, *Abba Hillel Silver*, 81.
[23] On Silver's leadership, see Urofsky, *A Voice*, 346; on the turnaround in the Zionist campaign in the US, see Oryan, 'The Leadership of Abba Hillel Silver' (Heb.), pt. I, 119.
[24] A few of the many examples are: 'Editorial: The Zionist Emergency Council', *Hadassah Newsletter*, 25/1 (Jan.–Feb. 1945), 3; 'Facing the Facts', *Hadassah Newsletter*, 27/5 (Aug.–Sept. 1947), 3); B. L. Sewer, 'Palestine before the United Nations', *Hadassah Newsletter*, 27/2 (Mar.–Apr. 1947), 5–6; 'Our Fight Begins', *Hadassah Newsletter*, 25/7 (Nov. 1945), 1.

political aims of American Zionism: '(1) To bring before the American public the urgency of immediate consideration of the Jewish problem in its post-war settings; (2) to mobilize Jewish and Christian support for Zionist objectives; (3) to move our Government to take concrete steps for the implementation of the positive stand on the Palestine question.'[25]

As the proportion of American Zionists in the world Zionist movement increased after the Second World War, so Hadassah's power in that movement also increased. Prior to the Twenty-Second Zionist Congress of 1946—the first to be held after the war, in Basel—Silver, as president of the Zionist Organization of America, urged the leadership of Hadassah to attend the congress as a single delegation with the ZOA, arguing that only by appearing as a united delegation could the American Zionists wield influence in the world movement. However, Hadassah's leaders, following their tradition of staunchly defending their own organization's interests, refused, for fear that their participation in a joint delegation would enable Silver to push his own views through on every point.[26]

In the event, for the first time in its history Hadassah attended the congress as a separate delegation of 28 (out of a total 378 delegates to the congress). The most prominent American delegation was that of the ZOA. Later Rose Halprin of Hadassah was one of the five Americans elected to the Zionist Executive Committee.[27]

The year 1946 saw a new intensity in the political struggle for the establishment of a Jewish state, and a climax in the growth of the different organizations in the Zionist movement. Leading figures in Hadassah played various roles in the campaign. As early as the beginning of that year, Judith Epstein represented Hadassah on the Anglo-American Committee and Rose Halprin was elected a member of the American Division of the Jewish Agency Executive in New York.[28]

Of the various components of the Emergency Committee, Hadassah was the most moderate.[29] Rose Halprin, the pre-eminent political leader of Hadassah at this time, opposed Silver's approach, supporting instead the more moderate line of

[25] 'Our Fight Begins', *Hadassah Newsletter*, 25/7 (Nov. 1945), 1. [26] Urofsky, *We Are One*, 117.

[27] On the Hadassah delegation to the 22nd Zionist Congress, see Hadassah Annual Report, 1948; Urofsky, *We Are One*, 117–18. On the election of Halprin to the Zionist Executive Committee, see *American Jewish Yearbook 1946*, 254.

[28] See Oryan, 'The Leadership of Abba Hillel Silver' (Heb.), pt. 1, 109–11, pt. 2, 375; testimony of Judith Epstein to the Anglo-American Committee (8 Jan. 1946), reviewed in 'Hadassah Testifies', *Hadassah Newsletter*, 26/1 (Jan.–Feb. 1946), 5–6, 31. On the appointment of Halprin as a member of the American Division of the Jewish Agency Executive in New York, see Oryan, 'The Leadership of Abba Hillel Silver' (Heb.), pt. 2, 375. [29] Gal, *David Ben-Gurion* (Heb.), 83.

action advocated by Wise.[30] For example, she argued against Silver's proposal to persuade the Jewish electorate to vote as a bloc against the Democratic administration in the 1946 US congressional elections in order to punish the government for its reluctance to exert pressure on Britain to change its position on Palestine. Nevertheless, the president of Hadassah, Judith Epstein, and some of the rank-and-file members did back Silver's more belligerent line.[31]

Also in 1946, at its own Thirty-Second Annual Convention, Hadassah declared that 'only the establishment of *a Jewish State* can meet the immediate needs of the Jewish people in Europe and elsewhere and ensure a solution of the root problem of Jewish minority status and the homelessness of the Jews as a people'. The women of Hadassah declared their deep consciousness of 'the unspeakable tragedy which has befallen the Jews of Europe, and of the desperate and continuing misery and homelessness of large numbers of those who have survived [the Holocaust]', and announced that they looked 'to the World Zionist Congress to determine a course which shall secure the immediate establishment there [in Palestine] of an *independent Jewish State*'.[32] Accordingly the leaders of Hadassah called upon the organization's rank-and-file members to take energetic political action in the United States.[33]

Rose Halprin was assigned, along with Hayim Greenberg of Po'alei Tsion, to promote co-operation and co-ordination among the major Jewish organizations in the United States.[34] The convention also adopted a resolution to recommend that the Zionist organizations in the United States co-ordinate their activities and to urge the American government to put a stop to the 'oppressive' British rule of Palestine; it expressed appreciation for President Truman's efforts to persuade the British government to allow the displaced Jews to enter Palestine.[35] For the first time since Hadassah was founded, a formal change in the aims of the organization (as set down in its constitution) was approved, with the original two being augmented by a third: 'To promote the establishment of a legally assured, publicly secured home for the Jewish people in Palestine.'[36]

[30] Urofsky, *We Are One*, 129; see also Ganin, *Truman*, 102.

[31] See Ganin, *Truman*, 102; Oryan, 'The Leadership of Abba Hillel Silver' (Heb.), pt. 2, 356.

[32] 'Jewish State', resolution adopted at the 32nd Annual Convention of Hadassah, Boston, 1946, HA, RG3, ser. Proceedings, subser. 32nd/33rd Conventions, box 13 (emphasis added). By permission of Hadassah, The Women's Zionist Organization of America, Inc. [33] Ibid.

[34] Oryan, 'The Leadership of Abba Hillel Silver' (Heb.), 427. [35] *American Jewish Yearbook 1946*, 251.

[36] 1947 Constitution, HA, RG17.

At Hadassah's Thirty-Third Annual Convention, in November 1947, a debate broke out about the partition plan proposed that month by the United Nations Special Committee on Palestine, which made provision for both a Jewish and an Arab state, with Jerusalem placed under international authority. Nahum Goldmann and Abba Hillel Silver came to the convention and presented reasons for and against the partition, respectively. After hearing the arguments, the convention decided to issue a statement in favour of the establishment of a Jewish state, without any commitment to support or oppose the plan for partition.

Hadassah's Educational Work in the United States

Hadassah's political activity in the three years between the end of the Second World War and the establishment of the State of Israel was only part of its overall programme. Another part, which the organization saw as one of its central roles, was the education of its members along Jewish and Zionist lines. By late 1947 every chapter of Hadassah was running a 'study group' that met regularly. In the Hadassah national office in New York, an Education Department and an Education Committee of the National Board were assisted by an advisory committee of experts in different areas of Jewish studies. The Education Department prepared study material that was distributed for a nominal fee to Hadassah chapters throughout the United States. The range of subjects covered included Jewish history, Zionism and the Yishuv, the Jewish community in the United States, the Bible, current issues within Judaism, the Hebrew language, Hadassah projects in Palestine, and Zionist political parties. Twenty-five publications were reported as being issued, with more in preparation.[37]

HADASSAH'S PROJECTS IN PALESTINE FROM THE EARLY 1930S TO THE ESTABLISHMENT OF THE STATE

A Shift in Emphasis

Parallel to these changes in the American scene, changes were also taking place in the 1930s in Hadassah's projects in Palestine. During these years Hadassah began systematically handing over the hospitals it had established outside Jerusalem—in Tiberias, Haifa, and Tel Aviv—to authorities in the Yishuv, in particular the municipalities and the health funds.[38] The intention behind this 'devolution policy'

[37] Hadassah Annual Report, 1948, 46–7.
[38] Niederland, 'The Influence of the German Immigrant Doctors' (1983) (Heb.), 144.

was twofold: to encourage the Yishuv to be self-sufficient, and to enable Hadassah to undertake new projects.[39] The policy ran in parallel with another change: development of medical work of an academic, scientific nature, as opposed to medical services orientated towards the immediate benefit of individuals in society. This trend was facilitated by the accelerated development during the 1930s of the Histadrut Health Fund, which took over a considerable segment of medical care in Palestine, thus enabling the Hadassah Medical Organization to concentrate on the fields in which it was the sole provider of services.[40] This change in the nature of its activity was consonant with the approach that guided Hadassah's activity in Palestine, namely that science should be harnessed to the service of medicine.

From this period onwards Hadassah invested most of its efforts in Jerusalem, and particularly in the Rothschild Hospital, rather than attempting to spread its work throughout Palestine, as it had in the 1920s. In 1939 the hospital, for which Hadassah bore direct managerial and financial responsibility, became affiliated with the Hebrew University, and was renamed the Hadassah Meir Rothschild University Hospital (referred to here as the Rothschild-Hadassah University Hospital). The hospital was now intended to function as a teaching institution and was consequently relocated near the Hebrew University campus on Mount Scopus.[41] However, Hadassah retained authority over its public health services, which were spread throughout Palestine. Only in 1952 did it devolve most of these services (with the exception of those in Jerusalem and the Jerusalem Corridor) to the authority of the Israeli Ministry of Health (see Chapter 9).

From the founding of the Hadassah Medical Organization until the late 1920s, Rothschild Hospital had been managed by American Jewish doctors.[42] Then, in 1929, Henrietta Szold appointed Dr Haim Yassky (1886–1948) as director general of the hospital and head of the Hadassah Medical Organization, on the authority of her position as head of the health department of the Va'ad Leumi. Dr Yassky was a young ophthalmologist who had acquired his medical education in Odessa before emigrating to Palestine as a pioneer.[43] This was the first appointment of a person not of American origin to a key position in Hadassah.

From the 1920s on, Rothschild Hospital was considered the best hospital in Palestine. It gained this reputation through its high standards of medical treatment, its having certain departments that were unique in Palestine, and the pro-

[39] On the devolution policy, see *Twenty Years of Medical Service in Palestine* (Heb.), 24.
[40] Niederland, 'The Influence of the German Immigrant Doctors' (1983) (Heb.), 144.
[41] Niederland and Kaplan, 'The Medical School' (Heb.), 145–6.
[42] Shvarts, *Clalit Health Fund* (Heb.), 94.
[43] Dash, *Summoned to Jerusalem*, 208; Shvarts, *Clalit Health Fund* (Heb.), 186.

fessionalism and scientific expertise that characterized the medical services it provided.[44] During the 1930s, the expulsion of Jewish physicians and scientists from their universities and places of work in Germany, and then the impossibility of their remaining safely within Germany at all, enabled Yassky, who aspired 'to create a medical institution that would be famous far beyond the boundaries of Palestine',[45] to recruit eminent individuals in various medical fields—sometimes upon their arrival in Palestine, sometimes before they had left Germany. Among them were Professor Ludwig Halberstaedter, an internationally acclaimed expert in cancer treatment from Berlin, and a well-known gynaecologist, Dr Hermann Zundek. They, and others like them, were expected to combine treatment in the hospital with scientific research under the auspices of the Hebrew University.[46] Meanwhile Hadassah, in co-operation with the university, dealt with the physical and organizational construction of the medical centre within which they would work.

The arrival of these immigrant physicians from Germany not only contributed to the growing prestige enjoyed by the hospital but also shifted its focus away from social and preventative medicine towards the more scientifically advanced approach and concerns prevalent in the institutions from which they had come. Thus, for instance, in 1933 Hadassah set up the first institute of its kind for radiology and cancer research under Professor Halberstaedter, which became a national and quickly also a regional centre for the treatment of malignant tumours.[47] The control established over the hospital wards by the German Jewish immigrant doctors led to a change in the nature of the health services provided by Hadassah in Palestine, associating the flagship hospital with 'scientific' specialist medicine,[48] and thus contributing to the elitist image it acquired during this period.

The Establishment of the Medical Centre on Mount Scopus

The hospital's rise to elite status was given additional impetus by its move in 1939 into a new medical centre at Mount Scopus in Jerusalem. This centre was conceived on a current US model, incorporating a hospital, a nursing school, medical research facilities, and a medical school under one roof.[49] The modern building was

[44] Niederland, 'The Influence of the German Immigrant Doctors' (1983) (Heb.), 144. [45] Ibid.
[46] Ibid.; Gelber, *A New Homeland* (Heb.), 444; Levin, *Balm in Gilead*, 154–5; Ben-David, 'Socialization', 74.
[47] Niederland, 'The Influence of the German Immigrant Doctors' (1983) (Heb.), 144; on the radiology institute, see Gelber, *A New Homeland* (Heb.), 442; Bartal, *Compassion and Competence* (Heb.), 31.
[48] Niederland, 'The Influence of the German Immigrant Doctors' (1983) (Heb.), 144.
[49] Shvarts, *Kupat Holim, the Histadrut and the Government* (Heb.), 30.

planned and equipped by American experts for the purposes of both applied medicine and research, and it was located close to the Hebrew University, which already had a department of biology and science, and employed many immigrant scientists from central Europe.

The idea of the medical centre had been raised as early as 1925, but various obstacles delayed its approval until 1932, among them the need to gain the support of the Mandate government and of the Rothschild family (which owned the old hospital at Hanevi'im Street).[50] As a result, it was not until 1934 that Hadassah was able to lay the foundation stone of the building.

The Mount Scopus medical centre was the only hospital in Palestine conducting medical research. In the years preceding the Second World War a bitter controversy had arisen in medical circles within the Yishuv on the issue of whether, in addition to their work treating hospital patients, doctors should also conduct medical research. Many in the Yishuv argued strongly that the most important duty of doctors was to take care of the medical needs of the population, and that there was no place in the community's hospitals for medical research. On the other side of the argument, Yassky and the German immigrant doctors claimed equally vehemently that the role of a hospital was not only to provide medical services but also to serve as a centre for study and research.

This question was vigorously debated not only in respect of the Mount Scopus centre but also in the context of Beilinson Hospital, opened in 1936 by the Histadrut Health Fund. The immigrant doctors argued that the health fund should invest its budget in a large hospital with 1,000 beds and facilities for university research, and that the outpatient clinics should be operated by the hospital to ensure that they had access to the innovations of the medical profession. However, the health fund preferred, for both ideological and practical considerations, to establish small dispensaries, and therefore rejected these proposals. As a result, Beilinson Hospital was established as, and remained, an institution for treatment only, and medical research was not conducted there.[51]

The new medical centre on Mount Scopus became home not only to the renamed Rothschild-Hadassah University Hospital, the largest hospital in Palestine,[52] but also to the Hadassah Nurses' Training School, the university's medical school for in-service training and research known as the Parafaculty of Medicine, and the Hebrew University's research laboratories.[53]

[50] Ibid. [51] Ibid. 29–3 [52] Ben-David, 'Socialization', 74.
[53] Miller, 'A History of Hadassah', 277; Niederland and Kaplan, 'The Medical School' (Heb.), 145.

The Hadassah Nurses' Training School

As noted above, the only training of nursing staff in Palestine at the beginning of the twentieth century was that given by doctors instructing women from the lower social classes in the specific tasks that were needed. For example, Dr Helena Kagan relates in her memoirs that in the early years of her medical work in Palestine she gave nursing training to Jewish and Arab girls, and the ophthalmologist Dr Ticho taught local women how to perform eye tests.[54]

As early as 1918 the Medical Unit sent to Palestine under the auspices of Hadassah had founded a school in Palestine to produce registered nurses on a US model. This institution, located at various places near to the hospital, became the first Jewish post-high-school training school for women in any profession in the Yishuv. The only one in its field in Palestine until 1936, it served as a model for others that began to emerge after that date, and remained Palestine's leading institution for training nurses throughout the Mandate period. Later it played a significant role in shaping the nursing profession in Israel.[55]

The establishment of the school in a vacuum, from the professional point of view, enabled its leaders and Hadassah to develop the nursing profession in Palestine according to their own ideas. It was through the work of this school that, from the early 1920s, nursing in Palestine became a profession in its own right.[56] This reflected the situation in the United States (where, as noted above, it was one of the first women's professions), in contrast to the approach prevalent in continental Europe, where a nurse was viewed merely as a doctor's assistant. The latter approach stressed the practical and necessarily limited skills of patient care, while the former also attached importance to theoretical knowledge in a wide variety of relevant subjects.[57] The contrast between the two can be illustrated by a comparison between the Jewish school of nursing established in Warsaw in 1922 under an American system by the Joint Distribution Committee, as part of its aid to the rehabilitation of Polish Jewry after the First World War, and the schools of nursing in Vilna and Kovno, managed by doctors. The Warsaw school, founded on the American guiding principle that nursing was a separate profession, had a degree of independence from the hospital, and the students, even though they were employed in the hospital, studied the theoretical and practical aspects of nursing

[54] Bartal, 'Establishment of a Nursing School' (Heb.), 274.

[55] On the foundation, see *Twenty Years of Medical Service in Palestine* (Heb.), 18; on the other information, see Bartal, *Compassion and Competence* (Heb.), 10, 24, 227, 349.

[56] Ben-David, 'Professionals and Unions'. [57] Bartal, *Compassion and Competence* (Heb.), 353.

according to a compulsory curriculum. The schools in Kovno and Vilna, in contrast, were managed by doctors who emphasized conservative goals, such as assisting the doctor and maintaining hygiene.[58]

The American system was strongly influenced by the work of Florence Nightingale, the founder of modern nursing, who had set up a school for training nurses in London in 1860, and the resemblance between the American and British approaches facilitated the establishment of an 'American' nursing school under the British regime in Palestine.[59] As the school developed, its leaders, and Hadassah's, strove to establish it as a first-class training institution on the model of the best in the United States.[60]

The American influence in the Hadassah Nurses' Training School was felt in the curriculum, the teaching methods, the requirement for key figures at the school to have taken advanced studies in the United States, and the use of American books and periodicals.[61] Following the practice in American nursing schools, there was a greater emphasis on theoretical as well as practical instruction than was the case in the European tradition. This is evident from a list of the subjects studied by the trainees from 1935 onwards, which included psychology, bacteriology, pathology, anatomy and physiology, sociology, pharmacology, chemistry, and English, as well as internal diseases, eye diseases and other specific ailments.[62] The school aimed to enable its graduates to meet the professional standards required by the state of New York in order to gain a certificate as a registered nurse in the state, which at the time was one of the most advanced in America in the field of nursing.[63]

The tendency towards the Americanization of nursing education was dominant in the school, but it also had its opponents. Most of the clinical and medical teaching in the school was done by doctors who were staff members of the Rothschild (later Rothschild-Hadassah University) Hospital and founders of the various medical disciplines at the Hebrew University. The majority had been trained in European schools, and from the outset some of them argued that the school should follow the European tradition or criticized the character of American nursing education.[64] Throughout the Mandate period there were power struggles in the school that reflected, among other things, the conflict over the proper training and role of the nurse.

[58] Bartal, 'Establishment of a Nursing School' (Heb.), 283–4.
[59] Bartal, *Compassion and Competence* (Heb.), 227. [60] Ibid. 351–2.
[61] Zwanger, 'Striving for Higher Education' (Heb.), 9; Bartal, *Compassion and Competence* (Heb.), 149, 230, 351. [62] Bartal, *Compassion and Competence* (Heb.), 379–81.
[63] Ibid. 230, 353; see also 54–5. [64] Ibid. 40.

Other factors also had an impact on teaching at the school—in the first instance the need to adapt the curriculum to the regulations of the British regime. Another major factor was the changing nature of circumstances there, which underwent many shifts in the course of the thirty years between the establishment of the school and the end of the Mandate as the Yishuv grew in size and strength, social conditions changed, and the health of the population improved. Local nursing knowledge also developed over this period. Thus, over time, the American tendencies that had dominated the school at the outset were gradually adapted and adjusted to conditions in Palestine, and also blended with the European and British approaches.[65]

The Nurses' Training School was also influenced by Zionist ideology, and became part of what was called 'the Zionist revolution' in Palestine. It was the first school of nursing in the world where the language of instruction was Hebrew. The decision to use Hebrew—in response to pressure from the students—caused serious problems, for neither the American teachers nor the students themselves, most of whom were immigrants from eastern Europe, had a good grasp of the language, and medical terms in Hebrew scarcely existed in the early 1920s.[66]

The key figures in the Hadassah Nurses' Training School were also those who laid the foundations of the profession in Palestine. While they came from diverse cultural backgrounds, they all had professional training and experience in the American nursing system (one, indeed, was herself a graduate of the school). In view of the important role these women played both in the history of Hadassah and in creating the necessary infrastructure for the emergence of a definitively female profession in Palestine and, later, Israel, it is worth looking at a few of them individually.

The first of these key figures was Henrietta Szold herself, the 'spiritual mother' of the school (although she was never its director), who shaped its ideology as the 'spearhead of American nursing' in Palestine. She remained involved in the life of the school for many years in various fields.[67] The woman who took over from Henrietta Szold, becoming the first official director of the Nurses' Training School in 1920 and holding the post until 1927, was the American Jewish nurse Anna Kaplan. She made a significant contribution, particularly in pressing for the recognition of nursing as a profession in Palestine. Born in Bialystok, Poland (then part

[65] Bartal, *Compassion and Competence* (Heb.), 64, 353; on adaptation to conditions in Palestine, ibid. 24, 40, 353; on the contrast between the US and British/European approaches, ibid. 59.

[66] Ibid. 79; *Twenty Years of Medical Service in Palestine* (Heb.), 18.

[67] Bartal, *Compassion and Competence* (Heb.), 158.

of the Russian empire), in the late 1880s, Anna Kaplan emigrated to the United States as a young girl. A few years later she began studying at the nursing school attached to the Lebanon Hospital (known today as Bronx-Lebanon Hospital) in New York City. She completed her studies in 1910 and received a licence to practise as a registered nurse from the Board for Nursing of the State of New York.[68]

Anna Kaplan began her professional career as a night-time supervisor at the Lebanon Hospital; from there she went on to serve for two years as the head nurse at Liberty Sanatorium.[69] From 1914 to 1918 she worked as a public health nurse, and in the latter year set out with the members of the American Zionist Medical Unit for Palestine. She stayed for a long time compared to most of the twenty-two nurses in that original group: when she left the country in 1927, only three nurses from the original American Zionist Medical Unit remained in Palestine. Upon her return to the United States, she worked as 'directress of nurses' at Beth Moses Hospital in Brooklyn, New York. She never married, and spent her last years in Manhattan. Anna Kaplan died in 1960.

The third leading figure and the school's second director (1928–33), Hadassah Schedrovitzky-Sapir, was born in the Polish city of Łódź in 1898 and emigrated to Palestine with her family in 1913. After studying at an agricultural school in Petah Tikva she wanted to study medicine, but after the head of the Medical Unit appealed for more trainee nurses she agreed instead to specialize in nursing, where the need of high-quality recruits was deemed to be greater. She was a member of the first graduating class of the Nurses' Training School and the first to be sent for further training to the United States, where she spent the years 1922–3 studying.[70]

Shulamit Cantor (born Frieda Yadid Halevy) was director of the school from the end of 1934 to 1948. This assertive and resourceful woman became widely known as the leader and founder of nursing in Palestine. Born in Beirut (at that time in Syria) in 1894 to one of the leading families of the Jewish community there, she studied at the nursing school of the American University in her home city. An independent-minded young woman, having trained as a nurse she then wanted to emigrate to Palestine, an ambition which brought her into conflict with her parents since it was not considered proper at that time for a woman to leave her parents' home before marrying. Eventually a compromise was reached and she was sent to live with an uncle in Tel Aviv. Shortly after arriving in Palestine she was accepted as a teacher in the Medical Unit's school of nursing, thanks to her nursing training

[68] For the information on Anna Kaplan from this point on, see ibid. 152–5.
[69] It is not clear whether this institution was also in New York.
[70] Bartal, *Compassion and Competence* (Heb.), 155–6.

and her knowledge of Hebrew (which the students were required to learn before being accepted on to the course). One of her jobs was to liaise between those members of the unit who did not know Hebrew and the students.[71]

In 1921 Cantor left the profession after marrying a member of the Medical Unit, the sanitation engineer Louis Cantor, who was involved in the campaign to eradicate malaria. She continued to be a prominent presence in Jerusalem, however, moving in elite circles including members of both the American colony and the British administration. In 1933 her husband died suddenly, leaving her with four children. The following year she was appointed director of the Nurses' Training School and served in this position until July 1948. She spent the rest of her life in Israel and died in December 1979.

Two other figures who contributed significantly to the school during its formative years were Dr Haim Yassky, director of the Hadassah Medical Organization and head of the Rothschild Hospital (see also Chapters 8 and 9) and Bertha Landsman (see Chapter 10).

The establishment of the nursing profession in the Yishuv was arguably one of the most important of all Hadassah's achievements. The organization also made a substantial contribution, alongside the Hebrew University, to the formation of the medical profession in what was about to become the State of Israel (see Chapters 10 and 12); however, although it helped to develop that profession, it did not create it. The foundation of a nursing profession in Palestine, by contrast, and the character it assumed, may be credited in very large measure to Hadassah.

Preparations for the Establishment of the School of Medicine

The idea of setting up a university Faculty of Medicine in Palestine was raised as early as 1913, at the Eleventh Zionist Congress, which took the decision to set up a Hebrew University.[72] The Institute for Microbiology was founded in 1918 and the Parasitology Department in 1924, and in 1925 the university itself officially opened. Also in 1924, Hadassah entered into a collaboration with the American Jewish Physicians Committee (referred to hereafter as the Physicians Committee), a body that had been founded in 1921 in the United States on the initiative of Chaim Weizmann, with the aim of establishing a medical faculty at the university. That same year the two organizations opened an X-ray institute, which remained for many years the only one of its kind in Palestine. The Physicians Committee raised

[71] For the information on Cantor from this point on, Bartal, *Compassion and Competence* (Heb.), 247–9.

[72] Levin, *Balm in Gilead*, 225; Barshai, 'Preparations' (Heb.), 65.

considerable funds for the purpose of setting up a Faculty of Medicine, and acquired 30 dunam (3 hectares, or about 7.5 acres) of land for its construction on Mount Scopus, but the project did not move ahead immediately.[73]

Also in 1924, the first contacts were made for the purpose of raising money to build what was to become the Rothschild-Hadassah University Hospital.[74] From this point, the history of the hospital became intertwined with that of the Hebrew University. A year later, Hadassah and the university founded a joint committee with the aim of raising a million dollars to fund the construction of both a Faculty of Medicine at the university, including a transformed university hospital, and a network of hospitals across Palestine. In 1927 Hadassah and the university agreed upon principles for close co-operation with the aim of promoting medical research and education in Palestine. The fundraising efforts ran into difficulties but continued into the early 1930s. Finally, in 1934, a plot was officially selected on which a complex was to be built to serve the purposes of both Hadassah and the Hebrew University.[75] Two years later the plans for a Faculty of Medicine took more specific shape when an agreement was signed between Hadassah and the university to establish a medical centre on Mount Scopus. Under this agreement, Hadassah undertook to establish and maintain a university hospital, and the university undertook to run and expand the medical research laboratories.[76]

Upon the establishment of the medical centre in 1939, the School of Medicine of the Hebrew University for In-Service Training and Research (known as the Parafaculty of Medicine) began to operate. Thus a new academic body was created for teaching and research in the field of medicine, with the intention that it should in due course become a fully fledged Faculty of Medicine.[77]

The Second World War delayed the continuation of preparations to open the School of Medicine, but immediately after the war, in July 1945, a further agreement was signed between the Hebrew University and Hadassah on co-operation in establishing the school. Both parties undertook to invest a joint effort in fundraising from the American Jewish community, and simultaneously launched a

[73] On the Institute of Microbiology and the Institute of Parasitology, see Niederland, 'The History of the Medical School' (Heb.), 28. On the joint activity with the Physicians Committee, see Barshai, 'Preparations' (Heb.), 77–8; Niederland and Kaplan, 'The Medical School' (Heb.), 145; 'The Hadassah School of Medicine and the Hebrew University', 5. [74] Niederland and Kaplan, 'The Medical School' (Heb.), 13.

[75] On the joint committee, see minutes of a meeting held in Judah Magnes's home, 22 July 1927, Hebrew University Archives; on purchase of the land on which Hadassah and the university could build, see Niederland and Kaplan, 'The Medical School' (Heb.), 146.

[76] Niederland and Kaplan, 'The Medical School' (Heb.), 145–6.

[77] Niederland, 'The History of the Medical School' (Heb.), 5.

campaign to collect the amount necessary to set up the school. In November 1945 the two organizations established a joint development committee to prepare curricula for medical studies and detailed budget proposals for the school.[78]

On the academic level, preparations for the school's work began as early as 1942. Between then and 1947 the Parafaculty of Medicine (whose staff consisted for the most part of doctors or professors from the Rothschild-Hadassah Hospital) held discussions on the character of the future school, considering questions about the preferred teaching approach and curricula to be applied. Upon the signature of the 1945 agreement Hadassah had set up a Medical Reference Board, which comprised a group of highly distinguished American Jewish physicians, medical directors, and experts in public health, to serve as consultants to the school on a voluntary basis.[79] The curriculum the board proposed was based on the curricula at medical schools in some of the leading US universities, namely Harvard, Columbia, and Johns Hopkins.[80]

In early 1947 one of the members of the Medical Reference Board, Dr William Ferlzweig, came to Palestine and presented the board of the Parafaculty with the principles of the American method of teaching medicine.[81] The board then accepted a resolution that the Faculty of Medicine at the Hebrew University would implement a system similar to that accepted in the medical schools of the United States.[82] The decision was influenced by Hadassah and Dr Yassky, who considered the American school of thought in medicine the height of modernity, and aspired to implant it in Palestine. This decision, and the teaching it brought in its wake, were accepted even though the majority of physicians at the hospital had obtained their medical education in central Europe, for many of them recognized that by this time America had established its superiority in teaching medicine. The expulsion of Jewish medical experts from Germany and the devastating outcome of the war across the continent had seriously reduced the standard of medical faculties in many European countries, including many of the leading medical schools in Europe; against this background it was hard to contest American supremacy.[83] Neverthe-

[78] On the agreement between Hadassah and the university, see Niederland, 'The History of the Medical School' (Heb.), 5; on Hadassah's decision to set up an appeal for the school of medicine, see ibid. 3; resolution adopted at the 31st Annual Convention of Hadassah (1945), HA, RG3, ser. Proceedings, subser. WWII conventions, box 12; on the development committee, see Niederland, 'The History of the Medical School' (Heb.), 5. [79] Niederland and Kaplan, 'The Medical School' (Heb.), 146.

[80] Prywes, *Hopeful* (Heb.), 260.

[81] Niederland and Kaplan, 'The Medical School' (Heb.), 156. For further discussion, see Chapter 9 below.

[82] See the minutes of the meeting of the board of the Parafaculty, 9 Feb. 1947, quoted in Niederland and Kaplan, 'The Medical School' (Heb.), 156. [83] Niederland and Kaplan, 'The Medical School' (Heb.), 156.

less, other influences were also accepted, and the actual curriculum at the school of medicine was planned in the light of experience in medical schools in England, Scandinavia, and several other European countries as well as those of the United States.[84]

As a result of the resolution, Dr Yassky and the Medical Reference Board decided to send the university hospital's brightest young physicians, who were to be groomed to teach at the school of medicine, to the United States to study the newest methods of Western medicine. Fellowships for the first in-service training course were granted in 1946.[85] The doctors were trained in both research and teaching methods, and attended clinical programmes in some of the finest American medical schools.[86] The Fellowship Programme (under which a small number of doctors also went to other Western countries to train) became a tradition of the university and has continued to the present.

During the Mandate period Hadassah was dominant in the health-care field in Palestine, a position it held because of the sheer extent of its activity (some of it conducted in co-operation with other organizations in the Yishuv), its specialization in certain areas of health care and medicine, and its effectiveness. On the eve of Israeli statehood, Hadassah was responsible for a considerable proportion of the public health services in Palestine, as well as the health care of new immigrants, and for hospitals with some of the best equipment and most professional personnel in the country. It also contributed actively to the care of children and young people and to vocational training, notably through its sponsorship of Youth Aliyah. By the time Israel gained its independence, Hadassah was an inseparable part of the Jewish community in the country and essential to its welfare.

[84] Proceedings of 33rd Annual Convention (1947), HA, RG3, ser. Proceedings, box 31.
[85] Dr Haim Yassky at the meeting of the Parafaculty board, 8 Dec. 1946 (Heb.), Hebrew University Archives; minutes of Hadassah National Board meeting, 3 Nov. 1948, 6 (spoken by Dr Eli Davis); interview, Prof. Andre De Vries, Tel Aviv, 28 Mar. 1992. The first person to be sent to the US on a training course in this context was Dr Aharon Yehuda Beller, a Polish-born neurosurgeon.
[86] Fact sheet on the Hebrew University–Hadassah Medical School, 5 May 1947, HA, RG2, ser. 52, box 90, p. 260.

CHAPTER THREE

The Leadership

WHO WERE THE WOMEN who, taking the opportunity offered them by social and historical circumstances, were able to make such a significant collective contribution to the well-being of the Jewish people? What were the resources on which they drew? The research literature deals, albeit not in an entirely methodical or comprehensive manner, with Hadassah's founders and some of the women who headed it until the 1940s. This chapter will discuss the organization's leadership after the end of the Second World War, in the years preceding and immediately following the foundation of the State of Israel.[1]

According to its constitution, Hadassah is directed by its annual convention. This structure crystallized in the early days of the organization.[2] However, in practice it is run by the National Board, which meets monthly and is authorized to manage the organization's affairs between conventions. The board is composed of thirty directors, who stand for election every three years.[3] The Executive Committee manages the organization between National Board meetings, but its activities require the approval of the National Board.[4] Its four officers—the president, treasurer, secretary, and recording secretary—are elected at the annual convention from a list of candidates presented by the Nominating Committee, and its four other members are elected by the board.[5] All officers are elected annually; they may serve until others are elected in their place, but for no longer than four consecutive years in the same position. This limits their power considerably and ensures the flow of new blood among the directors.[6] There is also a rotation system on the

[1] With regard to the founding leadership, in addition to the literature on Szold (see Prologue, n. 8), see also Kutscher, 'The Early Years of Hadassah', 64–122; Antler, *The Journey Home*, 98–129. For discussion of Rose Jacobs, see Antler, *The Journey Home*, 203–14; on Irma Lindheim, see Reinharz, 'Irma Lindheim' and 'Irma "Rama" Lindheim'. [2] See Miller, 'A History of Hadassah', 63, 47–9, 171.

[3] 1947 Constitution, article V. The constitution was approved by the 33rd Annual Convention in October 1947. The author has compared it with earlier constitutions, as well as that of 1956. On the annual convention's management of the organization, see 1947 Constitution, article VI ('National Board'), section 1; on the management between conventions, see ibid., article VI and 1956 Constitution, article VI(1); on the directors, see 1956 Constitution, article VII(1), all in HA, RG17. [4] 1947 Constitution, article VII(5).

[5] Ibid., article VII(4). [6] Ibid.

National Board.[7] All officers and directors are unpaid and are prohibited from receiving any remuneration from any Zionist group.[8]

Between the end of the Second World War and the end of Israel's first decade of statehood in 1958, Hadassah was headed by twelve of the thirty women who sat on the National Board. They can be divided into three groups according to their socio-economic and cultural background. One group (the largest) comprised members of families that had emigrated to the United States from eastern Europe. These women had been raised and educated in America, most of them in New York. The second group, consisting of women from a German Jewish background, falls into two sub-groups: American-born women of German Jewish origin who were married to men of east European origin, and very well-to-do women who came to the United States from Germany on the eve of the Second World War. The third group consisted of women who were involved in volunteer work in Palestine and, later, Israel. The members of this last group had a totally different background from that of the US leadership, but their work in Palestine over a long period justifies their inclusion in this review.

THE 'EAST EUROPEAN' LEADERS

Most of Hadassah's leading figures from the 1930s until the 1950s belonged to this group, among them the two most prominent women in the organization just before and in the first decade of Israel's statehood: Rose Halprin and Judith Epstein. Both were the children of immigrants to the United States from eastern Europe. The better-known of the two was Rose Halprin (1896–1978), Hadassah national president in the years 1932–4 and again in 1947–52, critical years in Hadassah as well as in the Zionist movement as a whole. Rose Halprin was the most prominent figure in Hadassah's top leadership and its relations with the Yishuv after 1945 and through the early years of the new state, and is arguably one of the most important Jewish leaders of the twentieth century. Short in stature, this clever, energetic, dominant, and purposeful woman always dressed elegantly, and was known in particular for the large hats she habitually wore to enhance her height.[9]

[7] National Board membership lists, 1948, 1950, 1952, and 1956, Hadassah National Office.

[8] 1956 Constitution, article VII(6).

[9] Information about Halprin is based on the author's interviews with Fanny Cohen, New York, 31 May 1991; Charlotte Jacobson, New York, 27 May 1991; Prof. Eli Davis (who described Halprin as an extremely powerful woman), Jerusalem, 11 Apr. 1992; Miriam Freund-Rosenthal, Jerusalem, 12 Aug. 1995; and Helen Karpa, Jerusalem, 14 Aug. 1995. For details about Halprin's family, see Rosen, 'Rose Halprin', 1206–7; Freund-Rosenthal, In My Lifetime, 4. On the parents' Zionist background, see Melvin I. Urofsky's interview

Born Rose Luria on the Lower East Side of New York to an ardently Orthodox Zionist family, she grew up in Borough Park, Brooklyn. Her parents gave her a Jewish education and taught her Hebrew, and unsurprisingly she became head of Kokhav Tsiyon (Star of Zion), the youth division of the Austro-Hungarian Zionists, a society in which her parents were active. However, as a teenager she was not an active member of a Zionist youth movement. She continued her Jewish education at the Teachers' Institute of the Jewish Theological Seminary of America in 1912– 13. Her studies here, and previously at her parents' home and with private teachers, gave her a thorough knowledge of Hebrew. In 1914 she studied at Hunter College of the City of New York, and later also at Columbia University. Hunter College was known for many years as the 'Jewish Radcliffe'.[10] This prestigious institution for women, which did not charge for tuition, was established in the mid-nineteenth century as a teachers' seminary and began granting academic degrees in 1908. From that time forward it grew a great deal, and in the 1920s it was the largest women's college in the United States. Its Lexington Avenue campus was joined by campuses in Brooklyn, Queens, and Staten Island. The policy of opening its doors to women of all races, religions, and ethnic groups, on condition only that they met the required academic criteria, distinguished the social composition of the student body from those of other colleges in the United States. Young Jewish women were welcome there at a time when many other universities and colleges in the country set severe limitations on the admission of Jews, and it was here that many young Jewish women of east European origin whose parents had emigrated to the United States gained their education, often going on to be teachers. Jewish life flourished at Hunter; there was Jewish activity among the students, who could keep the sabbath and holidays without fear of being disciplined for their absence from classes.[11]

with Halprin, New York, 23 Mar. 1973, Oral History Division, Avraham Harman Institute of Contemporary Jewry, Hebrew University, Jerusalem. On the place where Halprin was raised, see Freund-Rosenthal, *In My Lifetime*, 4. Details about her father are from author's interview with Miriam Freund-Rosenthal, Jerusalem, 12 Aug. 1995. Details about her emigration to Palestine are from author's interview with Ruth Kaslove (Rose Halprin's daughter), Jerusalem, 2 Aug. 1991. Other sources: Freund-Rosenthal, *In My Lifetime*, 4; Hadassah biographical material, 'Mrs. Rose Halprin', Rose Halprin files, HA, RG13; 'Rose Halprin Dies', *New York Times*, 10 Jan. 1978; Hyman and Moore, *Jewish Women*, i. 588.

[10] This institution was the counterpart of the City College of New York, which took male students and was known as 'the ḥeder on the hill' or 'the Jewish Harvard' because of the preponderance of Jewish students, who in 1920 made up 85% of the student body. See Moore, *At Home in America*, 190; Sarna, *American Judaism*, 221.

[11] Grunfeld, 'Hunter College'; Antler, *The Journey Home*, 177. For the history of Hunter College see Williams, *Hunter College*.

In 1914 Rose married Samuel Halprin, who later went into the import–export business, trading with Palestine and later Israel as well as other countries. The couple settled in Brooklyn and had two children.

In 1927 she was invited on to the National Board of Hadassah. Five years later, still only in her mid-thirties, she was elected Hadassah's president. Having completed her two-year term in office, in 1934 she was sent with her family to Palestine, where she remained throughout the construction of the Rothschild-Hadassah University Hospital on Mount Scopus. Gaining valuable personal knowledge of the Yishuv during these years, she served as a link between the National Board and Hadassah's projects in Palestine—a role facilitated by her fluency in Hebrew, Yiddish, and German. Her knowledge of these three languages, all of which were current among Yishuv residents, enabled her to get to know the Yishuv well during the five years she lived in Palestine in the 1930s. This experience made an enormous impression on her and had an immense influence on her future Zionist activity and her growing involvement in the international Zionist arena. When the Second World War erupted, the Halprin family returned to the United States. They lived in New York, but continued to make frequent trips to Palestine and, later, Israel: Rose herself visited the country over sixty times between 1939 and her death in 1958.

Judith Grace Epstein (1897–1988) was a completely different character: very down-to-earth, she was charismatic, warm, and personable, and had a gift for charming an audience—personal gifts that earned her the epithet of 'America's best-loved Jewish woman'. Born on 2 November 1895 in Worcester, Massachusetts, Judith was the eldest daughter of Sarah Baum and Edward Epstein. Her mother came from a long-established American Jewish family which dated its arrival in the New World to the 1840s; her father was born in Poland and emigrated to the United States as a teenager, going on to make his living as a wholesaler. Sarah and Edward Epstein, though deeply acculturated in America, were active Zionists, and Sarah was an early member of Hadassah. She was also active in various charities—a philanthropic impulse she inculcated in her daughter Judith.

When Judith Epstein was 2 years old her parents moved to New York, and she grew up on the Upper West Side of Manhattan. Her mother tongue was English; her parents read the *New York Times*—not a Yiddish newspaper, as most immigrants did—and their friends were American-born Jews.[12] But *yiddishkeit* was

[12] The information about Judith Epstein here and later in the book is based on Rosen, 'Judith Epstein'; *Hadassah News: National Department of Public Affairs* (n.d.), 1, published immediately after Epstein's death; *Who's Who in World Jewry*, 185; author's interviews with Fanny Cohen (a close friend of Epstein and a

important to the Epsteins: they kept kosher, and they were members of the Orthodox Jeshurun congregation on the Upper West Side, where Mordechai Kaplan, later the founder of Reconstructionist Judaism, was appointed preacher in 1903. This was one of the outstanding Orthodox congregations in New York at the beginning of the twentieth century, and included among its members many of the most prominent Ashkenazi Jews (Jews from central and eastern Europe and their descendants worldwide), both American-born and also successful immigrants who had arrived in the 1880s and 1890s. They considered themselves traditional Jews but nevertheless involved themselves in American culture, adopting the American lifestyle and enjoying social pursuits such as dancing and mixed swimming.[13]

Like 80 per cent of Jewish children in New York in 1910, the young Judith did not receive any formal Jewish education, although according to various testimonies she was influenced by Mordechai Kaplan even in her childhood.[14] Later, like most of Hadassah's leaders from the east European group, Judith Epstein studied at Hunter College. Although both her parents were Zionist activists and her mother was a member of the first generation of Hadassah members,[15] it was only here that she first became interested in Zionism. After graduating in 1916, Epstein taught English in a high school for a few years. In 1917, when she was about 19, she married Moshe (Mo) Epstein, the son of east European immigrants and a graduate of City College of New York. The couple ran a Conservative-style Jewish household. During the 1930s and 1940s Mo became a businessman in a successful non-Jewish company, which was very uncommon for Jews in those days. He was a Zionist from his youth, belonging to a society of Zionist students, and he strongly supported his wife's Zionist activity throughout their life together.

Judith joined Hadassah immediately after her marriage and became a very active member, even as a young mother and working teacher. Alone among the leading figures of this period, she began her career in Hadassah as a rank-and-file member, then becoming president of a group in the Upper West Side of New York City. As a young woman, she could be seen pushing her young daughter in a pram

member of the Hadassah National Board from 1952), New York, 31 May 1991; Helen Karpa, Jerusalem, 10 July 1991, 14 Aug. 1995; Naomi Cohen, Judith Epstein's daughter, 8 Jan. 2007 (by telephone); Frieda Lewis's farewell address at Judith Epstein's eightieth birthday celebration, Hadassah Archives, Judith Epstein folder (unsorted collection); Hyman and Moore, *Jewish Women*, i. 382–3.

[13] For the Jeshurun congregation, see Scult, *Judaism Faces the Twentieth Century*, 65–6.

[14] For data on Jewish education in New York in 1910, see Sarna, *American Judaism*, 175; for Mordecai Kaplan, see n. 24 below and Chapter 5.

[15] For an extensive discussion of the difference between 'the Zionism of the immigrants' and 'the Zionism of the second generation', see Schiff, 'A Different View of the Americanization of Zionism' (Heb.).

while distributing Hadassah flyers and engaging passers-by in conversation on Zionist issues. Later, with her talent for speaking and the immense personal warmth and charm for which she became famous, she made countless trips around America to recruit new members to the organization.

Judith Epstein was Hadassah's national president during the years 1937–9 and again during 1943–7, the critical years preceding the foundation of the State of Israel. However, her influence in Hadassah and in the world Zionist arena was renowned after her presidency as well. She did not know Hebrew (she was familiar with the characters of the Hebrew alphabet only from the prayer-book),[16] nor did she know Yiddish. Her many visits to Palestine and subsequently to Israel were short, and did not enable her to form a deep connection with the people of the country. This sets her in contrast with Rose Halprin and some other Hadassah leaders of east European origin who knew Hebrew and Yiddish and spent long periods in the country, and some of whose children went to live there.[17] She died in New York on 27 October 1988 at the age of 93, after more than sixty years of activity in Hadassah.

The third figure of east European origin to hold the presidency of Hadassah was Dr Miriam Freund (1906–99). She was born in Manhattan to Harry and Rebecca Kottler, immigrants respectively from Russia and Poland, who were active in Zionist societies on the Lower East Side. Like Rose Halprin, she grew up in a strongly Jewish environment in Borough Park, Brooklyn, where she belonged to the Zionist youth groups Young Judaea and Junior Hadassah. As a young woman, Miriam too studied at Hunter College, going on to take a master's degree at New York University. She was active in the Daughters of Zion on the Lower East Side and, later, in Hadassah.

In 1927 Miriam married Milton Freund, whose parents were also immigrants from eastern Europe, and who became involved in the textile business. The couple had two sons, whom Miriam raised while not only working as a high-school teacher but also continuing her academic studies at Columbia University. In 1935, the year she was awarded her doctorate for work on Jewish merchants in colonial America and their contribution to the development of the country, she visited Palestine for

[16] Information on Epstein's lack of knowledge of Hebrew from interview with Fanny Cohen, New York, 10 July 1991.

[17] Rebecca Shulman's son Paul Shulman, who served as an officer in the US navy during the Second World War, emigrated to Israel, and was appointed naval chief of staff and the first commander of the corps (May 1948–May 1949). Bertha Schoolman's daughter emigrated to Israel and lives in Kibbutz Sasa to this day (2005).

the first time and met Henrietta Szold and Rose Halprin. In the same year she was invited to join Hadassah's National Board. Three years later she left her teaching job, and for the next forty-five years, until her death in the winter of 1999, she was active on the National Board in a range of capacities. She was president of Hadassah from 1956 to 1960.[18]

From these brief biographical summaries it is possible to identify certain common features among the 'east European' leaders of Hadassah (some of which are shared by others discussed below). The three discussed above were all born in the United States to Jewish immigrants from eastern Europe. All three grew up in New York City, in a Jewish environment.[19] As the daughters of immigrants, they were acculturated into American society to some degree; but, as for most American Jews of the time, this acculturation was not total. All three attended college, and for all three this meant (for the reasons noted above) Hunter College. Thereafter, as was customary among the daughters of Jewish immigrants in America, they trained to be teachers.[20]

Entry into the teaching profession was every Jewish mother's dream for her daughters, for it earned them both prestige in the Jewish community and a modest salary, promising a ticket into the middle class; and it was a job in which they could observe the sabbath without jeopardizing their employment.[21] It was difficult for young Jewish women of east European origin to penetrate other professions, both for financial reasons and because they were not generally accepted as appropriate occupations for women in the Jewish immigrant society of the time; so teaching

[18] Information on Miriam Freund is based on author's interviews with Dr Miriam Freund-Rosenthal, New York and Jerusalem, 28 June 1991–3 Aug. 1991 (a detailed list appears in the Bibliography); Freund-Rosenthal, *In My Lifetime*, 6–7, 13–14; Levin, 'Dr Miriam Freund', *Encyclopedia Judaica*, vii. 167; Hyman and Moore, *Jewish Women*, i. 480.

[19] This was the case regarding a significant proportion of the women who led Hadassah in this period, although the findings are not unequivocal. Four of the five presidents of Hadassah between 1937 and the end of the research period (1958) were daughters of immigrants of east European origin (Rose Halprin, Judith Epstein, Rebecca Shulman, and Tamar de Sola Pool). Among the fifteen leaders of the organization during these years, only four were not of east European origin: Etta Rosensohn (see below), Denise Tourover, Gisela Warburg Wyzanski, and Anna Tulin (see Chapter 11). All the other leaders, with the exception of Judith Epstein, whose father was an immigrant but whose mother was born in the US, were daughters of two immigrant parents.

[20] Markowitz, *My Daughter, the Teacher*, 2. On the fact that Hadassah's leaders were college graduates, see information on Halprin, Epstein, and Freund, above; on Schoolman, see Chapter 11. On their being teachers, see: for Judith Epstein, Hyman and Moore, *Jewish Women*, i. 382; for Rosen and Schoolman, ibid. ii. 1212; for Tamar de Sola Pool, *Who's Who in World Jewry*, 589; for Marian G. Greenberg, Marian G. Greenberg biographical details, Hadassah National Office.

[21] Markowitz, *My Daughter, the Teacher*, 2.

was for most the limit of their professional options. Jewish women began to enter the New York public education system in large numbers after the First World War, with particularly striking growth taking place between 1920 and 1940. In 1920 only 20 per cent of the teachers in New York were Jewish; by the 1930s the proportion had reached 75 per cent.[22] Rose Halprin and Judith Epstein were ahead of their time, having completed their studies before the 1920s.

A substantial proportion of the young women of east European descent who became Hadassah's leaders studied at the Teachers' Institute of the Jewish Theological Seminary of America after graduating from Hunter College. The institute was opened, to both women and men, in 1909, when its first complement of students consisted of twenty-two women and only twelve men. For many years it was directed by Mordechai Kaplan, one of the great Jewish thinkers of the twentieth century and founder of the Reconstructionist movement, to which several of Hadassah's leaders of east European origin belonged. From its inception the institute was Zionist in orientation, placing emphasis on the study of Hebrew, of the Bible, and of Jewish history. This was the Jewish legacy that the east European leaders of Hadassah had received at the Teachers' Institute, and they brought it in turn to their organization, where it had a clear influence on ideology and priorities —for example, it is one of the reasons for the profound interest of Hadassah's leaders in Jewish education.[23]

Almost all the women who sat on the National Board in this period were wives and mothers. Those who were daughters of immigrants were married to men of similar background. Most of the leaders in this group identified themselves as Conservative–Reconstructionist Jews, and some were active members of the Reconstructionist movement.[24] As noted above, Rose Halprin, Judith Epstein, and

[22] Moore, *At Home in America*, 95–6.

[23] The Reconstructionist stream (known as such only from 1965, and before that as a movement) is the fourth stream in American Judaism, alongside the Reform, Orthodox, and Conservative streams. It was born out of the Conservative movement, but is very different from it theologically. The theological progenitor of the movement is Rabbi Mordecai Menahem Kaplan, who gave the primary exposition of it in his book *Judaism as a Civilization*, which was published in 1934. Reconstructionist Judaism developed strongly in the 1940s and 1950s.

[24] Author's interview with Fanny Cohen, 15 June 1991. When asked what denomination their mothers belonged to, Rose Halprin's daughter, Denise Tourover's daughter, Judith Epstein's daughter, Miriam Freund, and Fanny Cohen all replied 'Conservative'. I did not encounter any other answer to this question. The same response—'Conservative'—was also given to the question 'What was your parents' denominational affiliation, if any?' The conclusion regarding denominational identification is based on written information sent to the author by Ruth Kaslove (Rose Halprin's daughter), Naomi Cohen (Judith Epstein's daughter), Mendelle Woodley (Denise Tourover's daughter), Miriam Freund, and Fanny Cohen.

Miriam Freund were all raised in Zionist families and their parents were active Zionists in the Jewish immigrant neighbourhoods of New York. In many cases, then, these were members of the second generation of Zionist families.

Thus, for the most part, Hadassah's leaders in the 1940s and 1950s came from an entirely different cultural background, and differed in social, religious, and professional respects, from those of the founding generation, who were born into families of German Jews who had come to the United States far earlier. Whereas the earlier leaders were totally acculturated in American society, the women leading the organization at the end of the 1940s and during the 1950s were only partially integrated into the American way of life. A considerable number of the founders were social workers, while a large proportion of the newer generation were teachers by profession. Most of the latter were married and had families, while several of the founders were unmarried. Only a few came from well-to-do families, while more of the founding leaders came from relatively privileged backgrounds. Most of the founders belonged to the Reform stream of Judaism, while most of the leaders during the 1940s and 1950s were Conservative.

Those characteristics of east European background, the teaching profession, and marriage, along with a strong Jewish identity and an attachment to *yiddishkeit*, are already evident in Rose Jacobs, the most prominent leader of Hadassah in the 1930s. Hadassah's president in the years 1930–2 and again in 1934–7, Rose Jacobs was raised by her grandparents, Jewish immigrants from Lithuania who were living in New York's Lower East Side and who left a deep impression on her. As a child and teenager she studied in New York City, moving on to Hunter College, and became a teacher by profession. She ran her home on 'traditional' Jewish lines, more in cultural than in religious terms, and had connections with the Reconstructionist movement.[25]

These distinguishing features define the east European element in Hadassah's leadership in the post-war years as a separate social group, distinct in social composition from the Orthodox Mizrachi Women and probably also the Pioneer Women, as well as from the National Council of Jewish Women, most of whose members were of German descent and identified with the Reform movement. The daughters of east European immigrants who led Hadassah, none of whom was a

[25] For a fairly comprehensive account of Jacobs, see Antler, *The Journey Home*, 204–14; on her social background and her Jewish way of life, ibid. 207. Some of the same characteristics also apply to Tamar de Sola Pool (1890–1981), Hadassah national president from 1939 to 1943. Born in Jerusalem to parents of east European origin, she too was married and worked as a teacher (at college rather than high-school level) after studying at the Sorbonne in Paris. See Hyman and Moore, *Jewish Women*, ii. 1095.

Reform Jew, did not fit into that organization, for reasons to do with both social background and religious affiliation.[26]

The following chapters deal more extensively with the central values, both Jewish and American, of this idealistic group of women who were committed to public service on behalf of the Jewish people and dedicated to tireless work for their chosen cause.[27]

THE 'GERMAN JEWISH' LEADERS

The second group of Hadassah leaders came from a very different background. Most were brought up in well-to-do families of German Jewish origin and became involved in Hadassah through their husbands, who were active in the Zionist Organization of America. Two of them were immigrants who arrived in the United States just before the Second World War, fleeing the Nazis' depredations in their homeland, and worked actively in Hadassah on behalf of Youth Aliyah, as they had done in Europe.

The pre-eminent member of this group was the philanthropist and community worker Etta Rosensohn (1885–1965). She was born in Galveston, Texas, to the German Jewish financial magnate Morris Lasker and his wife; Lasker had emigrated to the United States from eastern Prussia at the age of 16 and become an oil tycoon. Etta's brother was the philanthropist Albert Lasker, and he and her two social-worker sisters, Florina and Lola Lasker, all contributed time and money to Hadassah's projects.[28]

The environment in which Etta grew up was very prosperous but also very distant from Jewish affairs, and as a teenager she knew nothing about Jews or Judaism. After graduating from college in Texas she moved to New York and, like

[26] The Orthodox Mizrachi Women (in full, the Mizrachi Women's Organization of America) and the Pioneer Women (in full, the Women's Labor Zionist Organization of America) were both founded in 1925. For the Pioneer Women, see Rojanski, *Conflicting Identities* (Heb.), 388–92; Raider, *The Emergence of American Zionism*, 114–34; id., 'The Romance and *Realpolitik* of Zionist Pioneering' (Heb.), McCune, 'Pioneer Women', Hyman and Moore, *Jewish Women*, ii. 1071–7. All these works deal mainly with the 1920s and 1930s. There is no information on the social composition of Pioneer Women in the 1950s, and it is unclear whether it differed from that of Hadassah. On the social composition of the National Council of Jewish Women, see Rogow, *Gone to Another Meeting*, 307–8.

[27] Information on the values underlying their work as a group from interview with Mendelle Woodley, Washington, DC, 26 June 1991.

[28] 'Etta Rosensohn', c.v. in Hadassah Archives, RG13, Etta Rosensohn files; on Morris Lasker, see 'Lasker', *Judaica*, x. 1434; on the other members of the Lasker family, see *Judaica*, x. 1435.

many women of the German Jewish elite, devoted her life to philanthropic work. She took a social work degree at the New York School of Social Work and embarked on a career as a social worker with a special interest in east European Jewish immigrants. She also became district head of the American Red Cross. After the First World War she joined the National Council of Jewish Women, as did many women of German Jewish origin. Between the two world wars she engaged in extensive voluntary work, especially as an active member, until 1930, of that organization's board of directors. She also founded one of its publications, *The Immigrant*.[29]

In 1918 Etta Lasker married Samuel Rosensohn, a Zionist lawyer of east European descent: a graduate of Harvard Law School and close associate of the judge Felix Frankfurter, he was also an active member of the Zionist Organization of America. It was primarily marriage to Rosensohn that brought about the subsequent change in her public activity; indeed, it was Samuel who 'made her a Zionist'.[30]

Rosensohn joined Hadassah in 1927, going straight in as a member of the National Board.[31] From 1947 to 1952 she headed the National Board committee for the Hadassah Medical Organization, and from 1952 to 1953 she served as Hadassah's president.[32] Perceived by others as a 'wealthy and aristocratic American woman',[33] she saw herself as a civil servant. Within Hadassah she focused her efforts on the field of health, seeing this as the crowning glory of her volunteer work. She was very close to other members of the 'German' group of Hadassah's top leadership but also had strong ties with the leadership of the Yishuv, enjoying a close friendship with David Ben-Gurion. However, she never spent long in the country and her knowledge of its people was never strong. The second figure of German Jewish origin was the lawyer Denise Tourover (1903–80), who served as Hadassah's representative in Washington at the outbreak of the Second World War and throughout the 1940s and 1950s. She was born in 1903 in New Iberia, Louisiana, to a wealthy American Jewish family of long standing that had been in

[29] Gladys Rosen, 'Etta Rosensohn,' *Encyclopedia Judaica*, xiv. 290; ead., 'Rosensohn, Etta Lasker', *Encyclopaedia of Zionism*, ii. 1121–2; author's interviews with Charlotte Jacobson, New York, 27 May 1991, Dr Miriam Freund, New York, 17 June 1991, Florence Perlman, Jerusalem, 17 June 1991; *New York Times*, 21 Sept. 1966.

[30] Author's interview with Fanny Cohen, New York, 10 July 1991, and with Charlotte Jacobson, New York, 27 May 1991.

[31] Interview with Charlotte Jacobson and Fanny Cohen, Jerusalem, 26 July 1991.

[32] *Who's Who in World Jewry*, 633; Hadassah national officers and National Board members, 1948, Hadassah National Office. [33] Author's interview with Fanny Cohen, New York, 10 July 1991.

the United States since the beginning of the nineteenth century. Denise's mother Blanche had emigrated to the United States from the French border region of Alsace-Lorraine. She and her husband spoke English and French and were very well acculturated in American life. They also had a strong personal sense of their Jewish identity, which filled them with a deep sense of mission; they took an active part in the Reform Jewish community in New Orleans,[34] the tradition within which Denise was raised.

Denise was in her teens when her mother died, leaving her with the responsibility for bringing up her younger sister. Around 1920 she moved to New York, following in the footsteps of one of her brothers, and then to Washington, DC, to study law at George Washington University. Law was a field that was not entered by many Jewish women of her generation, and in this sense she was unusual among the leaders of Hadassah.[35]

In 1926 Denise Levy married Raphael Tourover, a lawyer of east European descent. The couple had one daughter, Mendelle. For the entirety of their happily married life they lived in Washington, where Denise Tourover represented Hadassah in government circles; indeed, her working and social life revolved around Hadassah's activities.[36] She visited Israel only once, in the 1950s.[37]

THE HADASSAH COUNCIL IN ISRAEL

The body that was to become known as the Hadassah Council in Israel was originally established in March 1930 as the Palestine Council of Hadassah, and was originally intended to serve as a focus for liaison with the National Board of Hadassah in New York on all projects in Palestine except for the Hadassah Medical Organization (HMO). At some point after the outbreak of the Second World War the council was renamed the Hadassah Council in Palestine. It was also around this time that the council became involved with all of Hadassah's projects in Palestine, including the HMO. With the establishment of the State of Israel in 1948, the council's name was changed to the Hadassah Council in Israel.[38]

Most of the council's members were American Jewish women who had emigrated to Palestine, though some were of east European origin. A few men sat on the

[34] Interview with Mendelle Woodley (Denise Tourover's daughter), Washington, DC, 6 June 1991.
[35] Ibid.; *Who's Who in World Jewry*, 633.
[36] Interview with Mendelle Woodley, Washington, DC, 26 June 1991.
[37] Ibid. For more on Denise Tourover, see Chapters 5 and, especially, 11.
[38] Information given by Susan Woodland, Hadassah archivist.

council as well. In the 1940s and 1950s there were three central figures: Ethel Agron and Julia Dushkin, both immigrants from the United States, and Myriam Granott, who had immigrated from Europe. The 'Americans' had not been Zionists in their youth, becoming so after following their husbands—both extraordinary men—to Palestine.

Ethel Agron was born Ethel Lifschitz in New Jersey in 1896, one of five children of parents who had emigrated from Russia and Romania respectively. Her childhood and teenage years were spent in Baltimore. As a teenager, she lost her mother and brought up her younger brother and sister, who emigrated to Palestine in 1925.[39] Despite financial difficulties, Ethel managed, like many Jewish women of her generation, to acquire a higher education. She studied mathematics for a bachelor's and then a master's degree at Goucher College, a women's college near Baltimore, and around 1914 began working as a high-school teacher in a black mining town near Baltimore.

Ethel became romantically involved with a relative, Gershon Agronsky (later Agron; 1894–1959). Born in the Ukraine, he had emigrated to the United States in 1906 and from 1915 worked as a reporter on Palestine for British and American newspapers, first in the United States and later in Palestine, where he volunteered for service in the British army's Jewish Legion—battalions of Jewish volunteers — in the First World War. A committed Zionist, Agronsky made it a condition of marriage that his wife would emigrate with him to Palestine. Ethel, though American to the core, accepted this ultimatum and in 1924, by which time the couple had a 2-year-old son, the family duly moved to Palestine. They settled in Jerusalem, where Agronsky later became mayor, and had two more children, both daughters. In 1932 Agronsky founded the daily *Palestine Post* (which in 1950 became the *Jerusalem Post*), the English-language mouthpiece of the Yishuv, which was intended to spread the Zionist message to the British government.

The Agronskys were a wealthy couple and moved in the highest circles in Jerusalem. They were invited to visit the British High Commissioner, and their own home, which was furnished in fine taste and housed a collection of paintings by artists of the Yishuv, became the focal point of the city's high society. Ethel was an excellent hostess with great skill and taste in cooking and hospitality, and the 'open house' she and her husband held every Friday attracted a veritable 'Who's Who' of Jerusalem, some sixty to seventy people each time. Much of the couple's life

[39] The information on Ethel Agron from this point on is based on interview with Varda Tamir (Agron's daughter), Ramat Hasharon, 8 Dec. 2001.

revolved around entertaining and social events, conducted in the British style. During the Second World War journalists from across the world came to their house, and it became a political as well as a social centre of Jerusalem.

Ethel remained American through and through. The Yishuv and Israel were never her cultural and emotional centre. Most of her friends were American, although she was also close to some women in Jerusalem who had come from England with their Zionist husbands. These women constituted a closed, elitist group which had little contact with other Jews in Jerusalem or with the wider Yishuv, viewing the members of the latter merely as 'locals'.

Ethel Agron served the Hadassah Council as a volunteer for thirty years. She established a pattern of work that blended happily with her style of marriage and social life. Every morning she would go to the Hadassah office on Straus Street and work there until two or three in the afternoon, later meeting her friends for tea or cocktails while her husband worked in his office. From the beginning of the Second World War until Henrietta Szold's death, Ethel Agron worked closely under her supervision. From that period until the 1960s, she was involved in one way or another in almost all of Hadassah's projects in Israel: the playground enterprise, the School Luncheon Programme, and in particular the Alice L. Seligsberg Trade School for Girls (see Chapter 10). She also took an active part in raising funds to build the medical centre in Ein Karem (described in Chapter 9).

The second prominent figure on the Hadassah Council in Israel was Julia Dushkin. A warm, sociable woman, she had the talent of exercising her considerable organizational skills without appearing domineering. Like Ethel Agron, she enjoyed entertaining and gave many scintillating parties. Born Julia Aronson in Lithuania in 1895, she had emigrated with her family, including eight brothers and sisters, to the United States, where they made a living by sewing underwear—even the children joined in when they returned from school. Like many immigrant Jewish families of the time, the Aronsons made great sacrifices to send Julia to Cornell University, from which she graduated in 1917 as a Bachelor of Science in Home Economics and Nutrition. She was the only member of the family who acquired a higher education.[40]

In 1920, after about two years of working for the American Red Cross, she met Henrietta Szold, who persuaded her to go to Palestine with her and work there as a

[40] The information on Julia Dushkin from this point on is based on Julia A. Dushkin's c.v., HA; interview with Avima Dushkin Lombard (Julia Dushkin's daughter), Jerusalem, 17 Dec. 2000; biographical note in the guide to HA, RG6, 'Hadassah Education in Israel', written by Jeanne Swadosh.

nutritionist as part of the American Zionist Medical Unit. Julia agreed, but for professional rather than Zionist motives. The two sailed to Palestine, sharing a cabin.

Julia Dushkin was the first nutritionist in the Yishuv. She taught nutrition at the Hadassah Nurses' Training School, and in this capacity she worked together with Dr Brachyahu, head of the school's Hygiene Department (see Chapter 10), to coin nutrition terms in Hebrew. She also worked as a nutritionist in several kibbutzim along the banks of the Sea of Galilee. Like many members of the Medical Unit, she encountered numerous difficulties in her work with the kibbutz members: they were suspicious of this young American expert, while as a nutritionist she found it very frustrating that they refused to eat what she suggested and continued with the diet to which they were accustomed, which she considered very unhealthy.

During Julia's first year in Palestine Henrietta Szold introduced her to Dr Alexander M. Dushkin, a Jewish educator from New York, who later made a substantial contribution to the development of Jewish education in the United States. In early 1921 they were married on Mount Zion in Jerusalem. They lived in Palestine for another two years and then in 1923 moved to Chicago, where they stayed until 1934. During that period Julia made several visits to Palestine to help with Hadassah educational projects. From 1935 to 1939 she and her husband lived in Palestine, where he founded the Hebrew University School of Education and she was actively involved in medical and educational projects run by the Executive of the Hadassah Council in Palestine. During the Second World War they lived in the United States, where Julia served as chair of the nutrition committee of the city of New York. Because the couple moved around so much, however, Julia was generally unable to practise as a nutritionist for long periods. According to her daughter, this caused her great frustration, and her voluntary work at Hadassah offered some compensation.

In 1949 the Dushkins settled permanently in Israel. From then on Julia was continuously involved with the Hadassah Council in Israel, chairing several of the organization's major youth projects, as described in Chapters 10 and 11 below.

The last of the three central figures on the Hadassah Council in Israel, Myriam Granott, was not an American. She was born in Vilna, the daughter of Rabbi Chaim Ternowitz. The family emigrated to Palestine in 1910, but shortly thereafter she returned to Europe to study at the Lehranstalt für die Wissenschaft des Judentums in Berlin. She went on to study for a Ph.D. in Switzerland and married Avraham Granott of the Jewish National Fund (Keren Kayemet), who became the Fund's

managing director in 1922, chairman of its board of directors in 1945, and its president in 1960. She made a home with him at first in The Netherlands, where he joined the staff of the head of the Jewish National Fund in The Hague. In 1922, when the headquarters of the Jewish National Fund moved to Jerusalem, the Granotts settled there. In 1931 Myriam joined the Hadassah Council in Palestine, and from that time on held in turn almost every post that Hadassah could offer in Palestine and Israel, taking an active part in all the organization's projects for children and young people as well as serving on the Hadassah National Board committee that dealt with the Hadassah Medical Organization.[41]

It is clear from this brief review that the women who led Hadassah in the 1940s and 1950s came from diverse backgrounds, both socially and in terms of the Jewish and Zionist influences to which they were exposed. Most, and the most dominant group, came from the east European immigrant Jewish community in the United States. A small number belonged to the German Jewish elite, and became familiar with Zionism through their marriage to east European Jews. Another German Jewish group, also from a privileged socio-economic background, left Germany in the wake of the Nazi takeover. Different again was the group that was active in Palestine, composed mainly of American Jewish women, daughters of immigrants from eastern Europe, who were, ironically, not initially Zionists themselves.

[41] All the information on Myriam Granott is based on biographical details on Myriam Granott, HA, RG5.

PART II

THE AMERICAN SCENE
IDEOLOGY AND PRACTICE

The Jewish Foundations

THE FUNDAMENTAL VALUES and principles that guided Hadassah were not formulated in explicitly ideological statements, and so for the most part must be traced through its publications and activities. Over the years, Hadassah's ideology was shaped by its leaders, who conveyed it to the rank-and-file members through the organization's publications, especially the official *Hadassah Newsletter* but also various other documents and pamphlets produced by the Education Department, and at the annual conventions. I use the term 'ideology' in this book to refer to the organization's ideas, values, and modus operandi, whether formulated explicitly or not.[1]

THE ASPIRATION TO BE A BROAD ZIONIST MOVEMENT

We must build on our quarter million members until we have enrolled every Jewish woman in our communities.
 Hadassah Annual Report, 1948/9

One of Hadassah's basic principles was that it should be a mass Zionist movement for American Jewish women: that is, ultimately every American Jewish woman should be counted among its members. That Hadassah was to be a popular, mass movement, and not an elitist one, was a matter of ideological principle, not of organizational tactics.[2] In this, Hadassah was directly influenced by the outlook of the prominent leader of American Zionism (arguably the 'Herzl of American Zionism') and the man responsible for formulating some of its most fundamental concepts, Louis D. Brandeis (who was also the first Jew to be appointed as a judge to

[1] There is no widely agreed definition of the term 'ideology'. Because, as noted, Hadassah has no 'systematic . . . combination of ideas', I rely on Selinger's definition (in 'Fundamental and Operative Ideology'), which defines ideology as a system of ideas (including values and guidelines for action and not only abstract ideas) by means of which people place, interpret, and justify goals and means of organized social activity with the aim of sustaining, repairing, and uprooting or rebuilding a given reality.

[2] Minutes of Hadassah National Board meeting, Jan. 1949, 8.

the US Supreme Court). Brandeis believed that every American Jew should be a Zionist, and that American Zionism must become a mass movement. The movement's members, he believed, were its major asset—both its main resource and its power base: the source of funds for Palestine, of 'muscle with which to persuade governments', and of 'workers who would spread Zionist propaganda'. For Brandeis the Zionist movement was a financial and political means to realize the Zionist goals.[3]

Brandeis's outlook became an integral and basic element of Hadassah's ideology. Its leaders, too, believed that it must not be a movement for the elite, for in that case it would not be able to gain wide public support.[4] With the aim of helping every Jewish woman find her place in Hadassah, they did not impose excessive requirements, in terms of time, money, or personal qualifications, either on existing members or on new recruits. In fact, they felt it was important that the organization should make only moderate demands on its members and also respond to their needs.[5] Echoing Brandeis, the leadership of Hadassah also saw numbers as conferring power, including the political power the organization would need in order to realize its objectives.

Thus the principle of a broad-based, mass movement of Zionist Jewish women guided the policies and measures adopted by Hadassah. This basic goal was expressed in the daily work of the organization's activists and in their effort to persuade members at different levels that a strong numerical base was essential to its continued existence.[6] Vast amounts of energy were invested in recruiting new members. One of Hadassah's publications vividly described the work this involved: knocking endlessly on doors, writing thousands of letters, organizing tea parties and countless meetings, and spreading the word that membership of Hadassah supported Zionist interests in Palestine.[7]

Local activists were strongly urged to recruit new members, and the National Board used various techniques to increase the membership. One of these was the

[3] Excerpts from Urofsky, *American Zionism*, 145. On the great emphasis in Brandeis's Zionist view on the need for members, see Shapiro, *Leadership*, 78; Urofsky, 'Zionism: An American Experience', 228.

[4] See e.g. Rose Halprin's address, Meeting of the Zionist Executive in Jerusalem, 5–15 May 1949 (Heb.), CZA, 88.

[5] See e.g. address of the chair of the National Board Membership Committee, minutes of Hadassah National Board meeting, 10 Jan. 1951, 1.

[6] For additional examples of the strong emphasis placed on the need to increase the number of members, see Judith Epstein, quoted in Hadassah Annual Report, 1947, 5; also 'Hadassah Officers Training School Bulletin', Philadelphia chapter [n.d.], 7; author's interview with Sara Mishkin, New York, 21 June 1991.

[7] Proceedings of Hadassah's 35th Annual Convention (1949), HA, RG3, ser. Proceedings, box 32, 103.

concept of lifetime membership, adopted by the National Board in 1949.[8] Lifetime membership was attained not by paying the regular annual membership dues, but rather by paying a one-off fee. The idea was that Hadassah members would buy lifetime membership for their daughters as a wedding gift, and later for their granddaughters at birth; this was considered a relatively effortless way for existing members to bring in new members.

TRADITIONAL JEWISH AND AMERICAN ZIONIST PRINCIPLES

The Jewish fundamentals of Hadassah's ideology were drawn from a somewhat modified and secularized version of traditional Judaism, in a mode that was widespread in central and western Europe and in the United States.[9]

Hadassah's primary objective is to ensure Jewish survival, both physical and spiritual. This has been a central aim of Jews throughout the ages, of American Jewry from its inception, and subsequently of American Zionism. In this respect Hadassah was at one with the Zionist Organization of America, which defined its main duty as being 'to ensure Jewish survival in the United States'.[10] This concept was, and still is, twofold, comprising a physical aspect (commitment to the continued physical existence of individual Jews) and a spiritual aspect (commitment to the continuity of Judaism).[11]

The commitment to Jewish survival was expressed in the terms of Hadassah's organizational aims, formulated on its establishment: first, 'to promote Jewish institutions and enterprises in Palestine', and second, 'to foster Zionist ideals in America'.[12] These are clearly two distinct and separate aims, each of which geographically anchored the activity of Hadassah, throughout its existence, in one of two arenas: the Yishuv and Israel (in the physical realm) and the United States (in the spiritual realm).

[8] Ibid.

[9] On the definition of the term 'secularization', see Katz, 'Religion as a Unifying and Dividing Force', 132–5. Most relevant for present purposes is the definition on p. 135, where Katz describes a cultural process in which 'concepts, symbols and various types of linguistic means that emerged in religion were copied into a totally secular context'.

[10] The excerpt is from Kaufmann, 'The Other Zionism' (Heb.), 94. See also Gal, 'American Zionism between the Two World Wars' (Heb.), 79; id., 'The Historic Continuum Version' (Heb.), 270.

[11] Goldberg, *Hadassah Handbook*, 53. This publication was intended for internal use within the organization, with the aim of informing the active members about the organization and Zionism in general. It was first published in 1946, and revised editions were published at frequent intervals thereafter: in 1948, 1949, 1950, and 1953. The excerpts here and henceforth are from the 1950 edition.

[12] This definition of the organization's aims appears in *The Maccabean*, 14 July 1914, 16.

Supporting Jewish Physical Survival: Looking Beyond America

Hadassah believed that the Jews in the United States had no need to fear for their physical survival. Accordingly, its efforts in this regard focused on those in Palestine and, later, Israel, and also those who planned to emigrate there. Here its ideological commitment was expressed in three realms of its activity: its work in the fields of health and medicine; its support for the establishment of a Jewish state; and its sponsorship of the Youth Aliyah movement.

The development of health services in the Yishuv and later in Israel was guided by Henrietta Szold's view that 'the Zionist ideal is larger even than Palestine itself' and the building up of the Yishuv in Palestine 'a symbol, the concrete expression of your Zionist conviction that Judaism must be changed back from a creed to a way of life'.[13] From the perspective of Jewish tradition, Hadassah's activities in Palestine combined three main commandments of the Jewish religion traditionally considered the realm of women: charity, benevolence, and visiting (and caring for) the sick.[14] According to Jewish law, women are exempt from most of the time-bound commandments: they are not obliged to pray three times a day, they are not counted in the quota required for communal prayer, and they do not study Torah, even though this is considered the highest form of fulfilling the commandments. Nor, in traditional Jewish society, were women involved in the management of community affairs. Their role was limited to bringing up children and performing charitable and benevolent acts that would fulfil those three specific commandments. Even after secularization spread through much of Jewish society, women continued to be active in these fields, even as they became the responsibility of modern social organizations.[15]

This tradition of nurturing and charitable work found expression among the Jews who emigrated to the United States and England from Germany in the nineteenth and early twentieth centuries in their establishment of voluntary women's associations involved in mutual help and philanthropy. This kind of organization was familiar to them in their countries of origin; however, they were also influenced by the customary patterns of organization in American society, where volunteer groups were—and still are—part of the way of life. In the late nineteenth century almost every Jewish community in America already had one or more women's associations.[16]

[13] Passages from 'Message from Henrietta Szold to the Women of Hadassah, Addressed to the 14th Annual Convention of Hadassah, Pittsburgh, 27–29 June 1928', bound pages, n.d., Jewish National and University Library, Jerusalem, 3.

[14] 'Bikur holim', in Talmudic Encylopedia on Matters of Halakhah (Heb.), iv. 158.

[15] Kaplan, The Making of the Jewish Middle Class, 193–4. [16] Wenger, 'Jewish Women of the Club', 11.

Hadassah also incorporated patterns typical of American Jewish philanthropic activity not specifically associated with women. The most significant of these was the construction and support of hospitals. During the nineteenth century, wealthy Jews built Jewish hospitals throughout the United States.[17] Even before the Civil War activities on behalf of hospitals were well thought of, and it was a widely accepted practice among American Jews to make bequests for this purpose. The hospitals founded by these philanthropic Jews employed non-Jewish staff and offered treatment to anyone in need, on a totally non-sectarian basis.[18] In time, Hadassah also became involved in activity for the purpose of setting up and supporting hospitals in Palestine and, later, Israel, as well as non-sectarian treatment there.

The concept of *hatsalah* (literally 'rescue', but broadly understood as helping the disadvantaged) is a central element in Hadassah's ideology. Underlying all the organization's activity in the fields of medicine, health, and vocational education, it was most clearly expressed in its sponsorship of Youth Aliyah, which it considered a unique humanitarian social project in its commitment to the relief, rehabilitation, and re-education of children and teenagers.[19] The importance ascribed to this basic principle was expressed symbolically in the name of the organization: Hadassah was an alternative name for the biblical figure of Esther ('Hadassah, that is Esther', Esther 2: 7), the beautiful woman who rescued her people.

The same principle has been central to the activity of numerous modern Jewish organizations. Jews, especially in the Western countries, reacted to increasing persecution in the twentieth century in the spirit of the religious obligation to undertake the redemption of prisoners (*pidyon shevuyim*).[20] Indeed, the widespread political and philanthropic activity of American Jews has been interpreted as the secularization of this religious obligation.[21] Among the applications of this commandment in modern times was the establishment of international networks to express Jewish solidarity. Most of these were based in the United States, Hadassah among them; B'nai B'rith, the American Jewish Congress, the World Jewish Congress, and HIAS (Hebrew Immigrant Aid Society) are just a few more examples.[22] Thus Hadassah's activity in this field not only reflected general

[17] Kutzik, *The Social Basis of American Jewish Philanthropy*, 280, 285–8.

[18] Ibid. 308. [19] Hadassah Annual Reports, 1948/9, 28; 1955/6, 11.

[20] On the commandment of redemption of prisoners, see Hakham, 'Prisoners and Redemption of Prisoners', *Encylopedia Hebraica* (Heb.), xxxi. 381–4.

[21] Feingold, 'Rescuing and the Secular Perception' (Heb.), 161.

[22] Pinkus and Troen (eds.), *Jewish Solidarity* (Heb.), 7, 10–11.

humanistic values but was widely accepted by American Jewry, and in the Western
Jewish world as a whole.

The Spiritual Aspect: Hadassah and Jewish Education

One of Hadassah's aims was to strengthen the Jewish community in the United
States culturally and spiritually, and in the period immediately after the Second
World War the organization considered itself one of the most important forces for
ensuring the continuance of 'creative' Jewish life in the United States. Its activity in
the field of Jewish education was intended to promote this goal.[23] In expressing
its commitment to Jewish survival in the American setting through education,
Hadassah drew inspiration from the National Council of Jewish Women, which
was the first national Jewish women's organization in America and had long
been active in providing Jewish education to its members in the United States.
Hadassah's own efforts in this area took two forms: first and most prominently,
providing the organization's members with Jewish and Zionist education, and
second, supporting Zionist youth movements.

Jewish education was the focal point of the Hadassah leaders' activity in
America, as a means of imparting Jewish heritage to the next generation.[24] Many of
those leaders, as noted in Chapter 3, were trained in education (including Jewish
education) and had worked as teachers, writers, and editors, among them Tamar de
Sola Pool, who had been all three, and Marian Greenberg, a graduate of Cornell
University, who was an editor, a writer, and a member of the editorial board of the
Reconstructionist, the bulletin of the Reconstructionist movement. Other leading
figures were Dr Miriam Freund, a graduate of Columbia University and later
president of Hadassah, and Bertha Schoolman, a graduate of Hunter College and
the Teachers' Institute of the Jewish Theological Seminary of America, who,
together with her husband, the educator Albert P. (Aba) Schoolman, directed a
network of Jewish youth summer camps. These leaders and others sat on the
committees of the National Board of Hadassah, which approved programmes and
budgets for education, and influenced Hadassah's development and support of
Jewish education projects.

[23] Hadassah Annual Report, 1948/9, 39; Proceedings of Hadassah's 35th Annual Convention (1949),
HA, RG3, ser. Proceedings, box 32, 171, address by Esther Gottesman; *American Jewish Yearbook*, 51 (1950),
468; 53 (1952), 487; 54 (1953), 503; 1956 Constitution, HA, RG17, 2.

[24] For two examples among many of the interest of Hadassah's leaders in the continuity of Jewish exis-
tence, see Freund-Rosenthal, *In My Lifetime*, 24; Proceedings of Hadassah's 34th Annual Convention
(1948), HA, RG3, ser. Proceedings, box 32, 113–14, address by Miriam Freund.

In 1947 Hadassah republished a book by Milton Steinberg, a well-known Conservative rabbi and one of the most influential figures in the Reconstructionist movement. First published in 1934, it was entitled *The Making of the Modern Jew*.[25] The organization's Education Department prepared a guide to accompany the book, which is used in Hadassah's education programme to this day.[26] The book's central theme is Jewish survival. According to Steinberg, modern American Jews are a link in the continuum of generations, and they should study the Jewish past in order both to know and to understand themselves, and to draw from that past an example and inspiration for preserving their existence as Jews.

Steinberg considered Jewish emancipation in Europe the most crucial event in modern Jewish history and the key factor that shaped the modern Jew. The book discusses its spiritual implications and effects, concentrating on the processes of disintegration among the Jews. Steinberg perceived Zionism as important chiefly from the spiritual perspective, and as the outcome of and response to these processes of disintegration. He believed that Zionism was a synthesis between the ideas of Theodor Herzl and Ahad Ha'am, 'but the ideology and theory are almost universally Achad Ha'am's'.[27] Steinberg saw Zionism as a productive cultural force that fertilizes the Diaspora, and as 'the most powerful factor operating toward Jewish survival'.[28]

According to Steinberg, the Jewish state could not be a refuge for all the persecuted Jews of the world, as it did not have room for everyone, and it could not provide a full solution, even culturally, to their plight. The book discusses at length what its author saw as a revival of Hebraic culture in the Yishuv: folklore, art, a school system, and a university that conveyed 'the heritage of the past and the problems of the present'. In his view, 'Palestinian Jewry has been culturally creative as no Diaspora community has been in two thousand years'.[29] From his perspective, 'Zionism has made possible, at least in one land, a full Jewish life, a revival of a complete civilization' which did not have to compete with and adapt to the majority culture, and had ushered in a Hebraic cultural renaissance throughout the Diaspora.[30] Steinberg saw the return to Zion as the closure of a circle, and entitled the final chapter of his book 'Palestine Again'.[31]

Also in 1947, the Hadassah Education Department published another book by Milton Steinberg, *Basic Judaism*, in response to repeated requests from Hadassah

[25] Steinberg, *Making of the Modern Jew*.

[26] Goldberg, *Making of the Modern Jew: A Leader's Guide*.

[27] For the arguments and the quotation, see Steinberg, *Making of the Modern Jew*, 305.

[28] Ibid. 311. [29] Ibid. 310. [30] Ibid. 310–11. [31] Ibid. 294–312.

members for an introductory work on the Jewish religion.[32] This accessible text, which was written with a wide readership in mind, discusses 'those beliefs, ideals, and practices which make up the historic Jewish faith'.[33] The author proclaims his intention to be neutral in describing the various streams of American Judaism. Chapters of the book are devoted respectively to the Torah, the concept of divinity, the practical commandments (mainly those related to the sabbath, the dietary laws, and rites of passage), the synagogue, and the afterlife.

The choice of this book was based on Hadassah's desire to reach all Jewish women in America. As with *The Making of the Modern Jew*, the Education Department prepared an accompanying guide, the introduction of which explained that the book 'deals with those beliefs, ideals and practices common to all [American] Jewish groupings or sects'.[34] Like the book itself, the guide addressed the widest possible audience and all religious streams of American Jewry. In the introduction, its author expressed the hope that the book would foster greater 'appreciation of our religion' among the members of the organization.[35] This guide reflects Hadassah's general approach to the Jewish religion: it is deliberately neutral, expressing no opinion on the many different interpretations that exist among Jews in the United States.

In anticipation of the founding of the State of Israel, a new spirit of enthusiasm and creativity filled the Hadassah Education Department. At the January 1948 National Board meeting, the chairman of the National Board Committee for Education, Hannah Goldberg, argued that American Jewry had undergone essential changes that required Hadassah to change its educational approach. Zionism, she said, was not only a political revival, but also a cultural revival of the Jewish people, and Hadassah's education programme should stress the cultural aspect of this renaissance.[36] The practical implication of this approach was that greater emphasis should be placed on teaching both the Hebrew language and Jewish history, in order to ensure that those values of the Jewish heritage that were perceived as relevant to current Jewish life and to building the future were preserved and taught.[37]

Six months later, in July 1948, Goldberg presented her plans for the year ahead to the National Board. The primary aim, she said, was 'to maximize creative Jewish living in the United States integrated into the American scene'. Accordingly, the

[32] Steinberg, *Basic Judaism*. Hadassah sources claim that the book was published in 1948.
[33] Steinberg, *Basic Judaism*, p. vii. [34] Levin, *Basic Judaism: A Leader's Guide*, 3. [35] Ibid.
[36] Minutes of Hadassah National Board meeting, 5 Jan. 1948, 8. [37] Ibid.

Hadassah education programme concentrated for several years on three areas: political education, general Jewish education, and education in democracy.[38]

Immediately after the establishment of the State of Israel, Goldberg tried to add new emphasis to the study of Hebrew. Towards the end of 1948 she reported to the National Board on her contact with Professor Eliezer Rieger of the Hebrew University in Jerusalem (later to become executive director of the Israel Ministry of Education), and his agreement to prepare a basic course in the Hebrew language. Hadassah paid Rieger $2,000 for writing the book, and financed the printing. Rieger wrote the book using the method of language instruction developed in the US army during the Second World War, and tried the course out on members of the National Board.[39] Hadassah urged its members to study Hebrew, both because revival of the Hebrew language was an integral part of the Zionist movement and because the Hebrew language would serve as a bridge between American Jews and Israel.[40]

As part of the effort to expand Hadassah's educational activity, in 1951 a professional director was appointed to head the Education Department. Naomi Ben-Asher brought a new spirit to the department, which went on to publish several new courses that same year.[41] In presenting a personal statement of her approach and intent to the National Board in January 1951, she argued that Hadassah, as a mass movement and one of the principal influences on American Jewry, should have an educational programme designed to address all Jewish women in the United States, with due consideration for their different intellectual levels.[42]

A few months later, Esther Gottesman, chair of the National Board Committee for Education, argued that it was necessary to devote more time to an intensified education programme, which would both strengthen Jewish life in America and also help to increase Hadassah's membership to a quarter of a million. On the same occasion, Naomi Ben-Asher presented three new courses that were about to be published by the Education Department: a course on the foundations of freedom in Judaism; a course for young parents who wanted to impart Jewish heritage to their

[38] Ibid., 14 July 1948, 5.
[39] Ibid., 12 Dec. 1948, 9; ibid., 9 Dec. 1948, 8; on financing the book's printing, ibid., 18 May 1949, 4.
[40] Hadassah Annual Report, 1948/9, 40.
[41] Ben-Asher, *Democracy's Hebrew Roots*. In June 1951 the Education Department first published a bibliographical guide to books and pamphlets on 'Jewish and Zionist affairs' under the title *What to Read—Where to Find It—Survey of Pamphlets of Jewish and Zionist Interests Recommended by the Education Department of Hadassah*. See also Appendix D. The Education Department may also have published other study material in that year that it has not been possible to trace.
[42] Minutes of Hadassah National Board meeting, 5 Jan. 1951, 7.

children; and a course entitled 'Israel Today'.[43] Over the next three years, the Education Department offered Hadassah members a series of study materials on diverse subjects: Jewish history, Hebrew literature, Zionism, holidays and Jewish values, Israel, women's status in Israel, and Hadassah itself. In addition, a long list of recommended publications on Jewish topics was distributed to the membership (see Appendix D).

One of the most succinct expressions of Hadassah's educational view can be found in the speech delivered by Etta Rosensohn, then president of Hadassah, at the Thirty-Eighth Annual Convention (1952):

Hadassah, a product of Jewish, American and Israeli history, is aware of all three in every part of its program. We could not do what we do in Israel, did we not also do what we do here [in America] . . . It is our conviction that to influence the shaping of a creative, positive, meaningful Jewish life in America is as much a part of Hadassah's job as is our specific program in Israel. In fact, it is Hadassah's philosophy that one could not exist without the other . . . in order to create a Jewish life which shall have content and continuity we must know our history, our tradition, our successes and our failures. Hadassah's education program here is designed to give our members a sense of Jewish history and a high degree of responsibility for the continuing of a great tradition. It is not enough to be born Jewish—we must live as Jews. And we must give to our children the knowledge—the tools and the instruments—to make them want to live a positive Jewish life.[44]

In this spirit, Hadassah launched a project that constituted the crowning glory of its educational undertaking in the period under study here: publication of the book *Great Ages and Ideas of the Jewish People*, which deals with Jewish history and culture. In February 1953 the National Board enthusiastically approved Esther Gottesman's suggestion to initiate preparation of a course in Jewish history that would, as she put it, 'tell us why we are what we are today'.[45] At a meeting two months later of Hadassah's National Education Advisory Committee, which included scholars in various areas of Jewish studies, the names of possible editors of the book were put forward, and a subcommittee was appointed to meet in June and July.

Esther Gottesman intended to publish not a chronological history but a 'selective history'. She reported her plan to the National Board in late 1953, and they accepted it enthusiastically. She envisioned a history book that would 'stimulate a love of Jewish history . . . inspire a responsibility to Israel . . . point us to the bonds of

[43] Minutes of Hadassah National Board meeting, 5 May 1951, 8.

[44] Proceedings of Hadassah's 38th Annual Convention (1952), HA, RG3, ser. Proceedings, 37, Etta Rosensohn's speech. By permission of Hadassah, The Women's Zionist Organization of America, Inc.

[45] Minutes of Hadassah National Board meeting, 15 Feb. 1953, 8.

the Hebrew language . . . stimulate love of Israel in an absolute sense. With this deepened Jewish knowledge our women will take a more dynamic part in Hadassah and through Hadassah in the American Jewish community.'[46] The editor finally chosen—Leo W. Schwarz, a literary intellectual well known for his anthologies of Jewish literature—was accordingly charged with preparing 'a Jewish history' that would present 'the basic values and ideals of Judaism as they are evidenced in fifteen or eighteen decisive moments in Jewish History' and discuss the impact of these events on contemporary American Jewry. It was also agreed that Schwarz would recruit a team of prominent scholars to prepare the material.[47]

Great Ages and Ideas of the Jewish People was published in 1956, after three years of work. It deals with six defined periods in the history of the Jewish people: the biblical age, the hellenistic age, the talmudic age, the Judaeo-Islamic age, the European age, and the modern age.[48] The authors of the book were expert scholars in the different fields of Jewish studies, chosen with the twin aims of addressing a wide spectrum of readers and of crossing ideological lines: the Israeli biblical thinker and essayist Yehezkel Kaufman, of the Hebrew University in Jerusalem; the American Jewish philologist Professor Ralph Marcus, of the University of Chicago; Gerson D. Cohen, of the Jewish Theological Seminary of America; the Russian-born American scholar of Semitic languages Abraham Halkin, of the City College of New York and the Jewish Theological Seminary of America; the English Jewish historian Cecil Roth, of Oxford University; and the Polish-born historian Professor Salo W. Baron, of Columbia University. Most of them were associated with the central camp of the Conservative movement, and only those who adhered to the extreme forms of either Orthodoxy or Reform were liable to object to the book's content.[49]

Once again, the Education Department prepared a guide to the book, in which its purpose and character were set out by the editor, Leo Schwarz. It was, he said, an interpretation of Jewish culture and society, intended to familiarize readers with the history of that culture and society, in order to deepen understanding of their present and future. In accordance with this aim, the writers had chosen six cultural eras in Jewish history, rather than trying to provide a full chronological account. They wanted to integrate historical narrative with a presentation of Jewish cultural values, to describe and analyse the basic ideas on which Judaism was founded, and to trace their connections to the state of American Jews in the twentieth century.[50]

[46] Proceedings of 39th Annual Convention (1953), HA, RG3, ser. Proceedings; National Board meeting, 5 Jan. 1953, 3–4. [47] Ibid.

[48] The book has been published in seven editions, and is held by 1,313 libraries worldwide.

[49] For information on the authors, see ibid., 'Introduction'.

[50] Hadassah Education Department, *Leaders' Guide to 'Great Ages and Ideas'*, 1–2.

Through the sequence of six ages with which it deals, including a chapter in the section on 'the modern age' devoted to the American Jewish experience, the book presents a view of Judaism as a culture and society whose location has repeatedly changed over the course of history. Although the book makes no attempt to formulate a connection explicitly, this perspective somewhat resembles the position of the historian Simon Dubnow (1860–1941), which had a strong impact on American Zionist thinking. Dubnow saw Jewish history as the trace of the rise and fall of Jewish centres (Palestine, Babylon, Spain, Poland).[51] The book emphasizes Jewish creativity throughout the ages, and the Jewish contribution to Western culture. Emphasis is placed on the survival of Jewish culture, and an attempt is made to underscore those factors that sustained it despite confrontations with major assimilating cultures. Throughout the book analogies are drawn between the various ages in the history of Jewish culture and the current state of American Jewry.

One of the most interesting parts of the book is that which deals with the major developments in the history of the Jewish people in modern times, which was written by Salo Baron. Among other things, Baron discussed modern nationalism, and presented both Nazism and the different versions of Jewish nationalism as outcomes of the same impulses. Like Steinberg, Baron saw the importance of Zionism in perpetuating the living culture of Judaism, viewed Zionism as the outcome of the emancipation of the Jews in Europe and as a response to the subsequent processes of disintegration among the Jewish people, and claimed that Zionism was the means by which world Jewry could be unified.[52] Baron devoted a part of his essay to the revival of Hebraic culture, and claimed that, in aiming to locate its spiritual centre in Zion, cultural Zionism was performing a great service to humanity in general. As evidence in support of this claim he cited the Hebrew University, which, he asserted, was conceived not only as a school of higher education and a centre for the entire Jewish people, but also to serve humanity as a whole.[53]

Both *The Making of the Modern Jew* and *Great Ideas and Ages of the Jewish People* express Hadassah's perception of the essence of contemporary Jewish existence and the central goal of Zionism. According to this view, which is characteristic of American Zionism, Zionism is not a total revolution in the history of the Jewish people—as it is held to be by some of the Zionist streams in Europe (particularly those of a socialist persuasion)—but an inseparable continuation of Jewish history over the generations, which is perceived as a rich and complex past and a source of pride and inspiration.

[51] Gorny, *The Quest for National Identity* (Heb.), 40.
[52] Schwartz, *Great Ages and Ideas*, 338–59, 421–2. [53] Ibid. 434.

Great Ages and Ideas of the Jewish People presents a view of Judaism as a culture encompassing all aspects of life. This view was given prominent expression in the new constitution adopted by Hadassah in 1956, the year of its publication. In this document, for the first time in its history, Hadassah defined its aims in great detail, based on its commitment to the continued existence of the Jewish people in the United States. The constitution determined that one of the objectives and purposes of Hadassah was

to foster the ethics and ideals of Judaism among its members and among Jewish youth through a program of Jewish education designed to encourage, and to provide material and facilities for the study of the bible, Jewish history, traditions and culture, the Hebrew language and literature, Zionism; to strengthen the concept of a Jewish renaissance through the rebirth of Israel as a nation, in its ancient homeland; and to stimulate Jewish learning and study through the publication and dissemination of literature relating to Jews and Judaism.[54]

When *Great Ages and Ideas* appeared in October 1956, the Education Department used it not only for educational purposes but also for public relations—in which capacity (as the chair of the Education Committee announced in 1957) it made a significant impact. Radio, television, and press features accompanied its publication; the department published a brochure to promote the book; it was displayed in public libraries, in synagogues—including Reform synagogues—in high schools, and in university libraries. Hundreds of study groups studied the book, and most of them (88 per cent) also used the guidebook that the Education Department distributed. The book also constituted the basis for regional seminars of several days, organized in co-operation with the Education Department.[55]

The perception of Judaism as a 'culture' that emerges from *Great Ages and Ideas of the Jewish People* was derived, among other sources, from several major American Zionist thinkers. Hadassah adopted Zionist ideas from adherents of different world-views, so that its ideology included elements drawn from such disparate sources as the religious philosopher Mordecai M. Kaplan and the self-proclaimed non-religious thinker Horace Kallen.

It was Kaplan who best crystallized the notion of Judaism as a religious culture. In a series of articles and in his highly influential book *Judaism as a Civilization: Toward a Reconstruction of American Jewish Life* (first published in 1934), Kaplan offered a new understanding of Judaism. He defined the Jewish group in ethnic

[54] 1956 Constitution, HA, RG17, article II. By permission of Hadassah, The Women's Zionist Organization of America, Inc. [55] Hadassah Annual Report, 1956/7, 45.

terms, and claimed that Judaism should not be seen as a religion alone, but as a civilization, including 'history, literature, language, social organization, folklore, rules of behaviour, social and spiritual ideals [and] aesthetic values'.[56] The key components of Jewish civilization, he argued, are the Hebrew language, the connection with the Land of Israel, and the national history.[57]

The view of Judaism as an ethnic culture also sits easily with the concept of cultural pluralism developed by Kallen, which was the basis for the Zionist views of Louis D. Brandeis. According to this perspective, the United States is a 'cooperation of cultural diversities . . . a commonwealth of national cultures, aiming through Union, not at uniformity, but at variety, at a one out of many'.[58] Kallen compared American society to an orchestra, in which 'every ethnic group shall be a natural instrument [by means of which] a range [the ethnic cultures in America] is likely to become wider, richer, and more beautiful'.[59] Alongside the idea of cultural pluralism, Kallen also used the term 'Hebraism', referring to 'all that has happened in Jewish history, both religious and secular'.[60] According to Kallen, the Jewish religion is only one aspect of Judaism, which includes 'the sentiment, theories, doctrines, and practices which relate to God'.[61]

Hadassah's main investment in education during this period, then, took the form of the development of study material that would provide Jewish women in America with a basic knowledge of Judaism, Jewish history, Jewish ethics, and different aspects of Zionism.[62] An attempt was also made to teach members a basic vocabulary in Hebrew. However, despite the efforts invested by the Education Department, Hadassah's leaders were generally disappointed with the level of educational activity in the rank and file of the organization.[63]

The common form of study at local level was a 'study group'—the method used by the National Council of Jewish Women, following the practice customary in American women's clubs of the early twentieth century. This method was already commonly used in American Zionist women's associations in the early twentieth century, and has been adopted by Hadassah through to the present time. In theory,

[56] For the quotation, see Schweid, *History of Jewish Thought in the Twentieth Century* (Heb.), 265. Kaplan presented his overall view of Judaism as a civilization in two major books, *Judaism as a Civilization* and *Greater Judaism*. [57] Eisen, *The Chosen People*, 48.

[58] Schmidt, 'Towards the Pittsburgh Program', 20. [59] Kallen, *Culture and Democracy*, 124–5.

[60] Kallen, 'Democracy versus the Melting Pot', 190–4, 217–20, cited in Schmidt, 'Towards the Pittsburgh Program', 20. These ideas of Kallen's were further developed in *Culture and Democracy*.

[61] Schmidt, 'Towards the Pittsburgh Program', 20–1.

[62] See Appendix D. On Jewish ethics, see also Ben-Asher, *Democracy's Hebrew Roots*.

[63] Minutes of Hadassah National Board meeting, 5 Nov. 1952, 8.

groups should meet once a month to study one of the courses developed by the Education Department, with one of the members serving as the study leader. In practice, however, only a tiny minority of the members of the organization actually participated in the study groups.[64]

The leaders of Hadassah tried various ways of increasing study group participation. One method, proposed by Rose Halprin, was to institute a custom—still accepted today—of devoting ten minutes of each local group meeting to educational matters.[65] A more ambitious step was taken in the summer of 1954, when the National Board submitted a study plan to the chapter presidents. This introduced a course in Hebrew, Jewish history (including the Bible), and Zionism, to run alongside the existing course entitled 'Basic Judaism', based on Milton Steinberg's book. The members of the chapter boards were asked to devote half an hour at each meeting to studying the new course. This demand initially aroused resentment among the members of many groups, including chapter presidents; however, in time, enthusiasm increased to the point where, in many chapters, the board felt that the time allotted to studies was inadequate; indeed, several chapters set up study groups with the aim of completing the study of ground they had not had time to cover during the meetings.[66] However, the historical material available does not provide an adequate basis for more comprehensive conclusions regarding the degree of success, effectiveness, or popularity of Hadassah's educational activity among the members of the organization.

SUPPORT OF ZIONIST YOUTH MOVEMENTS

Given the organization's stated commitment to the continuity of Jewish life and the inculcation of Jewish heritage, it was natural that Hadassah should support relevant activity among American Jewish youth. It established a daughter movement, Junior Hadassah, and also supported two other national youth movements: Young

[64] Repeated answers in interviews with several active members of Hadassah in chapters in major cities and in small towns: Sara M. Rosenbaum, director general of the Philadelphia chapter 1943–76, Philadelphia, 16 July 1991; several veterans of the Philadelphia chapter (Betty Hieckhen, who joined Hadassah in 1926 and served as chair of the education committee of the chapter and as vice-president of different groups in Philadelphia; Ann M. Sebotnik; and Evelyne Berman, a member of Hadassah since 1932, all in Philadelphia); Selma D. Abusol (who in the 1950s lived in the town of Vicksburg, Va.), Bethesda, Md., 30 June 1991; Fanny Cohen, New York, 10 June 1991; and Rose Dorfman, New York, 7 June 1991.

[65] On Halprin's proposal, see minutes of Hadassah National Board meeting, 5 Nov. 1951, 8; information on the continued existence of the custom from author's interviews with Judith Diesendruck, Ra'anana, Israel, 20 Feb. 1991, and Sarah Mishkin, New York, 21 June 1991.

[66] Hadassah Progress Report: Projects and Activities, 1954/5, 62.

Judaea and the Intercollegiate Zionist Federation of America (IZFA), the first
national Jewish student organization in the United States.[67] All three movements
had a distinctly American character. They were apolitical movements supported
by adults, based on the American educational approach of directing adolescents'
rebellious impulses into constructive channels and emphasizing education in
democracy and leadership.[68] As apolitical educational movements they differed,
in essence and in purpose, from the type of Zionist youth movement prevalent in
eastern Europe (such as Hashomer Hatzair), which tended rather to foster re-
bellion against the values of parents, teachers, and society, and encourage a search
for new values and ways of living—sometimes bringing young people into conflict
with their parents in the process.[69]

The movements supported by Hadassah also differed from other American
Zionist youth movements with specific political or religious affiliations. Some of
these, such as Habonim (later Habonim–Dror North America), the Hashomer
Hatzair Zionist Youth Movement, and Noar Mizrachi of America (Noam), were
sponsored by political organizations.[70] The Habonim youth movement was con-
nected to Poalei Tsion, and adopted the latter's specifically socialist, humanist,
and democratic ideology; it also had an anti-militaristic and pacifist tradition.[71]
Habonim saw fulfilment of the pioneering ideal (ḥalutsiyut) as its main, albeit not
its only, aim, as reflected in its definition of goals in 1952 as the desire to train
'Jewish youth to become halutzim in Israel; [stimulate] study of Jewish life, history
and culture; [prepare] youth for the defence of Jewish rights everywhere; [prepare]
Jewish youth for active participation in American Jewish community life'.[72] The US
branch of the Hashomer Hatzair movement was even more tightly focused, not
setting itself any goal of contributing to creative Jewish life in the United States, but
claiming only to '[educate] youth and [provide] agricultural training for pioneering
and collective life in Israel'.[73] At the other end of the ideological spectrum stood
the religious youth movement Noar Mizrachi of America, part of the Mizrachi
Organization of America. This youth organization was also characterized by politi-
cal affiliation, but was not a pioneering movement. Its aims were more narrowly
religious: 'to aid in the upbuilding of Israel in accordance with the Torah and to
spread religious Zionist ideals to American Jewish youth'.[74]

[67] Hadassah Progress Report: Projects and Activities, 1954/5, 63–7; Hadassah Annual Report 1948/9,
60–2. [68] Grand, 'A History of Zionist Youth Organizations', pp. ix–x.
[69] Hurwitz (ed.), *Against the Stream*, 104. [70] Grand, 'A History of Zionist Youth Organizations', 341.
[71] Riemer, 'Jewish Youth' (Heb.), 47, 49. [72] *American Jewish Yearbook*, 53 (1952), 487; 54 (1953), 503.
[73] *American Jewish Yearbook*, 54 (1953), 503. [74] Ibid. 201.

Unlike all of these groups, the youth organizations sponsored by Hadassah were 'made in America' educational movements. They all emerged from and were rooted in the Jewish community in the United States; they all stressed Jewish education of a Zionist character and the relationship with Israel. Like Hadassah, they were movements that were open to everyone, demanding no ideological commitment except to the basic principle shared by the entire organized Jewish community in the United States: the continuity of creative Jewish life in America. They were all apolitical, remaining unaffiliated to any party either in the United States or in Israel

The three youth movements that Hadassah supported were run by activists on behalf of the Youth and Hechalutz (literally, 'pioneer') department of the World Zionist Organization.[75] The rationale for this support was set out by the chair of the National Board Committee for Youth Movement Activities in a speech given in 1955, in which she stated that Hadassah sponsored a national network of education for Zionist American youth in the belief that it was the younger generation who would determine the future of the Jewish people and its values, and that education of teenagers towards active identification with Jewish life was the key factor that would ensure the future of Judaism and of Zionism.[76]

Junior Hadassah was founded in November 1920, when various separate associations of young Zionist women were united into a national organization open to women up to the age of 25. The members of Junior Hadassah, the vast majority of whom were unmarried, worked to raise funds for projects in Palestine and, later, Israel, for example, the Hadassah Nurses' Training School and the Meir Shfeya youth village.[77]

The leaders of Hadassah tried to encourage the members of Junior Hadassah to attend classes to study Judaism and Zionism. They believed that, as an organization of young women, Junior Hadassah should hold more regular and systematic classes than those run for the older members. Thus in 1929 an education programme in Jewish history, Zionism, Hebrew, and the Jewish religion was

[75] Hadassah Progress Report: Projects and Activities, 1954/5, 63. [76] Ibid.
[77] Miller, 'A History of Hadassah', 232, 238. Meir Shfeya was the most important project supported by Junior Hadassah, for which it assumed full responsibility in 1925. Originally created as an orphanage for underprivileged Palestinian and immigrant children left without parents after the First World War, this 'youth village' was established near the colony of Meir Shfeya, from which it took its name, in the early 1920s. Despite the hardships that at times befell the village (such as basic survival issues and the surrounding instability), Meir Shfeya flourished as a creative learning and living environment combining agricultural and academic study. It encouraged the development of artistic and musical expression, and became well known for its children's mandolin orchestra.

instituted, designed for both individual and group study. In addition to this pro-
gramme, Junior Hadassah also held study circles and discussion groups on a
variety of topics, as well as courses in the Hebrew language.[78]

Although the youth groups Hadassah supported were not primarily pioneering
groups, Junior Hadassah did have a pioneering wing of its own, called Plugat Aliya
(a term literally meaning 'immigration company', which because of the military
connotations of the particular Hebrew term used in this context for 'company'
conveys the idea of a forceful determination to settle in Israel). In 1954–5 it had only
about 200 members, but in that year alone sixteen new groups were established.
Each catered for youth from a wide region, providing activities which included
Hebrew lessons, field trips, and celebration of Israeli holidays; various courses
were run, and several publications issued. Hadassah prepared an education pro-
gramme for the groups which covered Hebrew literature from all periods, current
affairs of the Zionist movement, and the problems faced by the Jewish people in
Israel and the Diaspora. The group leaders generally met once every two weeks in
order to discuss educational problems and ideology.[79]

Young Judaea was an apolitical Zionist youth movement for boys and girls aged
10 to 18; it was the first Zionist youth movement established in the United States,
and became the largest. It was founded in 1909 by the Zionist Conservative edu-
cator and thinker Israel Friedlander, with the central purpose of inculcating Jew-
ish heritage. By 1954 there were 14,000 youngsters in 800 clubs throughout the
United States, engaging in a variety of activities intended to increase their identi-
fication with Judaism and Israel, including sabbath and holiday customs, Israeli
songs, the study of various topics related to Israel, and correspondence with
Israeli teenagers.[80]

Young Judaea issued two periodicals for children and teenagers, dealing with
various topics related to the continuity of Jewish life in the United States and to the
subject of Palestine/Israel. *The Young Judaean*, issued monthly to younger mem-
bers, contained stories, games, poems, and pictures. *The Senior*, which appeared
sometimes monthly, sometimes less often, was issued to members of high-school
age; it was printed in newspaper format and contained articles about current
events, politics, and Young Judaean national and regional activities. Young Judaea
also developed special projects, the most notable being the Tel Yehudah summer
camp in Barryville, Port Jervis (on the border between the states of New York and

[78] Miller, 'A History of Hadassah', 239; Goldberg, *Hadassah Handbook*, 45; Hadassah Progress Report:
Projects and Activities, 1954/5, 67. [79] *Report on Activities 5711–5716 [1951–5]* (Heb.), CZA, 245.
[80] Hadassah Progress Report: Projects and Activities, 1954/5, 63–5.

Pennsylvania). As well as running all the usual activities of a summer camp, Tel Yehudah promoted Zionist ideology in classes and lectures. In between camp sessions there were regional conferences and local chapter activities. Young Judaea also organized tours, classes, and work experience for young people in Israel, over either a summer or a whole year. In addition, there was a 'pioneering circle' (*ḥug ḥalutsi*), which in 1954 numbered 150 teenage boys and girls over the age of 16 who were considering emigrating to Israel, drawn from affiliated clubs in Texas, New Jersey, Connecticut, Massachusetts, Florida, and New York. The education programme of the pioneering circle was designed with a view to the possibility that its members would emigrate to Israel and included, among other things, an intensive course on life in the country.[81]

From 1925 Young Judaea developed strong ties with the new Hebrew Tsofim (Hebrew Scouts) movement in Palestine. The relationship between the two movements was based on a degree of similarity in outlook, both being pluralistic, apolitical movements, drawing their members from diverse backgrounds (there were, for example, religious groups, as well as Arab groups).[82] Young Judaea also developed a noteworthy collaboration with the World Zionist Organization's Youth and Hechalutz Department. After the establishment of the State of Israel, the department invested effort in training leaders to work with young people in the Diaspora, and in initial attempts to bring as many youngsters as possible to Israel, for short or long periods. This included increasing the activity of the Institute for Jewish Youth Leaders from Abroad, which had been founded as early as 1946 but whose activity had diminished in the years prior to the establishment of the state and during the War of Independence. Beginning in 1949, the institute accepted a larger number of participants, who returned to their countries to be leaders in their own youth movements, including Young Judaea and Junior Hadassah.[83]

Study at the Institute for Jewish Youth Leaders from Abroad extended over a full year, about half of which was spent in study of the Hebrew language and literature, the Bible, Jewish history, the geography of Israel, the history of Zionism, and the Jewish settlement of Palestine, along with other subjects.[84] Because of the length of the course, only a very few members of Young Judaea came to Israel in this framework: in 1949 there were only eight. Although the take-up at this time was small, it

[81] Ibid.
[82] On the ties with the Tsofim, see Hadassah Progress Report: Projects and Activities, 1954/5, 64; Alon, *Be Prepared* (Heb.), index, various pages and esp. 379–84; on the religious Tsofim, see Alon, *Be Prepared*, 325–6; on the Arab Tsofim, see ibid. 43–5. [83] *Report on Activities 5707–5711 [1946–51]* (Heb.), CZA, 113.
[84] Hadassah Progress Report: Projects and Activities, 1954/5, 65; *Report on Activities 5707–5711 [1946–51]* (Heb.), CZA, 113.

marked the beginning of a stream of pioneering activity which later became a much broader project.

Hadassah also collaborated with the Youth and Hechalutz Department in developing a programme to enable youngsters to visit Israel during the summer. It saw this as the best means of developing close and lasting ties between young Americans and young Israelis, and assumed that the bonds formed in this way would foster a closeness that would lead to the participants engaging in further Zionist activity when they got older. This programme attracted many more young-sters than the year-long programme: in 1954 forty graduates of Young Judaea went to Israel in this framework.[85]

The third of the youth organizations supported by Hadassah was the Inter-collegiate Zionist Federation of America, which was founded in 1948 for Jewish college students, again as an apolitical organization and with the overall aim of 'promoting Zionism' among American Jewish youth. In 1949 IZFA had approx-imately 8,000 members on 136 campuses throughout the United States. It operated an education programme that was intended to encourage significant participation in various aspects of Jewish life. According to Hadassah publications, IZFA was particularly active in public relations on the college campuses.[86]

These three organizations were joined by a fourth when in 1954 the American Zionist Council founded the Zionist Students Organization and Hadassah, as one of the partners in the council, offered its support to this organization as well.[87]

Overall, the importance of Hadassah's work with young people was not recog-nized by Hadassah's rank-and-file members, and the leadership did not sufficiently persuade them of it. Consequently only a relatively small proportion of the organ-ization's budget was devoted to activities in this field.[88]

[85] Hadassah Progress Report: Projects and Activities, 1954/5, 65; a year later (1956) Young Judaea accounted for thirty-one of the participants (*Report on Activities 5711–5716 [1951–5]* (Heb.), CZA, 252).

[86] Hadassah Annual Report, 1948/9, 35.

[87] Hadassah Progress Report: Projects and Activities, 1954/5, 65–6. [88] Ibid. 97.

The American Foundations

A MERICAN ZIONIST IDEOLOGY, at least from Brandeis onwards, had much in common with core American values and the American ethos. Hadassah's ideology is no exception to this rule, echoing American national ideals and characteristics fundamental to American culture.

THE AMERICAN ETIIOS

In the absence of a national common denominator, such as country of origin or heritage, the American national consciousness was largely formed on the basis of ideological identification with and commitment to a set of universal values. An individual's American identity is based on a system of ideas that has penetrated the daily life of American society and constitutes a living faith for most Americans. In their exemplary essays on American nationalism, the scholar of nationalism Hans Kohn and the historian Yehoshua Arieli list three characteristics of the American national consciousness that are particularly relevant in this context:

1. consciousness of a difference from other nations;

2. attachment to democracy and freedom as the basic values that have shaped American society and its political institutions;[1]

3. belief in a universal mission and destiny, based on the conviction that the American people bear a message for the entire world and that the American social system is applicable for all humankind,[2] perceived in the American national consciousness as a responsibility to achieve the greatest possible freedom and democracy in American society, and to help all humanity benefit from the American model.[3]

These ideals played a significant role in shaping Hadassah's ideology.

[1] Kohn, *American Nationalism*, 31. [2] Arieli, *Individualism and Nationalism*, 187.
[3] Burns, *The American Idea of Mission*, pp. vii, 32.

PRACTICE, PROFESSIONALISM, AND 'SCIENTIFIC PHILANTHROPY'

In addition to the Jewish elements discussed in the previous chapter and the fundamental American ethos, Hadassah's ideology was also shaped, from its inception, by the ideas of 'doing' and 'the concrete'.[4] These originated both in American civilization and in the desire of Hadassah's founders to create an organization that would meet the practical, concrete, and natural needs of women, as they understood those needs within the context of views prevalent in early twentieth-century America, discussed in Chapter 1.

This attachment to the practical and the concrete found expression in the priority attached to science, technology, professionalism, and efficiency in twentieth-century American culture. These values, which became fundamental elements in Hadassah's ideology and practice alike, were the heritage of Progressivism. All had been widely embraced by American women's organizations following the introduction of scientific and professional methods in American philanthropic activity in the late nineteenth century. At the time, it was the conventional wisdom both in the United States and in western and central Europe that scientific and technological advance was the key to progress and a better future for humanity. In the women's organizations it was widely accepted that members working on behalf of needy immigrants should do so with the help of scientific and professional tools. The practice of 'scientific philanthropy' was popular in the American women's club movement in the early twentieth century, and was later adopted by the National Council of Jewish Women, which, as noted above, served as a model for Hadassah in many respects.[5]

The belief in professionalism and in science as the guiding principle in medicine was fundamental to Hadassah's practical work in the Yishuv and Israel. The organization's adherence to these principles was founded on a broader social vision that science should be mobilized for the benefit of all humanity.[6] This vision guided the development of Rothschild-Hadassah University Hospital, and—along

[4] Kutscher, 'The Early Years of Hadassah', 330. For the attachment to the practical and concrete as a particularly American characteristic, see Arieli, *Political Thought* (Heb.), i. 15, 18. Arieli characterizes the American mentality, among other things, as one of 'doing' and 'acting'.

[5] Rogow, *Gone to Another Meeting*, 196–7.

[6] On the American ethos in this context, see Gal, 'Hadassah and the American Jewish Political Tradition', 105. On the belief in science, see e.g. Proceedings of Hadassah's 33rd Annual Convention (1947), HA, RG3, ser. Proceedings, 89, 92 (Epstein); Proceedings of Hadassah's 38th Annual Convention (1952), HA, RG3, ser. Proceedings, 219.

with the ideal of 'pioneering' discussed in the next section of this chapter—led to
projects more in harmony with the scientific view being given preference over
others.

The central role of technology in Hadassah's thought and practice is reflected
not only in the effort to introduce modern equipment into Palestine, but also in the
attention devoted to the subject in its publications. Many examples can be found of
the importance of technology in Hadassah's practical work in Palestine and Israel:
to take just one, its insistence on supplying the boys' workshops in Hadassah's
vocational school in Jerusalem with the finest tools (see Chapter 10). In this case,
too, Hadassah made a point of publicizing the high standard of the school's tech-
nological equipment, again drawing attention to the great importance it ascribed
to this factor.

Alongside the emphasis on science and technology ran another key element
in Hadassah's outlook, namely its insistence on professionalism. This view, also
part of the heritage of American Progressivism, ran through all Hadassah's activ-
ity both in Palestine and in the United States. The organization employed not
only professional physicians but professional educators and writers, and its leaders
consulted regularly with professional advisers in special permanent advisory com-
mittees. Thus, for example, in the late 1940s and early 1950s Hadassah had advis-
ory committees for medical, financial, and educational affairs. Unlike the regular
membership of the organization, these committees were composed mainly of men,
including prominent American Jewish scholars and thinkers of the time. Among
them were Ira Eisenstein, a prominent disciple of Rabbi Mordechai Kaplan and
leader of the Reconstructionist movement; Dr Hayim Greenberg, a historian and
researcher of Jewish education from Duke University; the historian Oscar Janow-
sky; and various financiers and lawyers, some of them the husbands of Hadassah
leaders.[7]

THE FUNDAMENTALS OF HADASSAH'S VISION

Hadassah regarded its major Zionist contribution to building the Land of Israel as
developing its health services in keeping with the highest standard of American
knowhow, including hospitals, health education, social services, and preventative

[7] See Brown, 'Henrietta Szold's Progressive American Vision', 61. The data are based on the lists of
members of the National Board committees and members of the advisory boards for 1950/1 in the Hadas-
sah National Office.

medical services,[8] as well as medical training and research. Every member of Hadassah was considered a partner in the effort to develop these health services, and each one was regarded as contributing personally to building the Land of Israel.

Hadassah's role in this regard was derived from a vision of modernizing Palestine; in the words of Henrietta Szold, it grew out of 'the aspiration of a group of [Jewish] women in America to express their devotion to the Zionist idea by participating actively in the modernization of Palestine'.[9] This aim continued to be one of the guiding lights of Hadassah's activity; a much later analysis similarly recorded that the leadership of Hadassah 'saw their vision as a reflection of America in Israel in terms of medical care and worked to achieve it'.[10] Hadassah's leadership equated modernization with the adoption of accepted American professional perspectives and methods, and derived its modus operandi from this belief. Thus, it introduced advanced training in the United States for those in charge of its enterprises in Palestine (and later Israel), placed an emphasis on the most innovative American methods and instruments, and recruited American experts to provide training, supervision, and evaluation.

The leaders imparted this view to the rank-and-file membership by frequent reference in the organization's publications and in their own speeches to the 'medieval health conditions' that had prevailed in Palestine before Hadassah began its work, and to Hadassah's swift and systematic introduction of high American standards in the fields of medicine and public health.[11]

A key notion in Hadassah's ideology was that of *ḥalutsiyut*—'pioneering'—which guided its decisions about which specific projects to undertake. This idea served as the basis for the principle of 'devolution', by which Hadassah transferred authority over its projects, once they were past the 'pioneering stage' and able to 'serve a large population', to the Yishuv and, later, the Israeli authorities.[12] In the same spirit of support for the pioneering ideal, Hadassah established a hospital in Beersheba in 1949 as one of the foundations for the future Jewish city of the Negev, even though at the time the settlement had only twelve Jewish residents; it also

[8] 'Hadassah in Palestine 5679–5699 [1918–28]', speech by Henrietta Szold, 13. The term 'preventative medicine' appears frequently in Hadassah publications, in contradistinction to the term 'curative medicine'.

[9] 'Hadassah in Palestine 5679–5699 [1918–28]', speech by Henrietta Szold at the opening of the Nathan and Lina Straus Health Centre, Jerusalem, 20 Nisan 5779 [1929] (booklet), CZA, 7250.

[10] Author's interview with Prof. Kalman Mann, Jerusalem, 23 July 1992.

[11] See e.g. Proceedings of Hadassah's 33rd Annual Convention (1947), HA, RG3, ser. Proceedings, 32, 89; Proceedings of Hadassah's 35th Annual Convention (1949), HA, RG3, ser. Proceedings, 626–7.

[12] On the 'devolution' policy, see *Twenty Years of Medical Service in Palestine* (Heb.), 24; for the quotation, ibid.

undertook to set up a medical school (see Chapter 9). The same notion prompted Hadassah in 1952 to transfer 60 per cent of its preventative medicine facilities across Israel to the authority of the Ministry of Health, so that it would be free to initiate and develop other projects to support the pioneering effort. The agreement signed between the parties on this matter noted:

since 1919 the Hadassah Medical Organization [has] founded and managed a network of projects and services in the field of preventative medicine and was the pioneer in this field of activity in Palestine, and whereas . . . in accordance with the principles it set itself, to devolve projects and services it founded and which have become well established to other organizations and authorities that are capable of maintaining them at a suitable standard and expanding and developing them . . . the Hadassah Medical Organization proposes to devolve to the government some of the services in the field of preventative medicine.[13]

This principle of devolution reflects Hadassah's constant commitment to pioneering: 'to see the needs of tomorrow and try to respond to them'. Hadassah was always concerned to undertake new services; to initiate and develop services responding to national or local needs that the government of Israel, for lack of workforce or funds, was unable to initiate or direct; and, later, to devolve these services to the government at such time as the latter was able to assume responsibility for them.[14]

From the fundamentals described above emerged the final principle underlying Hadassah's activities and reflecting its adherence to the Zionist pioneering idea: that of introducing American models that would be emulated in the development of local enterprises. The leaders of Hadassah saw the organization as capable of imparting American standards, techniques, and skills, but recognized that Hadassah could not sustain the country's entire network of medical and social institutions by itself. This distinction gave rise to the idea of creating model institutions: Hadassah would set up an initial operation on the basis of American know-how and techniques in the expectation that similar institutions would follow, on the same pattern. Accordingly, Hadassah's hospitals, clinics, infant welfare centres, vocational schools, and vocational training centres served as models for other similar undertakings.[15]

[13] General memorandum issued by Haim Shalom Halevi (deputy administrative director of Rothschild Hospital) to the mayors and heads of local and regional authorities, ISA, RG57 (Ministry of Health), box 4245, file 214 (see also Chapter 9).

[14] Quotation from Proceedings of the 38th Convention (1952), HA, RG3, ser. Proceedings, 90, Kalman Mann's speech; the claim is from ibid. 321, Etta Rosensohn's speech.

[15] Hadassah Handbook, 58, 68; 'Hadassah in Palestine 5679–5699 [1918–28]', speech by Henrietta Szold, 13.

As noted above, alongside the idea of building up Palestine, and later Israel, as a homeland for the Jews, Hadassah's ideology incorporated a sense of universal mission, a conviction that the Zionist undertaking would benefit humanity as a whole. This was expressed in Hadassah's view of the establishment of health institutions in Palestine as a project that contributed to 'humanity as a whole and the State of Israel' (in that order) and its view of itself as a pioneer in bringing American medical and social services to the 'backward' Middle East, for the benefit of its entire population.[16] Hadassah's medical services were non-sectarian from the very beginning: its medical and social services were provided to Jews and Arabs alike, on the basis of 'the principle of equal treatment for all, regardless of race or faith'.[17]

AMERICAN PATRIOTISM AND THE DEMOCRATIC IDEA

As a patriotic American organization, Hadassah was deeply committed to the democratic idea and the cultivation of a democratic way of life in the United States and elsewhere.[18] Evidence of just how deep this commitment was can be found in the characterization of the typical Hadassah member as 'the American woman in this *great* land of ours, living a daily pattern of democracy and striving to make that daily pattern reach out and become the true fulfilment of the *great ideal of democracy*'.[19] Accordingly, the Hadassah leadership invested great effort in instilling a commitment to the democratic idea among its members, chiefly through the organization's education system.

Thus the Education Department of Hadassah worked both to inculcate democratic values and to link these with Jewish values. For example, in 1951 the department published a course entitled 'Democracy's Hebrew Roots', which remains part of the Hadassah education programme to this day. Referring to the biblical book of Judges, the course discussed the democratic elements in the biblical concept of social welfare and in the selection of judges (charismatic leaders in the ancient Land of Israel during the period between the death of Joshua and the

[16] See e.g. Proceedings of Hadassah's 33rd Annual Convention (1947), HA, RG3, ser. Proceedings, 326, Bertha Schoolman's speech; Engle, 'Hadassah Serves Arab Children'; Dehn, 'HMO Treats Arabs and Jews'.

[17] See Proceedings of Hadassah's 41st Annual Convention (1955), HA, RG3, ser. Proceedings, box 18, 2.

[18] Ibid.

[19] Quotation from Proceedings of Hadassah's 35th Annual Convention (1949), HA, RG3, ser. Proceedings, 557–8, emphasis added; Freund, 'Book Review of Maurice M. Shadovsky, *Anti Semitism in Eastern Europe*', *Hadassah Newsletter*, 34/3 (Nov. 1953), 13.

institution of the monarchy), both of which it presented as key foundations of the Western democratic system. The course developers were guided by the view that 'a study of the evolution of Western democracy must begin in the distant past of Hebraic history. Some of democracy's basic concepts have their origins within it.' This reflected a widespread aspiration among Jews in the United States to draw a connection between Jewish and American values, and to stress the contribution of Jewish culture to democracy.[20]

Another expression of Hadassah's commitment to the democratic idea and the concept of universal mission is the Henrietta Szold Citation and Award for Distinguished Humanitarian Service. This prize, which has been awarded annually since 1949, was specifically designated for Americans only.[21] In 1952 it was awarded to President Truman for 'his leadership in the struggle to preserve the democratic way of life',[22] the wording of the citation emphasizing the dual nature of the 'American mission', to defend democracy both within and beyond the country. The following year the prize was awarded to Supreme Court Justice William O. Douglas, in recognition of his fearless campaigning for democracy and human rights.[23]

THE AMERICAN FOUNDATIONS OF HADASSAH'S VISION OF THE JEWISH STATE

What kind of state did the Hadassah leaders envision during all these years of intensive effort in the cause of its creation? According to the sources available, it seems that they wanted Israel to be a Jewish state, not just the state of the Jews, and believed that one of its roles was to defend American Jewry from assimilation. It is no wonder that the leaders of Hadassah foresaw a state and society in the American image. The Jewish values that they hoped it would embody were liberal and humanistic values, grounded in the American spirit, and the state they hoped to see in existence was 'a Jewish State based on Jewish ethics and on the ideals of the United States'.[24]

Hadassah's vision of the Jewish state was clearly expressed in the manifesto formulated by Rose Halprin, president of Hadassah, shortly after the United

[20] For details on the course and the guidebook, see p. 81 above.
[21] Minutes of Hadassah National Board meeting, 25 Oct. 1953, 3–4.
[22] Friedman, 'Point Four and Hadassah', 2.
[23] *Hadassah Headlines*, May 1953, 4.
[24] Quotation from Gal, 'Hadassah's Ideal Image' (Heb.), 166.

Nations resolved in November 1947 to establish such a state. The statement expressed the hope that the Jewish state would be 'dedicated to the ideals of justice, equality, security, and peace [and would] embody the best ideals of the Jewish and human traditions'.[25] Only afterwards did the manifesto discuss the Jewish role of the state-in-the-making, and expressed the hope that it would be 'the spiritual centre of world Jewry and . . . the source of much of the inspiration for Jewish Living in America'.[26]

Another manifesto written by Halprin in honour of the establishment of Israel emphasized the democratic quality of the Jewish state and praised it as a peace-seeking country and 'the world's most promising democracy'.[27] Furthermore, the declaration of the establishment of the Jewish state was published in the *Hadassah Newsletter* against the background of the American Declaration of Independence, an imaginative iconic representation of the similarity between the two countries.[28]

A year later Rose Halprin wrote an editorial in honour of Israel's first anniversary as an independent state, in which she described the relationship between American Jews and Israel as

a partnership in a common enterprise for the furtherance of human brotherhood. With them [Israelis] and through them we shall try to extend the frontiers of the human spirit beyond rigid geographic boundaries. We, Jews of America, fortunate possessors of two civilizations, that of our ancient people and that of our modern, progressive democracy, dedicate ourselves to the extension of the democratic way of life to every corner where exploitation and injustice still exist.[29]

According to this declaration, the Jewish state was to serve the purpose of a universal mission, alongside its Zionist purposes, and even to help the Jews of America obtain the same general goals for which they worked as patriotic Americans.

A few months after the establishment of the State of Israel, Hadassah noted in its annual report that the new state would have to think about cultivating the welfare of all its citizens, Jews and non-Jews alike. At the same time the *Hadassah Newsletter* re-emphasized the democratic quality of the government in 'the world's youngest democracy', where all residents enjoyed equal rights and civil liberties.[30]

[25] For the arguments and the quotation, see minutes of Hadassah National Board meeting, 4 Jan. 1948, 10.

[26] Ibid. [27] Minutes of Hadassah National Board meeting, 12 May 1948, 1–2.

[28] Gal, 'Hadassah's Ideal Image' (Heb.), 164.

[29] 'We Herewith Pledge . . .', *Hadassah Newsletter*, May 1949, 4, quoted (translated into Hebrew) in Gal, 'Hadassah's Ideal Image' (Heb.), 164.

[30] Hadassah Annual Report, 1947/8, 32; see also Weigert, 'No Jim Crow in Israel'.

Over the following years the *Hadassah Newsletter* published many articles about democracy in Israel, and the Education Department used various means to spread the idea that Israel was a genuinely democratic state. For example, the organization's central manual, the *Hadassah Handbook*, which was published by the Education Department and distributed to the organization's members, contained a very detailed description of the system of government in Israel. Each of the parties in Israel was reviewed, in order to emphasize that political pluralism prevailed.[31] The Education Department also published a booklet entitled *The Government of Israel*, which presented an extensive discussion of the government of Israel and Israeli democracy. This too was distributed to Hadassah members throughout the United States.[32]

Many in Israel argued that the new state should have a written constitution.[33] Hadassah, through its publications, supported this line of thought and expressed the hope that the Jewish state would develop on the basis of a constitution that would ensure its democratic, free, and enlightened character. The Provisional Council of State (the state's constitutional body from the termination of the British Mandate to the establishment of the first Knesset in February 1949) appointed a committee to deal with the subject of a constitution, using one of the drafts as the basis for discussion. This draft was published in the *Hadassah Newsletter* and in the *Hadassah Handbook* in a very prominent manner, and heralded in celebratory tones.[34] A discussion of the draft constitution, including extracts and interpretations, was published in the January 1949 issue of the *Hadassah Newsletter*. The author of the review, Hannah Goldberg, chair of the National Board Committee for Education, defined the constitution as a 'great document', despite a few reservations about its content. She cited passages from the draft relating to the democratic character of Israel and its commitment to ensure the health, education, and welfare of the entire population, such as protection of workers' rights, assurance of a minimum wage, and limitation of the number of working hours. Special emphasis was placed on the concern for health as one of the basic duties of the state. The democratic character of Israel was underscored, among other things, by the fact that although Hebrew was the official language, each of the minorities living within

[31] *Hadassah Handbook*, 34–46.

[32] Hadassah Education Department, *The Government of Israel*. The booklet was first published in 1948. The original edition was sent for comments to the Israel Information Office. The manuscript can be found in the library of Hadassah's National Office in New York.

[33] Guttman, 'Israel: Democracy without a Constitution'; Neuberger, *The Issue of a Constitution in Israel* (Heb.), 22–3. [34] *Hadassah Handbook*, 47–51.

its borders was entitled to cultivate its own language and religious and cultural heritage and to operate its own education system. According to Hannah Goldberg, this was an exemplary democratic document, because Jews had themselves been a persecuted and oppressed minority for many generations and so were especially sensitive to the suffering of others and the sanctity of human life. Alongside the democratic foundations of the constitution, the author emphasized Israel's aspirations for peace.[35]

This brief overview testifies to the prevailing tendency in Hadassah at the time to interpret American values as Jewish values, or, conversely, to interpret Jewish values in such a way as to fit within the American world-view. In particular, the Hadassah leaders wanted to see in Israel a democratic state that was tolerant towards the minorities living within its borders, and a society that would allow minorities to cultivate their heritage.[36] The condition of Israeli Arab citizens was one of the few wider issues that was followed closely by the *Hadassah Newsletter*, which was for the most part dedicated to Hadassah projects in Israel.[37] Most of the articles it published on this topic stressed the equal rights given to the Arabs of Israel, the humane and democratic way in which the State of Israel treated them, and the improvement of their condition within its borders, both in comparison with previous periods in Palestine and in comparison with conditions in the Arab countries at that time. They noted that Israel granted its entire population equality of religious and civil rights, saw to their welfare, education, and health, and promoted the status of women. For example, an article published in the *Hadassah Newsletter* in May 1955, written by an Arab author, noted that the Israeli declaration of independence granted equal rights to Jews and non-Jewish citizens living within the borders of Israel, and that, for the first time in the history of Palestine, Jews and Arabs both voted in national elections.[38]

However, these articles were not critical at all. For example, they did not deal with the problematic nature—from the liberal perspective—of the military regime that governed the Arab population in the early years of the state, but voiced unreserved support for the government's policies towards Israeli Arabs. This approach is sharply at variance with that which prevailed among some of the leaders of Hadassah in the 1930s (see Chapter 2), and it reflects the change that had taken place in the organization's approach to the question of the Palestinian Arabs

[35] Goldberg, 'Draft Constitution'.

[36] On the expectation of a tolerant state towards minorities, see Gal, 'Hadassah's Ideal Image' (Heb.), 166. Parts of the draft were published in *Hadassah Handbook*, 47–51.

[37] On the *Hadassah Newsletter*'s coverage of the condition of the Arabs in Israel, see Gal, 'Hadassah's Ideal Image' (Heb.), 163. [38] See Khleif, 'The Arab Citizens of Israel', 5.

since 1941, when it became politically integrated within the Zionist mainstream. The change in the composition of the Hadassah leadership that began in the early 1940s, with the rise of Rose Halprin and Judith Epstein to senior positions, along-side the organization's unequivocal support for the State of Israel and commit-ment to engage in public relations on its behalf, led the Hadassah leadership to accept Israeli government policy towards Israeli Arab citizens. The general liberal views that had prevailed in the Hadassah leadership in the 1930s may have remained in theory, but in practice, after the establishment of the state and in the light of the threatening security situation, there was unequivocal support for the government's stance.

The perception of Israel as the bastion of democracy in the Middle East was characteristic of all American Zionists in this period. It was based partly on the recognition of their own identity first and foremost as Americans, which meant that, in order to express their American patriotism, they had to be able to identify fundamental American values with the values of the Jewish state. At the beginning of the Cold War, with fear of communism mounting, this goal was attained by portraying Israel as the only democracy in the Middle East, a barrier to communist invasion and to the influence of the Soviet Union and Muslim fundamentalism, and a clear ally of the United States.

Accordingly, American Zionists at the time emphasized that the interests of Israel were similar, if not identical, to those of the United States, and claimed that Israel resembled their nation in its commitment to democracy, industrialization, technology, and modernization. In doing so they were also responding to the op-ponents of Zionism in the American Jewish community, who argued that Zionism led to a dual loyalty and prevented full acceptance of the Jews in American society. Presenting Israel as a lone upholder of democracy in the Middle East put pressure on all American Jews to support Israel, if not as Zionists then as patriotic Ameri-cans, since the Jewish state could then be perceived as essential to American interests.[39] As early as the Thirty-Fourth Annual Convention (1948), Hadassah passed a resolution that presented Israel as the bastion of democracy in the Middle East, and accordingly determined that American interests would be best served by a policy that was friendly to Israel. Some time later it was noted that this was consistent with the United States' declared foreign policy intention of strength-ening democratic regimes wherever they were threatened.[40]

[39] Shapiro, *A Time for Healing*, 203.
[40] 'Zionist Affairs', resolution adopted at Hadassah's 34th Annual Convention, 5–9 Nov. 1948, Atlantic City, NJ, HA, RG3, ser. Proceedings, subser. 1948 Convention, box 14.

In reality, the presentation of Israel as a bastion of democracy was based not only on belief in the democratic idea but also on political motives, and especially on the need to obtain and sustain the massive American aid necessary to support the young state in grave economic and security conditions. Claims were repeatedly made in the *Hadassah Newsletter* and at the organization's annual conventions that Israel was at an important strategic crossroads, that supporting Israel served democracy and strengthened the democratic ideal, and therefore that doing so would strengthen America. In particular, it was argued that Israel ought to be rewarded for upholding democracy in the Middle East by being granted foreign aid, both financial and technical.[41] As some of the state's financial needs were funded by US government loans and grants, it was important for the American Zionist organizations to encourage US public opinion to look favourably on Israel.[42] For this purpose, too, Israel was presented as 'a vital outpost of democracy at a time when democracy is facing its sternest crisis on a global basis', and, with American aid, as 'a stronger bastion for democracy in the Middle East', in the words of two Hadassah publications of 1951.[43] In the same year, when Israel asked the US administration for financial aid of $150 million, the main argument presented by the American Zionists in the campaign to obtain the grant was that it was important to help the young republic not only for humanitarian reasons but also because Israel was a 'potential island of defense against aggressive Communist penetration'. The government approved the requested grant, and a year later awarded Israel another grant of $73 million.[44]

In 1954 Hadassah openly opposed the US government's decision to supply arms to Arab states, claiming that arming the Arab countries before peace had been achieved in the Middle East stood 'in opposition to friendship, partnership, and constructive service of the aims of democracy and peace'. The government was called upon, instead, to make peace in the Middle East one of the goals of American foreign policy, 'both as an end in itself and as the most vital step in strengthening the defense of the free world in that area'.[45]

[41] Hadassah, *Integrated Kit*, Mar. 1951, 2; on Israel being the sole bastion of democracy in the Middle East see Hadassah, *Integrated Kit*, Dec. 1953, pt. 3 (Education), 1. [42] Urofsky, *We Are One*, 201.
[43] Quotes from Hadassah, *Integrated Kit*, Mar. 1951, 2. [44] Urofsky, *We Are One*, 201.
[45] 'Zionist Affairs', resolution adopted at Hadassah's 40th Annual Convention, New York, 22–6 Aug. 1954, HA, RG3, ser. Proceedings, subser. 1952–5 conventions, box 18.

'AMERICAN AFFAIRS'

Second-generation Jews were ardent participants in the American political process. Democracy appeared to be the real religion of America and second-generation Jews embraced the new faith.
D. D. MOORE, *At Home in America*

In 1942, while US armed forces were still immersed in heavy fighting in the Pacific and in Africa, the Hadassah leadership undertook to sell war bonds on behalf of the American government. This deviation from the original organizational goals of Hadassah led to the creation of what became known as the 'American Affairs Program'—and to a battle within the Hadassah leadership between those who supported the programme and those who opposed it.[46]

The debate revolved around the question of whether Hadassah should involve itself in matters that were not purely Zionist issues. The opponents of the programme felt that to do so might jeopardize the identity of Hadassah as a Zionist organization. In contrast, its supporters claimed that it highlighted Hadassah's role as an organization that not only promoted the interests of the Jewish community living in another, far distant, part of the world, but also engaged in affairs that were relevant to every Jewish woman in America. Thus, they argued, it would attract members who were not primarily interested in Zionist activity.

The debate about the American Affairs Program remained unresolved many years after it was actually adopted, and the programme itself was for many years considered a 'stepchild' in the organization. Nevertheless, in the mid-1940s the American Affairs Department was established in the Hadassah national office in New York to concentrate exclusively on issues related to the United States. Over the following years the department conducted a varied programme of activities in pursuit of its numerous goals, which expressed the liberal tendencies of American Jews in that period. Its programme served simultaneously as a means to achieve certain political goals and as a means to attract new members to the organization.

Hadassah's ideological tendencies with regard to internal American social affairs were guided by the liberal political trends characteristic of contemporary American Jewry in general, and the development of the American Affairs Program and the department established to put it into practice should be considered against the background of the state of mind of American Jewry in the decade following the Second World War. At this time American Jews were highly concerned with their identity as Americans, and from 1945 liberalism became one of the most

[46] Tamar de Sola Pool, interview by Judith Epstein (transcription), HA, RG20, folder 2, p. 3; author's interview with Dr Miriam Freund-Rosenthal, New York, 2 June 1991.

prominent elements of American Jewish identity. After the war, the Jews of America sought to participate in civil and political life there with unprecedented force and effectiveness. Local Jewish community institutions were formed that played an active role in civic affairs, and energies formerly devoted to the protection of the rights of Jews were diverted into wider American affairs. The American Jewish Congress, for example, set up a department in 1945 with the aim of 'working for a better world . . . whether or not the individual issues touch directly upon so-called Jewish interests'.[47] American Jews at this time, then, had two public commitments, which were largely complementary: ensuring the security of Israel and fighting for liberal America.[48]

Embedding 'American Affairs' within Hadassah

In 1947 the president of Hadassah, Judith Epstein, claimed that the growing importance of the American Affairs Program was the result of learning the lesson of Jewish history that the fate of the Jewish people was bound up with that of the proponents of liberal forces.[49] A few months later, in January 1948, shortly after the UN General Assembly resolution on the founding of a Jewish state, Florence Perlman, chair of the National Board Committee for American Affairs, claimed that in view of the imminent establishment of a Jewish state the American Affairs Program should be increased. In support of her argument she presented a list of four points which expressed the multifaceted nature of the programme and its goals, as well as an attempt to tie American affairs to the Zionist issue.

1. The programme provided leverage for public relations on behalf of Zionism. It contributed to public relations in the interest of Zionism; thanks to it, the work of Hadassah was brought to the attention of the US State Department and War Department, as well as many non-Jewish organizations.

2. The programme was an important source of new members, and brought to Hadassah thousands of non-Zionist young Jewish women who wanted to belong to an organization that worked for democracy in the American arena.

3. The programme helped achieve political and liberal goals by striving for better government, and encouraging the use of the Jewish vote, social legislation, and protection of civil rights.

[47] Gal, 'Hadassah and the American Jewish Political Tradition', 90; Goren, 'A "Golden Decade"', 7.
[48] Ibid. 8. [49] Hadassah Annual Report, 1947, 14.

4. Against the background of the high hopes in the United States immediately after the establishment of the UN that the organization would be a tool to prevent the outbreak of wars, the American Affairs Program supplied Hadassah members with information about the UN and strove to strengthen it.[50]

In the following years, American affairs were incorporated into Hadassah's ideology and practice, and repeated efforts were made to tie them to the Zionist cause. At the Thirty-Fourth Annual Convention, in 1948, the following resolution was passed:

Whereas, the members of Hadassah are deeply aware of their responsibilities both as Americans and Zionists *for the preservation and strengthening of democratic institutions here in the United States and toward the strengthening of the United Nations as an instrument for peace throughout the world*, therefore be it resolved that Hadassah through its American Affairs Program make available to its members information on subjects of domestic and foreign policy, *consistent with our aims to strengthen Israel and to preserve democratic institutions here in the United States*.[51]

The Thirty-Fourth Convention also passed two other resolutions concerned with American affairs, one regarding genocide and the other concerning human rights.[52] In the following year, at the Thirty-Fifth Annual Convention, Hadassah declared that the American Affairs Program had a dual purpose: first, 'education and dissemination of information on such matters as civil liberties, pending legislation, United Nations, Human Rights', and second, 'directives for action in specific areas on issues where a position has been taken by the national organization'.[53]

Another year on, in 1950, the objectives of the programme were defined in greater detail as including

the preparation and dissemination of information concerning pending legislation, an analysis of democratic issues, and suggestions for action. Hadassah indicates to its members the best in progressive thought and action. It recommends organizations worthy of the

[50] Minutes of Hadassah National Board meeting, 6 Jan. 1948, 10.

[51] 'American Affairs', resolution adopted at Hadassah's 34th Annual Convention (1948), HA, RG3, ser. Proceedings, subser. 1948 Convention, box 14 (emphasis added). By permission of Hadassah, The Women's Zionist Organization of America, Inc.

[52] 'Convention Against Genocide' and 'Universal Declaration of Human Rights', resolutions adopted at Hadassah's 34th Annual Convention (1948), HA, RG3, ser. Proceedings, subser. 1948 Convention, box 14, 6b, 6c.

[53] 'Statement on American Affairs Policy', resolution adopted at Hadassah's 35th Annual Convention, San Francisco, 13–16 Nov. 1949, HA, RG3, ser. Proceedings, subser. 1948 Convention, box 15. By permission of Hadassah, The Women's Zionist Organization of America, Inc.

support of individual members, suggests material for reading and study, and points out ways in which the Hadassah member may make herself a factor in helping to extend democracy.[54]

It was further stressed that Hadassah 'cooperates with liberal groups in order to assist in achieving democratic principles'.

In January 1950 Judith Epstein, as chair of the National Board Committee for American Affairs, presented the board with a review of the department's activity. She described it first as an instrument for achieving the central aim of Hadassah, namely, aiding the State of Israel. However, she also associated the American Affairs Program with the aims of US foreign and domestic policy, in the context of the principles of mission and democracy. She explained, quoting Israel's foreign minister Moshe Sharett, that the State of Israel could not continue to exist and develop unless peace were achieved in the Middle East, and that the future existence and development of Israel were essential to the United States.[55]

Epstein went on to present another aspect of 'American affairs', namely the liberal one, arguing that in the light of President Truman's decision to build a hydrogen bomb the citizens of the United States must adopt a consistent foreign policy that strove for worldwide peace, justice, and equality among all inhabitants of the globe, and that the American Affairs Program was intended to prepare the members of Hadassah to take action in pursuit of these goals.[56]

In summary, the chair referred to the practical outcome of the programme, and reported that the educational material distributed to all Hadassah chapters was received with interest by the rank-and-file members and had also led to increased fundraising.[57]

In another meeting, in September 1951, the chair stressed America's leadership role in the international arena, and claimed that because the United States served as a model for the entire world, it was more important than ever to preserve and fulfil the democratic tradition of America; therefore education in American affairs was of the utmost importance.[58]

The energetic and forceful lawyer Denise Tourover, Hadassah's representative in Washington throughout the 1940s and 1950s, was also involved in the American Affairs Program in this period. Tourover, who played a central role in bringing the Tehran Children to Israel (see Chapter 11), worked alone in Washington, with no

[54] *Hadassah Handbook*, 68–9.
[55] For the arguments, see minutes of Hadassah National Board meeting, 4 Jan. 1950, 4.
[56] For the quotation and arguments, see ibid. [57] For the claims, see ibid.
[58] Minutes of Hadassah National Board meeting, 10 Sept. 1951, 2.

staff, making use of personal contacts in congressional circles she had built up since the 1920s.[59] In the years following Israel's independence she devoted most of her energy to obtaining donations, mainly of food products, to be sent to the population there. In fostering her connections in UN and US government circles, Tourover presented Hadassah as 'an organization devoted to the highest concepts of American and Jewish life', and one that undertook advocacy and action mainly in furtherance of fundamental American values.[60]

American Affairs and McCarthyism

The most outstanding expression of Hadassah's deepest faith in the values underlying the American Affairs Program can be found in two resolutions adopted by the organization in 1953–4, at the height of the McCarthy era. In this period the Jewish community in the United States was subject to tremendous pressure, following the conviction of Julius and Ethel Rosenberg on charges of handing over atomic secrets to the Soviet Union and their execution in 1953. All four defendants in the trial were Jewish, arousing concern that the affair would generate a wave of antisemitism. The leaders of the Jewish community tried to forestall the damage that might be generated, launching a campaign to convince American public opinion that Jews were not tainted by communism, and that the Soviet Union itself was hostile to Jews, Judaism, Jewish culture, Zionism, and the State of Israel. The American Jewish Committee employed someone specifically to investigate communist infiltration of Jewish community life. The American Jewish establishment chose to distance itself from the Jewish left, and to make certain that the community's leadership was placed in the hands of 'devout anti-Communists'.[61]

Notwithstanding the threat posed by this climate of witch-hunting and the defensive posture taken by the American Jewish establishment, Hadassah chose to come out strongly against McCarthyism, which it saw as a serious threat to the democratic character of America and a serious challenge to its deeply held liberal convictions. The central figure in this controversy was Hannah Goldberg, then chair of the National Board Committee for American Affairs. As early as the beginning of 1953 she announced Hadassah's determination to support the 'democratic belief' founded on 'the basic principles of American democracy and

[59] Interview of Denise Tourover by Gerry Geller, 18 Feb. 1968, HA, RG7, Special Collections, Hadassah Leaders Series, Denise Tourover, box 9, folder 37; L. D. Geller, 'Finding Aid: Scope and Content Note', HA, RG7, Special Collections, Hadassah Leaders Series, Denise Tourover, 3; information from Susan Woodland, Hadassah archivist, based on a previous study of Denise Tourover's correspondence.

[60] Tourover, 'Dateline Washington'. [61] Shapiro, A Time for Healing, 36–7.

the eternal truths of Judaism'. 'This belief', she continued, '[was] threatened by the great fear capturing a large portion of the American population.' Later in her speech, she noted Hadassah's concern about this fear and about the infringement of civil rights and freedom of speech taking place in educational institutions, which she deemed inappropriate in America.[62]

As its first measure against McCarthyism, the American Affairs Department planned a series of articles to be published in the *Hadassah Newsletter* discussing the threat it posed to American democracy and values. Hannah Goldberg published a moving cry against McCarthyism, and the next issue carried an article by a senior Democrat senator, Hubert H. Humphrey, calling for the protection of human intelligence, liberty, political diversity, and non-conformism, and systematically criticizing the undemocratic aspects of McCarthyism.[63]

Hadassah's struggle against McCarthyism was also clearly expressed at the Thirty-Ninth Annual Convention, held in late 1953. The convention included a session on 'belief in freedom', led by Esther Gottesman, chair of the National Board Committee for Education. The lecturers invited to speak at this session, scholars from Harvard University and the Jewish Theological Seminary of America, discussed 'the American democratic tradition' and 'the Jewish roots of freedom'. Esther Gottesman herself spoke in the same spirit.[64]

The high point of the convention in respect of this issue was a strong declaration publicly condemning McCarthyism. The statement also criticized the American administration and the policy of some Jewish organizations that had chosen to expel 'radical left-wing' elements.[65] The resolution read:

Hadassah . . . representing 300,000 American Jewish Women . . . records its continuing dedication to the principles of the Bill of Rights and its determination to work for the perpetuation and extension of the democratic way of life. We affirm that democracy can survive only if the fundamental principles of justice, equality and liberty are strengthened and prevail.

Fully recognizing the obvious need to preserve and to secure our political and social system from threats both within and without our land, we are the more concerned by growing practices and trends which tend to undermine the American tradition. We deplore the use of methods which, though they may be intended to protect our way of life, in effect through careless accusations and unproven statements, limit freedom of speech and expression, tend to control thought and interfere with free exchange of opinion.

[62] Gal, 'Hadassah and the American Jewish Political Tradition', 101.
[63] Ibid. 102. [64] Ibid. [65] Ibid.

We strongly urge a deepened faith in those ideals which make our country great and a renewed reliance upon those established legal and moral procedures which protect the individual against invasion of civil liberties and civil rights.[66]

Institutionalization of the American Affairs Program

In order to reaffirm the resolution of the Thirty-Ninth Annual Convention, a similar resolution was adopted at the next year's convention.[67] The American Affairs Program took on a definite tone of American patriotism and steadily became institutionalized. During 1954 and 1955, still in the context of the struggle against McCarthyism, every issue of the *Hadassah Newsletter* included an article about 'American affairs', written by an American of national stature. Each month, information was distributed that emphasized the need to fight for civil liberties, and the local chapters were instructed to devote five to ten minutes of every meeting to presenting current affairs. In 1955 the organization also began discussing the foreign policy of the United States, the National Board Committee for American Affairs having taken the view that Hadassah members should have an up-to-date understanding of US policy in this area.[68]

In February 1955 Judith Epstein, chair of the National Board Committee for American Affairs, presented to the members of the board a statement of the principles and thinking that guided the activity of the American Affairs Department. In it, she asserted that involvement in American affairs was the necessary conclusion of the historic memory of the Jews, together with 'deep faith in freedom and liberty and a deep and genuine understanding of the universality of humanity'.[69] The American Affairs Program was also presented as a means of aiding Israel. In the same statement, Epstein defined the three main realms of activity of the American Affairs Program and Department: first, civil liberties and rights; second, international issues related to the involvement and hegemony of the United States in the world following the Second World War, and to the need to give aid to Israel; and third, the United Nations, which was perceived as providing 'the only hope for a peaceful solution to the problems of the world'.[70]

At the Forty-First Annual Convention in 1955, some far-reaching changes were made in Hadassah's constitution. These amendments added, for the first time in

[66] Proceedings of Hadassah's 39th Annual Convention (1953), HA, RG3, ser. Proceedings, 285–6. By permission of Hadassah, The Women's Zionist Organization of America, Inc.

[67] 'American Affairs', resolution adopted at Hadassah's 40th Annual Convention, New York, 22–6 Aug. 1954, HA, RG3, ser. Proceedings, subser. 1952–5 Conventions, box 18.

[68] Minutes of Hadassah National Board meeting, 1 Feb. 1955, 8–11.

[69] For the quotation, see ibid. [70] Ibid. 10.

the organization's history, engagement in American affairs as one of Hadassah's important official spheres of activity, thereby broadening the organization's aims. The draft presented for the convention's approval suggested a change in the section on 'Objectives and Purposes' to include a new aim: 'to help strengthen American democracy through a program of study and information'.[71] Advocates of the amendment argued that American affairs were an essential aspect of Hadassah's activity in the United States, and that this should be expressed in the constitution; in other words, that the change to the constitution would merely formally establish a situation that already existed in practice. In its final form, as it appeared in the Hadassah constitution of 1956 (see Appendix C), the amendment stated that one of the aims of Hadassah was 'to help strengthen American democracy through a program of information and study designed to awaken its members to their civic responsibilities and an awareness of the issues of the day'.[72] Within this context the American Affairs Program was an educational and political programme, intended to inform the members of Hadassah about developments in the United States so that they could fulfil their duty as US citizens, and to direct them to concrete action in the American arena in areas that Hadassah deemed appropriate.

The American Affairs Program is central to our understanding of the unique character of Hadassah among the American Zionist organizations. The programme represented a departure from Hadassah's educational activity of the late 1940s and 1950s, which, in focusing exclusively on Jewish education, reflected one of the original Zionist goals of the organization in setting out to educate its members to work for the continuity of Jewish life in America. At least on the declaratory level, the American Affairs Program set a different goal, namely to educate the members to be good American citizens, and to sustain fundamental American values, as understood by the organization's leaders. The Zionist Organization of America, by contrast, undertook no comparable educational activity.[73]

The importance of the American Affairs Program as part of Hadassah's overall activity is also reflected in the facts that it was not run by the Education Department but had a separate department in its own right, and that a National Board committee was devoted to American affairs.

[71] Proposed constitutional amendments, resolution adopted at Hadassah's 41st Annual Convention, Chicago, 30 Oct.–2 Nov. 1955, HA, RG3, ser. Proceedings, subser. 1952–5 Conventions, box 18.

[72] 1956 Constitution, HA, RG17, article II(1)(e).

[73] This conclusion is based on the minutes of the annual conventions of the Zionist Organization of America from 1948 to 1956, and the ZOA periodicals *The New Palestine* and *The American Zionist* from the same years.

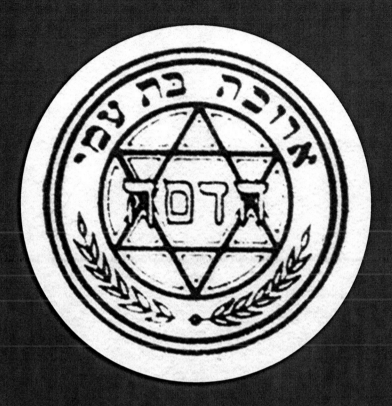

Plate 1. A Hadassah logo from the 1940s. The emblem includes the Hebrew motto *arukat bat ami* ('the healing of my people') and the *magen david* ('shield of David') at its centre, as was usual in the logos of Zionist organizations. Its colours are the blue and white of the Zionist flag (and now of Israel's)

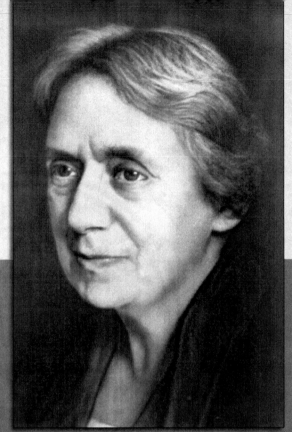

Plate 2. Portrait of Henrietta Szold, taken in 1938

Plate 3. Doctors, sanitarians, and administrators of the American Zionist Medical Unit, photographed in New York before sailing to Palestine in 1918. The group—including just one woman—are all dressed in American army uniform with the shield of David on the sleeve. Those in the front row are holding the Zionist flag (composed of Jewish symbols) and the American flag as a symbol of the unit's dual identity

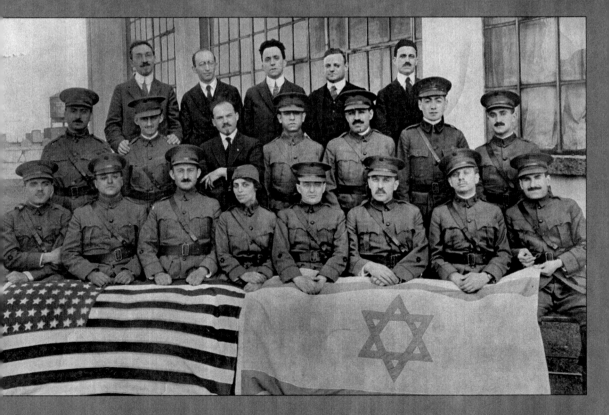

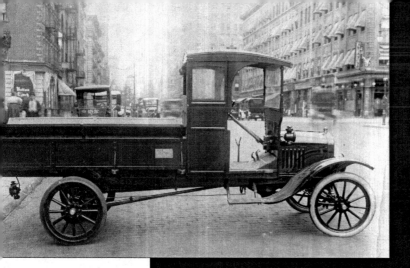

Plate 4. Motor truck donated by the Detroit chapter of Hadassah for the American Zionist Medical Unit, 1918

Plate 5. The handover of Rothschild Hospital to the American Zionist Medical Unit (later the Hadassah Medical Organization) on 3 November 1918. Performing the ceremony is James Armand de Rothschild (1878–1957), the eldest son of Baron Edmund de Rothschild, well known as a philanthropist and benefactor of the Yishuv. The American Zionist Medical Unit is represented here by Dr Harry Friedenwald and Dr Samuel Lewin-Epstein (*standing on the steps of the veranda*)

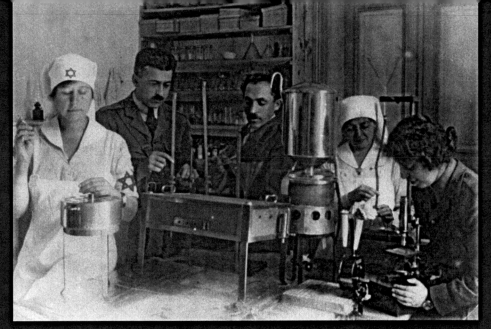

Plate 6. A laboratory in the Hospital of the American Zionist Medical Unit in Jaffa, 1919. *Left*: Madelein Lewin-Epstein, one of the twenty-two nurses of the American Zionist Medical Unit; *right*: the paediatrician Dr Sophie Rabinoff, the only female doctor in the unit

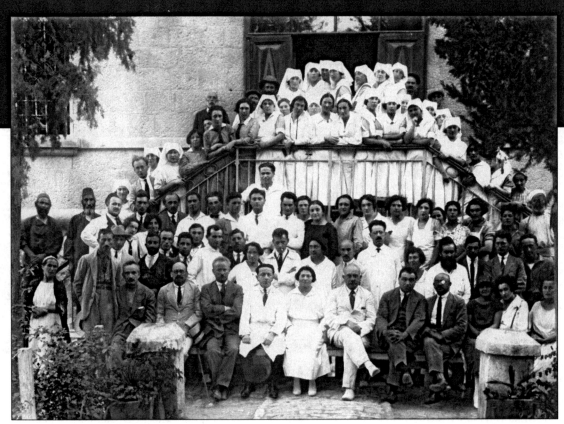

Plate 7. Hadassah staff of the Rothschild (Hadassah) Hospital in the 1920s, in front of the hospital building

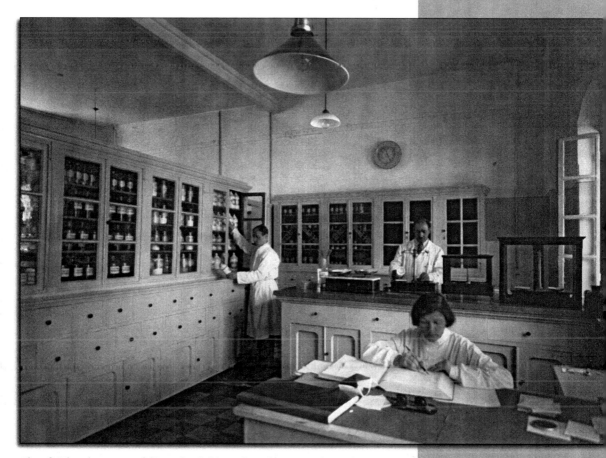

Plate 8. The pharmacy of the Rothschild (Hadassah) Hospital, 1920s

Plate 9. Patients waiting in the outpatient clinic of the Rothschild (Hadassah) Hospital (1920s). The photograph shows the wide range of people treated at the hospital, including Arabs as well as Jews of various communities

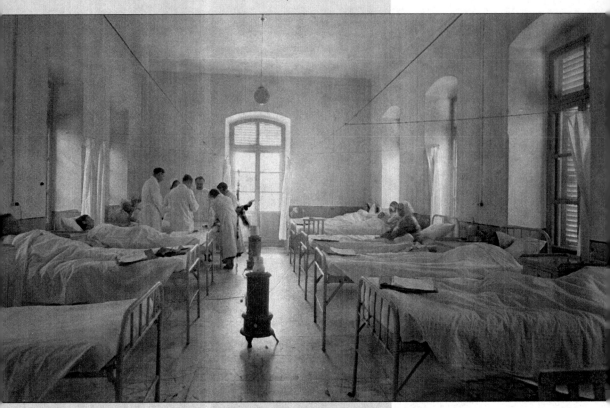

Plate 10. Women's ward in the Rothschild (Hadassah) Hospital, 1920s

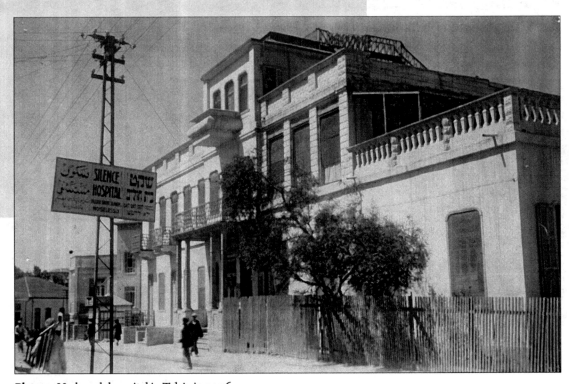

Plate 11. Hadassah hospital in Tel Aviv, 1926

Plate 12. Shulamit Cantor, 1946. Director of the Henrietta Szold School for Nursing from 1934 to 1948, Mrs Cantor was one of the founders of the nursing profession in the Yishuv and Israel

Plate 13. Rummage sale organized by Hadassah members in Des Moines, Iowa, July 1934

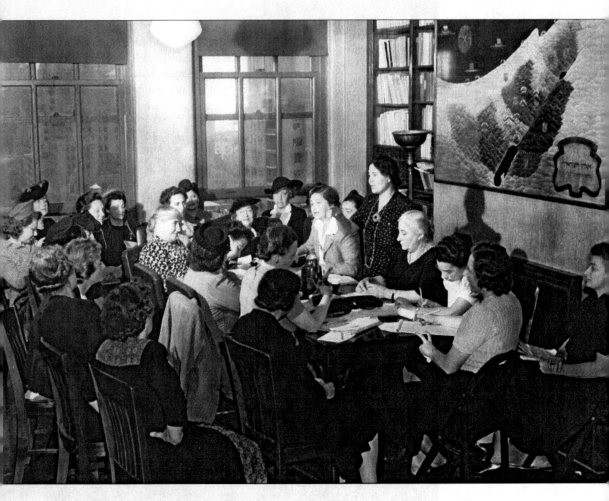

Plate 14. Hadassah National Board meeting, 1942. *Standing*:
Tamar de Sola Pool (Hadassah national president 1939–43); *to her
left*: Rose Jacobs (Hadassah national president 1930–2, 1934–7); *to
her right*: Bertha Schoolman (see Ch. 11). *In hat in front of right-hand
window*: Irma Lindheim (Hadassah national president 1926–8);
to her right, also in hat: Etta Rosensohn (see Ch. 3); *between windows,
without hat*: Jeannette Leibel (see Ch. 8). *Back row, seated facing
table, left to right*: Gisela Wyzanski, Marian Greenberg, Judith
Epstein; *in front of left window, centre*: Zip Szold (Hadassah national
president, 1928–30)

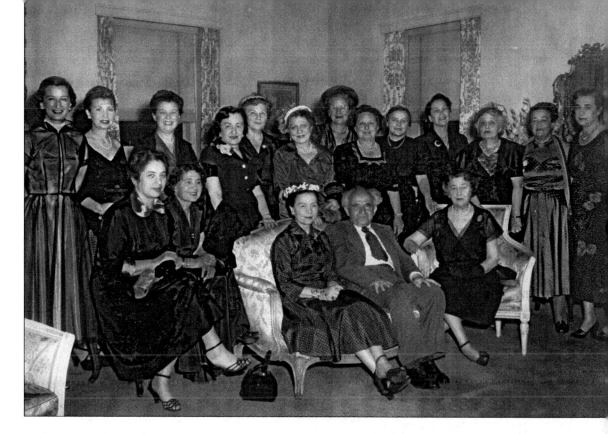

Plate 15. Members of the Hadassah National Board with David Ben-Gurion at the Waldorf Astoria Hotel, New York City, 1946. *Front row, seated, left to right*: Rose Halprin, David Ben-Gurion, Etta Rosensohn; *seated to left of couch, left to right*: Lola Kramarsky, Tamar de Sola Pool; *standing, left to right*: Sue Glassberg, Elaine Rosenbaum, Jeannette Leibel, Hannah Goldberg, Sara Dana, Florence Perlman, Marian Greenberg, Zip Szold, Anna Tulin, Miriam Freund, Judith Epstein, Rebecca Shulman, Denise Tourover

Plate 16. Rose Halprin, Hadassah national president 1932–4 and 1947–52 and arguably one of the most important Jewish leaders of the twentieth century. Portrait taken 1940s

Plate 17. Rose Jacobs, one of the most important leaders of Hadassah. Undated portrait, probably 1930s

Plate 18. Etta Rosensohn, Hadassah national president 1952–3. Portrait taken 1930s

Plate 19. Judith Epstein, Hadassah national president 1937–9 and 1943–7, at the podium in the 1950s

Plate 20. Young Judaea logo, 1950s

Plate 21. Tel Yehudah campers carrying the American flag alongside members of the Hebrew Tsofim carrying the Israeli flag, Tel Yehudah summer camp, Barryville, Port Jervis, New York, 1958

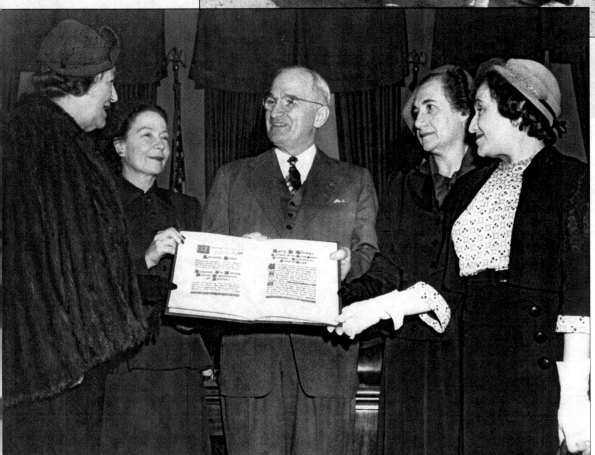

Plate 22. President Truman receives the Henrietta Szold Citation and Award for Distinguished Humanitarian Service, Washington, DC, 11 January 1951. *Left to right*: Etta Rosensohn; Rose Halprin, Hadassah national president; President Truman; Denise Tourover, Hadassah's representative in Washington (see Chs. 6 and 11); Hannah Goldberg (see Ch. 4)

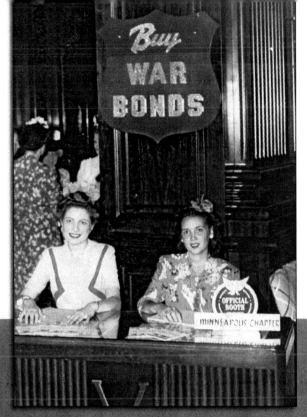

Plate 23. Members of the Minneapolis chapter of Hadassah selling war bonds, 1944

Plate 24. Hadassah members, dressed in American army uniform, selling war bonds at the Paris department store in San Francisco in 1944. With them (*front centre*) is the actress Olivia de Havilland, who played Melanie in *Gone with the Wind*

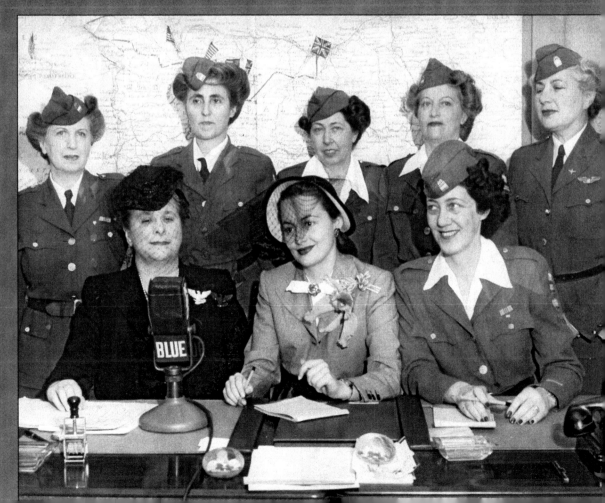

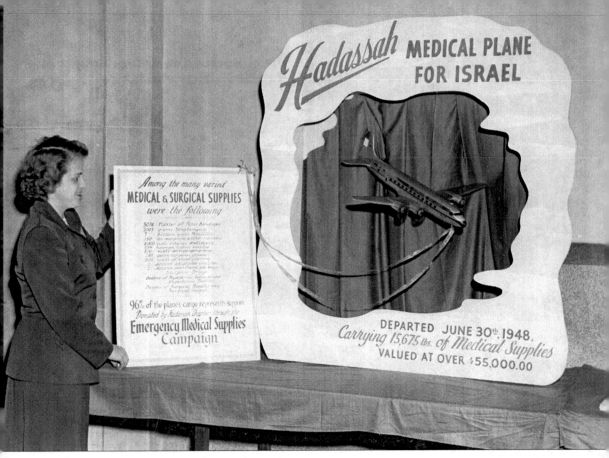

Plate 25. Fundraising posters for the purchase of emergency medical equipment during the Israeli War of Independence, exhibited at the Hadassah annual convention, 1948

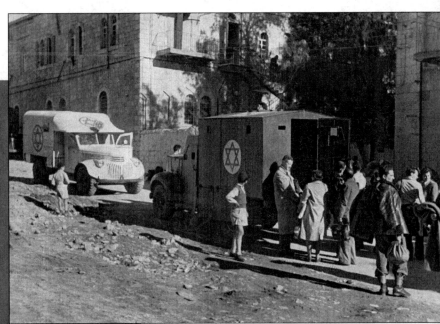

Plate 26. Hadassah staff outside the Hadassah Clinic in Hasollel Street in central Jerusalem, January 1948, waiting for transport to the hospital on Mount Scopus. They were taken in either under escort or in armoured vans marked with the *magen david* on all sides

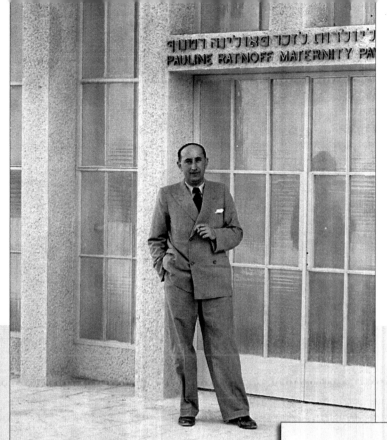

PAULINE RATNOFF MATERNITY PA[VILION]

ניילורית לזכר פוילינה רטנוף

Plate 27. The physician Dr Haim Yassky standing in front of the Ratnoff Maternity Pavilion at the Mount Scopus Hadassah-Hebrew University Medical Center (1945?). Dr Yassky was murdered in the attack of 13 April 1948 on a Hadassah convoy

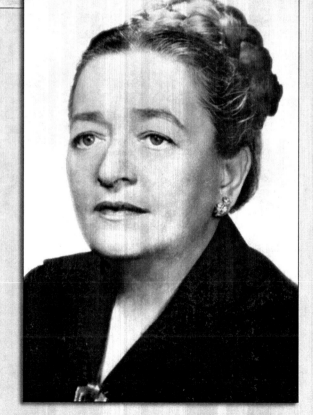

Plate 28. Rebecca Shulman, Hadassah national president 1953–6. Portrait taken early 1950s

Plate 29. Physician Dr Eli Davis (1912–97), director general of the Hadassah Medical Organization, 1948–51. Portrait taken 1946

Plate 30. Six nurses sent from the United States by Hadassah to work at the children's hospital in the Rosh Ha'ayin immigrant camp, standing outside the hospital, 1949

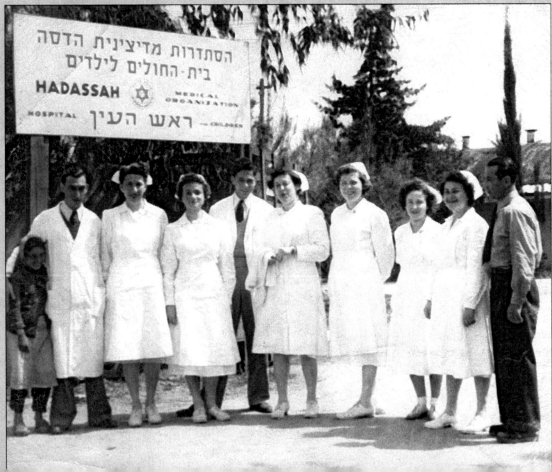

The political liberalism that characterized American Jewish identity from 1945 invariably involved a struggle for civil rights. Surveys and analyses of elections in the United States show that the political views of the Jews with regard to issues such as social justice, economic welfare, civil rights, minority rights, resistance to discrimination, and internationalism—all issues addressed within the American Affairs Program—were markedly liberal. In a research project conducted in the late 1950s, one-third of the respondents believed it was the duty of a good Jew to be liberal with regard to political and economic issues. For these Jews, then, being a Jew meant being a liberal; there is a general consensus among those who have studied the political orientation of American Jews that in this period there was a profound identification with liberalism.[74] Thus the salience and orientation of the American Affairs Program were consistent with values central to American Jewry of the time.

HADASSAH'S IDEOLOGY: THREE STRATA

Hadassah's ideology of the late 1940s and 1950s was formed from three strata. The first stratum was the ideas that were shaped at the birth of the organization by its first leaders. They gave Hadassah its main goals, which have not changed fundamentally to this day, but were developed according to the needs of the organization and changing times. These were, first, a dual focus on Palestine (and, later, Israel) in the physical realm and on the United States in the spiritual realm, and second, a focus on the practical—on projects that had concrete results. This stratum also defined the specific areas in which Hadassah was active in Palestine and Israel: health and the care of children and young people; the importing of American models for its projects; and the promotion of science and research. These basic goals and spheres of activity—including, most importantly, the dual focus on Palestine/Israel and America—were based on a profound understanding of the spiritual needs of American Jewry. These constitute inalienable assets for Hadassah that can be interpreted and endowed with new content by every generation in the light of current needs, without changing the fundamental character of the organization.

The second stratum is the Zionist views of Louis Brandeis, who formulated the leading principles of American Zionism and left a deep mark on Hadassah. One of his central tenets was that Zionism complements (and is supported by) American

[74] Medding, 'Towards a General Theory of Jewish Political Interests' (Heb.), 343, 359–60.

ideals.[75] This view was incorporated into Hadassah's ideology and was fully realized and elaborated in its American Affairs Program, its high point being the struggle for democratic values in a time of crisis, the McCarthy era.

The complementary nature of Americanness and Zionism was also evident in the notion that Hadassah's projects in Palestine and Israel were not only a Zionist enterprise but also a realization of the American universal mission, contributing to the spreading of democracy and the fundamental values of the United States. Indeed, according to Brandeis's vision, the establishment of the Jewish state was consistent with American ideals and would contribute to the advancement of humankind in general.[76] Within Hadassah, this view was expressed in the conviction that the Jewish state would put the American ethos into practice: indeed, Israel was described in its publications as the embodiment of the American ethos. Moreover, by basing their Zionist activity in Palestine, later Israel, on what they considered to be the best that America could offer, and combining it with American patriotism and 'American Affairs' activity at home, Hadassah's leaders brought Brandeis's idea of Zionism as complementary to the American ideal to its height.

The third stratum in Hadassah's ideology, which made an impact in the late 1940s and 1950s, was the thinking of the American Jewish theologian Rabbi Mordecai Kaplan. As we have seen, some of the central leaders of Hadassah were closely associated with the Reconstructionist movement he had founded. Judith Epstein, for example, was close to Kaplan personally and belonged to his congregation. Marian Greenberg was very active in his movement, and an editor of its periodical the *Reconstructionist*. Ira Eisenstein, a disciple and son-in-law of Kaplan and the second most important figure in the movement, was a consultant on the Hadassah National Board Advisory Committee for Educational Affairs, and took an active part in some of Hadassah's annual national conventions. The books of Rabbi Milton Steinberg, one of the thinkers closest to Kaplan, were, as mentioned in Chapter 4, distributed and studied in Hadassah's education programmes.

The central objective in Kaplan's thought was the reconstruction of Judaism in America—hence the name he chose for his movement, 'Reconstructionism'. In the Reconstructionist programme, and the thinking on which it is based, the development of the Yishuv in Palestine—which he believed was the only place

[75] For the quotation, see Strum, *Brandeis*, 114–15: Friesel, 'Brandeis' Role in American Zionism', 43; Urofsky, *American Zionism*, 128–9.

[76] Gal, *Brandeis of Boston*, 95; id., 'Brandeis' View on the Upbuilding of Palestine', 238; id., 'Independence and Universal Mission', 243; id., 'The Mission Motif', 370.

where Jewish civilization could be revived fully—was a necessary condition for the reconstruction of Jewish civilization and maintenance of Jewish life in the Diaspora. Therefore, the establishment of the Yishuv was one of the stages in the Reconstructionist programme.[77]

Most significant of the aspects of Kaplan's thinking that influenced Hadassah were, first, the view of Judaism as a civilization, which gave rise to the notion that American Jews live in two civilizations (American civilization lies at the centre of their being, and Jewish civilization is only secondary),[78] and second, the idea that the establishment of a Jewish state was essential to the continued existence of Jewish life in America. Hadassah's beliefs and Kaplan's thought were also very similar in terms of the importance they ascribed to democracy.[79]

According to Charles Liebman, the Reconstructionist movement expresses the mood of the 'popular religion' of the American Jews more than any other religious movement in American Judaism.[80] Indeed, study of the ideology of Hadassah shows that a substantial proportion of its elements echo what another scholar, Jonathan Woocher, calls 'the American Jewish civil religion', that is, the belief system accepted by most of American Jewry. According to Woocher, this belief system includes seven components or sub-beliefs: the unity of the Jewish people; Jewish survival; mutual responsibility, based on the traditional Jewish idea that 'all Jews are responsible for one another'; the centrality of Israel; the value of Jewish tradition; charity, philanthropy, and social justice; and Americanism as a virtue.[81] It can therefore be said that the ideology of Hadassah expressed the foundations of popular American Judaism, and realized them in its practical activity.

Hadassah's ideology, with its two aspects, Jewish and American, responded to the needs of American Jews in the 1940s and 1950s (and has continued to do so, to a great extent, to this day). It reflected their core values and their primary concerns: the perception of Americanism and the fundamental ideas of American democracy as nearly sacred, alongside an anxiety that their children might not continue to live as Jews. In fact, it is difficult to describe an ideology that would have better fitted

[77] See Kaplan, 'A Program for the Reconstruction of Judaism', 115–59.

[78] See Liebman, 'Reconstructionism in the Lives of American Jewry' (Heb.), 32; *Hadassah Handbook*, 78; Meeting of the Zionist Executive in Jerusalem, 5–15 May 1949 (Heb.), CZA, 82; a similar and even stronger wording is found in the Proceedings of Hadassah's 35th Convention (1949), 557, HA, RG3, ser. Proceedings.

[79] Kaplan, *Greater Judaism*, 456.

[80] Liebman, 'Reconstructionism in the Lives of American Jewry' (Heb.), 23.

[81] Woocher, *The Civil Religion*, 63–89.

these needs than that developed by Hadassah in the period discussed here. This Zionism combined American ideological positions and American patriotism with traditional Jewish foundations, offering an array of elements that many American Jews could consider as constituting a common ground reflecting both Jewish and American values. All these enabled Jews of different views to identify with the goals of Hadassah, its aims, and its activity.

PART III

THE WORLD ZIONIST
ORGANIZATION SCENE

Ideology and Politics at the Establishment of the State of Israel, 1948–1950

IN THE MONTHS AND YEARS after May 1948 the American Jewish community underwent a process of re-evaluating its relationship with the Jewish community in what was now the State of Israel. In the American Jewish arena in general, and the American Zionist arena in particular, the establishment of the state raised various issues regarding the relationship between the two Jewish communities. Some were practical, such as the division of roles between the Jewish Agency and the government of Israel. Others were more theoretical. For instance, there was concern about dual loyalty; there was the fundamental question of the role of the Zionist movement, now that its primary goal had been achieved; there were debates about who was a Zionist. Other dilemmas arose as time passed.

AMERICAN ZIONISTS AND THE JEWISH STATE

Hadassah began addressing the issues related to the existence of a Jewish state even before it was founded. In January and May 1948 two manifestos were published: on the relationship between Hadassah and the state-in-the-making, and on Hadassah's future role as a Zionist organization. The first statement was published in the January 1948 issue of the *Hadassah Newsletter*, in response to the UN resolution of 29 November 1947 to end the British Mandate and divide Palestine into a Jewish state and an Arab state. Entitled 'Relations with the Yishuv', it emphasized that the political loyalty of American Jews, as American citizens, lay exclusively with the United States, and argued that Hadassah's Zionist activity contributed to America by helping to realize American ideals outside the country as well as within it. The authors expressed the belief that the Jewish state would contribute to 'the ideals of justice, equality, security and peace . . . embody the best ideals of the Jewish and

human traditions and . . . have a significant and worthy contribution to make to the progress of civilization West and East'. In the spirit of Brandeis's synthesis, the leaders expressed their hope that the Jewish state would be a spiritual centre for the Jewish people and a source of inspiration for Jewish life in America, and that the American Jewish woman, with her dual American and Jewish heritage, would support the young state both financially and spiritually.[1]

The second of these statements was written in early May by Rose Halprin for publication on the 15th, the date on which the Jewish state was to come into being. Like the first, it addressed the bond between American Jews and the Jewish state and their role as Zionists. It too presented the Jews of America as an inseparable part, politically and culturally, of American society, and as politically faithful exclusively to the United States. It described American Jews and Jewish citizens of the new state as belonging to two separate political entities, and defined the Zionist role of the Jews in the United States as providing the new state with help, on the basis of the American tradition. Following Hadassah's tradition of setting practical, tangible goals, the manifesto suggested a concrete task for the needs of the moment: establishment of a nationwide appeal for medications, medical supplies, and medical equipment for the young state.[2]

THE SEPARATION ISSUE

About two months later, Hadassah had for the first time to take a position on a political issue with practical implications. The controversy over 'separation' (hafradah) was the first in a series of political conflicts that arose between the leaders of the Zionist movement in the Diaspora and the Israeli political network in the early years of the state. The arguments focused on the definition of Israel's relationship with the Jewish communities throughout the world, and in particular with the World Zionist Organization.

At the meeting of the Jewish Agency Executive on 18 August 1948, and at the first session of the Zionist General Council after the establishment of the State of Israel, held in Tel Aviv and Jerusalem from 22 August to 3 September, the Zionist delegates of the English-speaking countries, as a united bloc, demanded total separation between the State of Israel and the World Zionist Organization. This separation was to take two specific forms: first, the political affairs of Israel were

[1] 'The Jewish State and Hadassah', *Hadassah Newsletter*, 28/4 (Jan. 1948), 2.
[2] Ibid.; minutes of Hadassah National Board meeting, 12 May 1948, 1–2.

not to be discussed at all within the Zionist institutions; second, there was to be total separation of functions and authorities between the World Zionist Organization and the Israeli government. One of the implications of the second demand was that those members of the Zionist Executive who also served as ministers in the Provisional Council of State (the Israeli legislature, pending the inauguration of the first Knesset) would have to resign from their positions on the Zionist Executive.[3] The demands were presented by Emanuel Neumann, president of the Zionist Organization of America, and Professor Selig Brodetsky, president of the Zionist Federation of Great Britain and Ireland.[4]

The demand for separation was based on five factors. First, there was a fear that the State of Israel might try to manage the affairs of Jews in America, creating problems of dual loyalty. Second was the converse view that the power of American Jewry should not be exercised to dictate the activities of the State of Israel, which was now a sovereign state. Third was concern about the problem of fundraising for a sovereign state, as opposed to fundraising for the Yishuv prior to the establishment of the state. Behind this anxiety lay a genuine threat: at the time, the US government was considering declaring the Zionist Organization of America a foreign organization, and retracting its tax exemption on contributions raised for Israel.[5] Fourth, some of the leaders of Diaspora Jewry, in particular Nahum Goldmann of the World Zionist Organization, wanted to be involved in the decisions of the Israeli government, and this was not acceptable to the Anglo-Saxon delegates. Fifth, in the light of the weakened power base of the Mapai (Labour) party outside Israel as a result of the Holocaust, there was concern that the right-wing and centrist opposition in Israel would exploit its ties with American Jewry in order to exert pressure on Mapai (then the governing party in Israel).[6]

Neumann proposed a division of authority that would leave Israel responsible for its domestic affairs, including those related to its security and ties with other states, while the World Zionist Organization would be responsible for activities in the Diaspora, including cultural affairs and all matters concerning immigration to

[3] These were: David Ben-Gurion, Eliezer Kaplan, Moshe Sharett, Peretz Bernstein, Izhak Grinboim, Yehudah Leib Maimon, and Moshe Shapira.

[4] Urofsky, *We Are One*, 280–2. [5] Feldstein, *Gordian Knot* (Heb.), 25.

[6] Ibid.; Neumann, *In the Arena*, 288–91. On the demand that the internal affairs of the State of Israel should not be discussed, see minutes of the meeting of the Jewish Agency Executive, Tel Aviv, 18 Aug. 1948, CZA, S100/55a, 2. Hadassah's support for Neumann's and Silver's demand for separation is documented in the report presented by Rose Halprin and Judith Epstein to the Hadassah National Board meeting upon their return to New York. See minutes of Hadassah National Board meeting, 15 Sept. 1948, 8 (Judith Epstein) and 4 (Rose Halprin).

Israel. However, some members of the Provisional Council of State, led by the prime minister David Ben-Gurion, firmly opposed the demand for separation. According to Feldstein, Ben-Gurion's resistance to separation was not simply based on political pragmatism, but was part of a more comprehensive view. He was not willing to reduce the relationship of Israel with the Jewish people throughout the world to a mere network of links with the World Zionist Organization.[7]

In addition, Emanuel Neumann and Abba Hillel Silver demanded that the central institutions of the Zionist movement be moved from Jerusalem to New York. On this issue Hadassah disagreed with the Zionist Organization of America, and one of its representatives, Judith Epstein, found herself in conflict with Neumann and Silver. She argued that the political centre of the Zionist movement should be in Israel, and that this centre should direct and instruct the Zionist movement.[8] Rose Halprin also opposed the idea of transferring the central institutions of the Zionist movement to New York, even going to far as to claim that this would be an 'impossible situation'. First, she argued, the entire movement accepted that some of the departments (the settlement, immigration, and finance departments) had to be in Jerusalem, and therefore there was no point in moving the other departments to New York. Second, she said, the 'spirit and soul' of the Zionist movement 'is in Jerusalem, not in New York'. Third, it would be difficult to move the central institutions of the movement to New York for logistic and political reasons, among them the growing global division between communist and capitalist blocs.[9]

REDEFINING THE TASKS OF ZIONISM

Another aspect of the relationship between American Jews and Israel was the need to redefine the tasks of Zionism now that the Jewish state was in existence.

Upon the creation of the State of Israel, American Zionists began to ask whether the role of the Zionist movement was finished, since its main goal—the establishment of a Jewish state—had been achieved. This question arose in all American Zionist circles and in meetings of the Zionist Executive. As we shall see in more detail in Chapter 12, this was a critical question for the Zionist Organization of America, for both its membership and the volume of its activity rapidly declined

[7] Urofsky, *We Are One*, 280–1; Feldstein, *Gordian Knot* (Heb.), 31.

[8] Account of the meeting of the Jewish Agency Executive (Heb.), Tel Aviv, 19 Aug. 1948, CZA, S100/55a, 2.

[9] For the arguments and the quotations, see minutes of Hadassah National Board meeting, 15 Sept. 1948 (Rose Halprin), 4.

alarmingly, forcing it to seek new goals to replace those that had been the focus of
its efforts for the preceding three years.

Hadassah felt no pressing need for such a re-examination of roles, being fully
occupied with the grave problems facing its projects in Israel as a result of the War
of Independence, as will be discussed in Chapters 8 and 9. However, it could not
cut itself off from the American Zionist arena in general, and particularly from the
largest organization, the Zionist Organization of America; and as that body was
concentrating on re-evaluating its relationship with the Jewish community in
Israel, this process inevitably influenced Hadassah as well. Accordingly, at the
Thirty-Fourth Annual Convention, in November 1948, Judith Epstein presented
her view of Hadassah's Zionist tasks, in spiritual and practical terms, as well as in
the field of public relations.

In opening her speech, Epstein asserted that the task of the Zionist movement
had not been completed with the establishment of the State of Israel, and that for
the foreseeable future Jews across the world would have to continue to help Israel
absorb immigrants and settle the country. Then she moved on to present her
view of Hadassah's Zionist roles. In the spiritual realm, she argued, it was essential
to build a relationship with the Jewish inhabitants of Israel based on the ethnic
bond, a common historical memory, and the aspiration that ties between the two
communities should continue. 'Our spiritual ties must be deepened', she urged;
'we will have to gain from Israel the spiritual and intellectual richness, Jewishly,
that will give content and purpose to our lives here as Jews.'[10] In the practical realm,
the Zionist role of Hadassah was to bring the best of America to Israel in the field of
medicine. In public relations, it was 'to bring into every corner of this great country
first an interpretation politically of what is happening' before the Arabs did so, in
order to mobilize American public opinion in favour of Israel.[11]

The first serious discussion within Hadassah of the new situation created for
American Zionism and American Jewry as a whole by the foundation of the State
of Israel was held only later, at the midwinter conference of the National Board
(including Hadassah leaders from throughout the country) on 7–9 February 1949.
Here participants debated the questions that were currently preoccupying the
American Zionist movement, including the concept of ḥalutsiyut, the meaning and
role of Zionism, and the relationship of the Jews of the United States with those of
Israel.

[10] For the arguments and quotations, see Proceedings of Hadassah's 34th Annual Convention (1948),
HA, RG3, ser. Proceedings, 241. [11] For the arguments and quotation, see ibid. 239.

At one of the discussions the question arose whether Hadassah should continue to call itself a 'Zionist organization' or change this title to 'friends of Israel'. This was a significant question in terms of the identity of the organization. There was con-sensus among the participants that the name should not be changed, because 'friends of Israel' failed to express the true position of American Jews towards Israel: it did not reflect a strong enough commitment, nor did it correspond with the needs of Israel, which still required massive support from loyal and devoted Zionists.[12]

Another issue that arose was whether American Zionists who did not intend to emigrate to Israel had the right to call themselves Zionists at all. Some argued that because the Jewish state now existed, and the original goal of the World Zionist Organization had been achieved, those who did not intend to emigrate to Israel were nevertheless still entitled to continue to call themselves Zionists, their Zionism taking the form of helping Israel to develop and prosper and supporting the Jews living there. Judith Epstein asserted that although the basic goal for which the Zionist movement was founded—establishment of a Jewish state—had now been achieved, American Jews still faced huge challenges: the needs of Israel were great, and the Jewish Agency had a difficult task, which could be fulfilled only if all of world Jewry devoted itself to its success.[13]

Later in the discussion, some members of the National Board tried to define the term 'Zionist'. Some of them claimed that a distinction should be made between 'Zionist Jews' who lived in America and were Zionists in the sense that they worked on Israel's behalf, and 'real Zionists' who fulfilled the Zionist imperative by personally going to live in Israel.[14] Others argued that it was necessary to find a broad definition of the concept of a Zionist organization which could draw the entire Jewish people to Zionism.[15] Another view held that Hadassah's prime interest was in the Jewish people as a whole, and only a strong and multifaceted Zionist organization—not one dedicated to *aliyah* (emigration to Israel) alone—would have the power to pursue this interest fully. The meeting did not resolve these questions.[16]

[12] For the arguments and quotation, see minutes of Hadassah National Board meeting, 9 Feb. 1949, 8 (Tamar de Sola Pool, Etta Rosensohn, and Denise Tourover). [13] Ibid. 3–4.
[14] For quotation see ibid. 3. [15] Ibid. 4. [16] Ibid. 2–5.

WHAT IS 'PIONEERING'?
HADASSAH VERSUS BEN-GURION

In Israel's early years the issue of pioneering—*halutsiyut*—became a bone of political and ideological contention. The conflict on this issue was waged on several levels simultaneously: between Rose Halprin, president of Hadassah, and David Ben-Gurion, prime minister of Israel; between the Hadassah leadership and rank-and-file members of the organization; and between the Hadassah leadership and the Israeli delegates to the World Zionist Organization. The chief American player in the conflict was Rose Halprin, who saw herself as, and indeed to a large extent was, the chief spokesperson for the American Zionists and defender of the legitimacy of their Zionist views and right to preserve the special character of American Zionism. Sharp verbal exchanges accompanied the discussions, reflecting how important the issue of *halutsiyut* was to all the parties.

The debate between Rose Halprin and David Ben-Gurion is of particular interest. Research shows that Ben-Gurion was the architect of the connection between the Yishuv and the American Zionists in the struggle for a Jewish state, and the Yishuv's spokesman in its relations with American Jews from the late 1930s. Among the leaders of the Yishuv, it was Ben-Gurion who most clearly recognized the importance of the United States and American Jewry to Zionism, and who gained the backing of the greatest number of supporters in America, among both Jews and non-Jews. Historians have also drawn attention to Ben-Gurion's extended visits to the United States, aimed at recruiting American Jewry to the cause of attaining Zionist goals.[17]

David Ben-Gurion (David Green) emigrated to Palestine from Poland in 1906, driven by his belief that Zionism was first and foremost an act of 'fulfilment' (*hagshamah*). Until the early 1930s he was a leader of the labour movement, working within the Ahdut Ha'avodah party, the Histadrut, and Mapai. In 1935, when he was elected chairman of the Zionist Executive, his focus of activity shifted from the labour movement in Palestine to the Jewish national and international arenas, and he became a national leader.[18]

The great changes that took place both in the Jewish world and in international power relations in the late 1930s and 1940s led Ben-Gurion to recognize the pos-

[17] Brown, *The Israeli–American Connection*, 225. On the prolonged visits to the US, see ibid. 229, Gal, *David Ben-Gurion* (Heb.), 141, and Tevet, *David's Passion* (Heb.), 289. On the connections with Hadassah, see Gal, *David Ben-Gurion* (Heb.), 83, 107. See also Segev, *From Ethnic Politicians to National Leaders* (Heb.), 2–4. [18] Feldstein, *Gordian Knot* (Heb.), 9.

sibilities that lay in America, American Jewry, and the American Zionist move-
ment. Until the outbreak of the Second World War he had seen European Jewry as
the main resource for achieving the goals of Zionism; however, under the horrific
circumstances of the war he saw this role shifting to the Jews of America. In
parallel, he recognized the great potential of American Jewry, both as a political
force that would influence American foreign policy in favour of Zionist interests,
and as a financial force for building the Jewish state. At the same time, he wanted
to establish a pioneering movement in the United States which would produce
youngsters who would undertake the practical work of building up the new country
and protecting it in wartime.[19]

Despite, or perhaps because of, his perception of the importance of America to
the Zionist movement, Ben-Gurion was on occasion highly critical of some of its
elements, notably the leaders of the Zionist Organization of America in the late
1930s and 1940s. It has been alleged that he repeatedly accused the leaders of the
ZOA of being 'cowards', and until 1943, when Abba Hillel Silver rose to leadership
in the American Zionist movement, Ben-Gurion criticized its leaders for prevent-
ing the exercise of the power latent within the American Zionist movement. In con-
trast, Ben-Gurion established close ties with the Hadassah leadership as early as
1937, and had considerable admiration for the organization as a whole.[20]

The terms ḥaluts (pioneer) and ḥalutsiyut (pioneering) are concepts associated
with the several streams of the Zionist labour movement, from their inception to
this day. The use of these terms was almost always spontaneous, and few attempts
were made to define them clearly.[21] The term 'pioneer' was, however, given a parti-
cular meaning in the context of two movements founded at the end of the First
World War, one in Russia and the other in the United States. These were inspired
by central figures of the Yishuv—respectively, David Ben-Gurion, who had been
deported from Palestine to the United States, and Joseph Trumpeldor, who is
considered the first Jew to have served as an officer in the tsar's army. Trumpeldor
lost an arm in the Russian–Japanese war of 1904–5 and emigrated to Palestine in
1912, leaving again in 1917 to return to Russia and set up the Hechalutz movement
there. While the Hechalutz movement in the United States never stimulated
immigration to Palestine on a large scale, its counterpart in Russia, founded by
Trumpeldor, boosted the labour movement's settlement campaign.[22] Later the

[19] Gal, *David Ben-Gurion* (Heb.), 120, 182 (app. VII).
[20] Feldstein, *Gordian Knot* (Heb.), 25.
[21] Near, *Kibbutz and Society* (Heb.), 388, 393.
[22] Sarid, *Hehaluz and the Youth Movements in Poland* (Heb.), 177.

Polish branch of Hechalutz, the descendant of the Hechalutz movement in Russia, became the largest pioneering movement of all.

The American brand of Zionism was never pioneer-oriented Zionism in the sense of the term used in the Yishuv and later in Israel. However, the idea of pioneering was part of all American Zionist thinking, including that of Brandeis. In the late 1940s and 1950s the American Zionist leadership believed that the settlement of a group of American pioneers in Israel would benefit not only Israel but American Jewry as well.[23]

The Israeli leaders' stance on pioneering in the first years after the establishment of the state was based on their view that building up the young country and ensuring its security required the immigration of young, educated Jews with professional knowledge in technical, scientific, and intellectual fields. Not only the development of the new state but its very ability to survive in the midst of a hostile Arab world depended on its having a workforce of superior quality; yet Israel had a shortage of professionals in certain fields, and there were not enough professional training institutes there to respond to its needs.[24] The chief proponent of this approach was David Ben-Gurion, who wanted high-quality immigrants with professional skills—even in small numbers: he understood that mass emigration from the United States was not likely to happen, and recognized that the mass waves of immigrants flocking to Israel did not include sufficient individuals with the key essential skills and qualifications. He differentiated between the mass immigration of the late 1940s and the groups of immigrants who had come to Palestine from Europe before the establishment of the state, which included many professionals.[25] In the light of the rise of the United States to the status of a technological and scientific superpower after the Second World War, and the loss of the reserve of pioneers in Europe, Ben-Gurion saw the young Jewish people of America as the main—indeed, almost the only—source of a high-quality professional workforce for Israel.

Thus the leaders of the young state called for 'pioneers': for young Jews who would emigrate to Israel from developed countries and use their education and ability, especially in the technical, technological, and scientific fields, to contribute to the building up of the Jewish state.

[23] Urofsky, *We Are One*, 270.

[24] See e.g. *Israel Government Yearbook 5711 [1950–1]* (Heb.), 65–6; 5712 *[1951–2]*, 53.

[25] One of the clearest expressions of these views is his review 'Israel in the Nations' in the *Israel Government Yearbook 5713 [1952–3]* (Heb.), 7–43, esp. 23–42. On his defence views, see ibid. 15; *Twenty-Third Zionist Congress, Stenographic Account* (Heb.), CZA, 16–17. On his views on professional forces and the dependence on imports from abroad, see *Israel Government Yearbook 5713 [1952–3]* (Heb.), 18–19, 23.

The issue of pioneering was discussed by Hadassah's National Board in early 1949, and the main aspects of the organization's policy on this issue were crystallized at that time. Despite the controversy among those present, a consensus was finally reached that Hadassah wanted to encourage the 'pioneer-oriented' emigration to Israel of young American Jews who wished to contribute their skills and training, and that it saw pioneering as an integral part of the Zionist platform. However, it was agreed that Hadassah should make no public declarations on this issue, because it was controversial among American Zionists, many of whom—not to mention the non-Zionists—believed that they should contribute to Israel only in the field of public relations, and should not encourage pioneering.[26]

The Debates between Halprin and Ben-Gurion

In early September 1949 a storm erupted on the American Zionist scene over the issue of pioneering. The trigger was a statement made by Ben-Gurion on 31 August to a visiting delegation of American activists on behalf of the Histadrut. The American Jewish press presented his speech as a call to American Jewish youngsters to emigrate to Israel, whether their parents wanted them to or not. This caused an uproar and made the issue of pioneering, already controversial among American Zionists, all the more complex.[27]

Rose Halprin responded to Ben-Gurion's statement in a letter couched in uncompromising terms:

There is not one of us who questions that Israel needs American youth. If they are stimulated to go and make their contribution, all of us would have a sense of accomplishment. But this is quite a different approach to the one you advocate when you say 'Even if they (the parents of American youth) decline to help us, we will bring the youth to Israel.' Knowing the American scene as you do, you surely must understand with what opposition and even resentment such a statement was received. The whole question of chalutziut requires the careful and, if I may add, prayerful consideration of everyone concerned with it.

How to *achieve chalutziut without destroying or weakening the Zionist movement* is a problem uppermost in the minds of many of us.[28]

Rose Halprin, then, made a distinction, which apparently reflects a contradiction, between limited-scope 'pioneering' and 'mass pioneering'.[29] She claimed

26 Minutes of Hadassah National Board meeting, 9 Feb. 1949, 9.

[27] *Jewish Telegraphic Agency Daily News Bulletin*, 1 Sept. 1949, ISA, RG43, box 5561, folder 1; *American Jewish Yearbook*, 52 (1951), 123–4; Eliezer Livne, account of meeting in the Prime Minister's Office on 'Our Approach to American Jewry', 25 July 1950, ISA, 230.72.656 (old marking).

[28] Rose Halprin to David Ben-Gurion, 23 Sept. 1949, ISA, RG43, box 5561, folder 4 (emphasis added).

[29] For the quotation, see ibid.

that American Zionism differed from Zionist movements in other countries, and had 'never taken on . . . the character of a pioneering movement'. She held that this difference in the nature of the Zionist movements on the two sides of the Atlantic was founded in the deep and total identification of American Jewry 'with the political and economic fabric of the country of which they are citizens', unmatched in other Jewish communities.[30] It was in this spirit that Hadassah set its policy regarding pioneering, expressed by Rose Halprin as follows:

Hadassah stands behind the chalutz movement, but is opposed to any appeal which, whether directly or by implication, is made on the basis *that Jews of this country can find a safe future only in Israel.* If the time should ever come when Zionism becomes synonymous with chalutziut then it will lose the character of a mass movement . . . But in any event, the appeal for chalutziut, whether it will be as small as we estimate it, or as large as you would want it, should be made on a level which takes into account the situation in America and . . . *on the basis of a free and voluntary offering to a great cause.*[31]

The distinction she made between 'pioneering' and 'mass pioneering' testifies to the caution she exercised in addressing this contentious issue. The Israeli leaders, in contrast to the delegates to the World Zionist Organization, did not demand large-scale emigration from the United States, as this did not seem practical; they asked only that a small number of young American Jews, a few thousand a year at most, emigrate to Israel. However, the frequent repetition of Ben-Gurion's words to the Zionist public in the United States, along with the American Jewish community's mixture of enthusiasm about the establishment of the Jewish state and sense of guilt after the Holocaust, as well as the relatively small number of American Zionists in that period, led Hadassah's members to take this call as directed personally at them. They took what he said very seriously. The distance of Israel from the United States and the difficult living conditions there caused the Hadassah women—most of them mothers, some with sons who had fought in the Second World War—great concern, probably greater than that which prevailed in the men's Zionist organizations.[32] The Zionist youth movements in the United States also took on a new prominence, and there was a great deal of general voluntary activity for Israel. All these factors contributed to the stance Rose Halprin took on this issue.

In his response (written in Hebrew) to this letter, Ben-Gurion asserted that

[30] For the quotations, see ibid. [31] Ibid. (emphasis added).
[32] Information on the general climate from author's interview with Ada Lappin, Herzliya, 17 Sept. 1995.

these difficulties and others [that the young state is facing] . . . demand not only much money, very much (much more than it seems to the majority both in Israel and abroad) but the greatest scientific and technical talent, and personal and moral power which we call pioneer forces.

One of those things exists in America and only in America: scientific and technical talent that you call 'know-how'. We need Kaisers and Fords to set up our economy—industry, agriculture, communications and building. We need the greatest technical knowledge, to increase the output of labour and to speed up the processes of industry. We need modern machines for roads, buildings, the arms industry, factories, land and air communications. And we need people who know how to utilize these excellent machines and systems.

We need scientific equipment (laboratories), and we need scientists. American Jewry gave great help to the building of the land [Israel]—financially and politically. The main help that we need in this era is manpower to improve our techniques in building, labour management, the order of industry, transportation, agriculture, etc. Such manpower is available in large quantities among American Jews . . . It is necessary that the leaders of American Jewry to whom the State of Israel is dear—and I know that it is dear to them—understand this . . .

It is hard to imagine the blessing that *hundreds of American skilled men* can bring to Israel [emphasis added] . . . at this hour, it is not the *quantity, but the quality* [emphasis in original] which is important. Ten exceptional boys or girls, men of culture, will and vision, who would settle in Israel and help build her economically, would be more valuable to the Zionist movement in America (to say nothing about the land [Israel]) than hundreds of members in a Zionist organization in America.

I do not underestimate the value of quantity, and numbers are important in many things (not in everything) . . . But when one speaks of chalutziut and especially of chalutziut in America—the important thing is *quality* [emphasis in original]. If America should send to us ten or twenty thousand ordinary immigrants, nothing would be changed. But should America send us just *hundreds of chalutzim* [emphasis in original], chalutzim worthy of their name, both from a moral and intellectual standard [*sic*], much would be changed.[33]

This letter, albeit written in a positive, friendly spirit, represented sharp criticism of Rose Halprin and Hadassah in general. It implied that Hadassah was not helping Israel in a respect that Ben-Gurion saw as essential both to the development of the country and to its defence. Ben-Gurion disagreed fundamentally with the basic motive of Halprin's policy regarding pioneering in saying that he did not understand the 'value of quantity', and criticized even more severely her claim that the main problem facing Hadassah in the context of pioneering was 'how to achieve chalutziut without destroying or weakening the Zionist movement'. To this point

[33] David Ben-Gurion to Rose Halprin (Heb.), 2 Nov. 1949, ISA, RG43, box 5561, folder 4.

Ben-Gurion replied: 'If chalutziut stands in conflict with Zionism, then it is "Zionism" that has been drained of all its content, and which has developed an internal conflict.'[34]

The Formulation of Hadassah's Official Policy

Mindful of the basic conviction that Hadassah should be a mass Zionist movement, and in correspondence with the principles that Rose Halprin had presented in her letter to Ben-Gurion, the leaders who formulated Hadassah's official position with respect to pioneering did so with the utmost caution, for fear that a careless construction might cause a mass flight of members. The resolution passed at Hadassah's Thirty-Fifth Annual Convention in November 1949 was worded very cleverly. It began:

The five and one-half million Jews who comprise the great American Jewish community are rooted in this land, woven into the fabric of its life, contributing to the growing development of this country which will be the land of their children and descendants.

At the same time American Jews have indissoluble ties with the common history and cultural and religious kinship with the fledgling State of Israel. American Jews played an historic role in the establishment of the State and will continue to bring to it the moral and financial support to enable it to fulfill its destiny of the ingathering of the exiles.[35]

The wording of the resolution drew a connection between the future emigration of youngsters to Israel and American values, emphasized that their emigration would contribute to America and its values, and presented pioneering as the supreme expression of American voluntarism:

In this, the largest community of Jews in the world, there are and will be young men and women who, impelled by a desire for personal participation in the great drama of rebuilding a land and a people, will want to find their place in the growing life in that land. Some will be moved to pioneer in the tradition of America, safeguarding the borders, preparing the ground for the hundreds of thousands who will follow from all parts of the world. Others will be eager to bring to Israel the scientific skills, the technical knowledge, the American know-how which the world's youngest democracy must have if it is to absorb all those who are to come and help them achieve the good life which is their inalienable right.[36]

Alongside its presentation as the supreme expression of American voluntarism, pioneering was also depicted as the realization of another American ideal, and a

[34] For the quotations, see ibid.

[35] 'Chaluziut', resolution adopted at Hadassah's 35th Annual Convention, San Francisco, 13–16 Nov. 1949, 557–8, HA, RG3, ser. Proceedings, subser. 1949–1951 Conventions, box 15. By permission of Hadassah, The Women's Zionist Organization of America, Inc. [36] Ibid.

contribution to one of the basic principles in the American value-system: encouragement of democracy. In order to stress how critical the pioneers' contribution to Israel was, the drafters of the resolution quoted Ben-Gurion on Israel's need for American technological know-how, and announced that 'Hadassah declares it to be its privilege and responsibility to help those young people who will wish to throw in their lot with the new State, with those who will want to put at its disposal the skills and the knowledge that will make Israel a force for democratic living'.[37]

This resolution, perhaps the most important statement made by Hadassah in wrestling with the ideological dilemmas of the time, was intended to resolve the concrete problem that faced the organization's leaders in responding to their members, Ben-Gurion, and the world Zionist movement. However, when in February 1950 the National Board gathered to debate the issue of pioneering in depth, a sense of gloom hung over the meeting, reflecting the awareness of deep ideological rifts between the leaders of Hadassah and the Israeli Zionists, and of the fact that two camps had developed within the world Zionist movement, an 'Israeli' camp and an 'American' camp. Rose Halprin, the chief speaker on this topic during the meeting, presented all Israelis as sharing a uniform stand.[38] She told the delegates that there was a wide gap between the American Zionists and the Israeli Zionists, and claimed that Ben-Gurion saw the main role of the Zionist movement worldwide as encouraging pioneering and emigration, believing that the Jews of the Diaspora could help Israel only by emigrating, and particularly through the emigration of the young. The official Zionist position of Hadassah, as Halprin had presented it to the San Francisco convention, was viewed in Israel as an extremely weak interpretation of Zionism and not consistent with the position accepted in Israel, that the fulfilment of the Zionist vision meant ingathering 'all the exiles including the American ones'. Hadassah's pioneering programme, by contrast, she went on, encouraged only skilled workers and professionals to emigrate to Israel, in defiance of Israel's view that pioneering was the gradual emigration of tens of thousands of young people. She did not think that mass pioneering from America was possible, despite her belief that pioneering should be part of the programme of every Zionist organization, and it was her view that was reflected in Hadassah's stated policy, which envisaged American Jewry providing only a small, idealistic group of pioneering emigrants.[39]

[37] Ibid. 556–9.
[38] Minutes of Hadassah National Board meeting, 14 Feb. 1950, 1.
[39] For the arguments, see ibid. 2–4; for the quotation, see p. 4.

The Pioneering Principle in the Youth Movements

The principle of pioneering as presented by Rose Halprin was implemented in the three youth movements that Hadassah supported: Young Judaea, the Intercollegiate Zionist Federation of America, and Junior Hadassah. As noted in Chapter 4, these were not pioneering movements, and their main aim was to cultivate Jewish heritage and the Jewish community in the United States. Nevertheless, from 1949 on all the bulletins and reports issued by Hadassah publicized its support for pioneering activity. The annual report of 1948/9, for instance, reported under the heading 'Our Youngsters Participate in Building Israel' that in January 1948 the General Zionist Chaluziut Commission had been founded under the auspices of Hadassah and the Zionist Organization of America. According to the announcement, the commission was established in order to distribute information among Zionist youngsters in the United States to help them understand the important role of pioneers in building Israel, and the action being taken in this field. The commission co-operated with Plugat Aliya, the pioneering division of Junior Hadassah, Massada (a youth movement founded by the ZOA in the 1940s), and Haoleh, the pioneering division of IZFA.[40]

In similar vein, the *Hadassah Handbook* of 1950, which was distributed to leaders of all the local groups, reported that the activity of Junior Hadassah in the United States and in Israel was inspired by the ideal of pioneer-oriented emigration. It also reported, under the title 'Chalutziut', on the establishment of a training farm for Plugat Aliya. The farm was established as a joint project of Hadassah and the Zionist Organization of America; however, in September 1949 the ZOA withdrew its support from Plugat Aliya, and from that time until September 1950, the *Handbook* stressed, Hadassah bore the entire burden of funding the group itself. Young people who planned to serve Israel in agriculture were trained on the farm and gained an experience of collective life. According to the *Handbook*, in 1950 there were some twenty youngsters in Plugat Aliya who had declared their intention 'to serve the state of Israel'. It was also declared that many of the members were in training, and some of the first had emigrated to Israel and were about to establish themselves in a new settlement they had founded.[41]

Hadassah also drew attention to the pioneering activities of the Zionist student organization, IZFA. In the same section of the 1948/9 annual report, under the headline 'Our Youngsters Participate in Building Israel', several lines were devoted to its pioneering division Haoleh. The item also reported on settlement groups that

[40] Hadassah Annual Report, 1948/9, 32. [41] *Hadassah Handbook*, 74.

IZFA had established in Israel, and closed with the statement:

It is clear that with the cooperation of all the General Zionist Youth Groups, the idea of pioneering has been promoted and strengthened. But our work is just beginning . . . As information concerning Israel becomes more widespread, many young people turn to the Chalutziut Commission for the knowledge and the preparation necessary for personal identification with the land.[42]

American-Style Zionism

In the context of the World Zionist Organization, Rose Halprin undertook to make it crystal clear to the Israeli Zionists that American Zionism was essentially different from theirs. Its perspective was American, and America should be considered in this context as *sui generis*: American Zionists should not be expected to form a broad pioneering movement.

The issue of pioneering arose for the first time at the meeting of the Zionist Executive held in Jerusalem in May 1949. On this occasion, a disagreement broke out between Halprin and some of the Israeli delegates when she claimed that a European-style Zionist pioneering movement was not possible in the United States. She explained the fundamental distinction between the Zionist arena in Europe, perpetuated by the Israeli Zionists, and the American Zionist movement, which was totally different in its nature and motivation. Pioneering, she asserted, could become a mass movement only in the face of 'negative' factors; as these did not exist in the United States, pioneering emigration from the United States would continue to be on a very small scale, the choice of individual idealists. Accordingly, she went on, the tactics used to recruit pioneers in the United States should be different from those designed to appeal to Jewish youngsters in Austria and Poland before the Second World War, and based on ideals relevant to the situation of Jews in the United States.[43]

Some of the Israeli delegates from the leftist parties of Ihud Olami, Mapam, and Mapai totally rejected Halprin's view of the differences between young Jews in contemporary America and those in Europe prior to the Second World War. They argued that it was idealism, and not antisemitism or persecution, that had motivated young European Jews to emigrate to Israel, and was continuing to do so. Eliyahu Dobkin, head of the Organization and Information Department and of the Youth and Hechalutz Department of the World Zionist Organization, asserted that

[42] For the article, including the quotation, see Hadassah Annual Report, 1948/9, 64.
[43] Meeting of the Zionist Executive in Jerusalem, 5–15 May 1949 (Heb.), CZA, 168 (Rose Halprin).

young American Jews were no different from the youngsters 'that we had in Europe', and that 'the theory that only negative factors motivated [those young people] to flock in masses to Palestine is incorrect, they were actually moved by a positive force [the likes of which can] be generated among Jewish youth in America as well'.[44] Other delegates denied the significance of any distinction between the situation in pre-war Europe and that in America in the late 1940s, and insisted that the Zionist movement should stimulate idealistic motives among American Jewish youth through education, in order to turn American Zionism into pioneering Zionism.[45]

The following year, at the meeting of the Zionist Executive held in Jerusalem in April 1950, Halprin made her most emphatic statement on the subject: 'The American Zionist Movement did not see itself as a great chalutzic [pioneering] movement . . . the masses of the Jewish [people] who came to America . . . prepared to root themselves in the land that they had come to. They came to America to become citizens of the country.' She also claimed that the Jews of America had not joined the Zionist movement 'in the Hitler period' because they thought that 'it could happen here'; and that it was only in the light of the extreme circumstances of the war in Europe that they 'endorse[d] the concept that there must be a national home in Palestine *for other Jews—not for* [themselves]'.[46]

In the same fighting spirit, she continued to attack the Israeli delegates, charging that 'many leaders in Israel began to define Zionism as synonymous with the *chalutziut* concept'. She told the audience: 'we say: *kibbutz galuyot*, yes, but *kibbutz hagaluyot* [*ha* meaning 'the'], at this time, no'.[47] This distinction she made between the two terms, with and without the definite article, was a reference to a talmudic term that originally referred to the 'ingathering of exiles' associated with messianic times but was much in use in the first years of statehood as a synonym for the collective effort to build up the country through immigration.[48] Through the addition of the definite article, the phrase *kibuts hagaluyot* could be interpreted as meaning '*all* the exiles'—by implication, that the call to emigrate to Israel must be answered by all Jews, including the Jews of the United States, and it was to this demand that Halprin was objecting.

[44] Ibid. 221–2 (Eliyahu Dobkin).

[45] See e.g. Israel Mariminsky (Marom), ibid. 201; Baruch Zuckerman, ibid. 241.

[46] For the quotations, see speech by Rose Halprin, Meeting of the Zionist Executive in Jerusalem, 19–28 Apr. 1950 (Heb.), CZA, 87 (emphasis added). [47] Ibid.

[48] Y. Ndava, s.v. 'Return to Zion and Immigration' [Shivat tsiyon ve'aliyah], *Encylopedia Hebraica* (Heb.), xxxi. 790.

Ben-Gurion's speech at the same session was extremely moderate in comparison to those of others, and indicates some affinity with Halprin's views. Significantly, in ideological terms, he said that he 'was ready to accept Rose Halprin's definition of "ingathering of exiles"'. He claimed that he did not 'demand that the Jews of America emigrate to Israel like the Jews of Yemen are doing', and that 'the Jews of Yemen are not emigrating because they are better Zionists than the American Jews. I do not know whether they are Zionists at all. The Russian Zionists . . . also did not emigrate and were not willing to emigrate, and did not think it the duty of a Zionist to first and foremost emigrate to the land [Palestine]. Only [a] few did this.'[49] Thus he agreed with Halprin on the legitimacy of the expression 'ingathering of exiles [*kibuts galuyot*]', as opposed to the 'ingathering of *the* [by implication, *all the*] exiles'.

This view of pioneering was actually very similar to that of Halprin. Ben-Gurion also differentiated between mass immigration and pioneering, and stressed that pioneering was a vital condition for the existence of Zionism:

The Jews of America are not willing to emigrate in their masses—because they lack the motives that cause mass emigration . . . even when there are no conditions and motives for mass emigration, a Zionist movement is not possible without a pioneering movement and without the immigration of pioneers. Even if the American Zionists tell us that there is no place and no need for the pioneer movement in America, we will not listen to them . . . if you don't want to or can't set up a pioneer movement in America, we will do so. Rejection of the possibility of a pioneer movement from any country is *the rejection of Zionism* . . . there is no Jewish community in the world that is not capable of breeding pioneers within it.[50]

[49] Ben-Gurion's speech, Meeting of the Zionist Executive in Jerusalem, 19–28 Apr. 1950 (Heb.), CZA, 122. Later in his speech he claimed that 'there is no shortage of immigrants but there is difficulty absorbing them' (ibid.).

[50] For the quotation, see Meeting of the Zionist Executive in Jerusalem, 19–28 Apr. 1950 (Heb.), CZA, 128–9.

Ideology and Politics in the Early Years of the State of Israel, 1951–1956

HADASSAH AT THE TWENTY-THIRD ZIONIST CONGRESS

It will be sad for us all if, in time, a historian of the new Zionist movement of these times records that the Twenty-Third Congress, the first to be held in Zion, which convened more than three years after the establishment of the State of Israel ... was marked by a deep rift between the Israeli Zionist world view and the Anglo-Saxon world view.

ZVI LURIE, *address to the Twenty-Third Zionist Congress*

THE TWENTY-THIRD ZIONIST CONGRESS, the first to be held in Israel, convened in Jerusalem in August 1951.[1] The ghost of exterminated European Jewry hung over the meeting. The congress debates revolved around three specific issues: the organizational structure of Zionist activity in the Diaspora; the relationship between the State of Israel and the Jewish people; and *halutsiyut* (pioneering).

The delegates from Israel called for full implementation of this ideology, although there was no consensus—either among the Israelis or among the Americans—on what this meant. Israeli delegates voiced harsh criticisms of American Zionists and indeed of US Jewry as a whole. Although a few praised the Americans for their efforts on behalf of the establishment of the state, a clear majority of the delegates from Israel, covering the entire political spectrum, were party to this attack, which was deeply insulting to the delegates from the United States.[2]

[1] Most of the excerpts from addresses to the Twenty-Third Zionist Congress are translations of the original (Hebrew) stenographic account of the Congress sessions. No English version exists. However, some of the American speakers are quoted from Nahon, *Fundamental Issues of Zionism*, which contains a selection of excerpts from the speakers' addresses.

[2] See e.g. the addresses by Benjamin Browdy (General Zionists), *Twenty-Third Zionist Congress, Stenographic Account* (Heb.), CZA, 198, and by Jacques Torczyner, ibid. 217; *Ha'aretz*, 19 Aug. 1951, 1.

Among those who fiercely attacked the American Zionists was Ya'akov Hazan, a member of the left-wing socialist Zionist party Mapam. He strongly objected to the distinction they made between *galut* ('the place of exile') and 'Diaspora', and argued that 'exile is forever exile, and the cup of poison that one exile suffers will inevitably reach the others, as well'.[3] Hazan also condemned Ben-Gurion for condoning this distinction when visiting the United States prior to the congress.[4] The address by Israel Bar Yehuda (Idelman), also a member of Mapam, was no less biting. Bar Yehuda claimed that American Zionists 'don't want to understand that the problem on Grandierstrasse of the Weimar Republic is fundamentally the same . . . as in Brooklyn: rich or poor, all are *luftmenshen* [people oblivious to reality]'.[5] The minister of labour, Golda Meyerson (later Meir), herself a former American, also attacked the American Zionists for their claim that 'pioneering from America is impossible'.[6] On the other side of the ideological and political spectrum, Arye Leon Gellman, president of the Mizrachi Organization of America (1935–59) and chairman of the Mizrachi and Hapo'el Hamizrachi World Movement (from 1949), claimed that any diaspora—even 'the largest and most beautiful'—leads to 'tragedy and disaster'.[7]

Some directed their wrath directly at Hadassah. Zvi Lurie, a member of the Jewish Agency Executive, accused the American Zionist leadership of being 'in the same psychological state as German Jewry in 1932', and demanded that Hadassah remove 'the veto against the *aliyah* [immigration] of youth and of children from America to Israel'.[8]

Prime minister Ben-Gurion presented a more moderate position. In his opening address to the congress, he proposed a pragmatic approach which accepted and respected the basic views of Diaspora Jewry—actually of American Jewry, who constituted the largest Jewish community in the free world. He acknowledged that the decisive majority would not emigrate to Israel, and argued that the 'settlement campaign that laid the groundwork for the establishment of the Jewish state was not achieved by the Jews of the Yishuv alone. Without the partnership with the Jewish people throughout the entire Diaspora, it would not have emerged.'[9] He reminded the delegates of the loss of the main reservoir of Zionists in Europe, as a

[3] For the argument and the quotation, see the address by Ya'akov Hazan, *Twenty-Third Zionist Congress, Stenographic Account* (Heb.), CZA, 58. [4] Ibid. 61.

[5] Address by Israel Bar Yehuda, ibid. 105. [6] Address by Golda Meyerson, ibid. 177.

[7] See the address by Rabbi Arye Gellman, ibid. 224. Gellman (1897–1973) was one of the founders of Mizrachi in the US. He emigrated to Israel in 1949 and became chairman of the World Mizrachi movement.

[8] See the address by Zvi Lurie, *Twenty-Third Zionist Congress, Stenographic Account* (Heb.), CZA, 216.

[9] See address by David Ben-Gurion, *Twenty-Third Zionist Congress, Stenographic Account* (Heb.), CZA, 12.

result of the Holocaust and the Iron Curtain, and noted that, in contrast to immigration during the Mandate period, the current influx included only a few, if any, 'educated people and professionals'.[10] However, the leaders of Hadassah, and the American Zionists in general, interpreted even these relatively moderate words as another attack on them.

The main conflict was between the American Zionists and the representatives of the several strands of the Israeli labour movement, who constituted the majority of the Israeli delegates. The right-wing Revisionist party Herut sent only one representative to the congress, Dr Arye Altman; his main interest was the principle of *erets yisra'el hashelemah*, meaning 'the land of Israel in its entirety'—a reference to the unification of the Land of Israel within its historical boundaries—and he did not refer explicitly to American Jewry at all.[11]

Hadassah's delegation to the congress comprised thirty-two delegates. Some of them served on committees and two of them—Judith Epstein and Rose Halprin—took a very prominent part in the discussions. Judith Epstein articulated Hadassah's approach to the cluster of ideological issues that had emerged since 1948. She described the widespread enthusiasm among American Jews for the establishment of the state, and warned that 'these Jews may move away from the [Zionist] movement as quickly as they were drawn to it', just when 'these masses are essential if the state is to fulfil its historical mission: the ingathering of all the exiles'.[12]

She tried to explain the feelings of American Jews towards the United States; their perception of the role of Zionism; and the reciprocal relationship between them and other Jewish communities, which she attributed to the difference between the United States and other countries. For the most part, she continued, 'American Jews feel at home, an integral part of American life and American civilization. But, at the same time, [they] feel an integral part of the Jewish people, tied to Jews all over the world by common heritage and common tradition.' Their affinity with Israel arose, she went on, from their need for a cultural centre 'from which will come the revived Jewish culture', that would 'give meaning and value to Jewish life in America'. She concluded that American Jews wanted to and could 'give a great deal to Israel', and might provide great benefit to the state by virtue of their residence in the United States.[13]

[10] Ibid. 16.

[11] See address by Arye Altman, *Twenty-Third Zionist Congress, Stenographic Account* (Heb.), CZA, 465.

[12] On the number of Hadassah delegates to the congress, see Marian G. Greenberg, 'The Twenty-Third Zionist Congress Convenes', *Hadassah Newsletter*, 23/1 (Sept. 1951), 2; for the quotations, see address by Judith Epstein, *Twenty-Third Zionist Congress, Stenographic Account* (Heb.), CZA, 79. [13] Ibid. 79.

Rose Halprin responded to the attacks against American Zionists 'on behalf of a very large part of American Jewry and a very large part of American Zionists'.[14] Press reports of her speech noted that it was delivered 'with conviction and force' and clearly expressed the position of the American Zionist delegation.[15] She focused on three issues: the difference between 'exile' and 'Diaspora'; the difference between immigration and idealistic pioneering; and the policy that the Zionist movement should adopt if it wanted to continue to be a mass movement.[16]

In terms of Zionist ideology, her most significant remark was the revolutionary, though not original, suggestion that America was not a place of exile, since Jews are in exile only when they 'live in fear and mental anguish, or cannot leave their countries and migrate freely to Israel'. In contrast, American Jews live in freedom, can move at liberty, and have the choice to live in the United States or in Israel. Therefore, she declared, 'the concept of a place of exile, which denotes conditions of oppression, does not apply to us and we refuse to accept it'.[17] The criterion for her distinction between a place of exile and Diaspora was, then, the principle of freedom of choice, which is fundamental to the American ethos. Halprin's speech reflected the unique perspective of American Jews, which in effect made them an exception to the Zionist perception of Jewish history by portraying them as a unique, unprecedented case whose condition should not be considered as 'exile'.

The distinction between exile and Diaspora, as well as views in favour of the Diaspora and equating Jewish life in the American Diaspora with that in Palestine, were widespread in American Zionist thought almost from its inception. Such ideas can be found in the thought of the cultural Zionists, most clearly represented by Israel Friedlander, an influential American Zionist thinker. These ideologists saw themselves as followers of Ahad Ha'am, who differentiated between 'objective exile' and 'subjective exile', and wanted to adapt his idea, and Zionist ideology in general, to the situation in America. They wanted to see a flourishing Jewish centre in the United States, following the views of the historian and theorist of Jewish autonomism Simon Dubnow, who saw Jewish history as the rise and fall of a sequence of Jewish centres.[18] These views were widespread among American Zionist thinkers in the 1940s and 1950s.

In 1943 Abba Hillel Silver had articulated a similar approach to that now put forward by Hadassah. Silver claimed that once Jews had freedom of choice—to

[14] *Twenty-Third Zionist Congress, Stenographic Account* (Heb.), CZA, 149.

[15] Teller, 'American Zionists Move toward Clarity'; *Ha'aretz*, 23 Aug. 1951.

[16] See the address by Rose Halprin, *Twenty-Third Zionist Congress, Stenographic Account* (Heb.), CZA, 146–51. [17] See ibid. 149. [18] See Gorny, *The Quest for National Identity* (Heb.), 40–1.

return to their historic homeland or live in the country of their birth—in effect their state of exile was at an end. In arguments echoing Friedlander, Silver presented the Diaspora and Palestine as equal in value and claimed that the continued existence of the Jewish people depended upon a reciprocal relationship between them.[19] In 1946 the historian Salo W. Baron also called for efforts to build up the Diaspora for the sake of the Land of Israel, on the one hand, and to strengthen the Yishuv for the sake of the Diaspora, on the other.[20] These views were published in *New Palestine*, the bulletin of the Zionist Organization of America.

Also in the early 1940s, Ira Eisenstein, Mordecai Kaplan's disciple and a leader of the Reconstructionist movement, conceived of the Jews of the world and of Palestine as one entity with two poles. According to Eisenstein, the Diaspora would always need the assistance of Palestine in three spheres: national religious community organization, the revival of Jewish culture, and the reinforcement of religious belief. Similar views were expressed by the Conservative thinkers Louis Finkelstein and Milton Steinberg.

It must be acknowledged that not all American Zionists subscribed to these views: certain leaders of the American Zionist labour movement, such as Ben Halpern and Shlomo Grodzensky, saw life in exile as unequivocally negative, although their specific views varied.[21]

At the Twenty-Third Zionist Congress, the representatives of Hadassah were the only delegates who used the term 'Diaspora', and Halprin was the only American delegate who dared state explicitly, on behalf of American Jewry, that America was not a place of exile. Other American delegates accepted the term 'exile'. For example, Hayim Greenberg, a member of the Jewish Agency Executive, a leader of the American Zionist labour movement, and director of the Department of Education and Culture in the Diaspora (from 1946), divided the places of exile into those 'where Jews felt totally alienated and defenceless', and those where the Jew 'saw himself . . . as acculturated and rooted in his environment'.[22]

Emanuel Neumann, a key figure in the American Zionist movement, also used the term *galut* (the place of exile). Even Silver himself did not reject the term 'exile' in the American Jewish context, and did not stress the special character of Jewish life in the United States. In fact, he claimed that 'in our life of so many surprises,

[19] See ibid. [20] See ibid. 43.
[21] See ibid. 36 (on Louis Finkelstein), 44–5 (on Milton Steinberg). On the opposing views, see ibid. 52 (Ben Halpern), 53 (Shlomo Grodzensky and others), 55 (Hayim Greenberg).
[22] See address by Hayim Greenberg, *Twenty-Third Zionist Congress, Stenographic Account* (Heb.), CZA, 151–2.

none of us can predict in advance when and how lives of liberty and security may turn into exile'.[23] Other American Zionist leaders, such as the Conservative rabbi Israel Goldstein and Rabbi Shimon Federbush of Mizrachi, also used the term 'exile', and not 'Diaspora', with reference to the United States.[24]

Hadassah's position, then, profoundly American in spirit, was the complete opposite of that held by most of the Israeli delegates and more extreme than that held by the other American Zionists. The notion that American Jewry differed from all earlier Jewish collectives parallels one of the fundamental values of the American ethos (see Chapter 5), which distinguishes the United States from all countries of the Old World, and the American people from all other nations. On the basis of this principle, it followed that American Jewry differed from any other group of Jews in exile.[25] Both the leading speakers for Hadassah emphasized this notion, and in this respect they fought for recognition of the fundamental concepts of American Zionism.

Rose Halprin also spoke about the question of immigration (aliyah) and pioneering (halutsiyut). She reiterated the basic position that excessive pressure on the American Zionists in this regard would lead to a dwindling of the Zionist movement 'just when the Zionist endeavour needs the support of American Jews more than ever'. Claiming that 'when people live comfortably and in freedom, they do not migrate in the hundreds of thousands', she pointed out that even Zionist history demonstrates that mass emigration from Russia, Poland, Germany, and Czechoslovakia began only with the rise of the Nazis to power. Accordingly, a distinction should be made between mass immigration and idealistic immigration to Israel; the latter, she said, would increase one day, but in the meantime would remain a very limited movement. In closing, she again stressed that 'any attempt to make today's Zionist movement synonymous with pioneering' would dramatically reduce its numbers, leaving only a handful of Zionists in America (she estimated that out of 600,000 organized Zionists, only 20,000 to 25,000 would remain).[26]

Rose Halprin's rejection of the view of America as a place of exile was contested by the majority of Israeli delegates—not only those representing the extremes of the political spectrum, such as Hazan, but also moderate figures, such as Nahum Goldmann, a leader of the World Zionist Organization and later its president.

[23] See Emanuel Neumann's address, Twenty-Third Zionist Congress, Stenographic Account (Heb.), CZA, 91–6, 170–2. For Silver's address, see ibid. 164.

[24] For Goldstein, see ibid. 47–52; for Federbush, ibid. 82. See also Bert Goldstein (Ihud, USA), ibid. 119–21; Bluma Judith Goldstein (Mizrachi, USA), ibid. 179–80.

[25] See the first chapter, 'America Is Different', in Halpern, The American Jew, 11.

[26] See Halprin's address, Twenty-Third Zionist Congress, Stenographic Account (Heb.), CZA, 149.

Goldmann asserted that Halprin's criterion, according to which America was not a place of exile because 'the Jews are not forced to leave the US and were there of their own free will', was totally disconnected from the historical concept of exile.[27] Berl Locker, chairman of the Zionist Executive, also challenged her position, and questioned whether the American Jews believed that the basic principle of Jewish history, according to which 'either we were persecuted or our presence was persecuted . . . ceased to be relevant on the Atlantic coast and did not apply to the southern [sic] hemisphere'.[28]

Most of the non-American delegates, then, criticized Hadassah's distinction between exile and Diaspora. Hadassah stood at one end of the spectrum of debate on this issue, representing the view widely accepted among American Jewry, which saw itself as part of the Diaspora and American Zionism as a shield against assimilation. Towards the opposite end were ranged the non-American delegates, the Israelis—with the exception of Ben-Gurion—being the most critical, and the Zionist left-wing party Mapam holding the most extreme position of all.

THE DEBATE IN THE CONGRESS COMMITTEES OVER THE JERUSALEM PROGRAMME

No less controversial than the plenary session debate was the discussion in the committee dealing with the Jerusalem Programme: the statement which was intended to reformulate the ultimate aims of the Zionist movement and to take the place of the Basel Programme of 1897. Debate on the subject, and on the very meaning of the terms 'Zionism' and 'Zionist', was 'harsh, tense, and deep', as a result of fundamental disagreements between the Israeli and American delegates on questions such as the nuances of the terms *kibuts galuyot* ('ingathering of exiles') and *kibuts hagaluyot* ('ingathering of the exiles'), as discussed above.[29]

Eliyahu Dobkin proposed a resolution worded thus: 'Zionism aims to redeem the people of Israel by ingathering of its exiles in the Land of Israel and strengthening of the State of Israel.' Almost all the delegates from the United States demanded a more moderate form of words than 'ingathering of its exiles', which they interpreted as meaning ingathering of *all the* exiles, including the Jews in the United States. They suggested that the phrase be replaced with 'return to Zion'

[27] See address by Dr Nahum Goldmann, ibid. 229.
[28] See address delivered in response by Berl Locker, ibid. 232–9.
[29] See address by Ezra Shapira, ibid. 497; see also Shimoni, 'Reformulations of Zionist Ideology', 14.

(*shivat tsiyon*), which they felt was more general and represented less obligation to migrate. In the same vein, they proposed that the concept of 'redemption of Israel', which implied ingathering of the exiles, including Jews in America, be replaced with 'the aspiration for the continuous existence and the unity of the Jewish people', which better suited fundamental American Zionist principles.[30] An unnamed Hadassah delegate proposed the wording: 'the ingathering of all those Jews who wish to build their lives in the State of Israel'. Another representative of the organization argued that they could accept the wording 'ingathering of the exiles', as the term 'exile' did not apply to the United States.[31] A heated debate ensued, and it proved impossible to agree on the wording of the resolution. Accordingly, it was decided not to define the Zionist goal, but to focus instead on a definition of the 'task of Zionism', following Ben-Gurion's proposal: 'the strengthening of the State of Israel, ingathering of exiles in Erets Yisra'el [the Land of Israel], and the fostering of the unity of the Jewish people'.[32]

The Jerusalem Programme eventually put to the congress was, then, a compromise, intended to keep the peace within the Zionist movement and secure at least a three-quarters majority of the vote. The maximalists from Israel, including the representatives of the main Israeli labour movement, Mapai, conceded ground to the American representatives: instead of 'ingathering of the exiles', the final wording referred to 'ingathering of exiles in Erets Yisra'el'; and instead of 'redeem the people of Israel', the final wording was 'fostering of the unity of the Jewish people'.[33]

The American Zionist labour journalist Judd Teller, who covered the Zionist Congress for the Jewish Telegraphic Agency, described the feelings of the American Zionist delegates towards the congress following the declaration of the Jerusalem Programme. Notwithstanding the softening of the original wording, according to Teller they saw it as a 'threat' and an 'ultimatum', and felt that, after years of tremendous dedication to the cause, they were facing a 'new test'. It seemed that their willingness to 'provide Israel with a work force' was becoming the measure of their devotion to and sincerity about Zionism, and they felt it was unfair of the Israeli Zionists to treat their partners in this way.[34]

[30] See *Ha'aretz*, 23 Aug. 1951, 1; in the absence of minutes of the congress committee on fundamental problems, the only available sources were contemporary press reports.

[31] See *Davar*, 28 Aug. 1951; the delegate was not named.

[32] See address by Ezra Shapira, *Twenty-Third Zionist Congress, Stenographic Account* (Heb.), CZA, 496; Ben-Gurion's diary, 27 Aug. 1951/Monday 25 Av, Ben-Gurion Heritage Institute Archives, 16; the opposition to adopting the term 'ingathering of exiles' also appears in Ben-Gurion's diary two days earlier (25 Aug. 1951); the English version is quoted from Nahon, *Fundamental Issues of Zionism*, 135.

[33] *Ha'aretz*, 27 Aug. 1951, 2. [34] Teller, 'American Zionists Move toward Clarity', 44.

THE DISCUSSION OF THE CONGRESS BY
HADASSAH'S NATIONAL BOARD

After the return of the Hadassah representatives to the United States, the National Board held a discussion on the congress. Judith Epstein expressed her disappointment with the meeting, describing the events as a four-day assault that was directed particularly against Hadassah, which stood steadfastly for the principle that American Jews were *not* in exile, since they had the right to leave and to enter their country, and since they enjoyed all the rights of citizenship.[35] In her view, the Israeli attack revealed a wide gap between Israel and American Jewish women, and reflected the fact that the Israeli Zionists 'did not really understand America or American Jewry'. She also expressed her dismay with the Jerusalem Programme, arguing that, had it been implemented literally, it would have implied that the American Jews were in exile.[36]

On the same occasion, Rose Halprin presented a totally different view from the one she had presented to meetings of the Zionist Executive in 1949 and 1950, and at the Twenty-Third Congress in 1951, where she had spoken in the name of American Jews. Within the closed forum of the Hadassah leadership, Halprin argued that it was their duty to adopt an overall view of the conflict that had emerged at the congress, and of the future of the entire Jewish people. The current dispute between the Israelis and the American Zionists, she claimed, was the result of historical circumstance and deep conceptual differences between the parties. The leaders of Hadassah had to consider carefully the outcome of the debate between the two Zionist centres, and particularly the question of *aliyah* (immigration). For 'if we take ingathering of the exiles to mean only those who need or want to come, then in five years we shall have a Jewish state of a few millions, and the rest of the Jewish people, large in number, living in the Diaspora'.[37] Israel and the Diaspora would grow apart as soon as the present wave of immigration ended, and the unity of the Jewish people would be severely damaged. The leaders of Hadassah, she said, had to work to prevent the development of such a situation.[38]

Some board members, echoing the view prevailing among most of the rank-and-file members, were very unhappy with Halprin's ideas. One even complained that they caused her distress, saying that she completely agreed with what Halprin had said at the Zionist Congress, but not with the contradictory views she was now voicing, or the attempt to force American Jews to emigrate to Israel. The correct

[35] Minutes of Hadassah National Board meeting, 13 Sept. 1951, 1–2.
[36] Ibid. 2. [37] Ibid. 3. [38] Ibid.

perception of Zionism, this speaker argued, was a partnership between the American Jews and Israel. She said that 'everything that could be done to help Israel should be done, and that this is Zionism. Israel could not ask something of American Jews that they were not willing to give nor should the measuring rod be whether or not a Jew was willing to live in Israel or send his children there to live.'[39]

In an attempt to reach a compromise among the speakers, Judith Epstein said that Rose Halprin's forecasts would not necessarily be realized, and that the Zionism of Hadassah was not and never would be linked to emigration. There was room in the Zionist movement, she maintained, for those who believed that emigration was the essence of Zionism as well as for those who saw other goals for the Zionist movement. She added that pioneering would also continue in the American Zionist arena—as indeed it should do—but not as a mass movement.[40]

Other arguments presented at the meeting reflected views that were common among Hadassah leaders at the local level and the rank-and-file members. One speaker, voicing a view widespread among Hadassah members, identified Zionism with Judaism, and defined the role of Zionism as 'to bring more and more Jews back to Judaism'. She claimed that the majority of American Jews were 'electrified' by the establishment of the State of Israel, and that '[their] interest must be maintained by intensifying Jewish life here'. In contrast, the pioneering emigration to Israel 'should be absolutely arising from inner compulsion'.[41] Tamar de Sola Pool, a leading figure in Hadassah and its president during the early years of the Second World War, claimed that the organization had a triple duty: to help Israel, to strengthen Jewish life in the United States, and to encourage pioneering.[42] The discussion ended with a contribution by Bertha Schoolman, who said that Hadassah should strengthen Jewish life in the United States as well as creating a climate that encouraged young Jews 'to emigrate to Israel out of their own free will'.[43]

PRESENTATION OF EVENTS AT THE CONGRESS TO THE WIDER MEMBERSHIP

In the September 1951 issue of the *Hadassah Newsletter* no attempt was made to hide the controversy that had racked the congress or the struggles that had taken place among the delegations, including the role of Rose Halprin as a central figure speaking for American Zionists. Nor were the Israel delegation's poor opinion of

[39] Minutes of Hadassah National Board meeting, 13 Sept. 1951, 1–2.
[40] Ibid. [41] Dorothy Rossyn's comments, ibid. 3. [42] Ibid.
[43] Ibid. For more on Bertha Schoolman, see Chapter 11.

her words, or the attacks on them in the Israeli press, hidden from the general membership.[44] However, these events were reported in a very moderate tone, without any hint of the anger that had surfaced at the National Board meeting. Moreover, most of this issue of the *Newsletter* dealt with Hadassah's projects in Israel, counterbalancing the sense of discord that had arisen at the congress with description of practical achievements on the ground.

At Hadassah's annual national convention, held a few months after the congress, Rose Halprin took the role of defender of Israel. Her speech testifies to her political shrewdness and sense of discipline, according to which no criticism should be made of Israel in public, even if harsh words were uttered in private forums.

If the State of Israel had been established before the extermination of European Jewry then in fact Israel would have been the reservoir of manpower, the reservoir of the Chaluts movement in the great Jewish centres of Central and Eastern Europe.

But the State was established after those reservoirs were destroyed and the manpower was gone, never to be rebuilt or replaced.

So Israel turned to us . . . American Jewry, the largest Jewish community in the world and said to us—you have given generously of your money, you have given political help . . . now we ask something of yourselves, something of manpower of you, the great Jewish community of the world . . .

We gave answer in the name of this organization, gave answer in the name of 300,000 Jewish women . . . for the majority of the American Zionists and for the majority of American Jews.

And this is what we said:

The Jewish community of America is deeply rooted in America and in American life, and in its great majority here it will remain. We share with all citizens of this land the hope, the dreams, the aspirations of this great democracy in which we live. We owe it loyalty and allegiance.[45]

Theoretically, the annual convention is the executive body of Hadassah, but in practice it is an open meeting that does not make decisions. In this forum, Rose Halprin stated unequivocally that a Jew living in the United States was first and foremost an American. American Jewry was part of the Diaspora, 'which we do not reject since we believe that the Diaspora is part of Jewish history'.[46] She presented the controversy about the terms 'exile' and 'Diaspora' and, finally, spoke about

[44] Halprin, 'The President's Column', *Hadassah Newsletter*, 32/1 (Sept. 1951), 1. Halprin was severely attacked in *Davar*. See e.g. Yavnieli, 'Congress Happenings', *Davar*, 22 Aug. 1951, 2; 28 Aug. 1951, 2.

[45] Proceedings of Hadassah's 37th Annual Convention (1951), HA, RG3, ser. Proceedings, subser. 1949–1951 Conventions, 45–7. By permission of Hadassah, The Women's Zionist Organization of America, Inc.

[46] For the information and quotations, see Proceedings of Hadassah's 37th Annual Convention (1951) HA, RG3, ser. Proceedings, subser. 1949–1951 Conventions, 48–9.

'pioneering', which the Hadassah leadership unanimously agreed should be implemented in its narrow sense. Departing from the argument she had made at the National Board, here she presented Hadassah's view as one anchored in the American tradition of pioneering and fundamental American values:

As Americans we believe it is in consonance with American tradition not only because this land was built by pioneering groups . . . America has begun to understand that if we want to maintain the democratic way of life and strengthen it and extend it, we must go out to the far and near places of the world, that we must send out to those far and near places our skills, our know-how, our manpower, our personnel . . . just so we might strengthen the democratic way of life, not only here but abroad.

And in such a program as this, and for such a purpose as this, Israel has claim upon us and Israel is part of that world we want to create.

And so we deeply believe that there will be some American youth which will want to go and do that pioneering for democracy in Israel. Not only the Zionist movement will applaud them but men of good will, Jew and Christian alike, and . . . it is the task of the Zionist movement to give them moral support and as much material aid as they may need and we can give.[47]

This address to the Hadassah members emphasized the foundations of American patriotism and the attempt, so characteristic of American Zionists as well as of American Jewry as a whole, to link Zionism with American values and goals, highlighting its contribution to the United States as a whole. It also trod a tightrope on the contentious issue of pioneering, on which the views of the Hadassah leadership and the members at large were at variance. Among the national officers of Hadassah the view prevailed that pioneering was an essential condition of Zionism, and that pioneering immigration should be encouraged and supported; on the other hand, large-scale pioneering-spirited emigration from the United States was not practical, and any pressure in this direction might lead to a flight of members from the organization, even perhaps ruin Hadassah and the entire American Zionist movement. Accordingly, Halprin associated pioneering with American culture and values, and presented it as such to the rank-and-file members, in the best Brandeisian tradition.

Thus, on the issue of pioneering, which was so central to the character of American Zionism in the crisis period immediately following the establishment of the State of Israel, Hadassah, under the presidency of Rose Halprin, emerged as the voice of American Zionists and champion of the character of American Zionism as a non-pioneering mass movement.

[47] Proceedings of Hadassah's 37th Annual Convention (1951) HA, RG3, ser. Proceedings, subser. 1949–1951 Conventions, 48–9. By permission of Hadassah, The Women's Zionist Organization of America, Inc.

HADASSAH AND THE WORLD CONFEDERATION
OF GENERAL ZIONISTS

Another political arena in which Hadassah was very much evident during the formative years of the State of Israel was that of developments in the World Confederation of General Zionists. The World Confederation was founded in December 1946 in Zurich, during the Twenty-Second Zionist Congress, by delegates from forty-three countries. The leaders of Hadassah and the Zionist Organization of America were among its founders and the most influential members; two of their central figures, Rose Halprin and Emanuel Neumann respectively, were vice presidents of the confederation, alongside the president, Israel Goldstein.[48]

The confederation was composed of organizations representing a mosaic of ideas, united by the notion of unity itself. It saw itself as a tool for unifying Jewry and as a central liberal party, holding that particular group interests should be subordinate to national goals.[49] Hadassah's fundamental commitment to the preservation of unity among the Jewish people was in accordance with the classic ideology of the General Zionists, and this principle served as the basis for its policy on several major issues that were discussed at the General Zionist conventions during this period. One such issue was the question of political streaming in Israeli education, which emerged in response to the involvement of political parties in education and their exploitation of the education of immigrant children as a political tool. In this context, Hadassah objected to the streaming method, on the grounds that it sowed the seeds of divisiveness in Israeli society, and argued that the General Zionists, as a broad mass movement, should fight against this trend.[50]

While there was consensus among the different parties comprising the confederation on matters of education and economy, a bitter controversy erupted on the question of the identification of Zionist organizations in the Diaspora with political parties in Israel.[51] Within the Yishuv there had existed two factions of General Zionists, and this split led to the establishment of two parties in Israel in 1948. One group established the Progressive party (Hamiflagah Haprogresivit), which was of a distinctly centrist complexion. With a clear-cut ideology on matters of economics and society, it promoted democracy and human rights, consistently supported a

[48] Alcalay, *Origins and Development of the World Confederation*, 12; Goldstein, *My World as a Jew*, 213.

[49] Shimoni, *The Zionist Ideology*, 119–20; Goldstein, *My World as a Jew*, 231.

[50] World Confederation of General Zionists, *Report of the World Central Committee Meeting*, Jerusalem and Tel Aviv, 27 Nisan–12 Iyar 5710 (14–29 Apr. 1950), CZA, A364/939, 28 (addresses by Tamar de Sola Pool and Rose Halprin).

[51] Halprin, 'The Zionist Movement and General Zionism', *Hadassah Newsletter*, 30/3 (Apr. 1950), 4.

written constitution, rule by law, and equal rights for Arabs, and campaigned for an end to military rule, the appointment of a commissioner for public claims, and direct elections for mayors.[52] At the same time, a second group founded the General Zionist party, a distinctly right-wing party which generally opposed Mapai, joining it in the governing coalition only in the years 1952–5. Despite its declarations of 'general' loyalty to Zionism and its professed dislike of factionalism, whether class-based or religious, it drew most of its support and principles from the middle class. It represented the materialists, advocated a capitalist market and free enterprise, opposed the existence of a strong labour union, strove to reduce government control over the economy, and espoused a conservative, bourgeois approach to economic and social issues.[53]

In the following years, the debate within the confederation over identification with Israeli parties became more intense, particularly within the two major American member organizations, the Zionist Organization of America and Hadassah. As early as January 1948 Hadassah expressed firm opposition to the confederation's associating itself with any political party in the Yishuv.[54] After the establishment of the state, the debate centred on the question of whether it should identify with the General Zionist party (which was, as noted, a member of the government coalition only briefly), or with the Progressive party, which was in the opposition. Hadassah identified with the social approach of the Progressive party, but strongly opposed any official affiliation.[55]

Rose Halprin's address to the National Board in January 1951 clearly reflects this approach. She expressed her concern that the General Zionist party was in great danger, and might become a right-wing, bourgeois party. She herself did not want to be associated with a party whose main aim was to protect the interests of any particular class, and would not continue to be a General Zionist if such a thing happened; for she identified with General Zionism only in its classic form, as a liberal, progressive movement not identified with the interests of any particular group in Israel.[56] Were the confederation to align itself with any one group in Israel, its unity would be in jeopardy. Every effort should be made to show that, on the contrary, it supported General Zionism, that its main commitment was to serve all the different classes and groups in Israel, and that it refused to serve the interests of any single group.[57]

[52] Neuberger, *The Parties in Israel* (Heb.), 140–2.
[53] Ibid. 85–9. [54] Rose Halprin to Israel Goldstein, 9 Jan. 1948, CZA, A364/342.
[55] Minutes of Hadassah National Board meeting, Mar. 1951, 2. [56] Ibid. 6–7.
[57] Dorothy Rossyn, 'Midwinter Conference Deals with Fundamental Issues', *Hadassah Newsletter*, 31/1 (Jan. 1951), 3.

A few months later, in August 1951, the convention of the confederation passed two resolutions that condemned identification with political parties in Israel. In flagrant breach of these resolutions, the Zionist Organization of America passed a resolution at its fifty-fifth annual convention, in 1952, declaring its association with the General Zionist party in Israel. The leaders of the ZOA justified their decision by stating their conviction that it was the duty of Zionists outside Israel to express their opinion on social, economic, and cultural matters related to the interests of Israel, because these had implications for Jewish life in the Diaspora.[58]

THE CONTROVERSY INTENSIFIES

The Twenty-Fourth Zionist Congress convened in a completely different atmosphere from the Twenty-Third. Israel's security situation deteriorated in 1955–6, reaching a state of crisis unequalled since the end of the War of Independence in 1949. In April 1955 the Egyptian army set up bands of guerrilla fighters who called themselves *fedayeen* (martyrs); in late 1955 and early 1956 these units infiltrated Israel and committed acts of terrorism and sabotage, disrupting normal life, especially in the outlying areas where most new immigrants lived.[59] In September 1955 an arms deal was signed between Egypt and Czechoslovakia, which Israel saw as destroying its balance of power with the Arab states, and as a sign that war threatened. At the same time the military power of the Egyptian ruler Gamal Abdel Nasser, the most prominent and well-known leader in the Arab League, was increasing.[60] Under these circumstances Israel, in the course of its constant efforts to increase the stock of arms available to the Israel Defence Forces, turned to both the United States and the Soviet Union with a request for arms; but it was turned down. The acquisition and production of arms needed to maintain and strengthen the country's military systems placed a heavy tax burden on the population of Israel, forcing the government to turn to the Diaspora with a request for increased fundraising.[61]

In autumn 1955, in the light of the political and security situation of Israel, the date of the Zionist Congress had to be brought forward. By emergency order, it was set for 24 April 1956.[62] The congress convened, then, at a time of deep crisis for

[58] Editorial, 'Convention Reasserts ZOA Position on General Zionism, Israel Relations', *The American Zionist* (July–Aug. 1952), 4; Alcalay, 'Origins and Development of the World Confederation', 19.

[59] Dayan, *Diary of the Sinai Campaign* (Heb.), 14.

[60] Ibid. 10–11. [61] *Israel Government Yearbook 5717 [1955–6]* (Heb.), 89.

[62] On the change of the date of the congress because of the worsening security situation in Israel, and particularly in light of the Czech–Egyptian deal, see the address of Berl Locker, *Twenty-Fourth Zionist Congress, Stenographic Account* (Heb.), CZA, 4; 'The Wording of the Political Declaration', ibid. 267.

Israel; the sense of emergency was evident in all the meetings and strongly in-
fluenced the prevailing climate. The speeches of the delegates from the Diaspora,
including that delivered by Rose Halprin of Hadassah, expressed staunch support
for Israel in its hour of trial. Halprin's speech contained no hint of the argumenta-
tive tone that had characterized her address to the Twenty-Third Congress; on the
contrary, she declared that the members of the American delegation had come to
'tell the State of Israel and the residents of Israel that they are part of us, and that
American Jewry would extend any material and moral aid needed'.[63]

The Twenty-Fourth Congress, then, saw no renewal of the sharp ideological
debates that had marked the previous meeting. However, this is not to say that the
ideological differences between the Zionists of Israel and those of the Diaspora had
disappeared into thin air: on the contrary, they were expressed in the speeches on
both sides. The dominant mood of the congress was one of solidarity; but there was
also an underlying sense that the Zionist movement needed to do something that
would restore the vitality that had characterized it before the creation of the State of
Israel. In the course of discussions on how to achieve this, structural proposals
were made.

Among other things, it was suggested that national Zionist federations should
be established in order to detach the Zionist groups in the Diaspora from the politi-
cal parties in Israel. Zionists from the Diaspora repeatedly argued that the existing
ties with political parties in Israel were an obstacle to recruiting many Jews who felt
a bond with Zionism but were unwilling to identify with an Israeli political party.
For example, it was argued that the Zionist Organization of America had lost many
potential members as a result of its association with the General Zionist party in
Israel.[64]

Comparing Hadassah's policy with that of the Zionist Organization of America,
Judith Epstein explained that Hadassah was part of the World Confederation of
General Zionists, but had no affiliation with either of the General Zionist parties in
Israel. In its efforts to recruit new members, she said, Hadassah emphasized the
importance of the existence of Israel, of strengthening it and forming close ties
with it, and of making it a large Jewish centre that would project its richness upon
Jewish life in America.[65]

Contrary to the atmosphere of amity that prevailed at the Zionist Congress,
within the World Confederation of General Zionists the controversy over identi-
fication with political parties in Israel intensified. Its convention, which met at the

[63] Rose Halprin's address, *Twenty-Fourth Zionist Congress, Stenographic Account*, CZA, 86–8 (translation
from Heb.). [64] Ibid. 286–7. [65] See Judith Epstein's address, ibid. 286.

same time as the Twenty-Fourth Zionist Congress, passed a resolution, in spite of Hadassah's opposition, stating that every Zionist faction affiliated to the confederation was permitted to form relationships, as it saw fit, with organizations of views similar to its own. Word of the agreement reached Hadassah in July 1956. It was discussed and rejected by the National Board committee on Zionist affairs, a decision that was then approved unanimously by the full National Board.[66]

In October 1956 Rose Halprin proposed to the National Board that Hadassah leave the confederation. She explained that the chances of bridging the ideological gap between Hadassah and the Zionist Organization of America on this issue were slight, as were the chances that the latter would change its position, notwithstanding considerable dissent from the leadership's stance within its ranks. She also proposed that Hadassah's delegates be given the authority to negotiate the foundation of a federation of General Zionists for Diaspora Jewry alone, whose meetings the Israel political parties would attend in an advisory capacity only.[67]

On the question of relationships with political parties, it is interesting to compare Hadassah not only with the Zionist Organization of America, but also with the Women's International Zionist Organization (WIZO). This organization was established in July 1920 in London, and its founding core was composed of the wives of central activists in the British Zionist Federation (Rebecca Sieff, Vera Weizmann, Edith Eder, and Romana Goodman, the founder of the Kultur Verband branch in England). Though its headquarters were in England, a decision was made at the outset to establish a presence in Palestine, and in 1949, after the establishment of the State of Israel, the headquarters moved to Tel Aviv.[68]

Just as Hadassah was composed of chapters throughout the United States, WIZO was made up of chapters established all over the world, except in the United States. This was in accordance with an agreement reached between the two organizations in 1923 which determined that Hadassah would bear responsibility for the Zionist endeavour among women in the United States, while WIZO would bear this responsibility for the rest of the world.[69]

WIZO's activity focused on the establishment and maintenance of training enterprises for women, both in agriculture and in more traditionally feminine

[66] Minutes of Hadassah National Board meeting, 11 Oct. 1956, 3 (Rose Halprin's comments).

[67] Ibid. 4 (Rose Halprin's comments).

[68] On the Kultur Verband (Verband Jüdischer Frauen für Kulturarbeit in Palästina), see Chapter 1. After the foundation of WIZO the Kultur Verband branches were absorbed into the new organization. On WIZO see Greenberg and Herzog, *A Voluntary Women's Organisation*; Greenberg, 'WIZO'.

[69] McCune, 'The Whole Wide World', 133.

spheres like home economics, day-care centres for children, and the establishment of social services. Special emphasis was always placed on aid to new immigrants.

As WIZO was composed of many small federations in different countries, mainly in Europe, in the period between during the two world wars Hadassah was considered the more successful of the two organizations. Nevertheless, the personal closeness of WIZO's leaders to the Zionist leaders and the location of its centre in London, in proximity to the centre of the World Zionist Organization, brought it closer to the male Zionist leadership—as did the fact that WIZO's ideology was closer to the European version of Zionism.

Hadassah took a middle road, understanding that nothing could be achieved in the World Zionist Organization without some ties to a political party. Thus it was part of a Zionist party in the Diaspora; but it would not form a relationship or even publicly identify itself with Israeli party. Even its close ties with members of the Progressive party in Israel never developed into formal affiliation, in contrast to the relationship between the Zionist Organization of America and the General Zionist party.[70] WIZO, by comparison, saw itself as totally unaffiliated with any political party in the Diaspora, and refused to have party ties of any sort. Consequently, it held no organizational role in the administrative bodies of the Jewish Agency for twenty-five years, and was not represented in the institutions of the Zionist movement. This contrasted with its being in many places (outside the United States) the 'organization that maintained the Zionist movement, without which it would have fallen apart completely'.[71] Thus, its insistence on total independence resulted in a disproportion between WIZO's membership and its role in the World Zionist Organization. The middle road taken by Hadassah, as an apolitical organization, afforded it appropriate representation in the institutions of the Zionist movement and, therefore, a substantial influence on it.[72]

■

Despite Hadassah's unrelenting focus on practical work, it could not ignore the questions about the essence of Zionism that arose as a result of the establishment of the State of Israel. In the context of debates over *aliyah* and *halutsiyut*, the question arose whether Hadassah was a Zionist organization or an organization of

[70] Gal, 'Hadassah's Ideal Image' (Heb.), 164 and n. 23.

[71] See Rebecca Sieff's address, *Twenty-Third Zionist Congress, Stenographic Account* (Heb.), CZA, 319–20. See also the decisions of the Zionist General Council, 1947 (Zurich) as quoted in *Report on Activities 5707–5711 [1946–51]* (Heb.), CZA, 76, 86.

[72] For data on the representation of Hadassah in the world Zionist movement, see *Twenty-Fourth Zionist Congress, Stenographic Account* (Heb.), CZA, 15–19 (list of delegates by party); 6–9 (list of office-holders).

'friends of Israel'; the leaders of Hadassah firmly refused to 'demote' the organiza-
tion to the level of 'friends of Israel'. Another focus of debate between the Zionists
in Israel and American Zionists was the concepts of 'exile' and 'Diaspora'. In this
respect Hadassah, more than the other Zionist organizations in the United States,
supported the view that can be defined as affirming the value and authenticity of
Jewish life in the Diaspora.

Although the principles that guided Hadassah's policies on the issues discussed
in this chapter were the outcome of organizational tradition and various ideological
influences, Halprin nevertheless emerged as the leader and spokesperson of Amer-
ican Zionism as a distinct strand within the worldwide movement, in contrast to
the negation of the Diaspora that was so widespread elsewhere in the Zionist
movement.

The questions that arose in Hadassah derived not from any internal organiz-
ational need for ideological clarity, but from the fact that it was a prominent part of
the American Zionist movement, which was trying to define itself in that period. At
local level the rank-and-file members of the organization took no part in the heated
debates that echoed within the World Zionist Organization in these years. The
Hadassah Newsletter devoted little space to the ideological discussions between
Israeli and American Zionists; most of its pages were devoted to Hadassah's
practical work. The policy of the organization's leadership was to portray Hadassah
as a successful organization, to highlight its achievements, play down problems,
encourage members to be active, and present the best of Israel. The same policy
was also applied at the public forum of the organization's annual conventions. On
these occasions Rose Halprin, the president of Hadassah from 1947 to 1952 and its
key champion at the conventions of the World Zionist Organization, justified the
views of American Zionism to the rank-and-file members, and legitimated the
requests of those Israeli leaders at whom she roared so ferociously behind closed
doors. There was almost no hint in her speeches to the conventions of the intensity
of the struggles in which she engaged within the other arenas.

Thus there emerges a picture of a Hadassah leadership concerned to avoid any
criticism of Israel in public or to its rank-and-file members. Even if harsh words
were spoken in meetings of the National Board and other committees, these
exchanges were not publicized; there was to be no public washing of dirty linen.
The differences in what Halprin said in the three forums—the joint Zionist
meetings of Israelis and Americans, the National Board of Hadassah, and Hadas-
sah's annual conventions—reflect the diplomatic prowess which enabled her to
move successfully among the different arenas.

The question further arises whether the ideological discussions and debates held in the World Zionist Organization in the early 1950s had any impact on Hadassah. It emerges that, although there was minimal ideological discussion within Hadassah because its position was clear and consolidated, these debates did leave their mark. In effect, by prompting the organization to stress its role in promoting the spiritual survival of American Jewry they played a similar part to that of the American Affairs Program developed by Hadassah in its role as a patriotic American organization. The ideological discussion thus reinforced Hadassah's primary objective, namely, the preservation and cultivation of Jewish life in the United States.

This commitment to striving for the spiritual health of American Jewry is evident in a statement issued after the Twenty-Third Zionist Congress in 1951, in which the National Board stressed the duty of Hadassah to see that American Jews became 'more Jewish'. Apparently, this matter was in no way connected to the discussion of the topic at hand, and was raised by the members. Thus the ideological discussion consolidated Hadassah's position as a movement that placed the strongest emphasis on its educational heritage, as a tool to ensure the survival of the Jewish community in the United States.

As for the controversy that arose in the World Confederation of General Zionists, several conclusions can be drawn. First, Hadassah's policy in this forum was based on its fundamental principle that it should be a broad, popular Zionist movement, and a general, apolitical body that could appeal to everyone. Second, the association, albeit informal, of the Hadassah leadership with the Israeli progressive movement, which was affiliated with the Mapai party, and its liberal positions on social issues, placed the organization, politically, slightly to the left of centre. Third, the question of ties with political parties in Israel highlighted the different inclinations, both in principle and in political complexion, of Hadassah and the Zionist Organization of America. The declared association of the ZOA with Israel's General Zionist party rendered it a political organization of a distinctly right-wing complexion. In openly taking this stand, without any attempt to diminish its significance, the organization took a totally different direction from that chosen by Hadassah.

PART IV

THE ISRAELI SCENE
HADASSAH AND THE NEW STATE

Hadassah in the War of Independence, 1947–1949

ISRAEL'S WAR OF INDEPENDENCE began on 30 November 1947, the day after the UN resolution to divide Palestine into a Jewish state and an Arab state. It ended with the signing of the last ceasefire agreement, with Syria, on 20 April 1949. The war can be divided into two major periods: from 30 November 1947 until the end of the British Mandate on 15 May 1948 (the day after the Jewish state was officially declared); and from the next day until the end of the war.

The war began as '"riots", which quickly developed into the conflagration of battles'.[1] In the first period, Arab gangs assisted by volunteers from neighbouring countries attacked essential transportation routes, concentrations of Jews in mixed (Jewish and Arab) cities, and isolated settlements. At this stage resistance was mounted by underground organizations of the Yishuv, particularly the Haganah. When the British left, the regular armies of Egypt, Transjordan, Syria, Iraq, and Lebanon, as well as volunteer units from Saudi Arabia, Libya, and Yemen invaded, with the aim of destroying the State of Israel in its infancy. They were met by Israel's army, known since 30 May 1948 as the Israel Defence Forces (IDF).

Over the whole period of the war some 6,000 Jews died, from a total Jewish population of 650,000.

REQUESTS FOR HEALTH FUNDING

At the Twenty-Second Zionist Congress, which convened in Basel in December 1946, David Ben-Gurion, already heading the Zionist Executive, assumed responsibility for the 'security portfolio' of the Yishuv. By that point the Zionist leadership had already reached the conclusion that when British forces left Palestine the Arab armies would invade, with the aim of taking control of the entire territory;[2] and so, from then on, Ben-Gurion laboured constantly to assess and deal with the defence

[1] Rivlin and Orren, Editors' Introduction to Ben-Gurion, *The War Diary* (Heb.), i. 3.

[2] Ibid.; Pa'il and Ronen, *A Rift in 5708* (Heb.), 1.

problems of the state-in-the-making. The urgency of the task could not have been greater. As noted above, the very day after the UN approval of partition the Arabs began their assault. Among other incidents, the attack on the Hatikva neighbour-hood of southern Tel Aviv and the murder of Jewish workers at the Haifa oil refineries in the first month of the war were grim harbingers of what was to come. The attacks spread across the country and casualties mounted rapidly: in the first two weeks of the war, ninety-four Jews were killed and one hundred wounded.[3]

It was against this background of crisis that, on 22 December 1947, Ben-Gurion sent a highly confidential telegram to the Hadassah leadership in which he explained that the Yishuv was on the brink of full-scale war and it was therefore essential that Hadassah commit itself to taking responsibility for all medical ser-vices for the Jewish community in Palestine. Hadassah was, he stressed, 'the only [body] that could undertake this task'.[4] This request, in essence a call for large-scale funding, was discussed at the National Board meeting on 31 December 1947, after the medical implications of the emergency situation in Palestine had been studied. Different views were expressed during the discussion; eventually the board decided to tell Ben-Gurion that Hadassah would help to provide the medical services required in the emergency situation, but did not want to commit itself to spending more than $100,000. The reply also specified that the money would come from the reserve fund, 'so that the burden would not fall upon the local chapters, which could not handle it'.[5]

In early April 1948, after four months of fighting in which the Yishuv had suffered heavy losses in both life and property, Hadassah received another request for finance, this time in anticipation of the imminent end of the British Mandate, which had been set for 15 May. Ben-Gurion believed that as yet the Yishuv's enemies had mobilized only a small proportion of the forces at their disposal, and that the attack on the Jews was likely to grow much more intense.[6] This time Hadassah was asked to undertake the funding of all the army's health and medical services. Again, the National Board reached the conclusion that the organization could not meet the request in its entirety, offering instead to allocate a sum of between $50,000 and $100,000 for this purpose, and to do all it could in respect of sending medical equipment to Palestine.[7] Even at this early point, then, the

[3] Ben-Gurion, *The War Diary* (Heb.), i. 65 (9 Dec. 1947).
[4] David Ben-Gurion to Rose Halprin, 22 Nov. 1948, cited ibid.
[5] Minutes of Hadassah National Board meeting, 31 Dec. 1947, 8.
[6] Ben-Gurion, *The War Diary* (Heb.), i. 33.
[7] Minutes of Hadassah National Board meeting, 7 Apr. 1948, 9.

Hadassah leaders realized that they would not be able to cover the total expense of all the medical care required in the emergency situation created by the war.

Nevertheless, Hadassah allocated $100,000 to equipping the hospital erected at the former American military base at Tel Letvinsky. There had been a US army hospital here until 1943, after which some of its facilities had been used by British forces. They had left in January 1948, and on Passover that year the site was occupied by Yishuv forces and designated the main hospital of the military medical service. The aim was to establish a large hospital with about 1,000 beds, which would also serve as a research centre, attract physicians, provide medical care to the wounded in wartime, and serve the civilian population in peacetime (it later became the Tel Hashomer Hospital, and is known today as the Chaim Sheba Medical Center). The hospital was immediately filled with both casualties of the fighting and ailing new immigrants.[8] The National Board also asked the Hadassah chapters throughout the United States to contribute medical supplies and equipment for the Yishuv as a whole.[9]

Jerusalem, the centre of most of Hadassah's health and medical projects in Palestine, endured the lion's share of the horrors of the war, standing out from all the other cities in Palestine as an arena of prolonged conflict. In the other predominantly Jewish cities—Tel Aviv, Haifa, Tiberias, and Safed—the fighting quickly reached a decisive end, and Jewish control was established even before the British left; but the battles in Jerusalem did not stop for one day from the beginning of December 1947 until July 1948, and continued sporadically even after that. Both sides saw victory on this front as tantamount to overall victory in the war. Moreover, despite the large number of Jewish residents in Jerusalem in 1948 (100,000 out of a total population of 165,000), the Jewish parts of Jerusalem were hard pressed by the emergency conditions, which amounted to a state of siege. The Jewish settlements in the vicinity were few and not contiguous with the city, so that its entire supply of food, fuel, consumer goods, and raw materials had to be brought from the coastal plain. For many kilometres this lifeline passed alongside an Arab area, making it vulnerable to attempts to cut the city off. Supplies had to be sent to Jerusalem from the coastal plain in armoured convoys, and the Arabs made concerted efforts to block their passage.[10]

In early June 1948, when Jerusalem had been steeped in war and siege for over

[8] Shvarts, 'Clalit Health Fund' (Heb.), 270–1.
[9] Minutes of Hadassah National Board meeting, 7 Apr. 1948, 9.
[10] Levitse, *Jerusalem in the War of Independence* (Heb.), 14–16.

five months, the National Board of Hadassah discussed another request for help, this time from two doctors at the Rothschild-Hadassah University Hospital on Mount Scopus, Professor Arie Dostrovsky and Professor Aryeh Feigenbaum. In view of the difficult situation in Jerusalem, they suggested, Hadassah should undertake full responsibility for hospitalization and preventative medicine among the IDF in the Jerusalem area. They estimated the cost of providing these services at 10,000 Palestine pounds per month.[11] Etta Rosensohn, chair of the National Board Hadassah Medical Organization Committee and at this juncture the key figure in Hadassah with regard to medical and health-related activities in Israel, noted that the leaders of the Hadassah Medical Organization in Israel ascribed great importance to this additional aid from Hadassah for Jerusalem. In fact, they suggested that the necessary funds be taken from money originally designated for medical services in other regions of Israel. The National Board approved the request, and recommended an allocation of 33,000 Palestine pounds for unspecified 'other needs'. On the same occasion, it also approved the budget for surgery and essential medicine. A few days later, Hadassah asked its representatives in Israel for information on the medical and paramedical staff and medical equipment needed, including blood donations, and announced its intention to send 7,500 kg of medical equipment and supplies, including anaesthetic.[12]

THE BLOOD BANK

One of Hadassah's most impressive projects during the War of Independence was the momentous effort to collect blood donations in the United States and ship them to Israel. In spring 1948 the Jewish press in the United States carried an announcement of a blood shortage in Palestine, prompting calls to Hadassah from private individuals who wanted to donate blood, and from haematologists who wanted to help organize a blood bank for the Yishuv. In response, Hadassah decided to sponsor the establishment of a blood bank and shipment of the blood (2,500 units) to Israel, where some of it would be directed to Hadassah health projects and some to the Haganah and the IDF.[13]

[11] The Palestine pound was the unit of Israeli currency until June 1952.

[12] Minutes of Hadassah National Board meeting, 2 June 1948, 2 (telegram sent on 27 May 1948); Eli Davis to Ethel Agronsky, 5 June 1948, cited in minutes of Hadassah National Board meeting, 16 June 1948, 2.

[13] Minutes of National Board Hadassah Medical Organization Committee, 8 June 1948, HA, RG2, ser. 46, box 84, folder 2.

This ambitious project kept the organizers busy for several months, and reports on its progress appeared frequently in the minutes of National Board meetings through the spring and summer of 1948. Establishing the blood bank required complex logistics. Private donors had to be linked with local hospitals, whose consent and co-operation had to be obtained for the blood to be taken and stored. Those hospitals capable of producing plasma from the blood donated had to be approached for their assistance. At the same time, information on the quantities and types of blood needed had to be obtained by telegram from Israel. Finally, arrangements had to be made for the safe transport of the blood to its destinations.[14]

The campaign began in Philadelphia, continued in New York and Chicago, and in early June was under way in Los Angeles as well.[15] By 8 June 1948, 1,350 units of blood had been obtained, some donated and others purchased with money contributed for the purpose. In New York, blood was taken at five hospitals (the New York Postgraduate, Beth Israel, Mount Sinai, and Bronx hospitals, and the Hospital for Joint Diseases), all of which offered their services without charge. However, ironically, it was in this of all cities, which at the time was home to the largest Jewish community in the world, and consequently that from which the greatest potential contribution could have been expected, that complications arose. In 1948 there were only three centres in the United States where it was possible to produce plasma from blood, and they were in Philadelphia, Los Angeles, and San Francisco. It seems likely that the scope of the campaign in New York would have been greater had there been a laboratory in the city for separating the plasma from the blood, or if it had been possible to carry out the separation in a laboratory that was then in operation in Philadelphia. However, because of the limited capacity in Philadelphia, the blood units that were collected in New York would have to have been transferred to laboratories on the west coast—in Los Angeles and San Francisco—a process rendered impracticable by cost and technical complexity.[16] Another problem was the very enthusiasm of donors, generating a very heavy workload at the hospitals, which, as noted above, were taking the blood donations free of charge.[17] Nevertheless, by November 1948 Hadassah was able to report that 6,000 units of plasma supplied through its campaign had been used for emergency medical work in Israel.

[14] Minutes of Hadassah National Board meeting, 24 Apr. 1948 (Report on the State of the Blood Bank Project), 10.

[15] Minutes of National Board Hadassah Medical Organization Committee, 8 June 1948, 23.

[16] Ibid. [17] Ibid.

MEDICAL EQUIPMENT AND FOOD

The special National Board meeting held on 12 May 1948, two days before the declaration of the State of Israel, was addressed by Rebecca Shulman, one of the chief activists in Hadassah and later president of the organization, who had just returned from Palestine. She informed the board that the medical equipment they had sent had not reached its destination. The need for it was desperate, she emphasized, and she recommended that Hadassah charter a plane or a ship to take more equipment out as quickly as possible. The meeting agreed that this issue should be accorded top priority, and she was given the authority to take action.[18] A week later, on 19 May 1948, the National Board unanimously approved the decision to hire a freight plane to carry the necessary medical equipment to its destination.[19]

Lola Kramarsky, a member of the National Board, and Jeanette Leibel, Hadassah's executive director, flew with the equipment to Israel, making an interim stop in Amsterdam for the equipment to be transferred to another plane. Israel did not yet have a civilian airport where a plane carrying such a heavy load could land, so in the evening of 4 July 1948, after several 'terrifying hours', the plane, carrying 7,500 kg of medicine and medical equipment, touched down at the former British air base near Kibbutz Ein Shemer, east of Hadera. The next day a convoy of trucks transported the shipment to Jerusalem.[20]

The city of Tel Aviv also applied to Hadassah for medical equipment. The request from Israel Rokah, the mayor of Tel Aviv, was discussed at the National Board meeting held on 16 May 1948, rather than by the National Board Hadassah Medical Organization Committee, because of the latter's heavy load. The members of the board considered the implications of Hadassah's taking responsibility for medical activities outside Jerusalem as well as its existing commitments in the city, and concluded that, notwithstanding the scale of its commitments in Jerusalem, it should make an effort—even if this amounted to only a symbolic gesture—to assist in Tel Aviv as well. It was decided to investigate the cost of the equipment required, which was found to be slightly under $10,000. On 25 May 1948 the board wired Israel Rokah, informing him that Hadassah would supply the requested equipment as a gift.[21]

[18] Minutes of Hadassah National Board meeting, 12 May 1948, 8.
[19] Minutes of Hadassah National Board meeting, 19 May 1948, 6.
[20] Levin, *Balm in Gilead*, 220; letter from Eli Davis to Etta Rosensohn (Eng.), 4 July 1948, HA, RG2, ser. 33, box 68, folder 5, p. 3. [21] Minutes of Hadassah National Board meeting, 16 May 1948, 5.

Because of the severe shortage of food in besieged Jerusalem, the Jewish Agency Executive asked Hadassah to purchase 150 tons of milk powder, 50 tons of egg powder, and cocoa powder. The Jewish Agency's request reached Bertha Schoolman, who was at that time living and working for Hadassah in Israel (see Chapter 11), and she in turn referred it to the National Board, reporting as she did so on the difficult conditions in the city. She also told the board that the Jewish Agency had made a commitment to pay for the food that Hadassah would send. The National Board immediately ordered the purchase.[22]

CARE OF THE WOUNDED AND TRAINING OF SURGEONS

In the fiscal year 1947/8 Hadassah treated 4,000 injured soldiers and civilians, and over the whole period of the War of Independence cared for 90 per cent of the war-wounded in Jerusalem.[23] The medical team that operated in the Jewish Quarter of the Old City of Jerusalem is especially noteworthy. All those wounded in the quarter were brought to the Misgav Ladakh hospital, where three Hadassah physicians— Dr Abraham Laufer, Dr Zvi Neumann, and Dr Agon Reis—worked with the assistance of nurses and volunteers, as well as IDF staff. Sometimes bullets penetrated the rooms where the wounded were housed and treated. The doctors could rest for only a few hours a night, and in the final days of the fighting they performed surgery under shelling, and without anaesthetic.[24] When fighting broke out in Safed, Hadassah's hospital for tuberculosis patients was transformed into a general hospital for those wounded in the northern region. Half the medical staff were Hadassah physicians, the other half military doctors.[25]

Israel lacked specialists in some of the areas most relevant to the care of war casualties. To help relieve this problem, Dr Arthur Heilfet, an eminent orthopaedist from South Africa, was invited to Palestine under the joint auspices of Hadassah and the IDF. Heilfet, funded by Hadassah, organized and trained two teams of surgeons to undertake this essential work. The teams included specialists in general and plastic surgery, ear, nose, and throat treatment, and orthopaedics. Anaesthetists and physiotherapists were also trained. One team worked in Jerusalem, the other in Haifa. The surgical teams were also expected to serve as teaching staff at the medical school being planned in Jerusalem, in order to raise the level of these fields of medicine in Israel.[26]

[22] Minutes of Hadassah National Board meeting, 4 June 1948, 2.
[23] Hadassah Annual Report, 1948/9, 14. [24] Levitse, *Jerusalem in the War of Independence* (Heb.), 371.
[25] Hadassah Annual Report, 1948/9, 14. [26] Ibid. 11.

THE HADASSAH CONVOY TO MOUNT SCOPUS

When the war broke out in December 1947, Mount Scopus, where the Rothschild-Hadassah University Hospital and the Hebrew University were located, was totally cut off from the Jewish residential areas of Jerusalem. Convoys were organized to take staff and patients to and from the hospital, driving along St George Street, which passed through the Arab neighbourhood of Sheikh Jarah. In that first month of the war, shots were fired at several ambulances making their way to the hospital on Mount Scopus; after a brief, two-week lull, violence flared up again in north Jerusalem in January 1948 between Arabs and Jews, with the supervising British forces between them. In one convoy, a nurse from Hadassah was killed on her way to the hospital.[27]

Activity on Mount Scopus was reduced to a minimum: the university cancelled all classes and left only research and service employees there, and in January Hadassah was granted use of the building of the Order of Saint Joseph (known as the English Mission) on Hanevi'im Street in western Jerusalem, where most of the Jewish population of Jerusalem was concentrated, to set up a temporary hospital. This rapidly expanded, spreading to the adjacent buildings and reaching a capacity of hundreds of patients. Concerned that this growth in activity at the temporary hospital, combined with the drastic reduction in operations at Mount Scopus, would prompt the British to claim there was no longer any need to keep the latter open, Hadassah decided to leave a few incurable patients in the wards there and keep the hospital operating, albeit in a limited fashion. Thus two buses owned by Hamekasher, the bus company serving the Jews in Jerusalem, carried on transporting a few doctors, nurses, researchers, and maintenance staff up the mountain, escorted by armoured cars. This arrangement continued throughout January, February, and March 1948.[28]

The British commander of the Jerusalem area personally promised the heads of Hadassah and the university—Judah Leon Magnes and Haim Yassky—that his forces would protect Jewish transportation to Mount Scopus during the daytime. Although there was some scepticism regarding this British promise, the Jews assumed that Hadassah and the Hebrew University had a special status in British eyes, and that consequently the convoys that travelled to Mount Scopus would indeed be granted reliable protection. Up to April this trust seemed to be vindicated.[29] On 11 April a large convoy drove up Mount Scopus and returned safely. In co-ordination with the British command, the next convoy was arranged for two

[27] Levitse, *Jerusalem in the War of Independence* (Heb.), 191. [28] Ibid. 191–2. [29] Ibid. 191.

days later. On the morning of 13 April, one of the Haganah observers announced that fortified windows with shooting slits had been installed in one of the houses in the Sheikh Jarah neighbourhood. At the time this information was received, the Hadassah convoy was preparing to set out from Shmuel Hanavi Street. The Haganah intelligence officer for northern Jerusalem notified the escorts and the drivers, and instructed them to keep an eye on the house. The commander in charge of escorting the convoy noticed that the road was empty, with not one Arab vehicle in sight. Suspicious, he delayed the convoy and sent a liaison officer to the British police station, which was located in the Me'ah She'arim neighbourhood, to enquire whether the road was safe. The police officer in charge assured the liaison officer that it was, and furthermore said that two armoured vehicles had been sent to Sheikh Jarah to protect the convoy.[30]

At 9.30 a.m. the convoy set out: two ambulances, two buses, and three trucks. One armoured escort vehicle headed the convoy, the other travelled at the end. When the first armoured vehicle reached the entrance to Sheikh Jarah, a mine exploded under it. The engine failed and the vehicle stopped in its tracks, stuck on the right-hand side of the road. Heavy machine-gun and rifle fire opened on the convoy from positions in the houses and fields on both sides of the road, manned by some 200 Arabs. Dozens of hand grenades fell on the vehicles, which were unable to move. One of the ambulances tried to turn back, but was disabled by enemy fire. The larger ambulance, the three trucks, and the final escort vehicle did manage to turn around and return to their point of departure on Shmuel Hanavi Street, their tyres riddled with holes. This left four vehicles stranded in the centre of Sheikh Jarah. The first was the leading armoured vehicle; a few metres behind it was the small ambulance, holding fourteen passengers, among them, seated next to the driver, Dr Yassky, head of the Rothschild-Hadassah University Hospital. Approximately 20–30 metres behind the ambulance were the two buses, carrying between them seventy-four university and Hadassah employees. The escort vehicle returned fire and prevented the Arabs from repeating their attempts to approach the convoy. It also silenced a heavy machine gun on the roof of one of the houses about 20 metres away, not far from the home of the *mufti*, injuring the machine-gun operators and overturning the gun.[31]

British soldiers sitting just 100 metres from the convoy in Antonius House did not intervene, allowing the Arabs to attack the convoy without interference.[32] The

[30] Ibid. 192. [31] Ibid.
[32] Ibid.; Antonius House was the former home of an affluent Arab where British forces had established themselves at the end of January in order to safeguard military transports.

two armoured British police vehicles that had been sent to safeguard the convoy and were posted on the bend in the road at the Sheikh Jarah intersection, just a few metres from the two buses, also observed the events without intervening. The two buses of the convoy had come to a halt not far from the intersection, next to the turning to the Ramallah road. The front escort vehicle was unable to give them adequate protection, and the escort at the end of the convoy had turned back, leaving the bus passengers to their fate.[33]

From their distant posts in the Jewish neighbourhoods of Beit Israel and Nahalat Shimon, the Haganah fighters saw what was happening and opened rifle fire on the houses in Sheikh Jarah, but to little effect. At 10.30 a.m., about fifty minutes after the attack had begun, the British commander at Antonius House called for reinforcements of armoured vehicles and heavy arms. The army conveyed the demand to the police, who replied that they would send backup, but in fact did nothing. In the meantime, the liaison officer for the convoy called the army commander and demanded urgent action to rescue the vehicles and their occupants. He was promised that the reinforcements would get there quickly, but again nothing was done. The number of casualties in the vehicles was growing, while the British, who were supposed to have safeguarded the convoy, simply watched the killing. The two armoured police vehicles and the British forces at Antonius House could easily have stopped the Arab fire, but they did not, and it was hours before the British reinforcements arrived. It seems that their dilatoriness was deliberate, intended to allow the Arabs to perpetrate their crime.[34]

A few hours later the battle was over. The loss of life from this single incident was grievous. Seventy-eight of the people travelling in the convoy, including doctors, nurses, soldiers, Hebrew University employees, convoy escorts, and Hamekasher drivers, were killed. Only thirty-one bodies were identified and recovered for burial. Body parts from twenty-five others were found but not identified; these were buried in a common grave at the Sanhedria cemetery in Jerusalem, about one and a half miles from the battle's location. Twenty-two of the people in the convoy were not found and remain missing to this day.[35]

Among those killed in the attack were Dr Yassky and two other central figures in the effort to establish and organize the medical school: Dr Moshe Ben-David, who was secretary of the Development Committee of the Pre-Faculty of Medicine, and

[33] Levitse, *Jerusalem in the War of Independence* (Heb.), 194. [34] Ibid.

[35] 'In memory of those killed in the convoy on the way to Mount Scopus who died defending their country on 4 Nissan 1948', Hadassah Medical Organization pamphlet (Heb.), HA, RG2, 7.

Professor Leonid Doljansky, head of the Department of Pathology and the cancer research laboratories.[36] The massacre left the entire Jewish community of Jerusalem stunned and in mourning, 'especially in light of the murder of so many doctors, nurses, and university scientists . . . as well as in light of the fact that only a few were killed immediately, and the others could have been saved if the British army convoy had responded to their cry for help'. A mass funeral was held in Jerusalem the next day, 14 April.[37]

For sixteen days after the attack the hospital on Mount Scopus was totally isolated. A hundred patients, the same number of employees, and 250 medical staff, as well as essential medical equipment, were evacuated by convoy. Only fifty to sixty beds, and approximately fifty staff members and guards, remained there. The patients evacuated from Mount Scopus were moved to the English Mission, which was equipped with seventy beds, as well as a maternity ward with sixteen beds for newborn infants.[38] Shortly afterwards Hadassah set up two more hospitals in old hospital buildings on Hanevi'im Street in western Jerusalem, in addition to the English Mission hospital, which became known as Hadassah Aleph (A): the German hospital, later renowned as Ziv Hospital, and Beit Hadegel. With no other option available, the medical centre evacuated from Mount Scopus was housed in these temporary buildings. Naturally, the conditions and equipment here were far from suitable for the requirements of a modern medical centre.[39]

SELF-EXAMINATION IN A TIME OF CRISIS

The outbreak of the war, and in particular the assault on the Mount Scopus convoy, plunged the Rothschild-Hadassah University Hospital, the centre of Hadassah's medical activities in Palestine, into a state of grave crisis. Hadassah had lost some of its finest medical staff, including the director of the hospital and other key figures in the project to establish a medical school. In addition, it had lost its large, modern, well-equipped building for medical care and research, which had begun operating only nine years earlier and was considered the most advanced hospital in Palestine,

[36] Levitse, *Jerusalem in the War of Independence* (Heb.), 196; Niederland and Kaplan, 'The Medical School' (Heb.), 147. [37] Zipora Porath to her parents, 14 Apr. 1948, in Porath, *Letters* (Heb.), 159.
[38] On the isolation of the hospital following the assault on the convoy, see Halevi and Brzezinski, *Under Double Siege* (Heb.), 16; Ethel Agronsky to Rose Halprin, 26 Apr. 1948, HA, RG2, ser. 33, box 68, folder 5. For the numerical data on the evacuation, see minutes of National Board Hadassah Medical Organization Committee, 27 May 1948, HA, RG3, ser. 20, box 92, folder 3, 15.
[39] Minutes of Hadassah National Board meeting 3 Nov. 1948 (report by Eli Davis), 6; Prywes, 'Medical Education' (Heb.), 16.

indeed in the entire Middle East. Thus the two partners in the operation, the Hadassah Medical Organization in Palestine and the Hadassah leadership in the United States, were forced to relocate the hospital's facilities under war conditions, and to cope with grave losses and very serious practical problems. In view of the depth of this crisis, it is not appropriate to speak of a continuous development of activities and projects from the pre-state Yishuv to the Israeli period but rather of a rupture in normal activity followed by renewed vitality after the crisis had abated.

Alongside the problems caused by the War of Independence, Hadassah had to deal with the far-reaching changes in the health field in Israel which accompanied the transition to statehood. Within the Yishuv of the Mandate period, health services had been run entirely by voluntary organizations; when the state was established, the Ministry of Health became responsible for providing health and medical services to its inhabitants. One of the greatest challenges facing the new ministry was the need to provide hospital facilities for the growing Jewish population of the country. There was an immediate demand for more beds in the general hospitals, and the Galilee and Negev regions had no hospitals at all (except for the Hadassah Hospital in Safed, which was not a general hospital but dealt only with tuberculosis). To meet these needs, provisional hospitals were set up in military bases that had been abandoned by the British and the Arabs, and existing institutions were expanded and reorganized. In 1948 sixteen military hospitals were established by the IDF to cope with the many wounded in the harsh battles that took place on the eve of the declaration of the state.[40] Among them, as we have seen, was the Tel Hashomer Hospital, which later became a large medical and research centre.

By late 1948 there were 2,659 hospital beds in Israel, and of all the organizations that maintained them, Hadassah had the smallest number—290 beds in all its institutions: less than the government, the health organizations, private hospitals, or local authorities.[41] This situation led to concern among the leaders of Hadassah, and especially some of the doctors at the Rothschild-Hadassah University Hospital, that the Hadassah Medical Organization might lose its leading position in the field of health and medicine in Israel, and ultimately be overtaken to the point of redundancy. It was against this background that the assistant deputy director of the Rothschild-Hadassah University Hospital, Haim Shalom Halevi, wrote a memorandum on 17 June 1948 about 'the problem of the future activities of Hadassah in Palestine'.[42]

[40] Nadav, 'Hospital 5' (Heb.), 442.
[41] Memorandum by H. S. Halevi, 17 June 1948, HA, RG2, ser. 61, box 101, folder 7. [42] Ibid.

Halevi predicted that the political changes accompanying statehood, together with the isolation of Jerusalem, where most of the Hadassah health services were located, would strongly influence the position of the organization within the emerging Israeli health-care system. In his view, the medical activities of Hadassah in Palestine had been justified under the British Mandate, when the regime showed no interest in the health of the Jewish residents. However, in a sovereign Jewish state the health ministry would provide health services and, by definition, do its utmost to protect public health and foster the advancement of medicine. Thus the importance of the voluntary organizations that had previously fulfilled this role would naturally diminish. In addition to these implications of the transition to statehood, Halevi also noted the weakened situation of the Hadassah Medical Organization following the massacre of the Mount Scopus convoy. Taken together, he suggested, these circumstances could well lead to the collapse of Hadassah as a Zionist organization whose activities in the United States revolved around and depended on its health projects in Palestine.[43]

In order to prevent this, Halevi proposed ways to maintain Hadassah's prominent role within the Israeli health system. He suggested that Hadassah undertake the role of 'ministry of health' in the Jerusalem area, which was consistent with both the needs of the organization and those of the medical school being developed; and that it should cease to run health services for immigrants. He stressed, furthermore, that the organization should decide what it wanted to do as soon as possible, because any delay was liable to worsen its future situation.[44]

On 15 September 1948 the National Board discussed the future of the Hadassah Medical Organization projects. Etta Rosensohn, who led the discussion, stressed the gravity of the crisis. She also presented the range of opinions prevalent among the doctors at the Rothschild-Hadassah University Hospital regarding what action should be taken. One view was that Hadassah should continue its efforts to establish a medical school, because it was the only organization that could do so. Another was that it should set up a children's hospital with a capacity that no hospital in Israel—not even the Rothschild-Hadassah University Hospital—could offer. Another idea was that Hadassah should set up a hospital for tropical diseases.[45]

She went on to review the constraints on Hadassah, and the difficult decisions it had to make. First, she noted, the establishment of the state had totally changed the status of the organization within the health system in Palestine; second, Hadassah had lost the leading personality in its health projects, Dr Haim Yassky; third, it had

[43] Ibid. [44] Ibid. [45] Minutes of Hadassah National Board meeting, 15 Sept. 1948, 2.

to work within budgetary limitations that precluded expansion of its medical activities; and fourth, there were organizational problems within the Hadassah Medical Organization.[46]

Etta Rosensohn argued that, in deciding the future course of its health-related activity in Israel, Hadassah should follow certain guidelines. Specifically, it should undertake a project that responded to a basic need of the kind that it was capable of fulfilling, and it should rehabilitate its medical projects in Jerusalem, rather than on the coastal plain, as a way of strengthening the city. It should also aspire not to quantity, but to quality and pioneering spirit, and build a hospital that would set a standard of excellence.[47]

From Dr Yassky's murder in April until November 1948, the Hadassah Medical Organization functioned without an official director; however, the role was performed unofficially by Dr Eli Davis, a physician who had emigrated from England. Mendel Krupnick served as his deputy until he himself resigned in October 1948. The appointment of Davis as official director of the Rothschild-Hadassah University Hospital and head of the Hadassah Medical Organization was presented to the full National Board in early November 1948, with Davis himself present during the discussion.[48]

At that same meeting the board returned to the topic of the future plans of the Hadassah Medical Organization. Davis spoke about the impact that statehood had had upon the organization. Like Etta Rosensohn, he stressed that its status as an uncontested provider of medical services was likely to be lost within a short time, since the 'very ambitious' State of Israel would quickly reach the current standard of Hadassah in this field. He stressed the need for action to maintain Hadassah's existing advantage and to gain widespread recognition of its superiority over other bodies providing medical services in Israel. For this purpose, he said, it must train doctors at the highest level, establish their expertise in specialist areas of medicine, set the highest standards, and follow the example of the most highly acclaimed medical institutions in the United States.[49]

A sense of crisis persisted at the National Board meetings in mid-June 1949. At the meeting of the Medical Reference Board on 16 June, Etta Rosensohn spoke about the disasters that had befallen the Hadassah Medical Organization and added that Hadassah had now lost the position it had held during the Mandate period as the main medical agency for the general public in the Yishuv. Israel had made great

[46] Minutes of Hadassah National Board meeting, 15 Sept. 1948, 2. [47] Ibid.
[48] Minutes of Hadassah National Board meeting, 4 Nov. 1948, 16; Hadassah Annual Report, 1948/9, 11.
[49] Minutes of Hadassah National Board meeting, 4 Nov. 1948, 16.

advances in the field of medicine, and several of its hospitals—such as those established by the government in Haifa and Tel Aviv, and the Histadrut Health Fund's Beilinson Hospital in Petah Tikva—were of an excellent standard.[50] Also, Jerusalem had undergone a radical change in its condition and status. During the Mandate period this city, in which the health and medical services that Hadassah had developed in Israel were concentrated, was the official, administrative, and diplomatic capital of Palestine, while Tel Aviv was the cultural and economic capital. In the wake of its isolation during the War of Independence, Jerusalem was badly damaged in demographic, political, and economic terms. It was now a border city and access to it was awkward. Government, political, and diplomatic institutions had largely moved to Tel Aviv; by the end of the first year of statehood its population had dropped by a quarter, and Tel Aviv held the upper hand in all spheres.[51]

Naturally, this shift concerned Hadassah's national board.[52] There was concern within Hadassah that these changes would diminish the importance of Hadassah's medical projects and its status in Israel, because it had concentrated its activity in Jerusalem and could not supply the needs of the new government, which were concentrated elsewhere.[53]

All these factors were discussed at several meetings of the National Board. The prevalent view among the Hadassah leadership, both at headquarters in New York and at the Israel office, was that the establishment of the state and the outcome of the War of Independence had jeopardized the existence of the Hadassah Medical Organization. The organization therefore had to reshape its health projects in Israel and seek ways to regain its status in the field of health and medicine. Two groups in particular were interested in restoring the position of Hadassah in Israel: the doctors at the Rothschild-Hadassah University Hospital, who feared the loss of their prestige and status; and the leaders of Hadassah in the United States, who were concerned that a diminution in the prestige of the Hadassah Medical Organization would harm the mother organization, Hadassah itself.

[50] Minutes of meeting of the Medical Reference Board of Hadassah and the Hebrew University, 16 June 1949, HA, RG2, ser. 31, box 64, folder 2, p. 7.

[51] For the data on Jerusalem, see Lisak, 'Jerusalem as a Mirror' (Heb.), 17.

[52] Minutes of Hadassah National Board meetings, 9 May 1949, 2; 9 June 1949, 2–3. [53] Ibid.

A Young State with Many Needs

WHEN THE STATE OF ISRAEL declared its independence on 15 May 1948, it opened its gates to unlimited Jewish immigration. From the Zionist perspective this marked an important achievement, for which the Yishuv had fought since the 1930s, and particularly in 1946–8: offering a life in Palestine to any Jew who wanted to come. Israel, which had a population of 650,000 when it was established, absorbed more than as many Jews again in its first three years and eight months (from May 1948 until the end of 1951): some 687,000 immigrants, flocking to Israel from around seventy countries.[1] No one had predicted how vast this wave of immigration would be.[2] Absorption of the newcomers was a central aspect of Israel's existence after the War of Independence; it was a focus of attention for the entire Jewish population as well as the country's leadership, and required tremendous financial resources.[3]

The immigrants came from Europe, the Muslim countries of the Middle East, and northern Africa. They included Holocaust survivors, as well as the entire Jewish communities of Bulgaria and Yugoslavia; almost a total transfer of the Jewish communities of Yemen, Iraq, and Libya; and large groups from Turkey, Morocco, Tunisia, Algeria, Iran, and Egypt. Also in this period groups of children and teenagers arrived in Israel as part of Youth Aliyah. (This movement is discussed separately in Chapter 11.)[4]

This immigration was not a spontaneous event. It was the result of a clear-cut decision, expressed in Israel's diplomatic and economic activity, which placed a heavy financial and organizational burden on the new state. In some cases, for example with Hungary, Bulgaria, and Poland, trade agreements were signed to cover up payments made to secure permission for the Jews to leave. In others, negotiations took place openly, the emigration of Jews being treated like any other business transaction, even down to bargaining over the price to be paid per head.[5]

[1] Assaf, 'The Population' (Heb.), 667. [2] Hacohen, *Immigrants in Turmoil*, 58.
[3] Ibid. 5, 24. [4] Ibid. 22–3, 246. [5] Ibid.

These agreements, which involved huge sums of money, could not have been concluded without help from outside Israel. The central source of funding was the American Joint Distribution Committee which worked in co-operation with the Jewish Agency and the government of Israel to organize immigration. The Joint helped maintain the transit camps for immigrants in France, Italy, Aden (for immigrants from Yemen), and other places, and financed most of the cost of transporting the immigrants to Israel.[6]

The vast majority of these immigrants went to Israel because of hardship in their home countries; in some cases, they were actually fleeing physical danger.[7] Almost none had any significant financial resources. There were a few wealthier people among them—idealists who had chosen participation in building the nation and the state over a comfortable life—but the overwhelming majority of immigrants were from the poorer sections of the Jewish population in their countries of origin. On the whole, capitalists, prosperous merchants, and members of the free professions who were able to establish themselves in their countries of origin or elsewhere preferred such arrangements to immigration to Israel.[8]

Very few of the immigrants came from Western countries. The proportion was especially low from the United States, where there were about six million Jews: only 3,000 of them emigrated to Israel between 1948 and 1954. Of the three million Jews in western Europe, less than 1 per cent emigrated to Israel. Even some of the Holocaust survivors interned in displaced persons camps (DP camps) in Europe took their chances in other countries. Out of the 600,000 Jews in northern Africa, only 16 per cent went to Israel between 1948 and 1951. In contrast, among the Jews of Asia, who numbered some half a million people, about 240,000 emigrated to Israel, more than half of them from Iraq.[9]

The Jewish Agency began to prepare for immigrant absorption even before the establishment of the state, and the first wave of immigrants actually arrived during the War of Independence, despite the war conditions and the logistical problems. Most of the immigrants disembarked in the lulls between battles, brought in by boat from Cyprus, where Jews who had survived the Holocaust and wanted to enter Palestine were kept in detention camps by the British between 1946 and 1948. In this first wave 24,000 Jews arrived in Israel.[10]

[6] Ibid. 23, 38.

[7] On Iraq, see *Report on Activities 5707–5711 [1946–51]* (Heb.), CZA, 204–5; on Bulgaria, ibid.; on Yemen, ibid. 208–10; on Libya, ibid. 213–15. [8] Hacohen, *Immigrants in Turmoil*, 246–7.

[9] Ibid. [10] Ibid.

The peak year of the post-war immigration was 1949, when the plan was to absorb 330,000 immigrants. Because of the difficulties with absorption, especially in housing, this total was not reached; nevertheless, between October 1948 and the end of 1949, some 300,000 Jewish immigrants arrived in Israel from fifty-two different countries.[11]

HADASSAH AND MASS IMMIGRATION TO ISRAEL

One of the gravest challenges in absorbing the immigrants was their state of health.[12] By 1948 the general physical condition of the population of the Yishuv was immeasurably better than it had been when Hadassah and the health funds began operations at the beginning of the Mandate period. Diseases that were widespread at the beginning of the twentieth century—notably malaria and trachoma—had disappeared almost completely. Children were inoculated against tuberculosis, diphtheria, and smallpox; infant mortality had declined, and the life expectancy of the Jewish population had risen significantly.[13] This situation now changed completely: tuberculosis, trachoma, malaria, schistosomiasis, and other diseases that had been virtually wiped out re-emerged, because they were common among the immigrants. In addition, many immigrants were suffering from both physical and mental fatigue and emotional trauma.[14] The health services in the new state were inadequate to cope with the serious problems that accompanied the mass immigration.

In the first decade of statehood Israel's Ministry of Health was in an extremely difficult position and unable to provide adequate care for all the immigrants.[15] Even though new hospitals were set up and existing ones enlarged, the health system nearly collapsed under the demand, with severe shortages of hospital beds, medical equipment, and medical staff, as well as funds.[16] In order to meet this challenge to the state, it recruited help from ten organizations, some voluntary. These were the health funds (the Histadrut Health Fund, the Popular Health Fund, the National Workers' Health Fund, and the Maccabi Health Fund), Hadassah, the Jewish Agency, Malben (the welfare organization set up by the Joint Distribution Com-

[11] Hacohen, *Immigrants in Turmoil*, 23.

[12] Ibid. 137. [13] Ginnton, 'Twenty Years of Health in Israel' (Heb.), 6.

[14] Shvarts, 'Clalit Health Fund' (Heb.), 271; Hacohen, *Immigrants in Turmoil*, 137.

[15] *Report on Activities 5707–5711 [1946–51]* (Heb.), 209; Shvarts, 'Clalit Health Fund' (Heb.), 271.

[16] On the establishment of hospitals, see Shvarts, 'Clalit Health Fund' (Heb.), 270–1; on the health system see Hacohen, *Immigrants in Turmoil*, 139.

mittee in Israel in 1949 to relieve the government and the Jewish Agency of the burden of caring for the aged, chronically ill, and handicapped immigrants), the Israeli union of volunteers for providing first aid, Magen David Adom, and the IDF medical corps. Yet even together with the local authorities, these bodies provided health care and health insurance to only 60 per cent of the population in Israel.[17]

Hadassah defined its role in immigrant absorption in a resolution passed at its Thirty-Fifth Annual Convention (1949). The wording established that 'the great task of the ingathering of the exiles' was 'not the responsibility of Israel alone', and that American Jewry should share this responsibility. It emphasized that Hadassah would continue to devote itself to pursuing and intensifying its projects of 'healing, teaching and research', as its share 'in the fulfilment of the Zionist objective of establishing a home where every Jew who needs or wants to may have the opportunity of becoming a free and productive citizen of a democratic country'.[18] A year later, another resolution was adopted that repeated and confirmed this statement.[19]

As noted, Hadassah had been involved in providing health services to immigrants since the early 1920s. In December 1944, towards the end of the Second World War, the Jewish Agency set up the Immigrant Health Service (Hasherut Harefu'i La'oleh), which was originally intended to provide medical care for Holocaust survivors. The service was headed by Dr Theodore Grushka, who worked with a committee composed of representatives of the Jewish Agency, the Va'ad Leumi, the Hadassah Medical Organization, and the Histadrut Health Fund. The service insured every immigrant in the Histadrut Health Fund for the first three months after arrival, including hospitalization and medical care in other medical institutions.[20] In October 1946 the service assumed in addition responsibility for health care at immigrant hostels and transit camps. Budgets for the medical supervision and health care of immigrants were the joint province of the Immigration (Aliyah) Department of the Jewish Agency and Hadassah.[21] Thus, at the time the state was established, the Immigration Department was responsible for the health care of immigrants upon their arrival, and it provided this treatment through Hadassah and the Histadrut Health Fund.

[17] Shvarts, 'Clalit Health Fund' (Heb.), 271; Hacohen, *Immigrants in Turmoil*, 146.

[18] 'Greeting to the State of Israel', resolution adopted at the Hadassah's 35th Annual Convention, San Francisco, 13–16 Nov. 1949, HA, RG3, ser. Proceedings, subser. 1949–1951 Conventions, box 15.

[19] 'Greeting to the State of Israel', resolution adopted at Hadassah's 36th Annual Convention, New York, 20–3 Aug. 1950, HA, RG3, ser. Proceedings, subser. 1949–1951 Conventions, box 15.

[20] Shvarts, *Kupat Holim, the Histadrut and the Government* (Heb.), 144–5; Hacohen, *Immigrants in Turmoil*, 146–7. [21] Hacohen, *Immigrants in Turmoil*, 146.

According to this agreement, Hadassah accepted responsibility for medical services in the immigrant hostels and transit camps, including outpatient care, hospitalization, and convalescence. It contributed 50 per cent of the funding for these services, and in 1948 took sole responsibility for running them.[22] In early March 1948, however, Dr Haim Yassky informed Eliezer Kaplan, treasurer of the Jewish Agency, that Hadassah could not run the service with the existing budget (160,000 Palestine pounds, half of which was provided by Hadassah, and half by the Jewish Agency).[23] He suggested two possible solutions to the problem: either the Jewish Agency could commit itself to covering the expenses exceeding the annual sum budgeted by Hadassah (80,000 Palestine pounds), or Hadassah could be relieved of the job of managing the medical services for immigrants. Yassky's letter was accompanied by an official termination of the agreement between Hadassah and the Jewish Agency as of 1 October 1948.[24]

By the end of May, no response had been received from the Jewish Agency. Ethel Agronsky, chairman of the Hadassah Council in Israel, sent another letter to Kaplan, now Israel's finance minister. In it, she reiterated Hadassah's resolution not to raise its contribution above the agreed sum of 80,000 Palestine pounds and noted that if the Jewish Agency did not enlarge the budget for medical care for immigrants it could expect many difficulties in its work, in view of the general rise in prices in Israel, increased hospitalization costs, and, above all, the forecast of immigration 'of unprecedented proportions'. At the time, the overall budget of the health services was estimated at over half a million Palestine pounds.[25]

Kaplan responded that the Jewish Agency was about to reorganize the health services for immigrants and was currently discussing their transfer to the Ministry of Health. However, he expressed his hope that Hadassah would continue to donate the same amount to the service that it had until then.[26] Shortly after this, Hadassah received two proposals for continued participation in the medical services to immigrants, within the budget it had set: undertaking the care of immigrants suffering from tuberculosis or, alternatively, undertaking the health care of immigrant children.[27]

[22] Proceedings of Hadassah's 33rd Annual Convention (1947), speech by Dr Yassky, HA, RG3, ser. Proceedings, subser. 32nd and 33rd Conventions, box 13.

[23] Letter from Ethel Agronsky to Eliezer Kaplan, 25 May 1948, CZA, J113II/139/3 (Heb.).

[24] Ibid. [25] For quotation and claims, see ibid.

[26] Letter from Eliezer Kaplan to Ethel Agronsky, 14 June 1948, CZA, J113II/139/3 (Heb.).

[27] H. S. Halevi, 'Memo on the Question of the Future Participation of Hadassah in the Medical Services for Immigrants' (Heb.), 1 Aug. 1948, CZA, J113II/139/3.

As early as May 1948 it was decided to transfer the health care of immigrants to the Ministry of Health, on the assumption that Hadassah would continue to provide financial support for this cause.[28] The minister of immigration, Moshe Shapira, announced this plan in an official statement to the leaders of the Hadassah Council in Israel in July 1948,[29] and the announcement was sent to Hadassah's National Board in New York, with a request that it be discussed as soon as possible.

This discussion took place at a board meeting in late July 1948. It began with an announcement by Etta Rosensohn, who expressed her dismay at the measure. However, she said that the Hadassah Medical Organization had decided to accept the plan and was pressing for continued support from Hadassah in financing the service at the same level, namely 80,000 Palestine pounds, on the condition that it was promised that the money would not be swallowed up by administration, but would be used to treat tuberculosis among the new immigrants. She said that Hadassah could not and did not need to decide immediately whether to continue to contribute to financing health care for immigrants on the basis of the new situation that had emerged. She argued that the question should be considered in the overall context of Hadassah's budget for 1948/9, along with all the organization's health projects, and in the context of that programme as a whole.[30]

Shortly after that, at a National Board meeting in October 1948, Hadassah's president Rose Halprin stated unequivocally that the health care of immigrants was beyond the financial capabilities of Hadassah, and that it also lacked medical staff capable of undertaking this task.[31] In April 1949 the health care of immigrants was transferred from the authority of the Jewish Agency and Hadassah to the Ministry of Health.[32] The transition was finally made, then, as the result of a combination of factors, chief among them the 'tendency of the Ministry of Health to take control, as much as possible, of the different health services', and Hadassah's decision to limit its funding for these services to 80,000 Palestine pounds a year.[33]

The medical service for immigrants operated by the Ministry of Health from 1948 to 1951 gave immigrants full access to medical care. This included the services of doctors, the provision of medication, 'sick rooms' in the immigrant camps, inpatient treatment and care in government hospitals for the sick (including

[28] Letter from Dr Theodore Grushka (head of the Social Department of the Ministry of Health) to Mendel Krupnick, 18 June 1948, CZA, J113II/139/3 (Heb.).

[29] Letter from Ethel Agronsky to Moshe Shapira, 19 July 1948, CZA, J113II/139/3 (Heb.).

[30] Minutes of Hadassah National Board meeting, 28 July 1948, 4.

[31] Minutes of Hadassah National Board meeting, 14 Oct. 1948, 5.

[32] *Israel Government Yearbook 5712 [1951–2]* (Heb.), 69.

[33] For the quotation, see Halevi, 'Memo on the Question of the Future Participation of Hadassah in the Medical Services for Immigrants' (Heb.), 3.

tuberculosis patients and the mentally ill) and for women giving birth, supervision
of the Jewish Agency's infant homes, preventative medicine (including inocula-
tions), dental care, recuperation after serious diseases, rehabilitation of people with
disabilities, and supervision of sanitation.[34] The service was brought to an end in
1951, after which prospective immigrants were examined by physicians at the
centres abroad, and medical care was provided, if needed, by the existing services.
Moreover, every immigrant was automatically insured by a health fund upon arrival
in Israel (this insurance continued to apply even after the government scheme was
wound up in 1951).[35]

Hadassah was not, then, the main party in the vast effort to provide health and
medical services to immigrants in the first years of the state. The only field in which
Hadassah did take responsibility for treating new immigrants on a large scale was
the care of tuberculosis patients; previously, 50 per cent of the entire Yishuv–Jewish
Agency budget for health care for immigrants was allocated for this purpose.[36]
Tuberculosis was the most common chronic infectious disease among all strata
of the immigrant population. It was especially widespread among Holocaust sur-
vivors and immigrants from Yemen and northern Africa. The large numbers
affected made the disease one of Israel's major medical challenges in its early years.
Medical institutions that were originally intended to deal with other needs became
hospitals for tuberculosis patients. Tests conducted on the immigrants in the
Sha'ar Ha'aliyah transit camp near Haifa revealed that nearly 5 per cent were
suffering from tuberculosis. The Ministry of Health estimated that by the end of
1949 about 3,500 tuberculosis patients would reach Israel, but only about 800
hospital beds were available for them. The problem of hospital provision for
children with tuberculosis was particularly severe.[37]

There were disagreements between the Hadassah Medical Organization in
Israel and the Hadassah leadership in America regarding the decision to take
responsibility for immigrants with tuberculosis, arising from the concern that
Hadassah would not be able to stand the financial burden even of this more
circumscribed commitment.[38] However, the National Board eventually approved
the plan. A decision was made to set up new institutions for the care of tuberculosis
patients, and to expand the scope of their operations to include facilities that up to
that point had either been completely lacking or had been available only minim-
ally, such as throat surgery and chest radiology, preventative medicine (including

[34] *Israel Government Yearbook 5712 [1951–2]* (Heb.), 69.
[35] Ginnton, 'Twenty Years of Health in Israel' (Heb.), 6.
[36] *Israel Government Yearbook 5713 [1952–3]* (Heb.), 54.
[37] Ibid. [38] Minutes of Hadassah National Board meeting, 14 Oct. 1948.

inoculation), and the training of nurses to care for TB patients.[39] In the course of 1949 three institutions were established for the care of tuberculosis patients: in the township of Gedera, south of Rehovot; in the township of Zikhron Ya'akov, on Mount Carmel; and in the Mekor Haim neighbourhood of Jerusalem. The last included a special ward for children, as well as operating theatres.[40]

As the wave of immigration swelled, so the associated medical demands intensified. Somehow transport had to be arranged for the whole Jewish population from certain places, including the displaced persons camps in Europe and countries such as Bulgaria and Libya whose Jewish communities were emigrating almost in their entirety. A particularly severe problem arose with regard to the many ailing, disabled, and elderly people arriving from these places. The Jewish Agency negotiated an agreement with the Joint Distribution Committee by which the latter would take responsibility for treating the ailing and the disabled; this somewhat eased the immediate pressure, but the underlying problem was not resolved, and over the course of 1949 it intensified.[41]

In 1949 the government of Israel once again asked for assistance from Hadassah. The organization's Medical Reference Board discussed the request on 22 December; however, at that meeting there was a general consensus that the medical care of immigrants remained beyond Hadassah's capabilities, as Rose Halprin had argued the previous year.[42]

The problem of financing health services for immigrants had become particularly acute in the summer of 1949, in the context of the urgent need to provide medical care for those arriving from Yemen. This particular wave of immigration consisted of almost the entire population of one of the oldest Jewish communities in the Diaspora, numbering 50,000 people in dozens of villages, towns, and cities throughout Yemen. The Yemeni government was a fervent supporter of the Arab struggle against Zionism and Israel, and its giving the country's Jews permission to leave in the summer of 1949 was quite unexpected. As a result of very complex political circumstances, the Jews from Yemen came to Israel via Aden. The British authorities there were willing to co-operate, but insisted that the Jews remain outside the city to avoid the spread of epidemic disease. The Jews were therefore taken to a camp that was hastily erected by the Joint Distribution Committee, who also financed and supervised it. The camp was called Geula, a Hebrew word meaning 'redemption'. Conditions were primitive, with no sanitary facilities.

[39] Eli Davis, 'Hadassah to Build First Negev Hospital in Beersheba', *Hadassah Newsletter*, 29/5 (Jan. 1949), 1. [40] Hadassah Annual Report, 1948/9, 16–17. [41] Hacohen, *Immigrants in Turmoil*, 54.
[42] Minutes of Hadassah National Board meeting, 22 Dec. 1949, 7.

Within a few weeks of the first arrivals in June 1949, the population of the camp had grown to thousands. The would-be immigrants had made their way from Yemen by foot or riding on donkeys over rough terrain; they encountered bandits and were attacked by hostile villagers. The few immigration emissaries from Israel who managed to enter Yemen were able to give them only very little help. It was not until they reached Haj, near Aden, that they were approached by workers of the Joint Distribution Committee and taken to Camp Geula. They were short of food, and thousands were near death from starvation.

In August 1949 the influx of Jews from Yemen increased still more. A delegation of physicians (including some from the Hadassah Medical Organization) sent to Aden by the Israeli government to examine the prospective immigrants were shocked by what they saw. One of them described the scene as 'a broad field covered entirely by masses of people lying closely together on the desert sand. Protruding from the sea of human beings were many spots of white. As we approached, we saw low benches upon which the dead had been laid out in their shrouds; they had not yet been buried.'[43] The medical delegation was informed that the British had sealed off the border with Yemen as a result of the typhus epidemic in that country; furthermore, the British authorities announced that they would bar the entry of any more refugees until those at Camp Geula had been evacuated. Closure of the border was literally a death sentence for those who were en route to Aden. As a result, six Skymaster planes were commissioned to fly the immigrants to Israel in a clandestine operation called Operation Magic Carpet.[44] In the meantime, the immigrants received medical care at the hospital set up in the camp by the Israeli doctors.[45]

The wave of immigration from Yemen reached its peak in October 1949, when 11,705 migrated to Israel out of a total of about 47,000 from Yemen, in addition to approximately 2,000 immigrants from Aden, Asmara (the capital of the district of Eritrea in northern Ethiopia), and Djibouti (in east Africa on the coast of the Gulf of Aden), who arrived in 1949 and 1950. The Jews from Yemen arrived in Israel suffering very serious diseases, including malaria, which was widespread in the transit camp in Aden, eye diseases (mainly trachoma), skin diseases (mainly tropical ulcers), stomach typhus, and dysentery.[46]

[43] Quoted in Hacohen, *Immigrants in Turmoil*, 67. [44] Ibid.

[45] *Report on Activities 5707–5711 [1946–51]* (Heb.), CZA, 209; correspondence from Dr Y. Meir (director general, Ministry of Health) to the Hadassah Medical Organization management, 19 Oct. 1949, CZA, J113II/140/4 (Heb.).

[46] *Report on Activities 5707–5711 [1946–51]* (Heb.), CZA, 209; Dr Y. Meir (director general, Ministry of Health) to the Hadassah Medical Organization management, 19 Oct. 1949, CZA, J113II/140/4 (Heb.).

On 26 October Dr Eli Davis, who was at this point deputy director of the Rothschild-Hadassah University Hospital and head of the Hadassah Medical Organization, attended a meeting of the Hadassah National Board in New York. In his address he spoke about the difficult situation of the Yemeni immigrants living in the immigrant camps, where basic living accommodation was provided in tents or tin huts. He reminded those present that Hadassah had not operated in these camps since the beginning of the year, and pointed out that, although the Histadrut Health Fund had undertaken responsibility for the care of those within them, it was unable to cope with the situation. The condition of the Yemeni immigrants was so grave, he said, that it was imperative Hadassah provide them with medical assistance.[47]

Davis spoke about the Rosh Ha'ayin immigrant camp, east of Petah Tikva, where many immigrants from Yemen were living in an abandoned British army camp that had been an Arab base during the War of Independence:

Rosh Haayin [camp] (near Petah Tikvah) was suddenly opened as there was no more room in the other areas. At the end of the week they had 7000 people, but nobody there to serve them. The medical officer in charge of this camp came instinctively to Hadassah instead of first approaching the Government, and said 'I came to you for your help. If you don't help me fourteen children will die this morning . . .' Until then Hadassah had to resist because we had given 50 nurses to the country—and there is such a shortage of nurses—and we are down to our very limit in nursing staff. One can't run a hospital or a school and go down below this standard. But we helped out again and 20 patients were taken care of the first day. Even if it meant closing beds in Jerusalem, we still would have sent the personnel, because the same number of nurses who run 10 children's beds in Jerusalem can service 100 children's beds in Rosh Haayin . . .[48]

Davis went on to express his hope that Hadassah would set up a team in every immigrant camp to administer preventative medical care.

When he had finished speaking, Etta Rosensohn submitted a proposal to allocate the amount of funding necessary to set up such teams.[49] The proposal was accepted and a hospital for immigrant children was set up in Rosh Ha'ayin; originally intended to be a one-year project, it operated until 1951 alongside the hospital for adult immigrants set up by the Joint Distribution Committee.[50]

The hospital in Rosh Ha'ayin treated children suffering from very severe diseases, mainly malaria, with which about 60 per cent of the immigrants from

[47] Minutes of Hadassah National Board meeting, 26 Oct. 1949, 6. By permission of Hadassah, The Women's Zionist Organization of America, Inc. [48] Ibid. [49] Ibid.
[50] Author's interview with Prof. Kalman Mann, Jerusalem, 23 July 1992; minutes of Hadassah National Board meeting, 26 Aug. 1949, 9; ibid. 19 Oct. 1949, 5.

Yemen were infected, but also other eye and skin diseases.[51] It also provided first aid for minor injuries in Rosh Ha'ayin and the immediate vicinity.[52] Located in the building that had been used as a canteen by the British air force officers, it quickly grew into a hospital with 100 beds. Dozens of ailing children came to the hospital daily. Many of them were brought in a serious condition straight from the planes that had flown them from the transit camp in Aden, and it was not long before the hospital physicians had difficulty handling the load.[53] In January 1950 Hadassah sent six nurses from New York to the hospital in an attempt to ease the severe shortage.[54]

Initially the hospital in Rosh Ha'ayin had to improvise solutions to the various challenges it encountered, among them sanitation problems such as plagues of mice, rats, and mosquitoes—the last raising concerns that the Hadassah employees were at risk of contracting malaria.[55] Gradually, medical equipment arrived and the hospital became well organized. The child mortality rate was very high in its first months, but declined over time. In January and February 1950 the monthly mortality rate was over 20 per cent; a year later it had fallen to 4 per cent.[56]

Shortly after the establishment of the hospital, the Hadassah Medical Organization turned its attention to the need for preventative medicine, and set up an infant welfare station (a facility known in Hebrew as Tipat Halav, meaning 'a drop of milk') in the camp. Like all such stations in Israel, it monitored pregnancies, administered blood tests and X-rays, and provided advice on nutrition. When infants were born, they were routinely examined, monitored, and provided with milk and clothing. At first the new immigrants from Yemen were suspicious of the welfare station, but in time it became popular, and its work was expanded to include children of school age.[57]

The work of the hospital and its infant welfare station led to considerable improvement in the health of the residents of the Rosh Ha'ayin immigrant camp.[58]

[51] Minutes of Hadassah National Board meeting, 19 Oct. 1949, 5.

[52] Letter from G. Mandel (director of the hospital in Rosh Ha'ayin) to Dr Kalman Mann, 31 July 1951, CZA, J113II/140/7 (Heb.).

[53] Information on the difficulty of handling the emotional load from author's interview with Prof. Kalman Mann, Jerusalem, 23 July 1992.

[54] Rebecca Shulman, 'US Nurses Welcomed to Israel', *Hadassah Newsletter*, 30/6 (Feb. 1950), 2; on the severe shortage of nurses, see Hacohen, *Immigrants in Turmoil*, 140–1.

[55] On the plague of mice, see letter from Dr Kalman Mann to Mr Naftali (Dept. of Plant Protection) (Heb.), 16 Nov. 1949, CZA, J113II/140/4; on the rats and the concern about malaria, see letter from Dr Kalman Mann to Prof. Shaul Aldar (director of the Institute for Parasitology at the Hebrew University) (Heb.), 9 Nov. 1949, CZA, J113II/140/4 (Heb.). [56] Letter from G. Mandel to Dr Kalman Mann, 30 Dec. 1951 (Heb.), ibid. 7.

[57] 'The Hadassah Medical Organization in the Yemenite Camp of Rosh-Haayin', CZA, J113II/140/7.

[58] Ibid.

As the date originally scheduled for its closure approached, the Hadassah Medical Organization succeeded in obtaining funds for another year. When that year had passed, the local residents appealed to Hadassah in a moving letter to keep the hospital open.[59] Their cause was taken up by Dr Chaim Sheba, director of the Ministry of Health, who met with Eli Davis and asked him how Hadassah could close down a hospital in such a difficult time of mass immigration. Davis replied that the plans for closure of the hospital had been announced in advance; and indeed, it closed in early September 1951.[60]

THE HADASSAH-YASSKY MEMORIAL HOSPITAL IN BEERSHEBA

In May 1948 the Hadassah National Board decided to honour the memory of Dr Haim Yassky, killed the previous month in the assault on the Mount Scopus convoy, by setting up a hospital, or a department in an existing hospital, in his name. In November that year a budget of $300,000 was allocated for setting up a small hospital and medical centre in the Negev, to be called the Hadassah-Yassky Memorial Hospital. The Jewish Agency and the Jewish National Fund responded enthusiastically to the idea of setting up a hospital in the Negev, and recommended building it in the small town of Beersheba, which was occupied in autumn 1948.[61] This town of 4,000 inhabitants, most of them Muslims with a minority (5 per cent) of Christians, had served as the seat of the British district officers during the Mandate period, and was now designated for population by Jewish residents. In order to begin this process, health services had to be set up.[62] The Israeli army's medical service also supported the establishment of a hospital, which would relieve it of the burden of caring for the civilian population that was expected to live in the city,[63] and offered to transfer authority over an abandoned Arab hospital building to Hadassah as early as 1949. This took the form initially of a verbal agreement

[59] Letter from residents of Rosh Ha'ayin, Chairman of the Religious Community Council, Shalom Yeshayahu Mantsura, to Dr Kalman Mann (trans. into Eng.), n.d., CZA, J113II/140/7.

[60] Letter from Eli Davis to Etta Rosensohn, 21 May 1952, CZA, J113II/140/7.

[61] Minutes of Hadassah National Board meeting, 3–4 Nov. 1948, 7.

[62] For the details on Beersheba, see Shaham, *Israel: Forty Years* (Heb.), 38; Avi Yonah, s.v. 'Beersheba', *Encylopedia Hebraica* (Heb.), vii. 519–21.

[63] Letter from Lt. Col. Chaim Shiber (Surgeon General, IDF) to the financial bureau of the Ministry of Defense (Heb.), 19 Feb. 1949, IDFA, 56/580; memorandum from Lt. Col. Shumacher and Major Tulchinski to Lt. Col. Chaim Shiber, 'Proposals for a Method to Close Hospitals and the Current Situation' (Heb.), 6 Apr. 1949, IDFA, 56/580.

between the military medical service and Hadassah under which Hadassah would take over the hospital building and the abandoned equipment within it, which included beds, night cupboards, furniture, and a pharmacy. Plans were also made for Hadassah to set up a health centre in a building next to the hospital.[64]

The hospital began operating on 1 November 1949 in what was the only building in Beersheba that had running water at the time. At the outset it provided medical services to the army, the kibbutzim in the area, and the local Arabs.[65] It was intended to serve the entire area between Rehovot and Eilat, including the Gaza Strip, and to provide for the medical needs of the entire population, Jews and Arabs alike. It was also planned that the hospital would be equipped with special facilities for treating tropical diseases, as well as outpatient clinics for eye and skin diseases.[66] In May 1950 the outpatient clinics of the hospital opened their doors to the population. Within three years the number of people using its facilities had increased tenfold, and in 1953 was close to 10,000. In 1951 the hospital opened its first course in practical nursing, which was intended to train nurses to serve the entire Negev region.[67]

At the same time as the hospital was set up, the Hadassah-Haim Yassky Memorial Health Centre was opened in an adjacent building. Hadassah undertook to cover the cost of preventative health services in Beersheba in the town's first days as an emerging Jewish centre in order to assist the residents who settled there— most of them new immigrants—and facilitate their absorption. The health centre's laboratory enabled pregnant women to have routine testing by taking samples which were then sent off to be examined at the Rothschild-Hadassah University Hospital in Jerusalem.[68]

The question arises why Hadassah decided to set up a hospital in Beersheba at a time when the organization was still suffering from the problems caused by the tragic loss of the Mount Scopus convoy and was facing other grave difficulties with its medical projects in Israel. The answer to this question lies in the ideology that underlay Hadassah's modus operandi. The establishment of the hospital in Beersheba in autumn 1948 was consistent with the fundamental principles of Zionist vision and practical pioneering work that had always guided Hadassah's medical

[64] Memorandum of a meeting between Lt. Col. Shumacher, Major Tulchinsky, Lt. Col. Chaim Shiber, and Mr Eliezer Peri (director general of the Ministry of Defense), 6 Apr. 1949, IDFA 56/580.

[65] Letter from Eli Davis to Etta Rosensohn, 8 Mar. 1949, HA, RG2, ser. 17, box 49, folder 9.

[66] E. Davis, 'Hadassah to Build First Negev Hospital in Beersheba', *Hadassah Newsletter*, 29/5 (Jan. 1949), 1.

[67] Mann, 'The Hadassah Medical Organization Program', 38, 42.

[68] H., 'Review of My Visit in Beersheba', n.d., CZA, J113II/331/6 (Heb.).

activities, as shown by the narrative thus far. Dr Aharon Brzezinsky, a member of the staff at the Rothschild-Hadassah University Hospital, was one of those who supported the foundation of the new hospital for ideological reasons. He noted that establishing a hospital in the Negev was important to the development of Hadassah, and that a project of this type was consonant with its pioneering tradition.[69]

In the summer of 1948 Mendel Krupnick, the deputy director of administration of the Hadassah Medical Organization, submitted to the National Board a list of proposals for restoring the status of Hadassah in Israel, including a recommendation to set up a central hospital for immigrants in the Negev, the only area in Israel where, as he put it, 'there is room to spread out'. He advanced several arguments in its favour: that maintaining its concentration on activities in Jerusalem was liable to push Hadassah to the margins of the Israeli health services; that the establishment of such a hospital would be a worthy cause which Jews throughout the world would support; and that, in the pioneering settlement of the Negev, with its subtropical desert climate, medical problems were likely to arise. Furthermore, he suggested that the hospital be associated with the Rothschild-Hadassah University Hospital, giving graduates and students of the medical school an opportunity to specialize in the study and treatment of diseases typical to Israel.[70]

Krupnick's suggestion was accepted as an ideal way to put into practice the resolution reached that May to honour Dr Yassky. Once the plan had been approved by the National Board, it was widely anticipated that the hospital would not only serve the residents of Beersheba, but grow into a centre for tropical diseases with a climatological research laboratory that would research problems related to the acclimatization of Europeans and Americans in Israel, as well as providing study and training opportunities for the medical school in Jerusalem.[71]

As the Jewish population in the Negev grew, from just a handful in 1949 to close on 60,000 by 1957, so the hospital also grew and expanded its services. It was to the Yassky Hospital that the wounded were evacuated during the Sinai Campaign of 1956. In 1957, still the only hospital in the Negev, it had 150 beds and a staff of 127, and served approximately 13,000 people (including the outpatient clinics).[72]

[69] Letter from Dr Aharon Brzezinsky to Dr Eli Davis, 10 Nov. 1948, HA, RG2, ser. 17, box 49, folder 9, p. 2 (Heb.). See also letter from Dr Aharon Brzezinsky to Rebecca Shulman, 5 Feb. 1950, HA, RG2, ser. 17, box 49, folder 9, p. 2.

[70] For the quotation and argument, see memo from Mendel Krupnick to Ethel Agronsky, 18 July 1948, CZA, J113II/331/6. [71] Hadassah Annual Report, 1948/9, 17.

[72] Hadassah Progress Report: Projects and Activities, 1957/8, 4.

THE HEBREW UNIVERSITY-HADASSAH
MEDICAL SCHOOL

The Establishment of the Medical School

The jewel in the crown of Hadassah's projects in Israel during this period was the establishment of the first school of medicine in Israel, in 1949. In spite of the slide into war in early 1948, the Parafaculty (as it was originally known) continued to stand by its position that studies should begin that autumn. However, the university strongly objected to this proposal. It argued that the security situation was reducing the pace of development to a crawl, that the financial position was not secure enough to permit courses of study to begin, and that there was still uncertainty regarding the respective parts the two partners—Hadassah and the Hebrew University—would play in funding. These arguments were compounded by the detachment of the medical centre on Mount Scopus from the western, Jewish, part of Jerusalem by war conditions, and then by the massacre of the Mount Scopus convoy in April 1948 as described in Chapter 8, in which some of the central figures in the enterprise died. Eventually, those involved in setting up the medical school had to accept that there was no choice but to delay the process by a year or two at least.[73] However, the management of the Hadassah Medical Organization insisted on making a public announcement that the establishment of the medical school was its main objective in the field of health, that it would continue to work towards its advancement despite the massacre, and that the school would be opened as soon as possible.[74]

In the summer of 1948 Rose Halprin visited Israel as part of a delegation from the Hadassah National Board, and, influenced by several individuals from the Jewish Agency, considered giving up the immediate establishment of the medical school in favour of participation in providing health services for immigrants.[75] In September, Dr Chaim Scheiber (later Sheba; 1908–71), then IDF's Surgeon General (the commander of the IDF medical corps), entered the scene, writing to Eli Davis to demand that the medical school be opened immediately. He was motivated in part by the need to set up a study framework for students who had come from abroad in order to take part in the war effort, in response to his appeal of

[73] Niederland and Kaplan, 'The Medical School' (Heb.), 151. [74] Ibid.

[75] This conclusion is based on the author's interview with Prof. Eli Davis in Jerusalem, 14 Sept. 1992, but without written evidence. The conclusion regarding the date is based on the dates of Rose Halprin's visit to Israel in July–Aug. 1948; see also Niederland and Kaplan, 'The Medical School' (Heb.), 151.

January 1948 to all medical students studying overseas, but above all by a concern about a shortage of doctors.[76] Scheiber hinted that if his request were not met, he would set up a medical school under the auspices of the army.[77]

In early November Davis travelled to the United States to persuade the National Board that Hadassah should support the establishment of the school, despite the heavy financial burden it would impose. He backed up his position with no fewer than six arguments:

1. If Hadassah did not complete the task it had undertaken, Israel would not have a medical school.

2. This project would be a prominent achievement for Hadassah, as no other women's organization in the world had established a medical school.

3. This would be a unique contribution by Hadassah to Israel, which could not be matched by any other organization.

4. The medical school would attract doctors of the highest calibre to Israel, both from the United States and from other countries.

5. By means of the medical school, Hadassah would be able to keep the finest doctors in Israel.

6. The government of Israel wanted there to be a medical school and wanted Hadassah to undertake this task.[78]

After Davis's speech, the National Board saw the early establishment of the medical school as a fait accompli; later in the discussion, Etta Rosensohn presented a fundraising quota that had been established for this purpose.[79] Rose Halprin noted that Hadassah had reached the conclusion that it should participate in the establishment of the school now, for three reasons: first, it would be a very long time before a school of medicine could be established in Israel without the aid of Hadassah; second, the Rothschild-Hadassah University Hospital needed a medical school in order to enhance its prestige; and third, the school was necessary in order to transform the Rothschild-Hadassah University Hospital into a teaching hospital.[80] Later in the meeting Judith Epstein proposed that a committee be set up

[76] Niederland and Kaplan, 'The Medical School' (Heb.), 153.
[77] Ibid.; the wording of the letter (10 Sept. 1948) is cited in Levin, *Balm in Gilead*, 227.
[78] Minutes of Hadassah National Board meeting, 3–4 Nov. 1948, 6–7.
[79] Ibid. 7. [80] Ibid. 9.

to examine the possibilities for fundraising throughout the United States and present its conclusions to the National Board. This was agreed, and the members of the committee were elected then and there.[81]

Davis repeated his speech at Hadassah's annual convention, held on 5–9 November 1948. He stressed the importance of a medical school to the prestige of Hadassah, and expressed his opinion that the status of the hospital would be maintained by the high standard of the medical faculty who would be working there.[82] The convention passed a resolution to begin a campaign for the establishment of the medical school.[83]

A few days after the National Board meeting, Hadassah and the Hebrew University Development Committee decided that clinical studies would begin in the course of 1949. However, the committee subsequently reflected that because the intended students had already studied medicine in different places in Europe they would have varying levels of medical knowledge, and that it might be necessary to begin with second-year pre-clinical studies, proceeding to clinical studies only later.[84]

The partnership agreement between Hadassah and the Hebrew University regarding the medical school was signed in May 1949.[85] However, the event that finally precipitated its opening was a demonstration by prospective students—all soldiers—who, having studied medicine in Europe, had come to Palestine to fight in the War of Independence. Now, refusing to wait until the beginning of the next academic year, they travelled to Jerusalem and mounted a protest in front of the Terra Sancta building, to which some of the departments of the Hebrew University had been relocated after the evacuation of Mount Scopus, demanding that the school be opened as soon as possible. This persuaded the university and Hadassah to open the school immediately, and the first class began studying in the summer of 1949.[86]

The Early Days of the Medical School

The opening of the school presented Hadassah with tasks and challenges that would preoccupy it for a long time to come. Some of these derived from the problems of the medical school itself, others from the implications of the partnership

[81] Minutes of Hadassah National Board meeting, 3–4 Nov. 1948, 6–7. [82] Ibid. 6–7.

[83] 'Medical School', resolution adopted at Hadassah's 34th Annual Convention, Atlantic City, NJ, 5–9 Nov. 1948, HA, RG3, ser. Resolutions, subser. 1948 Convention, box 14, 20.

[84] Golan, *Doctor Moshe Rahmilevitz* (Heb.), 87.

[85] 'Medical School Opens on May 17', *Hadassah Newsletter*, 29/9 (May 1949), 12.

[86] Golan, *Doctor Moshe Rahmilevitz* (Heb.), 128.

with the Hebrew University. The acquisition of equipment for the school, fundraising for construction and maintenance of its buildings, monitoring the development of the curriculum, and the attempt to learn from other medical schools around the world were all issues of concern for Hadassah from the day the new institution opened.[87] The first instruments for the medical school were purchased in the United States: great care was taken to acquire the most modern equipment, and this was widely publicized.[88] In the first months after the establishment of the school, Hadassah ran a campaign to raise funds for it, together with the American Friends of the Hebrew University.

The Medical Reference Board, which was one of the groups that had advocated the establishment of the medical school, remained an advisory body, and its composition barely changed. Only the name was altered, to the Medical Advisory Board of the Hebrew University and Hadassah.[89]

Upon opening, the medical school itself faced several practical problems, including a shortage of teaching staff of the appropriate standard, a lack of suitable buildings, a shortage of equipment for medical research, and a lack of textbooks. Other problems arose from the decision to adopt the American approach to teaching medicine: some of the hospital staff, remaining faithful to the German model in which they themselves had been taught, could not, or would not, adjust to it. Yet other problems arose from the lack of physical infrastructure at the school's new location, to which it had been forced by wartime conditions to move from its intended home at Mount Scopus.[90]

The leaders of Hadassah in America continued to take a close interest in developments at the medical school after its establishment. In June 1949 two department heads from the Rothschild-Hadassah University Hospital, Professor Hermann Zundek and Professor Aryeh Feigenbaum, visited New York, and laid the problems of the medical school before the Medical Advisory Board of the Hebrew University and Hadassah. They listed the difficulties caused by the lack of available

[87] See e.g. the extensive correspondence between Prof. Davis and Etta Rosensohn regarding Davis's tour of hospitals and medical schools in England, Sweden, and Denmark: discussion between Prof. E. Davis and Dr D. Sheehan, New York University Medical School, 23 Nov. 1949; notes on a discussion with Dr Sol Bender, deputy chief of the Department of Gynaecology, Liverpool University and Medical School, 27 Nov. 1949; notes on a telephone conversation with Dr J. M. Joffe, London to Bristol, 28 Nov. 1949; notes on a conversation with Dr Samson Wright, Middlesex Hospital Medical School, 29 Nov. 1949; notes on a conversation with Dr T. Ehrenpreis, Stockholm, 1 Dec. 1949; notes on a visit to Uppsala, Sweden, 6 Dec. 1949; notes on Dr E. Davis's visit to Copenhagen Medical School, 9 Dec. 1949; notes on a conversation with Dr Joseph Vesely, World Health Organization, Geneva, 13 Dec. 1949: all in HA, RG2, ser. 49, box 87, folder 9.

[88] Hadassah Biennial Report, 1949–51, 23. [89] Ibid. 24.

[90] Golan, Doctor, Moshe Rahmilevitz (Heb.), 128–9.

beds, the looting and destruction that had occurred during the war, the shortage of space for laboratories, and the lack of equipment for research and operating theatres.

Professor Zundek explained that the medical school was dependent on research, and yet the staff who should carry it out were leaving his department at a worrying rate. He said that he had started out with an excellent team of young doctors, but that, in the absence of the conditions necessary for medical and scientific work, and because of the low salaries, most of them were leaving Hadassah in favour of other hospitals and research institutions or government positions. Therefore he asked for permission to send two young doctors from his department to the United States for postgraduate studies, for a period of six to nine months. In response, Etta Rosensohn remarked that a committee in Jerusalem was preparing a three-year plan for training young staff, and another committee was submitting recommendations for candidates for the Warburg scholarship.[91]

Professor Feigenbaum then presented his proposals for solving the problems. He pointed to the gap between the medical training of students who had studied in western and central Europe and that of students who had received their medical education in eastern Europe, and suggested a system of contacts and agreements with hospitals where students could specialize at the highest level. He called for an arrangement of this type to be established immediately, so that the class that had already begun to study could benefit from this training. Feigenbaum also stressed the need to create a curriculum in psychology and to open a good psychiatric department. In closing, he said that the medical school should not only be an important institution in the life of Israel, but must also earn international recognition.[92]

On 13 May 1952 the school of medicine awarded its first MD degrees to sixty-three graduates. In September 1958, some 450 students, originally from eighteen different countries, were studying there.[93]

The Contribution of the Medical School to Health Care in Israel

The Hebrew University-Hadassah Medical School was the crowning achievement of Hadassah's contribution to health and medical care in Israel. Of all Hadassah's enterprises, it had the greatest long-term impact on the medical profession and consequently on the character of medical care in Israel (see also Chapter 13).

[91] Meeting of the Medical Reference Board of Hadassah and the Hebrew University, 16 June 1949, HA, RG2, ser. 31, box 64, folder 6. [92] Ibid.
[93] On the awarding of medical degrees (MD), see Niederland and Kaplan, 'The Medical School' (Heb.), 161; on the number of students in 1958, see the Hadassah Annual Projects Report, 1958, 8.

Following the decision to adopt the American method of teaching, Dr William Perlzweig, a member of the Medical Advisory Board of the Hebrew University and Hadassah, had been invited to Palestine to advise the university on all matters relating to the medical school. On his recommendation the period of study was set at seven years, the first two years to be devoted to pre-medical subjects, the next two to pre-clinical studies, the following two to clinical studies, and the last year to practical experience (those students who graduated in 1952 had completed their pre-clinical studies in other countries).[94]

The adoption of the American method of teaching was significant in many respects. The teaching and study method used between the two world wars in central Europe, and particularly in Germany, where the largest number of medical students in Europe studied, was characterized by frontal instruction, an almost total absence of any practical training, and an unlimited number of students. Anyone who wanted to study medicine could do so. The students would gather in very large lecture halls where they listened to learned and highly experienced professors. Even when a teacher wanted to demonstrate what he was saying, he would do so in that lecture hall. Thus, for example, a microscope was set up in the centre of the room and the students passed by it, one by one. This teaching method relied upon the uncontested authority of the professors, each of whom held exclusive control over a certain field of medicine. In the course of the lectures, the professors also conveyed their medical philosophy, which was usually humanistic: the patient was seen primarily as a human being to be cared for. They did not place technology, research, or science first in their order of priorities.[95]

In the period between the two world wars, this teaching method, especially its reliance on instruction dispensed in overcrowded lecture halls and the total absence of practical training, attracted much criticism, in Europe—particularly in Germany—and beyond. Leading figures in medical instruction in central Europe tried to introduce reforms to the system, with particular focus on reducing the number of students in the classes and offering them more practical experience.[96] Their efforts largely failed, chiefly for economic reasons: the American method of teaching in small groups was inevitably much more costly than frontal instruction in large groups, and in the economic conditions of interwar Europe such an expensive change of system was simply not feasible.[97]

The customary method of medical training in the English-speaking countries, and particularly in the United States, was quite different. Here medicine was

[94] Niederland and Kaplan, 'The Medical School' (Heb.), 157. [95] Ibid.
[96] Bonner, *Becoming a Physician*, 296. [97] Ibid.

viewed as an empirical science. In order to prepare for studying the medical sciences, students in the United States undertook longer basic pre-medical studies than their counterparts in Europe. This programme took two years, and covered all fundamental areas of the natural sciences.[98] In this system, pre-clinical and clinical medical studies were based on small study groups, laboratory work (again in small groups), training groups, seminars, and bedside teaching. Such studies, in groups of eight to twelve students, allowed for direct and close contact between the students and their instructors. The method was based on teamwork, in which the student was perceived as an integral part of the medical team. Students learned the theory of medicine by means of personal experience, independent research, and continuing interaction with their teachers.[99]

The American method was very expensive. The vast financial and human resources required made it possible to train only a small number of students, and in only a limited number of institutions. Schools that could not afford the expense disappeared from the scene when this style of instruction was introduced, in the early twentieth century, as the accepted method in most medical schools in the United States.[100] The American approach applied in the first medical school in Israel accordingly had a direct impact not only on its teaching methods but on its admissions policy. In order to provide each student with personal guidance and teach in small groups, the school accepted only a small number of students each year. Indeed, to this day, the school is careful to take no more than fifty to ninety students annually. All the pressures exerted on it, mainly in the early years, to enlarge the student body were firmly rejected. In order to ensure a high standard of entrant, the school held a pre-selection process consisting of competitive examinations and a personal interview with each candidate. The adoption of the American approach to teaching also influenced the choice of equipment for the medical school, requiring funds to be found for the necessary modern, sophisticated technology. The school's embrace of the American method also had other far-reaching effects, as discussed in Chapter 13.[101]

Two other impressive projects were connected with the establishment of the medical school: grants for students, and the Fellowship Programme. The women of Hadassah worked hard to raise money for scholarships to the medical school, an important project because of many of the would-be students were new immigrants

[98] Bonner, *Becoming a Physician*, 289; Niederland and Kaplan, 'The Medical School' (Heb.), 157.
[99] Niederland and Kaplan, 'The Medical School' (Heb.), 157; Bonner, *Becoming a Physician*, 293–4.
[100] Bonner, *Becoming a Physician*, 292–4.
[101] Niederland and Kaplan, 'The Medical School' (Heb.), 157.

and lacked the necessary means to finance a long period of study. Some of these grants were financed by leading figures in Hadassah and their families: examples include the Captain Adrian Memorial Fellowship (named after the nephew of Tamar de Sola Pool), the Lasker Family Fellowship, and the Marian Greenberg Fellowship.[102]

The Fellowship Programme contributed significantly to shaping the character of medical care in Israel. It was established in 1946, the year in which, as noted in Chapter 2, physicians from Rothschild-Hadassah University hospital were first sent to study in the United States, and as early as 1949 fifteen doctors underwent in-service training in America. As part of the preparations for the establishment of the medical school, some of the department heads of the Rothschild-Hadassah University Hospital were sent to the United States, to study new techniques in various areas, and to meet with colleagues. At the same time, arrangements were made to fund further visits by the hospital's doctors to the United States for in-service training, drawing on contributions made by the women of Hadassah and other American Jews.[103]

A related, but later, development was a programme of long-term in-service training for doctors, which made it possible to send senior and junior staff to the United States for periods of between three months and two years. The programme was two-way, although not symmetrical: American experts visited the medical school for brief periods, in order to deliver lectures and to bring the 'finest methods' to the State of Israel.[104]

The Fellowship Programme was not restricted to doctors alone: health managers, nurses, and other paramedical professionals were also sent to the United

[102] Minutes of Hadassah National Board meeting, 20 July 1950, 4.

[103] For information on those who attended in-service training up to 1949, see Hadassah Annual Report, 1950, 2. Among the department heads sent for in-service training in the US were Dr Emil Radler, specialist in physiotherapy; Prof. Arie Dostrovsky, specialist in dermatology and dean of the faculty of medicine; Prof. Abraham (Adolph) Druckman, a radiology specialist; Dr Israel (Lipman) Halperin, founder of the neurology department; Dr Arie Sadowsky, gynaecologist; Prof. Walter Straus, expert in hygiene and public health; and Dr Henry Unger, chief of the pathology department. Younger and less senior doctors were also sent; these included the orthopaedic surgeon Dr Meyer Makin, the paediatrician Dr Yehuda Matoth, the throat surgeon Dr H. Milwyidsky, the neurologist Dr Max Streifler, and the nephrologist Dr Theodore David Ullman (Hadassah Biennial Report, 1949–51, 25). On financing the fellowships, see correspondence from Dr Eli Davis to Anna Tulin, 8 Aug. 1949, HA, RG2, ser. 49, box 87, folder 9, and minutes of Hadassah National Board meeting, 20 July 1950, 4; on the institutionalization of the programme, see Hadassah Biennial Report, 1949–51, 23–4.

[104] Minutes of Hadassah National Board meeting, 15 May 1954, 9 (Financial Management of Hospitals and Audiology).

States for training.[105] From the beginning of the scheme in 1946 until September 1958, about 140 doctors and health administrators received in-service training as part of the programme in the United States, where the institutions they attended included the medical school of Harvard University and the School of Public Health at Boston University,[106] England, and Sweden. A few years after the establishment of the medical school, the programme not only offered staff an opportunity to become acquainted with Western medical methods, but also provided medical researchers from the school with the chance to present their work in international forums.

The medical orientation of the in-service training was, as noted, American or Anglo-American. The Medical Advisory Board of the Hebrew University and Hadassah, which approved the applications for fellowships, did not generally approve in-service courses in countries that practised the European school of medicine, and turned down a proposal from Dr Kalman Mann, medical director of the hospital from 1951, to set up a European advisory board for physicians who were unable 'for one reason or another' to travel to the United States. The reason given was that the European approach to medical education was so radically different from the American that there was no point in establishing such a board. The National Board of Hadassah also determined that 'it has already been agreed that the Medical School has "an Anglo-American orientation", and therefore it was not desirable to add a different perspective, which may emerge from a European advisory board'.[107] In retrospect, it seems that the Fellowship Programme was one of the means of adapting the teaching methods of the school and its research orientation to methods accepted in the United States.

Some four years after the establishment of the school of medicine, in November 1953, two associated schools were officially opened. These were the School of Dentistry and the School of Pharmacology. The former was set up with the assistance of members of Alpha Omega, a society of Jewish dentists in the United States and Canada. Dr Samuel Lewin-Epstein, one of the members of the American Zionist Medical Unit, had raised the idea of its establishment several years earlier, and the process of its development was accelerated in recognition of an anticipated shortage of dentists in Israel once those currently practising, most of whom were approaching retirement age, had ceased work. The school of pharmacology was also established with the help of several Jewish physicians' societies in other

[105] Hadassah Biennial Report, 1949–51, 23–4.
[106] Hadassah Progress Report: Projects and Activities, 1957–8, 24.
[107] For the arguments and quotations, see minutes of Hadassah National Board meeting, 21 Jan. 1954, 4.

countries. It became part of the Hebrew University, but had—and still has—no connection with Hadassah.[108]

The establishment of the Hebrew University-Hadassah Medical School marks the beginning of university-level medical education in Israel, but also the end of the historic role of Hadassah as the first provider of modern health services in Palestine. Its creation paved the way for other schools of medicine following, in various forms, the same model, and also advanced studies in medicine, public health, and nursing, as discussed in the Epilogue.[109]

The existence of the medical school also encouraged and accelerated the trend among the staff at the Rothschild-Hadassah University Hospital towards a more academic approach and to additional concentration on advanced medicine and medical research. Research activity had been conducted at the hospital since the 1930s, but now gained extra visibility and status, formalized when academic appointments in the school of medicine were raised to the same level as appointments throughout the university, which also underwent an accelerated process of growth and academic professionalization beginning in 1949. Consequently, almost overnight, medical research became a central element in the personal career of hospital physicians and in the operation of the hospital in general.[110]

As a result of the changes that took place at the Rothschild-Hadassah University Hospital in the light of its transformation into a teaching institution, Dr Kalman Mann defined part of his task as medical director of the hospital in terms of 'the responsibility of providing a clinical field for medical teaching'. Of the hospital, he said that 'its work had increasingly shifted from quantitative to qualitative considerations and the various services adjusted to the latest development in medical science, [among others] the introduction of the latest techniques and methods [and] the installation of modern and up-to-date equipment'.[111]

The hospital's role as a teaching institution, with an obligation to provide its students with the opportunity to study all fields of medicine, led to the development

[108] The Hebrew University–Hadassah Medical School, 4. On the school of dentistry, see letter from Dr Ino Shacky to the Minister of Health, 8 May 1953; on its being part of the medical school, see Joseph Burg, Minister of Health, 'To Whom It May Concern', 23 Dec. 1951; on the concern about a shortage of dentists, see letter from Dr Chaim Sheba, director general of the Ministry of Health, to the director general of the Prime Minister's Office, 10 Kislev 5712 (9 Dec. 1951); letter from the Union of Dentists in Israel, Planning Committee, to the Minister of Health, 3 Dec. 1951; letter from Dr Samuel Lewin-Epstein to the Minster of Health, 23 Apr. 1952; letter from Dr Ino Shacky to the Minister of Health, 18 May 1953 : all in ISA, RG57, box 4229, file 10 (Heb.).

[109] On the schools, see also Y. Leibowitz, s.v. 'Medicine', Encyclopedia Hebraica (Heb.), xxxi. 263, and below in this chapter. [110] Ben-David, 'Socialization', 74.

[111] Mann, 'The Hadassah Medical Organization Program', 39.

of more specialisms and a considerable growth in the number of departments in the hospital.[112] With funding from Hadassah, the hospital also added training courses for occupational therapists and X-ray technicians, and served as a training centre for these professions.[113]

THE PARAMEDICAL PROFESSIONS: THE CASE OF OCCUPATIONAL THERAPY

The Genesis of Occupational Therapy in Palestine

One of the main methods of rehabilitation used by the Mount Scopus Medical Centre was occupational therapy, a paramedical profession that emerged from several professions, including nursing, and—like nursing—was viewed in the United States as a women's profession and introduced in Israel by Hadassah. The first department in Palestine for occupational therapy with disabled people was established at the Rothschild-Hadassah University Hospital in 1944.[114] Run accord-ing to the American model and equipped with modern equipment, it provided services to some veterans of the British army, as well as to disabled people who had been injured in accidents and by illness. Until 1948, however, there was almost no call for rehabilitation related to chronic disease, as most of the population of the Yishuv was made up of young, relatively healthy 'pioneers'. If any such rehab-ilitation was necessary, it was done within whichever hospital department was treating the patient.[115]

The idea of developing occupational therapy in the Yishuv came from Ethel Adina Bloom Benor. Born in New York in 1903 to an Orthodox family, Ethel Bloom emigrated to Palestine in 1931 and worked in an administrative job at the Rothschild-Hadassah University Hospital. In the late 1930s she contracted typhoid fever and was ill for a long time. While hospitalized, she occupied herself with embroidery, and this inspired her, in 1939, to organize a group of women volunteers to occupy the patients with different crafts. She called this *ripui be'isuk* 'healing through activity', which has become the accepted Hebrew term for occupational therapy.[116]

In 1941, for personal reasons, Ethel Bloom returned to the United States, where

[112] Mann, 'The Hadassah Medical Organization Program', 39–40.
[113] On training occupational therapists, see ibid. 40; on training X-ray technicians, see ibid. 42.
[114] Ibid. 14. [115] Sussman, 'The History of Occupational Therapy in Israel', 63.
[116] Sussman, 'The Development of Occupational Therapy in Israel' (Heb.), 147.

she set about realizing her plan to develop occupational therapy in Palestine. (In her memoir, she writes that Henrietta Szold was a close friend of hers and encouraged her to put this project into practice;[117] however, there appears to be no other documentary evidence of this.) She asked Hadassah for a study scholarship to acquire an academic education in occupational therapy, and when her request was granted studied for a bachelor's degree in rehabilitation at New York University. At the same time she specialized in clinical work in occupational therapy under the supervision of a qualified occupational therapist, and in November 1945 she received her own licence as an occupational therapist. In order to prepare herself as well as possible for the ambitious enterprise she had undertaken, she also studied towards a master's degree in management, which she was awarded in 1946.[118]

Ethel Bloom believed that it would take more than one occupational therapist to develop the service in Palestine, and that therefore it was necessary to train local people according to what were considered in the United States to be the highest professional criteria, namely, those of the American Occupational Therapy Association (OTA).[119] At this stage Hadassah became involved, setting up an advisory committee on occupational therapy and rehabilitation. One of the members of the committee was Marjory Fish, chair of the OTA Education Committee, who was responsible for teaching occupational therapy at Columbia University; from that point on, she was deeply involved in the project. The committee, believing with Ethel Bloom that additional qualified professionals would be needed if occupational therapy were to be developed in Palestine, decided to work towards establishing a course there for licensed occupational therapists that would be based on professional standards determined by the OTA and the American Medical Association (AMA), which supervised the OTA.[120]

In order to get the programme under way, in 1945 Hadassah offered scholarships for training in occupational therapy in the United States, open to those who were willing to travel to Palestine after their training. The scheme was publicized in all Hadassah chapters, as well as in the journal *Occupational Therapy and Rehabilitation*. Marjory Fish also made the announcement to the Occupational Therapy Association Education Committee, and informed the directors of schools of occupational therapy in the United States.[121]

At the recommendation of Marjory Fish, Ethel Bloom visited the major occupational therapy clinics throughout the United States before setting off for Palestine. She also met with the leaders of the education committees of the

[117] Sussman, 'The History of Occupational Therapy in Israel', 63. [118] Ibid. [119] Ibid.
[120] Sussman, 'The Development of Occupational Therapy in Israel' (Heb.), 147. [121] Ibid. 148.

Occupational Therapy Association and the American Medical Association, and became familiar with the minimum professional requirements. On the basis of this research, and working with Fish, Bloom planned the course curriculum. She also acquired the necessary equipment to set up the clinic at the Rothschild-Hadassah University Hospital, according to a list prepared with the help of the Department of Occupational Therapy at Columbia University, and with recourse to the professional literature. Then, in early 1946, taking with her forty boxes of equipment, Bloom sailed for Palestine.[122]

Upon arrival in Jerusalem, she opened an occupational therapy clinic at the Rothschild-Hadassah University Hospital and began a campaign to inform the public about occupational therapy. As a result, the Histadrut Health Fund became interested in her work, and in the summer of 1946 she met with Dr Cott, the director of the special branch of the health fund that served people with physical and mental disabilities, known as the Disability Fund (keren naḥut). She suggested that Dr Cott, together with Hadassah, direct the planned training course for licensed occupational therapists. The Histadrut Health Fund committed itself to sharing the burden of funding the course equally with Hadassah, and an advisory board was set up, comprising representatives of both organizations, to oversee the programme of study and ensure that its standard was maintained. The training programme was called a 'course' and not a 'school', as the plan was to run it only once: even then, there was doubt whether work would be found for all the graduates.[123]

As noted, the course was based on contemporary occupational studies programmes in the United States, so it seems certain that the American model served as the basis for the study of this profession in Palestine, as it did for other areas of medicine and health care. It is noteworthy that all those involved—with the exception of the hospital nurses, who were concerned that the occupational therapists might jeopardize their own position—enthusiastically welcomed the idea of the course and the American working methods it advocated.

Hadassah's call to study occupational therapy in the United States had drawn four young women—Rosalind Cohen, Elaine May (later Ilana Vardi), and Helen Ricon, all from Philadelphia, and Lilian Greenstein from Minnesota. The first three embarked on their studies at the School of Occupational Therapy in Philadelphia, and the director of the school, Helen Vilard, reported regularly to the Hadassah national office on their progress. Lilian Greenstein went out to Palestine in 1946, while the others went out when they finished their studies in 1947.[124]

[122] Sussman, 'The Development of Occupational Therapy in Israel' (Heb.), 148.
[123] Ibid. 149. [124] Ibid.; Sussman, 'The History of Occupational Therapy in Israel', 65.

In 1947 the first students embarked on the joint Hadassah–Histadrut Health Fund occupational therapy training course: twenty-four women, aged 19–32, all high-school graduates with a suitable personality who had been accepted on the basis of an interview. The course lasted two years, and all of them had promised to work for another two years, wherever they were sent, after graduating.[125] When the War of Independence broke out the course continued as planned, an agreement having been reached between Hadassah and the military authorities according to which ten of the graduates would enter the army on completion of the course, while the others would be divided equally between the Histadrut Health Fund and Hadassah. In the event the health fund was forced to forgo most of its promised quota, despite the fact that by the time the students graduated its hospitals, particularly Beit Levinstein near Ra'anana, were filled with wounded soldiers for whom occupational therapy could be very helpful.[126]

The Establishment of Occupational Therapy as a Profession

The vast number of wounded from the War of Independence and the great wave of immigration that followed the war increased the need for occupational therapists and fuelled the expansion of the profession in Israel's early years. Neither circumstance had been predicted, of course, when the first training course was prepared; hence the doubt at that time as to whether it would be repeated. In the event a shortage of trained professionals made it necessary to run a second course in 1949. This was closely based on the first course, but with improved practical training, which took place in ten different clinics under supervisors who had all graduated from the first course.[127]

The training scheme for occupational therapists, based on the programme prepared by Ethel Bloom and the advisory committee, created an excellent professional infrastructure, in terms of both the curriculum covered and the quality of the professionals it produced, who stood up well to comparison with practitioners in this field in the United States, Britain, and Australia.[128] However, the pressing demand for occupational therapy in these years had implications for the quality and development of the profession. Faced with a shortage of occupational therapists, the Ministry of Health and Malben (see page 176 above) were forced to employ non-professionals, particularly in the field of psychiatry, working under the supervision of a professional occupational therapist. In all Malben and Ministry of Health

[125] Sussman, 'The History of Occupational Therapy in Israel', 65. [126] Ibid. 14.
[127] Ibid. 90. [128] Sussman, 'The Development of Occupational Therapy in Israel' (Heb.), 153.

hospitals there was at least one professional occupational therapist; however, that single qualified professional had to supervise ten to twenty auxiliary staff members, as well as delivering lectures and running workshops for them.[129] To address this acute shortage of qualified practitioners, in 1953 the Be'er Ya'akov Psychiatric Hospital, south of Rehovot, opened an accelerated (one-year) course for occupational therapists in the field of psychiatry, sponsored by the Ministry of Health. Nevertheless, the problem of non-professional employees clouded the profession for many years.

By early 1949 there were ten occupational therapy clinics operating in Israel. Seven were established in order to respond to the need to train students, and one was opened at the Tel Hashomer Hospital during the War of Independence. Further clinics opened in the following years in response both to the needs of the country and to developments in various medical fields. In 1956 there were twenty-three clinics, belonging to several different medical organizations, including, in Jerusalem, Hadassah, Malben, and Ilan (the Israeli Organization for Handicapped Children). Some of the clinics were located in general hospitals, while others specialized in certain areas, such as psychiatry, tuberculosis, chronic diseases, and children's diseases.[130]

Between 1949 and 1956, then, occupational therapy was established as a profession in Israel. However, at that point a change occurred in the training provided, when the American teachers who had taught the first courses returned to the United States. Ethel Bloom left Israel for America as early as 1949, and Rosalind Cohen, who had agreed to direct the second course, followed her back to the United States in 1951. After they left, the director of the Hadassah Nurses' Training School took over the occupational therapy course and made changes in the curriculum.[131] From 1956 the courses were again directed by occupational therapists, but they remained subordinate to the director of Hadassah's nursing school.[132] These developments inevitably led to some dilution of the American model of training and practice imported by Ethel Bloom.

The introduction of occupational therapy in Israel is reminiscent of previous patterns of Hadassah activity in the Yishuv, and particularly of the development of the Hadassah Nurses' Training School. Both projects were embarked upon with the aim of establishing a medical profession according to American professional standards; both involved an effort to instil these principles by training local people,

[129] Sussman, 'The History of Occupational Therapy in Israel', 84.
[130] Ibid. [131] Interview with Nira Sussman, 24 Jan. 2001.
[132] Sussman, 'The History of Occupational Therapy in Israel', 153.

using teachers who had studied in the United States, with an emphasis on the finest equipment and the cultivation of American methods. In the case of occupational therapy, this effort applied to work not only within Hadassah institutions but outside them as well.

ESTABLISHMENT OF THE NEW MEDICAL CENTRE IN EIN KAREM

The establishment of the medical school underscored the need for a new medical centre. As described in Chapter 8, the centre on Mount Scopus had been cut off from the Jewish, western part of Jerusalem in April 1948, at the height of the War of Independence, and budget estimates drawn up the following month reflect the acknowledgement both by staff at the Rothschild-Hadassah University Hospital and by the Hadassah National Board that the hospital and medical centre would need to be rebuilt. At the meeting of the National Board Medical Organization Committee on 27 May 1948 (six weeks after the convoy massacre) Etta Rosensohn presented her conclusion that the budget for reconstructing the hospital in 1948/9 would be approximately $2.75 million.[133] The intention at this point was to rebuild the existing hospital, not to create a new one. However, by spring 1950, with Mount Scopus cut off from the Jewish part of the city (a situation that persisted until 1967), the National Board had come round to the view that there was no choice but to build a new hospital, given the crowding, intolerable conditions, and wide dispersion of the hospital buildings in west Jerusalem.[134]

The decision to build a new medical centre was taken after long deliberation, and only when the National Board was convinced, on the one hand, that the hospital on Mount Scopus could not continue in operation and, on the other, that it was not possible to provide fitting medical care and proper medical instruction under the conditions prevailing in the temporary clinics and buildings scattered around Jerusalem.

Financially this was not an easy decision.[135] However, in late 1950 the Israeli prime minister, David Ben-Gurion, approved the launch of a campaign among Jews in the Diaspora—within which American Jewry was the largest and richest community—to raise funds to build a new medical centre: something he had

[133] Minutes of Hadassah National Board meeting, 27 May 1948, 8.

[134] Address by Dr Davis to Hadassah's 36th Annual Convention (1950), HA, RG3, ser. Proceedings, subser. 1949–1951 Conventions, box 15, 154; minutes of Hadassah National Board meeting, 18 Aug. 1950, 5 (address by Dr Davis to the pre-convention meeting of the National Board).

[135] Niederland and Kaplan, 'The Medical School' (Heb.), 161.

refused to countenance up to that point, for fear it would be tantamount to conceding that Mount Scopus had been lost.[136] Hadassah had already resolved, at its Thirty-Sixth Annual Convention in August 1950, to build a new medical centre in Jerusalem, in place of the hospital that had been abandoned on Mount Scopus.[137] Ben-Gurion sent a moving message to the Hadassah convention, in which he stressed the urgent need for a new hospital in the light of the population growth in Jerusalem and in Israel as a whole. He went on to say that the future hospital, of which the Hebrew University-Hadassah Medical School would be an integral part, would serve not only the residents of Jerusalem, but all the residents of Israel.[138]

The estimated cost of building a new medical centre was $5 million, and in November 1950 Hadassah had only $2 million available. It planned to raise the rest over four years: $1 million in 1950/1, and another $2 million in the following three years.[139] This sum, it estimated, would build a general hospital with 450 beds and a nursing school. The cornerstone-laying ceremony was scheduled for the time of the Twenty-Third Zionist Congress, in summer 1951.[140]

The location of the new Hadassah-Hebrew University Medical Center was discussed at length among the different bodies concerned: the Hadassah National Board and its various committees, the Medical Advisory Board of the Hebrew University and Hadassah, and the relevant Israeli authorities. A sharp difference of view emerged between, on the one hand, the Hadassah Medical Organization and the Medical Advisory Board of the Hebrew University and Hadassah, which wanted to build the centre in Ein Karem, on the outskirts of Jerusalem, and, on the other, the governing body of the Hebrew University, which wanted it to be in the centre of the city. Initially, Hadassah and the Hebrew University were offered a plot in Neveh Sha'anan, in the area where the Israel Museum stands today, and it was at this site that plans were first made to build the centre at Hadassah's 1950 annual convention.[141] Later, alternative sites were suggested: the Dir Yassin area near Kiryat Shaul, Mount Herzl, and, as noted, the ridge above the Ein Karem neighbourhood of Jerusalem. Finally, in 1954, the university management decided to locate the medical school in Ein Karem, and the other departments of the university in Givat Ram.[142]

[136] Niederland and Kaplan, 'The Medical School' (Heb.); author's interview with Prof. Kalman Mann, Jerusalem, 19 July 1992. [137] Minutes of Hadassah National Board meeting, 18 Aug. 1950, 5.

[138] Proceedings of Hadassah's 36th Annual Convention (1950), HA, RG3, ser. Proceedings, subser. 1949–1951 Conventions, box 15, 217. [139] Hadassah Biennial Report, 1949–51, 58.

[140] R. Shulman, 'Hadassah Builds Again', Hadassah Newsletter, 31/3 (Nov. 1950), 9.

[141] Minutes of Midwinter Conference of the National Board, 1 Mar. 1954, p. 1; proceedings of Hadassah's 36th Annual Convention (1950), HA, RG3, ser. Proceedings, subser. 1949–1951 Conventions, box 15, 155 (Dr Davis's address). [142] Niederland and Kaplan, 'The Medical School' (Heb.), 161.

The architectural plan for the medical centre was presented to the National Board of Hadassah at its midwinter conference in March 1954.[143] The planners' vision was to create a facility where medicine and research could be conducted at the highest level, so that this would be, as Kalman Mann said, 'one of the greatest medical centres in the world'. They had accordingly set out designs for a nine-storey general hospital building, to be equipped with 430 beds, a medical school, a nursing school, outpatient clinics with a capacity to serve 20,000 patients a year, clinical laboratories, research laboratories, and a medical library, intended to be the most important of its kind in Israel.[144]

These multiple needs and functions made the construction of the new medical centre a very complicated undertaking: alongside the architectural difficulties, problems also arose as a result of the involvement of 'two owners, and many diverse personalities coming from varied cultures and ways of life'.[145] The size and complexity of the enterprise are reflected in the growth of the Hadassah committees involved. In 1950/1 the National Board Hadassah Medical Organization Commit tee numbered twenty-four members; by the end of 1953 it had swelled to thirty-one, and at the height of the construction project, in 1956–7, the Medical Centre Committee was added, bringing the total number to seventy-four.[146]

To organizational pressures were added financial pressures. Hadassah had borne a heavy financial burden for its work in Israel since 1948; now this was com-pounded by the need to raise funds for building the centre, with a target of at least $1 million a year. Its goal was reached only in 1956, and in the intervening years the contributions reached the desired amount only in 1952/3, when a total of $1.2 million was raised.[147]

FOCUS ON MEDICAL TEACHING

In keeping with Hadassah's trend towards providing more specialist and academic services in Israel in these early years of the state, on 1 June 1952 it transferred its preventative health services, with the exception of those in Jerusalem and the Jeru-salem Corridor, to the Ministry of Health.[148] This transfer was effected at Hadas-sah's request, on the basis of its devolution principle (see Chapter 2), according

[143] Minutes of Midwinter Conference of the National Board, 1 Mar. 1954, p. 1.

[144] Ibid. [145] For the argument and quotation, see Hirsh, *The Hadassah Medical Organization*, 77.

[146] Lists of the National Board committees for 1950–6, Hadassah National Office.

[147] Hadassah Biennial Report, 1949–51, 17; Hadassah Annual Reports, 1952, 20; 1953, 13; 1955/6, 16. On the aim of raising at least $1 million a year, see Hadassah Progress Report: Projects and Activities, 1954/5, 6.

[148] General memo issued by Haim Shalom Halevi (deputy administrative director of Rothschild-Hadassah University Hospital) to the city mayors, local councils, and regional councils; circular from

to which those services originally provided by Hadassah would be devolved to the authority of the Yishuv, or later, the state, once they could support themselves. (The exception was the Rothschild-Hadassah University Hospital, to which this principle was never applied.) The declared reason for the move was the need 'to devote Hadassah's means and efforts to establishing and developing the Hebrew University-Hadassah School of Medicine, and release it from the other medical activities to the extent possible'. The services thus handed over to government included, among others, the infant welfare stations, school hygiene services, the 'war on trachoma', and ringworm treatment services.[149]

In mid-1955 there were 12,113 hospital beds in Israel, of which 4,381 were in government hospitals, 1,784 in hospitals run by the Histadrut Health Fund, 1,590 in Malben hospitals, and only 226 in Hadassah hospitals.[150] The number of infant welfare stations reached 400 in 1955: of these, 175 were under the authority of the Histadrut Health Fund, 18 under the authority of the City of Tel Aviv-Yafo, and only 34 under the authority of Hadassah.[151]

These data reveal the relatively minor role of Hadassah as a health provider in Israel by the mid-1950s, with the exception of the field of university medical education, in which it remained the exclusive provider until 1965, when the school of medicine at Tel Aviv University was established. The data for 1955, when Hadassah had a medical school, a school of dentistry, a programme in occupational therapy, a school for registered nurses, and a school for further studies in medicine, show the organization's total hegemony in medical teaching in a wide range of fields, and bear witness to the huge expansion that had taken place since 1948.[152]

Dr Kalman Mann to the municipalities and local councils, 16 May 1952; list of twenty-four stations in the Jerusalem Corridor where Hadassah maintained preventative medical care on the date of signature of the devolution agreement; letter from Kalman Mann to Chaim Shiber (director general of the Ministry of Health), 7 July 1952; memorandum of understanding between the management of the Hadassah Medical Organization, the Union of Clerks, Organization of Nurses, and Committee of Hadassah Employees: all in ISA, RG57, box 4245, file 4 (Heb.). See also letter from Mann to Shiber, 7 July 1952, ISA, RG57, box 4245, file 23. On the assessment that the medical services in the Jerusalem and Jerusalem Corridor region, which remained under the authority of Hadassah, constituted 40% of all services, see Kalman Mann to Yoseph Burg (Minister of Health), 5 Aug. 1952, ISA, RG57, box 4245, file 23; on the decision that Hadassah would retain authority over the health services in Jerusalem and the Corridor with the aim of serving the medical students and the nurses in training at Hadassah's nursing school, see Hirsh, *The Hadassah Medical Organization*, 35.

[149] For the quotation and the information, see, 'Draft 1' and 'Draft 2'; also letter from Kalman Mann to Yoseph Burg, 5 Aug. 1952 (Heb.), both in ISA, RG57, box 4245, file 23.

[150] *Israel Government Yearbook 5717 [1956–7]* (Heb.), 105; for similar details updated to Jan. 1955, see Halevi, 'The Population' (Heb.), 721. [151] Halevi, 'The Population' (Heb.), 723. [152] Ibid.

Welfare and Education Projects for Children and Teenagers

IN ADDITION to its involvement in health care, Hadassah was also engaged in a large number of projects to benefit children and teenagers, both during the Mandate period and after the State of Israel was established. These projects were consistent with the perception of appropriate realms of activity for women in the United States since the end of the nineteenth century—nursing (especially within the field of public health), social work, and education—and in this sense expressed Hadassah's identity as a women's organization more than its health and medical projects did. Hadassah's activity in this field also reflected the concerns of the time at which the organization was founded. No previous period in the history of the United States had been so focused on children as the Progressive era (1890–1920), during which many new movements emerged to benefit children and numerous new educational methods were developed.[1] This focus on children and youth had considerable influence on the path that Hadassah took.

The need for these reforms arose as part of far wider social changes. These took place in the context of rapid expansion in industry and trade accompanied by large waves of immigration (including that of two and a half million Jews from eastern Europe—one-third of east European Jewry at the time and approximately 10 per cent of all immigrants to the United States between 1880 and 1914), and by enormous growth in the populations of the large cities.

Many of the Progressive activists—including well-educated, upper-middle-class urban women, who had the time and the resources to devote to charitable and volunteer organizations[2]—placed the welfare of children at the top of their list of priorities. They invested great effort in public health and in improving living conditions in poor neighbourhoods, whose inhabitants they perceived as backward.

[1] Rothman, *Woman's Proper Place*, 98. [2] Simmons, *Hadassah and the Zionist Project*, 50–1.

This perception reflected the view held by the established American population of all immigrants arriving in the United States at that time, who differed from them not only in language but also, for the most part, in religion (the majority of the newcomers were Catholics and Jews) and in country of origin (most of the immigrants came from eastern and southern Europe, regions perceived by Americans as deprived).

The emphasis on child welfare (and on educating mothers, as those who were responsible for bringing up children) came from concern about the high percentage of infant mortality in the slums. This percentage was even higher among the immigrants, and the Progressive activists concluded that this was related in part to customs and ethnic traditions—perhaps even to heredity—and that education in proper motherhood could help reduce it and in any case could be beneficial to the health of the family.[3] An additional assumption of welfare activists was that the immigrants' lives would improve greatly if they adopted a 'scientific' approach to household management; they therefore attempted to educate the immigrant mothers in proper nutrition and cooking, and in keeping their homes aired and hygienic.[4]

Thus Hadassah's founders had before them examples of children's welfare projects and of the first attempts by reform activists (including therapeutic professionals, mainly nurses and social workers) to resolve the distress of children in the slum neighbourhoods of the big cities in the United States. In the course of these attempts, the welfare activists were creating original and innovative enterprises motivated by philanthropic as well as educational intentions.

On the basis of these American models, Hadassah put children and teenagers, and their mothers, at the centre of the welfare enterprises that it established in Palestine. Historian Erica Simmons claims that Hadassah women regarded the population of new immigrants to Palestine (as well as the Arab women for whom they cared) in the same way that the American welfare workers regarded the immigrant women in the slum areas of the large US cities.[5] Furthermore, she claims, Hadassah nurses in Palestine thought that many mothers were guided by 'stupid customs' and superstitions which endangered the children's welfare, and attempted to educate them to operate in rational ways based on an approach considered at the time to be scientific.[6]

The original impetus behind most of Hadassah's projects in this field was provided by Henrietta Szold, who, as head of the Social Welfare Department of the

[3] Simmons, *Hadassah and the Zionist Project*, 54. [4] Ibid. 57. [5] Ibid. 57–8. [6] Ibid. 53.

Va'ad Leumi during the 1930s, took a special interest in the problems of children. Most of Hadassah's projects for young people were begun on her initiative. As noted in Chapter 1, the American Zionist Medical Unit began setting up projects for the benefit of children and teenagers in the Yishuv as early as 1919; Hadassah continued and developed these projects and added others, each one the first of its kind in the Yishuv. After the establishment of the State of Israel, with the completion of Hadassah's role as founder of modern health services in Palestine, its involvement in the public health projects it had established and maintained also ceased, with the exception of the health welfare stations in Jerusalem and the Jerusalem Corridor.

PUBLIC HEALTH

Hadassah founded and developed four public health projects in the Yishuv aimed at children and young people: hygiene and health services in schools (the School Hygiene Service, launched in 1919); infant health welfare stations (known as Tipat Halav, launched in 1922); the School Luncheon Programme (1922); and the playground enterprise (1928). All were modelled on similar projects in the United States. For the most part these projects were run by local people. In 1936 the Hadassah National Board decided that since the public health, welfare, and school lunch projects presented 'an underlying unity of scope and continuity of development and together contribute immeasurably to the welfare of the Yishuv' the projects should be combined 'into one inclusive child welfare program'.[7]

School Hygiene Services

As early as 1919, as we have seen, the American Zionist Medical Unit set up the Department of School Hygiene, whose activities are described below. Hygiene services and inspection of sanitation in educational institutions first developed in the nineteenth century in Europe and the United States, with the aim of preventing the spread of infectious diseases.[8] In the United States the supervision of hygiene in schools began in the 1870s, and by the early twentieth century school hygiene was part of the public health system. With the rise in immigration during this period various illnesses, particularly eye and skin diseases, became widespread in the poor neighbourhoods of the large cities, and it became increasingly important

[7] *Hadassah Newsletter*, 17/2 (Nov. 1936), 12, cited in Miller, 'A History of Hadassah', 306.

[8] Rosen, *A History of Public Health*, 365–87. See also Shehory-Rubin and Shvarts, *Hadassah for the Health of the People* (Heb.), 40.

to teach children and their parents hygiene in order both to help them deal with these conditions and to prevent the spread of disease. One effective method of doing this was first developed in New York by the Jewish nurse Lillian Wald, the founder of community nursing in the United States (see Chapter 1). She appointed school nurses to carry out routine tests for signs of infection. In time, other methods were developed in the United States to achieve the same ends.[9]

The theory of hygiene was brought to Palestine from the United States and Europe in the early decades of the twentieth century. It was based on empirical research and on principles considered rational, and it developed models considered at that time correct and healthy for life management. According to this theory the sphere of hygiene is divided into several sub-spheres, including 'personal hygiene', 'sexual hygiene', 'racial hygiene', 'school hygiene', and 'mental hygiene'.[10]

Prior to the work of the American Zionist Medical Unit there was no health inspection in the schools in Palestine, with the exception of Gymnasia Herzliya in Tel Aviv (the first school in the Yishuv to hire a private doctor) and some initial initiatives elsewhere in the inspection and treatment of skin and eye diseases. The Medical Unit set up a department for the purpose, concentrating on teaching hygiene, sanitary inspection, and treatment of skin and eye diseases. From its inception it was headed by Dr Mordecai Brachyahu (originally Borochov; 1882–1959), who served from 1912 until the outbreak of the First World War as the doctor of Gymnasia Herzliya in Tel Aviv and after the war as a physician in the moshavot of the Upper Galilee.[11] Dr Brachyahu developed the School Hygiene Department and made it responsible for several spheres. The principal one was the treatment and prevention of diseases (primarily malaria, trachoma, and the dermatological diseases ringworm and pediculosis). Additional spheres were hygiene education, sanitary supervision, the mental health of children, and the education of children with special needs. He even determined the professional criteria for each of these spheres. In developing the various spheres of hygiene, Dr Brachyahu was assisted by physicians and psychiatrists; the latter were mainly new immigrant refugees from Germany who arrived in Palestine in the 1930s.[12] In 1929 and 1931 he even sent teachers to the academy for *Heilpädagogy* (pedagogy therapy, a German method of therapy in what was then known as education of the retarded) in Berlin.[13] Preventative medicine in both the physical and mental spheres, and the

[9] Rosen, *A History of Public Health*, 367. [10] Hirsch, '"We Are Here to Bring the West"' (Heb.), 107.

[11] Shehory-Rubin and Shvarts, *Hadassah for the Health of the People* (Heb.), 40; information from Dafna Hirsch, researcher on hygiene in the Yishuv.

[12] Zalashik, 'The Development of Psychiatry in Palestine and Israel', 109–10.

[13] Brachyahu, *The School and the Student* (Heb.), 23.

educational basis of the work, were very prominent in all spheres of the department's activity.

Initially the School Hygiene Department operated only in Jerusalem. But early in 1920 its activity was extended to schools in Tel Aviv and Haifa, and thereafter quickly encompassed all the educational institutions of the Yishuv.[14] The necessary examinations and treatment were carried out by physicians or nurses in the schools themselves. In addition, the department established a network of clinics (including dental clinics), and developed an educational programme for teaching hygiene to pupils and their parents, aimed at preventing the spread of epidemics.[15] Nurses working in these clinics weighed the children, examined them in order to treat and prevent the spread of pediculosis, ringworm, and trachoma, gave inoculations, provided first aid, made house calls, and educated the parents.[16] The physicians were employed mainly in examining pupils, and each was responsible for many schools. Educational projects were also integrated within the department, including the 'health societies' initiated by Henrietta Szold in accordance with the American model: groups of children operating in the schools who were responsible for imparting hygiene habits to other pupils.[17] Simmons argued that children who participated in the school hygiene project, and also in another important Hadassah welfare project, the School Luncheon Programme (discussed below), operated as agents to pass health education on throughout the Yishuv.[18]

Dr Brachyahu was also involved in education and mental health. He established three 'consultation stations' for children with special needs,[19] which laid the foundation for today's educational psychology services, which operate under the Ministry of Education. He also established early diagnosis for these children and treatment of delinquent children (whom Henrietta Szold transferred to him from the Social Welfare Department of the Va'ad Leumi), and in 1929 and 1934 he established two schools for 'retarded' children.[20] Thus the School Hygiene Department established the first institutions for children with special needs in the Yishuv.

Health Welfare Stations

In 1922 Hadassah set up a station for the care of pregnant women and newborn infants which became a model for the entire Yishuv. It was established in the Old

14 Shehory-Rubin and Shvarts, *Hadassah for the Health of the People* (Heb.), 43.
15 Brachyahu, *The School and the Student* (Heb.), 4, 29, 30.
16 *Twenty Years of Medical Service in Palestine* (Heb.), 21.
17 Shehory-Rubin, 'Hadassah's Education and Health Projects' (Heb.), 109.
18 Simmons, *Hadassah and the Zionist Project*, 58.
19 Brachyahu, *The School and the Student* (Heb.), 20–3. 20 Ibid. 23–5.

City of Jerusalem by a young American Jewish nurse, Bertha Landsman, who arrived in Palestine from New York in late 1920 with the second wave of medical teams that came to support the activity of the Medical Unit. She later set up a network of similar infant welfare stations (later known as Tipat Halav) throughout the Yishuv.[21] These stations, like the one set up by the first nurses sent by Hadassah to Palestine in 1913, were based on the district nursing method developed in the United States, which in turn was inspired by the English concept that poor people should be treated in their homes and mothers educated on how to take care of their children.[22] Accordingly, the nurses visited the young mothers in their homes, although care and advice were also provided at the stations themselves

We have very little information about Bertha Landsman. She lived in Palestine for many years, and never married. Like most of the nurses who came to Palestine with the Medical Unit, she acquired her training as a nurse at the Lebanon Hospital in New York (today Bronx-Lebanon). Thereafter she worked for the New York City Health Department as a public health nurse, in infant welfare stations and in school hygiene, and was involved in the scheme to distribute milk to infants that had been set up by the American Jewish philanthropist Nathan Straus in 1893 and was supported by him until 1919, as described in more detail below.[23]

Like the settlement house set up by the two nurses who arrived in Palestine in 1913, Bertha Landsman's station was based on the district nursing concept.[24] It provided mothers and infants with various services: distribution of milk, counselling (mainly on nutrition and infant care), and periodic testing.[25] Over the following years, health welfare stations based on this model were set up throughout the Yishuv, mostly by the Hadassah Medical Organization. In some cases help was provided by the Federation of Hebrew Women, a group that contributed to the foundation of social work in the Yishuv. This organization was founded in 1920 by Batsheva Kesselman, a former member of Hadassah's National Board who moved to Palestine with her husband, and several other women working in Jerusalem, Jaffa, and Tel Aviv, with the aim of responding to local problems and helping needy

[21] On Landsman's immigration to Palestine, see Levy, *Chapters in the History of Medicine* (Heb.), 182. For the other information, see Shehory-Rubin, 'Hadassah's Education and Health Projects' (Heb.), 123, 138–9.

[22] Letter from Bertha Landsman to Dr Blustone (director, Hadassah Medical Organization), on 'District Nursing in Tel Aviv', 1 Jan. 1927, Leah Zwanger personal collection.

[23] Addams, 'The Creation of Community Nursing'; author's interview with Yehudit Steiner Freund, Jerusalem, 20 Feb. 2001.

[24] Letter from Bertha Landsman to Dr Blustone (director, Hadassah Medical Organization), on 'District Nursing in Tel Aviv', 1 Jan. 1927, Leah Zwanger personal collection; Zwanger, 'Preparation of Graduate Nurses'. [25] Shehory-Rubin, 'Hadassah's Education and Health Projects' (Heb.), 138–43.

women, mainly in the field of social welfare.[26] The organization developed a strong relationship with Hadassah, and Batsheva Kesselman in fact suggested that it become an affiliated organization of Hadassah. A plan for collaboration between the two organizations was later developed, but in 1927 the Federation of Hebrew Women became affiliated to WIZO.[27]

In parallel to the mother and child stations and generally together with them, Hadassah developed another project for mothers and children in Jerusalem—the 'milk kitchens' (mitbaḥei ḥalav). The need for these arose from nutritional deficiencies that meant many mothers did not produce sufficient milk to nurse their babies.[28] These kitchens were modelled on Nathan Straus's 'milk stations' in New York.

The network of milk stations that Nathan Straus funded in New York was the result of his collaboration with Progressive welfare activists, who were appalled by the high infant mortality rate among the poor in the United States, and particularly in the big cities. In 1890, after research had shown that digestive problems and nutrition were the principal factors in infant mortality, the supply of safe milk had become a top priority of the American public health movement. Welfare activists soon approached Straus, who was known to be an extremely generous benefactor, with a request to fund milk depots that would supply safe milk for poor mothers at no charge or at minimum cost. Once Straus became convinced that unpasteurized milk was the cause of the high infant mortality, he dedicated a great deal of time and money to solving the problem. Thanks to his support, the first milk depot opened in 1893 on the Lower East Side of Manhattan, an area in which many Jewish immigrants lived.[29]

Straus developed a system that was eventually applied in twenty-six such stations across the United States. The composition of the milk was modified according to a set formula (hence the expression 'formula milk'), bottled, and distributed to mothers to feed their children. In 1902 these stations distributed 250,000 bottles of milk.[30] In 1917 eighteen milk depots were operating in New York, all funded by Straus. They supplied 'ready to drink' pasteurized milk at no charge or at a nominal charge to mothers of babies. The depots gradually expanded into centres which dealt with the general issue of infant welfare.[31]

Straus and Hadassah shared a common perspective on public health enterprises.

[26] Ibid. 138; Shvarts, 'The Women's Federation for Mothers' (Heb.), 66.
[27] Shvarts, 'The Women's Federation for Mothers' (Heb.), 67–8; Twenty Years of Medical Service in Palestine (Heb.), 20; Shehory-Rubin, 'Hadassah's Education and Health Projects' (Heb.), 133–6.
[28] Shvarts, 'The Women's Federation for Mothers' (Heb.), 66.
[29] Simmons, Hadassah and the Zionist Project, 55.
[30] Rosen, A History of Public Health, 355. [31] Simmons, Hadassah and the Zionist Project, 55.

It was he, after all, who had provided the funds for Hadassah to send two public health nurses to Palestine in 1913. Furthermore, Straus and the women of Hadassah also shared a common viewpoint regarding the links between sanitation, hygiene, nutrition, and public health, and made the treatment of mothers and children a first priority. Straus also shared with Hadassah the conception that services on behalf of the population in Palestine must be provided for all—Jews, Muslims, and Christians.[32]

Again working with the Federation of Hebrew Women, Hadassah set up the first 'milk kitchen' in 1921 in the Old City of Jerusalem, following the model of Straus's stations in New York. In its first year the kitchen provided pasteurized cows' milk on a daily basis to sixty infants a day, including some who lived outside the city. The milk was poured into bottles and transported on donkey-back in ice-filled buckets. In 1922 another kitchen was established, this time under the auspices of the Rothschild-Hadassah University Hospital.[33]

In the first two years of operation, the kitchens delivered milk to the mothers' homes. In 1922 the Federation of Hebrew Women had difficulty funding this, and it was agreed that Hadassah would take over sole responsibility for this activity.[34] The following year Hadassah decided to centralize the milk distribution in the health welfare stations that Bertha Landsman had organized.[35] This meant that when mothers came to get milk, Hadassah could also provide them with guidance in caring for their infants, as well as the services of a nurse and a doctor. In 1927 the supply of whole milk to mothers ceased, to be replaced by milk powder supplied by the Federation of Hebrew Women. Despite the end of the liquid milk distribution scheme, the health welfare stations continued operating under the name Tipat Halav.[36]

The educational aspect of this Hadassah project was very prominent. The health welfare stations were staffed by student and graduate nurses from the Hadassah Nurses' Training School, who encouraged the women to come at least once a week to hear the talks on infant care given in Hebrew, Yiddish, and Arabic by Hadassah nurses and guest doctors. They also weighed the babies and gave them check-ups, as well as supplying milk. In 1938 Hadassah ran twenty-eight health welfare stations (not including those that Hadassah had devolved to the authority of the city of Tel Aviv in 1936).[37]

[32] Simmons, *Hadassah and the Zionist Project*, 55.
[33] Shehory-Rubin, 'Hadassah's Education and Health Projects' (Heb.), 133–6.
[34] Shvarts, 'The Women's Federation for Mothers' (Heb.), 71–2.
[35] Ibid. 72. [36] Ibid. 74; *Twenty Years of Medical Service in Palestine* (Heb.), 20.
[37] On the activity of Hadassah in the health welfare stations, see *Twenty Years of Medical Service in Palestine* (Heb.), 20; on the health centres that Hadassah ran in 1938, see ibid. 18–19.

Hadassah's health welfare stations served as a model for the Mandate government's Department of Health, which opened its own stations for the first time in 1925. Its public health nurses were trained in Hadassah's stations. Other stations were opened in non-Jewish areas by municipalities and various charities.[38] According to the department's figures, the infant mortality rate in the Yishuv dropped from 14.4 per cent in 1922 to 5.8 per cent in 1938.[39]

The Health Welfare Stations in the Period of Mass Immigration

From 1947 to 1951, and particularly in the peak year of 1949, the swelling tide of immigration and the poor health of many of the new arrivals prompted the Hadassah Medical Organization to set up additional health welfare stations in places with a high concentration of immigrants. Many mothers and infants in particular, among both the Holocaust survivors and the immigrants from the Islamic countries, were in a very poor state, suffering from exhaustion, malnutrition, and various diseases, exacerbated by the rigours of the trip to Israel and conditions in the transit camps and temporary immigrant settlements (ma'abarot).[40] To attempt to relieve this hardship, health welfare stations were set up in Lod and Ramla, in Jaffa, and in Ein Karem (in Jerusalem), all abandoned or partially abandoned Arab communities where immigrants were being settled, as well as in other places throughout the country.[41] Because of the immigrants' needs, the care provided by these health welfare stations was more comprehensive than it had been in the decades prior to statehood.

In 1950 and 1951 the Hadassah Medical Organization was repeatedly asked to set up health welfare stations to cater for the new immigrant moshavim (see Chapter 11) and the temporary immigrant settlements being established throughout Israel. Unsuccessful in raising additional funds from Hadassah in New York, it applied to the local authorities in the areas to be served by the stations, asking them to fund the activities according to their ability. The better-off settlements covered the full cost of operations.[42]

The network of health welfare stations that had developed from the first one set up by Bertha Landsman played a crucial role in providing services to mothers and infants during the period of mass immigration. Indeed, the health welfare stations

[38] *Twenty Years of Medical Service in Palestine* (Heb.), 20. [39] Ibid. 36.

[40] Hacohen, *Immigrants in Turmoil*, 141. [41] On the population of Lod and Ramla, see ibid. 80.

[42] On the repeated demands to set up infant welfare stations and the request from Hadassah in New York, see letter from Pinhas Chen to David Tuviyahu (mayor of Beersheba), 26 Apr. 1951, CZA, J113II/332/61 (Heb.).

were one of Hadassah's most significant contributions to public health in the Yishuv and, later, in Israel. The underlying idea of this project has remained essentially the same to this day.

The Children's Feeding and Nutrition Project

The nutrition of children was the third realm of public health imported by Hadassah in the Mandate period. Like the first two enterprises, it was modelled on an American enterprise of the early twentieth century aiming to relieve hardship among the poor, namely, the School Lunch Movement. This initiative began in New York City in 1908, following research that revealed that 60,000–70,000 children in the city came to school hungry. Similar projects were developed in Philadelphia, Chicago, and other cities.[43] Common to them all was the provision of hot midday meals for school pupils and the promotion of education in proper nutrition, which in 1918 became part of the curriculum in American schools. During the Great Depression of the 1930s the movement expanded its activity, and in 1938 hot lunches for school pupils were provided in almost all US states.[44]

The School Lunch Movement in the United States served as a model for Hadassah's feeding and nutrition project for children and teenagers in Palestine, the School Luncheon Programme. This was both a social welfare project (aimed at relieving the problem of hunger) and an educational project (aimed at teaching nutrition). Founded in 1922, it was in full operation by the early 1930s and became one of the Yishuv's most important welfare projects. The impetus behind the School Luncheon Programme was, like that behind the US School Lunch Movement, the hunger suffered by children and teenagers, in this case those in Jerusalem.

In the early 1920s, hunger among children and teenagers in Jerusalem was a matter of concern to teachers. In 1921 kindergarten teachers began cooking meals for nine of the twelve kindergartens in three underprivileged areas—the Old City, the Bukharan neighbourhood, and Kfar Hashiloah. Parents paid only what they could afford.[45] Then, in December that year, Yeshayahu Peres, the principal of a school for girls in the Old City of Jerusalem, went to Henrietta Szold to describe the condition to which his students had been reduced by hunger and ask her to appeal to Hadassah for aid.[46] Shortly after that, in early 1922, the Reform rabbi and educator Dr Maurice H. Harris visited Palestine and, shocked by the gravity of the

[43] Rosen, A History of Public Health, 299–300. [44] Ibid.
[45] Shehory-Rubin, 'Hadassah's Education and Health Projects' (Heb.), 182.
[46] Ibid.; Szold, Foreword (1943) to the 2nd edn. of Bavly, Our Nutrition (Heb.), 1.

situation, went to Szold and offered to contribute $50 for 'lunches for the poor'. This was the Hanukah money that children at his Reform synagogue in Harlem, New York, had given to him to help poor children in the Holy Land.[47]

Henrietta Szold used this initial donation to provide lunches for needy children in Jerusalem; moreover, according to Harris, she was convinced of the need for a permanent meal programme and suggested that Hadassah set it up. On his return to New York, he presented the idea to the Hadassah National Board, which the same year established a committee to implement it, composed of members of the boards of directors of Jewish Sunday schools and representatives of Hadassah. Soon thereafter the project was transferred to Hadassah, and in 1922 the School Luncheon Programme (also known in the US as the Palestine Penny Lunches Fund, and in the Yishuv as Keren Hamisadot) was established. By 1930 lunch programmes were operating in a total of eight schools in Jerusalem, Haifa, and Tiberias.[48]

In 1930, aged only 30, Sara Bavly was appointed director of the project, which she headed until it was taken over by the government in 1952. Born in Amsterdam to a religious Zionist family of Polish origin, she had been active in Zionist youth and student organizations before graduating with a master's degree in chemistry from the University of Amsterdam. When she discovered that she could not work as a chemist in Palestine because there was no demand for the profession, she postponed her emigration for a year to study nutrition and home economics, finally emigrating only in 1926. She became the first teacher of nutrition and dietetics in the Yishuv, remained a leading figure in the field of nutrition education until her retirement in 1965.[49]

Upon her arrival in Palestine, Bavly taught nutrition for a short time at the WIZO agricultural school at Moshav Nahalal in the Jezreel Valley, and then as a dietitian at the Hadassah Hospital in Tel Aviv; she was then asked to teach nutrition and dietetics at the Hadassah Nurses' Training School. After a year Dr Ephraim Blustone, the director of Hadassah, offered her the opportunity to study in New York for a year in order to prepare herself for the position of Hadassah's chief dietitian, with responsibility for all five of Hadassah's hospitals in Palestine.

[47] Miller, 'A History of Hadassah', 299–300; Shehory-Rubin, 'Hadassah's Education and Health Projects' (Heb.), 183; Szold's Foreword to the 2nd edn. of Bavly, *Our Nutrition* (Heb.), 1.

[48] Levin, *It Takes a Dream*, 123; Miller, 'A History of Hadassah', 299–300; S. Bavly, 'A Short Review of the Development of Hadassah's Keren Hamisadot for the 25 Years of its Existence', 9 Mar. 1949, CZA, A/580/7 (Heb.).

[49] S. Bavly, 'Biographical Landmarks', preface to a list of files in the Sara Bavly Archive, CZA, A/580/7, 3–4 (Heb.); author's interview with Miriam Bavly (Sara Bavly's daughter), Jerusalem, 12 Jan. 2000; Endevelt, 'Sara Bavly'.

Accordingly, she went off to Columbia University Teachers' College in 1928/9, where she earned a master's degree in nutrition; at Henrietta Szold's request she specialized in the field of school nutrition as well, so that she could apply this knowledge in directing the School Luncheon Programme.[50] On returning to Palestine, she established and supervised dietetic departments in all the Hadassah hospitals: Jerusalem, Tel Aviv, Haifa, Tiberias, and Safed.

Sara Bavly's second task was to educate the public in nutrition. To this end she set up a nutrition department at the Nathan and Lina Straus Health Centre in Jerusalem, which was established in 1929 to serve the city's growing population, and there she gave lectures, courses, and demonstrations in the preparation and cooking of food.[51]

In 1930 Sara married Dr Yehudah Brumberg (1902–43), who had emigrated to Palestine from Poland in 1919 and subsequently studied in Italy, where he received doctoral degrees in both law and economics; after returning to Palestine he went on to become the assistant director-general of the Hadassah Medical Organization. The couple Hebraized their name to Bavly. After her husband's premature death from cancer, Sara brought up their two children on her own in the Rehavia neighbourhood of Jerusalem, where she lived until her death in 1993.[52]

Sara Bavly's contribution to cooking and nutrition education in the Yishuv and Israel later expanded to cover the provision of training courses for heads of dietary departments and hospital dietetics, instruction in nutrition and dietetics for nurses, adult education in nutrition, and nutrition research. In 1946 she was given grant funding by Hadassah to study for a Ph.D. in the United States, and gained her doctorate in nutrition from Columbia University. On returning to Israel she was involved in establishing the College of Nutrition and Home Economics, a training college for teachers and dietitians that was founded in 1953, and became its dean. She also served as head of the Nutrition Department of the Israeli Ministry of Education. After her retirement from the department in 1960 she continued to work in research, university teaching, and publishing.[53]

The School Luncheon Programme in the 1930s and 1940s

One of Sara Bavly's first acts after she was put in charge of managing the School Luncheon Programme was to initiate training for cooking instructors in schools. The first two courses took place in 1930, and subsequently cooking and nutrition

[50] Author's interview with Miriam Bavly (Sara Bavly's daughter), Jerusalem, 12 Jan. 2000; S. Bavly, 'Biographical Landmarks', 3–4; Endevelt, 'Sara Bavly'.
[51] Endevelt, 'Sara Bavly'; S. Bavly, 'Biographical Landmarks', 3–4.
[52] Ibid.; Hadassah Annual Report, 1947/8, 23. [53] Endevelt, 'Sara Bavly'.

instructors were trained in nutrition classes given at teachers' seminaries in Jerusalem and Tel Aviv, or in short courses. The instructors in these courses were supervisors from the School Luncheon Programme. From that time on Sara ran a methodical training course for nutrition teachers, and gave lectures and advanced study courses to teachers. In 1941 the School Luncheon Programme established a special course for training cooking and home economics teachers at the Hebrew Teachers' Seminary in Beit Hakerem in Jerusalem. All participants had to receive teaching certification from the Education Department of the Va'ad Leumi before they were appointed to their positions.[54]

Under Sara Bavly, the School Luncheon Programme was extended beyond its original educational aim as its contribution to children's health came to be increasingly acknowledged. It grew throughout the bloodshed of 1936–9, when Arab attacks on the British and, mainly, Jews intensified along with Jewish immigration to Palestine and Jewish hopes for an independent state, and particularly strongly after the outbreak of the Second World War, which exacerbated nutritional problems, especially among the underprivileged population. Over time the programme expanded to include children of working mothers, who could not make them a midday meal, and children whose parents wanted them to eat at school for social reasons.[55] It also expanded its geographical reach, operating in schools in remote areas as well as in towns. In these locations the older children made the meals and brought them in to the schools, sometimes by mule.[56]

By 1944 most schools were benefiting from the scheme, which became one of the Yishuv's most important social services.[57] The expansion was financed by the British Mandate government and the Va'ad Leumi, as well as by municipalities and local councils. It thus became a means for feeding thousands of needy children and teenagers—by 1942, approximately 25,000. That year, 65 per cent of the project's expenses were funded by local Yishuv organizations.[58] In 1946 the total number of schoolchildren covered by the scheme reached 28,217.[59]

In 1940 the scope of the School Luncheon Programme was extended to include teaching home economics to girls in elementary schools. The aim was to teach them 'the way to arrange and organize your home so that it serves as a home in

[54] Ibid.

[55] Dushkin, 'Hadassah's Child Welfare Program', 7–8; Deutsch, 'The Development of Social Work' (Heb.), 209. [56] On the remote schools, see Dushkin, 'Hadassah's Child Welfare Program'.

[57] On the state of the project in 1944, see Deutsch, 'The Development of Social Work' (Heb.), 209.

[58] Dushkin, 'Hadassah's Child Welfare Program', 7–8; on the expansion of the programme, see also Deutsch, 'The Development of Social Work' (Heb.), 207–8; on inclusion of local organizations, see ibid. 208. [59] Shehory-Rubin, 'Hadassah's Education and Health Projects' (Heb.), 206.

the full sense, and centre of the family life'.[60] As with so much of Hadassah's work, the inspiration for this programme was a women's movement of the Progressive era in the United States, the 'home economics movement', which saw this subject introduced into the curriculum in American high schools. The concept behind the movement was based on the view that management of the home should be professional, efficient, and 'scientific', and that it should be run as a business, a skill that must be learned.[61]

This movement developed against a backdrop of optimism about the possibilities inherent in science for improving the face of society. Against this backdrop a large number of experts arose, the majority of them women, who attempted to implement scientific principles in the tasks of household management and parenthood. In the words of a leading activist in this movement, 'The significance of this was to implement industrial standards of efficiency on household management together with the understanding that managing a home was a serious endeavour.' Equipped with scientific notions about the spread of disease, the first women home economists took action to teach immigrants how to preserve, handle, and prepare food, and how to ensure personal and general household hygiene in order to prevent disease.[62]

A particularly fervent advocate of instructing women in the 'proper' management of their households was the reform activist Mabel Hyde Kittredge. She became involved in the home economics movement out of distress at the manner in which children were being brought up and households run in immigrants' homes in New York. She developed unique pedagogic methods to educate immigrant women in proper 'scientific' and efficient management of the household. She was also an ardent believer in the notion of the child as one who bestows knowledge on his or her parents. Historian Erica Simmons argues that Hadassah representatives in Palestine shared with Kittredge the passion for turning women into efficient household managers and implemented her methods in their enterprises in Palestine.[63]

The School Luncheon Programme: Hadassah's Perspective

The educational basis of the School Luncheon Programme was laid by Henrietta Szold, but under Sara Bavly's management it grew into a large-scale welfare project and a twofold educational programme, providing education in nutrition, cooking,

[60] Shehory-Rubin, 'Hadassah's Education and Health Projects' (Heb.), 187.
[61] Powers, The 'Girl Question' in Education, 12–13.
[62] For the quotation and argument, see Simmons, Hadassah and the Zionist Project, 69, 71. [63] Ibid. 69.

and home economics for elementary schoolchildren, and training for cookery and nutrition teachers. By means of the School Luncheon Programme, Hadassah wanted to teach the Yishuv's children correct eating habits, economical cooking, table manners, and hygiene. All this was to be done through practical learning, with the children themselves cooking in most of the kitchens. Boys and girls alike took part in these studies. Thus the project encompassed both components—the social and the educational—of the American School Lunch Movement.

Hadassah saw the project primarily as an educational endeavour, aimed at setting an example. The purpose was to establish a few schools in major cities in Palestine that would serve as a model of correct nutrition for the residents of the Yishuv who, in Hadassah's view, lacked correct eating habits. The widely held view on this subject within Hadassah was expressed in an article published in the *Hadassah Newsletter* in 1936: 'the oriental community likes plenty of vegetables but they [sic] prepare them soaked in oil . . . neither the Eastern nor the Western communities drink sufficient milk or consume enough cereal foods. The cooking lesson and the theoretical talks the school lunch teachers are designed to influence all these differences in diet.'[64]

The intention was to educate school pupils in proper nutrition with the goal that they would transfer to their parents the habits they acquired at school.[65] Hadassah's leaders were very troubled by what they perceived as ignorance of the basic principles of nutrition in the Yishuv and the consequences for the population's health, and by the immigrants' lack of knowledge of how to adapt to local conditions in Palestine the nutritional customs they had brought from their countries of origin. Pupils were therefore taught how to purchase food, how to compose a balanced menu, and how to prepare and cook food. Afterwards they served the food they had prepared to their friends, at which point an emphasis was placed on table manners.[66]

As in the American model, education in nutrition was incorporated as part of the school curriculum: the School Luncheon Programme became part of the Yishuv's education system. Under the programme, Hadassah employed cookery teachers who were trained in the various courses described above and received a teaching permit from the Education Department of the Va'ad Leumi before being appointed.[67] The social welfare purpose of the programme—to provide needy children with hot meals—was perceived as a secondary aim.[68]

[64] *Hadassah Newsletter*, 17/3 (Dec. 1936), 7, cited in Miller, 'A History of Hadassah', 305.
[65] Hadassah Annual Report, 1947/8, 23. [66] Simmons, *Hadassah and the Zionist Project*, 64.
[67] Hadassah Annual Report, 1947/8, 24. [68] Dushkin, 'Hadassah's Child Welfare Program', 3–4, 6–7.

However, the differences in nutritional customs among the various groups from different countries of origin made it difficult to implement the educational objectives. Many pupils were unable to assimilate into the home the new knowledge about cooking that they acquired at school, especially where what they learned at school relied on products provided as contributions from abroad that most parents could neither find locally nor afford. A characteristic example of this—by no means the only one—occurred at the Talmud Tora Mizrachi, a boys' school in Jerusalem affiliated to Mizrachi, the religious Zionist movement, where the cafeteria served wholewheat bread, which was far more expensive than the 'regular' bread available in Jerusalem.[69]

The School Luncheon Programme after the Establishment of the State of Israel

During the War of Independence the School Luncheon Programme operated in besieged Jerusalem to provide at least one hot meal a day to the population remaining in the Jewish Quarter, which was unable to feed itself.[70] Thus it temporarily became a mass feeding project for the army, the refugees of the Old City, and families in Jerusalem and throughout Israel who had lost their homes because of the war.[71]

In early 1949, a few months after the state was established, the National Board of Hadassah discussed the idea of devolving the School Luncheon Programme to the authority of the Ministry of Education, mainly for financial reasons, and in anticipation of the heavy burden that increased immigration would place on the project and on Hadassah's funds.[72] A few months later, in June 1949, Etta Rosensohn told the National Board that such devolution was essential and should begin immediately. At the same meeting the National Board approved the outline of a plan to move Hadassah's child welfare services to the Ministry of Education. The plan called for a gradual transfer over four years: in the first two years, Hadassah would continue to subsidize the services to the same level as in 1950; in the third year, the aid would be cut to 50 per cent, and in the fourth, to 25 per cent. At the end of the fourth year Hadassah's support would cease completely.[73]

Preparations for the handover took over two years, from June 1949 until the beginning of its implementation in 1952. First, the project was transferred to the

[69] Author's interview with Avraham Katzburg, a pupil at this school at the time, Jerusalem, 12 May 2005.
[70] Hadassah Annual Report, 1947/8, 24.
[71] Proceedings of Hadassah's 34th Annual Convention, HA, RG3, ser. Proceedings. subser. 1948 Convention, box 14, 466. [72] Minutes of Hadassah National Board meeting, 9 Feb. 1949, 11.
[73] Minutes of Hadassah National Board meeting, 15 June 1949, 12.

Ministry of Social Welfare, where a Department for Child Feeding was established. The ministry intended to expand the project to include all schoolchildren in Israel, in recognition of its social and educational importance. The department expanded the School Luncheon Programme, particularly in distributing food to the children of immigrants, whose numbers grew in 1952 and 1953 to nearly 60 per cent of those receiving meals within this framework.[74] The project remained under the responsibility of the Ministry of Social Welfare until 1953, when it was transferred to the Ministry of Education.[75]

At the outset of the programme, Hadassah had felt it necessary to emphasize the educational aspect, and the need to inculcate principles of nutrition and eating habits in the entire population. It believed that schoolchildren should be taught correct nutrition, on the assumption that immigrant parents learn from their children, and that teaching proper nutrition in the schools would fulfil a social mission in this respect.[76] However, as the scale of the mass immigration grew, so did the need for the School Luncheon Programme as an instrument of social welfare.[77]

Playgrounds

The fourth child welfare enterprise that Hadassah launched in the Yishuv was a project to establish and maintain playgrounds. Again, this was modelled on a movement that emerged in the Progressive era in the United States, this time in response not only to poverty but to the level of crime prevalent in the poor neighbourhoods of towns and cities, populated mainly by immigrants. The US playground movement, founded in 1906 by Jane Addams and other welfare activists, operated to establish playgrounds in the poor neighbourhoods of large cities. These activists, drawing their inspiration from the thinker and educationalist John Dewey, saw playgrounds as a way to shield children against the harmful influence of the street and thus as a means of preventing crime as well as directly benefiting children.[78] In 1906 the Playground Association of America was founded, the first association of its type in the world.[79]

[74] On the trend and motives for expanding the programme, see the *Israel Government Yearbook 5711 [1950–1]* (Heb.), 137; on the Department for Child Nutrition as part of the welfare ministry, see the *Israel Government Yearbook 5713 [1952–3]* (Heb.), 142.

[75] On the devolution to the Ministry of Education, see the *Israel Government Yearbook 5713 [1952–3]* (Heb.), 142 (Department for Child Nutrition). [76] Hadassah Annual Report, 1947/8, 23.

[77] Hadassah Annual Report, 1950, 3.

[78] Rothman, *Woman's Proper Place*, 124, 168; Simmons, *Hadassah and the Zionist Project*, 71–2.

[79] Simmons, *Hadassah and the Zionist Project*, 72; Shehory-Rubin and Shvarts, 'The Guggenheimer–Hadassah Playgrounds' (Heb.), 81.

The playground movement, like other American movements of the time, grew out of the impulses of social responsibility and philanthropy characteristic of the Progressive era. It was based on the view that play is essential to children's psychological development, and that this would be facilitated by well-equipped, supervised places of recreation for city children. The educational aim was to organize the children's activity after kindergarten and school and teach them good living habits, which they would not learn at home in their poor neighbourhoods. Supervised activities were organized in the playgrounds, which were protected areas, fenced off and with closed gates, in the afternoons and during school holidays. Like most of the Progressive era enterprises, the playground movement aimed to reach the entire community, and opened the playgrounds to members of all ethnic groups.[80]

Following this model, in 1925 Bertha V. Guggenheimer, an American Jewish philanthropist from Lynchburg, Virginia, established a playground on Mount Zion in Jerusalem, as well as a fund for setting up playgrounds in Palestine. Earlier that year she had visited Palestine with her niece Irma Lindheim (one of the founders of Hadassah and president of the organization from 1926 to 1928), and both women had been profoundly shocked by the wretchedness of the children in the Old City, who spent their free time wandering the narrow, gloomy alleyways, playing cards, sitting idly in Arab coffee-houses, and scrabbling though rubbish cans. As a member of the association that had initiated the establishment of playgrounds in the United States, Bertha Guggenheimer took it upon herself to do the same in Jerusalem.[81]

These playgrounds were intended to achieve three objectives: to get children and teenagers off the streets after school, to direct them to worthwhile activity, and to provide a place where Jewish and Arab children could meet and learn to live together—a notion Guggenheimer took from the inclusive aims of the American playground movement. A few months after the Mount Zion playground opened, Jewish children (both Sephardi and Ashkenazi) and Arab children were playing there together. The activities encouraged included games, songs, crafts, and drama.[82]

In 1928 the trustees of the Guggenheimer Fund transferred the management of the project to Hadassah, which took on responsibility for its development and budgeting. Under Hadassah's sponsorship the playground scheme continued as

[80] Rothman, *Woman's Proper Place*, 168.

[81] Simmons, *Hadassah and the Zionist Project*, 71; Shehory-Rubin, 'Hadassah's Education and Health Projects' (Heb.), 210–11.

[82] Miller, 'A History of Hadassah', 308–10; Shehory-Rubin and Shvarts, 'The Guggenheimer–Hadassah Playgrounds' (Heb.), 83.

an inclusive, interdenominational programme: every effort was made to encourage children of all Jewish ethnic communities as well as Christian and Muslim children to use the playgrounds, and instructions were given in Hebrew, English, and Arabic. The 'games and services' programme provided was expanded, and a nurse was added to the playground staff to examine the children before they entered: any who were ill were not allowed in, and some were given medical care.[83]

As with the School Luncheon Programme, the first playgrounds were intended to serve as a model for additional projects. Hadassah planned to set up several playgrounds in the major towns to set an example for other local authorities. Every playground was managed by professional leaders; most included a paved and fenced-in sports ground, a hut for arts and crafts activities, and showers, as well as playground equipment, and offered a range of activities including crafts, gardening, drama, rhythm, and music. The playgrounds were open after school for two to three hours, six days a week.[84]

With the outbreak of the Second World War it became necessary to set up as many playgrounds as possible as quickly as possible, in order to provide children with places to play where they could be supervised in the event of an air raid. Within the two years from 1939 to 1941 the number of playgrounds in Palestine doubled, an expansion achieved through co-operation with various Yishuv organizations, including local authorities, the working mothers' organization, and the Va'ad Leumi education department, among others. In the playgrounds that Hadassah built in the moshavot its main partner was WIZO, the Women's International Zionist Organization, whose local committees were responsible for maintaining the playgrounds, while Hadassah dealt with inspection and funding of playground activities.[85] The involvement and financial support of local organizations made it possible for Hadassah to expand the scope of the project beyond its own financial capacity; but it also meant a certain loss of control over the individual projects. Some of the local bodies set up playgrounds that were less expensive to equip and run than the original model, for example. Thus the playgrounds established in this period were not all based on the American pattern, and varied both in their character and in the activities they provided.[86]

[83] On transferring the project to Hadassah, see Shehory-Rubin and Shvarts, 'The Guggenheimer–Hadassah Playgrounds' (Heb.), 309–10; on the playground activities, see ibid. 311; 'A Proposal to Devolve the Hadassah–Guggenheimer Recreational Projects to the State Education Department', ISA, RG71, box 1227, file 1 (n.d., Heb.). [84] Dushkin, 'Hadassah's Child Welfare Program', 12. [85] Ibid. 13.

[86] Ibid. For a review of the recreational activities in the playgrounds founded by Hadassah–Guggenheimer in the moshavot and examination of the need to renew activities in Tel Aviv, see 'A Proposal to Devolve the Hadassah–Guggenheimer Recreational Projects to the State Education Department' (Heb.).

What, then, was the extent of the American influence in the playground scheme as it evolved in Palestine? The first playground, set up by Bertha Guggenheimer in 1925, was equipped in a similar manner to the playgrounds in the United States, and was managed by an American, Lillian Cornfield. The American Progressive concept of providing playgrounds where children of different ethnic groups, religions, and races could mingle was translated into the aim of bringing Jewish and Arab children together in order to promote understanding between the two peoples.

However, while there was undoubtedly some similarity in the motivation behind the projects, the playgrounds in Palestine developed along lines adapted to their specific circumstances. The propensity to depart from the pure American model was demonstrated in the appointment of Rachel Schwartz, a member of the Yishuv, as director of the playgrounds in Jerusalem after Hadassah took responsibility for the project in 1928, and her subsequent appointment as supervisor of all Hadassah's playgrounds in Palestine. Schwartz had acquired her training as a kindergarten teacher in England, and it is doubtful whether she was familiar with the American model at all. Moreover, the third playground built in Jerusalem—at the Kol Yisrael Haverim school—was not organized on the original American idea, but instead was based on local experience gained in the two earlier playgrounds. Subsequently, playgrounds were built throughout the country (in Tel Aviv, Rehovot, Ekron, Gedera, and other places) on the basis of this new model.

No less important is the fact that the playground activity was organized with the help of a committee recruited entirely from the Yishuv, headed by Moshe Schwabe. Schwabe was a German-born educator whose educational principles were formed in Kovno, Lithuania, where he directed a secondary school and actively promoted Zionist ideology in the context of training youngsters in the Hechalutz movement. The aims of the playgrounds as formulated by Schwabe indicate the addition of at least one new objective to the original American model, namely, to prepare youngsters for life in a productive, co-operative society in Palestine.[87] Since the people supervising the playgrounds were largely immigrants from European countries who were guided by European educational principles and Zionist ideals, practice soon diverged from the original American model as educational aims unique to the local context were added.

At the beginning of the 1947/48 school year, the Hadassah–Guggenheimer Committee had eighteen playgrounds under its supervision, in Jerusalem, Tel Aviv, Jaffa, Lod, and Tiberias, and in and around Haifa.[88] This expansion was not

[87] Shehory-Rubin and Shvarts, 'The Guggenheimer–Hadassah Playgrounds' (Heb.), 82–5.

achieved without difficulties. A particular problem was that of recruiting youth leaders for the part-time jobs supervising playgrounds in the moshavot. Various attempts were made to cope with this problem: for example, good youth leaders were offered jobs in the schools to supplement their playground work. In 1947 Hadassah, together with the Tel Aviv municipality, set up an institute with a two-year programme for training youth leaders, but this encountered difficulties. Hadassah also funded in-service courses for playground youth leaders.[89]

After the establishment of the state, other public recreation projects were added to Hadassah's playground scheme. Every year Hadassah held two-week summer camps in Kfar Vitkin, north of Netanya, for the children who attended its playgrounds. Brief camps and trips were also held during the short vacations.[90] With the co-operation of local authorities, playgrounds were created in crowded urban neighbourhoods to operate in the summer only; some became permanent. Recreational activities were also introduced in fifteen Youth Aliyah institutions. Another related project was the initiation, promotion, and establishment by Hadassah of youth hostels, in co-operation with the Israeli national hostels association.[91]

On 1 October 1949 Hadassah handed over responsibility for all its playgrounds and other recreational projects to the Ministry of Education.[92]

VOCATIONAL EDUCATION PROJECTS

The establishment and development of vocational education training institutions in the Yishuv was one of the ways in which Hadassah fulfilled its aim of promoting progress and modernization. Underlying this work was one of the main principles that inspired all Hadassah's enterprises: pioneering.

In the Yishuv itself, however, the development of vocational education was not an obvious priority. On the contrary, until the late 1950s it was a marginal concern.[93] Three main factors accounted for this. First, the socialist strands of the Zionist movement, and to some extent others too, laid emphasis on the creation of a broad productive base and in consequence a transformation of the traditional structure of Jewish society. Agricultural work was central in this view. Despite the fact that many vocations, including the production of working tools, were considered productive, vocational education and training for work in industry were perceived as inferior to agriculture, and were therefore accorded less attention.

[88] See 'A Proposal to Devolve the Hadassah–Guggenheimer Recreational Projects to the State Education Department'. [89] Ibid. 1–2. [90] See ibid. 1–3. [91] Ibid. [92] Ibid.
[93] Zucker, 'Vocational Education' (Heb.), 449; Avigad, 'Technological Vocational Education' (Heb.), 166.

Second, the Jewish tradition and the social structure of European Jewry had always attached prestige to academic rather than vocational study. Third, Palestine, where industry was old-fashioned and generally small-scale, lacked any tradition that would serve as the foundation for industrial development. Together, these factors led to an almost total absence of demand for graduates of vocational courses. The political institutions that controlled most of the capital invested in the Jewish sector accorded no priority to developing industry, and instead channelled funds to settlement, agriculture, security, and immigration. There was no tradition of training technical or industrial workers, nor any concern that the country should create its future workforce.[94]

As a consequence of these attitudes, in the late 1940s only about one-third of pupils in the Yishuv attended agricultural and vocational schools, and of these almost one-half were in agricultural schools. In 1948 only about 2,000 students were enrolled in vocational schools.[95] Even at the end of 1949, by which time the population had doubled, only 4,000 students were attending vocational schools, and only a few hundred were enrolled on a four-year programme that combined academic and vocational studies. Most of the students in the vocational schools were taking two- or three-year courses where they acquired low-status skills, such as embroidery, sewing, carpentry, mechanics, and the like. The Ministry of Education complained that the vocational schools could not provide the workforce the Israeli economy needed, or even key workers for industry.[96]

Hadassah's view of the importance of vocational education and its potential contribution to the state-in-the-making was entirely different from the attitude of the Yishuv's leadership. As early as the mid-1940s Hadassah's leaders expressed their conviction that the youth of the Yishuv should be trained 'to take part in the modern industrial world', so that they could 'meet the productive standards of the era of mechanization'.[97] They believed that vocational training projects for young people were a way to import American technological know-how to the Yishuv and to make it a part of what was to become, in their view, a substantial element of youth education in Palestine.[98] Accordingly, in the years immediately before and after statehood, Hadassah strove to develop unique new fields of vocational training and

[94] Zucker, 'Vocational Education' (Heb.), 450–6.

[95] 'Students by Type of Institution', *Israel Government Statistical Yearbook* (Heb.).

[96] Tsameret, *A Narrow Bridge* (Heb.), 53.

[97] For the quotations and the argument, see J. Epstein, 'To Meet the Challenge of Industrialization', *Hadassah Newsletter*, 25/7 (1945), 20.

[98] Testimony of Judith Epstein before the Anglo-American Committee, *Hadassah Newsletter*, 26/1 (Jan.–Feb. 1946), 6.

education, and to set up institutions to train the workforce necessary for the new state's industrial development, a workforce armed with up-to-date knowledge and the ability to use state-of-the-art equipment.[99]

After Israel's independence Hadassah saw the provision of vocational training for young people from all sectors of the population as an even more immediate and pressing priority.[100] For example, an article by the chair of Hadassah's National Board Vocational Education Committee, published in the *Hadassah Newsletter* in 1954, claimed that the most urgent need for the economic security of Israel was to train young people in the fields of industry and agriculture. Since the Israeli government financed only elementary schools, organizations such as Hadassah, with government encouragement, put their efforts into providing young people with vocational training.[101]

Hadassah based its involvement in this field on two assumptions: first, that it could not meet all the nation's vocational education needs, and that it should therefore set up models to be followed by other institutions; and second, that, as an American organization, it could contribute American approaches and know-how which, again, would serve as an example for others to follow.[102]

The Brandeis Vocational Centre

Hadassah's systematic activity in the field of vocational education began in the early 1940s, almost twenty years after it embarked upon its public health projects. Its first venture was the establishment in Jerusalem of the Brandeis Vocational Centre. This originally comprised three elements: a trade school for girls, a vocational training centre for boys, and a vocational guidance bureau, but it was subsequently expanded as described below.

The Alice L. Seligsberg Trade School for Girls (often referred to as the Alice Seligsberg Vocational School) was founded in 1942. (It was named after Hadassah's second president, who had held office from 1921 to 1923.)[103] There were already two vocational schools for girls in the Yishuv, but neither provided any general studies;[104] the idea now was to create a vocational high school of a high standard that would enable talented young women to gain a general education alongside vocational training. Several educational ideals that were revolutionary at

[99] 'Hadassah's Work Described at Social Work Conference', *Hadassah Newsletter*, 30/11 (July–Aug. 1950), 7.
[100] Minutes of Hadassah National Board meeting, 5 Oct. 1950, 4.
[101] F. Perlman, 'Training Youth for Israel's Future', *Hadassah Newsletter*, 34/6 (Feb. 1954), 6.
[102] Memo on the Seligsberg School, n.d., ISA, RG71, box 1719, file 241/1. [103] Ibid.
[104] H. Kittner, 'Review of Vocational Education for Girls', 27 Sept. 1943, CZA, JI7/3477, 3–5 (Heb.).

the time guided the work of the school in its early years. In particular, it aimed, first, to offer girls from underprivileged backgrounds the opportunity to acquire both a general education and a trade, and to improve their quality of life by training them as both home-makers and professionals; and second, to uproot a misconception—as Hadassah's leaders considered it—originating in Zionist pioneering ideology to the effect that the roles of women were inferior to those of men. This aim was consistent with the 'social feminism' that had guided Hadassah from the outset. Accordingly, one of the school's objectives was to change the approach of the girls to work in the domestic arena,[105] as well as to train a good workforce in the 'women's professions' needed in the Yishuv: sewing, cooking, nursing, and office work.

At the time the school was founded, in the middle of the Second World War, it was all but impossible to leave or enter Palestine. Consequently, the preliminary planning and preparations for the opening were carried out by a management committee comprising representatives of the Hadassah Council in Palestine (see Chapter 3) and the Va'ad Leumi. Among the most difficult of the committee's tasks was the selection of a principal for the school, for there were no candidates who had the appropriate general and professional education to run a school of this type and also knew Hebrew. They finally chose Helen Kittner, a woman in her early thirties who had previously directed the WIZO vocational school in Haifa and was married but had no children.[106] Helen had been brought up in Poland and had studied literature and classical languages at university in Lwów. She had no formal training in the field of vocational education, but only some training in education in crafts, which she had acquired in Vienna. Kittner shaped the final concept of the Seligsberg School. As its principal she was viewed by her pupils as a person who demanded very high standards, insisting on precision and perfection, and they feared her.[107]

When the Seligsberg School opened in 1942, forty-two girls enrolled. An effort was made to supply the school with the best of American techniques and equipment. Among other things, a great deal of material on pattern-making originated in the United States, where it was translated into Hebrew before being sent to Palestine. Two collections of books—most of them on general and technical topics, but also a considerable number of classics and literary works—were sent from the United States to form the core of a library. Hadassah also sent professional

[105] Memo on the Seligsberg School, n.d.
[106] Minutes of the third meeting of the management committee for the Seligsberg Trade School for girls, 9 June 1942, CZA, J17/3477 (Heb.).
[107] Ibid.; interview with Nina Caspi, student at the Seligsberg School 1956–60, 15 Dec. 2000.

literature developed by the US Federal Vocational Education Department in Washington, DC. Professional teachers were recruited to the teaching staff; after the war, some of them were sent to the United States with Hadassah fellowships for inservice courses, as was customary in all Hadassah's projects in Palestine, while others were sent to Switzerland for training.[108]

The Seligsberg School belonged to the network of schools operated by the Va'ad Leumi and was subject to its supervision. Final formulation of the concept underlying the school, the choice of principal, the renewal of her appointment, the development of the curriculum, and the management of its operations were all carried out locally and by local people; unlike so many of Hadassah's other activities, it is therefore not possible to identify an underlying American model. Indeed, the planners explicitly said that they could not base themselves on models from other countries as the conditions prevailing in the Yishuv were unique.[109]

By 1950 the Seligsberg School was offering three training programmes: secretarial work, baking and home economics, and sewing. It also offered girls courses in cooking, baking, weaving, embroidery, and other subjects.[110] Later, it introduced programmes for dental technicians (1955), laboratory technicians, and other specializations required by the Hadassah Medical Organization. In 1957 there were 325 girls in six programmes: fashion (sewing and pattern-making), handicrafts (making wood and metal souvenirs), nutrition (cooking), clerical skills (secretarial skills and book-keeping), and courses for laboratory technicians and dental assistants.[111]

In keeping with Hadassah's tradition of sending its project managers to study in the United States, in 1957 the school principal, Helen Kittner, went to America to study for five months. On her way back she stopped in Paris to buy patterns based on the latest fashions in the French capital. The annual report submitted to Hadassah's Forty-Fourth Annual Convention in 1958 proudly announced that the wife of the president of Israel, Rachel Yanait Ben-Zvi, wore a dress made by the

[108] On the number of students when the school was founded, and on Helen Kittner, see approval of Helen Kittner's appointment from Dr Michael Ziv (director of the Ministry of Education Department of High School Education), 23 July 1958, ISA, RG71, box 7888, file 3 (Heb.); on the equipment of the school and the library, see 'Vocational Education', *Hadassah Newsletter*, 24 (Convention Issue) (Nov. 1944), 18–19; on the teachers at the school, see e.g. memorandum of understanding from the meeting of the supervisory committee held 31 Jan. 1951, ISA, RG71, box 1719, file 5; letter from Helen Kittner to Michael Ziv, 10 Jan. 1956, ISA, RG71, box 7888, file 3. [109] Kittner, 'Review of Vocational Education for Girls', 3.

[110] Hadassah Annual Report, 1950, 1 (Hadassah Youth Services).

[111] Letter from Engineer M. Peled (supervisor of crafts instructions) to M. Niv (Pedagogical Secretariat), 13 Mar. 1957, ISA, RG71, box 7195, file 1 (Heb.).

Seligsberg School to the official reception held by the president and his wife for the queen of The Netherlands. Some of the gifts presented to the queen were also made by the school's students, the report noted. The same year, the cornerstone was laid for the school's new building on Hanevi'im Street.[112]

In 1957, after three years of preparation, the structure of the school was changed to a twin-track system: a technical and academic study track leading to a Ministry of Education matriculation (*bagrut*) certificate, alongside a vocational track leading to a Ministry of Labour graduation diploma. That year the Seligsberg School became the first vocational school in Israel to receive Ministry of Education approval to administer matriculation examinations.[113]

The Brandeis Centre workshops for boys were also upgraded after Israel's independence, and by 1954 there were 100 students.[114] Hadassah was particularly proud of the workshops' high-standard equipment, and the fact that they were among the best, if not the very finest, in Israel.[115]

The Vocational Guidance Bureau, established as the third part of the Brandeis Vocational Centre in 1942, was an integral part of Hadassah's vocational training projects in Palestine. (Later, in 1965, it became the Vocational Guidance Institute and then, in 1989, the Hadassah Career Counselling Institute.) Like many of Hadassah's projects, it was stimulated by Hadassah's aspiration to allow the Yishuv to benefit from the newest American techniques. However, the final decision to set up the bureau came as a result of a recommendation by Dr (later Professor) Eliezer Rieger, a senior figure in the Va'ad Leumi's Education Department and one of the founders of the Hebrew University High School in Jerusalem. Hadassah appointed a founding board of directors, which was composed of the best scholars in psychology and education at the Hebrew University, as well as some key practitioners in these fields in the Yishuv. Dr Alexander Dushkin, the husband of Hadassah's first nutrition expert in Palestine, Julia Dushkin (herself a member of the Hadassah Council in Palestine), was appointed to represent Hadassah. To oversee the establishment of the bureau Hadassah recruited Dr Irwin Ernstein, who had previously directed a vocational guidance bureau in Haifa and was considered the finest of the few experts in the Yishuv in the field of vocational guidance.[116]

At first, the Vocational Guidance Bureau focused on developing psychometric tests, as a tool for examining the skills and interests of its clients. The bureau was not the first institution in the Yishuv to apply such examinations; several such tests

[112] Hadassah Progress Report: Projects and Activities, 1957/8, 30. [113] Ibid.
[114] Hadassah Annual Report, 1953/4, 33. [115] See e.g. Hadassah Biennial Report, 1949–51, 36.
[116] Sardi, *The First 45 Years*, 6–11.

were already in use, but most were translated from foreign languages and not adapted to the local situation. Furthermore, the bureau claimed that the existing tests examined only a relatively limited range of fields. Therefore, it undertook to prepare the first psychometric tests which covered all fields required at the time, and to adapt them to the situation in Palestine. As early as 1946/7 the institute tested students in Jerusalem, Haifa, and many other places, reaching approximately 20 per cent of the total number of students in the Yishuv.[117]

The Vocational Guidance Bureau expanded its activities after the state was established, to include promoting the field of vocational guidance in Israel. As early as 1950 it administered diagnostic tests to all elementary school graduates in Jerusalem and Haifa, and also gave vocational counselling to students, recently demobilized soldiers, new immigrants, and the underprivileged. The range of tests included intelligence tests, personality tests, and tests of proficiency and skills.[118]

In 1951 the bureau began advising candidates for the Nurses' Training School and for teaching missions to Jewish schools in the Diaspora. In this way, the bureau enlarged its target public and its activity in general. By the early 1950s its services were widely used: the IDF frequently consulted the bureau and co-operated closely with it,[119] as did government ministries and other public agencies. The education system also began using the bureau's diagnostic tests regularly, as a tool for guiding children finishing elementary school regarding their further education. In 1951 guidance tests were administered to all elementary school graduates in the three largest cities in Israel (Tel Aviv, Jerusalem, and Haifa), as well as in Netanya and elsewhere. The bureau was also involved in testing prospective employees of several government ministries.[120]

Recognizing the need to train psychometric testers to administer the tests, in 1952 Dr Ernstein and Professor Dushkin introduced the first course of this type in Israel. In co-operation with the Ministry of Education, the IDF, Tel Aviv municipality, and other authorities, all of which had responded enthusiastically to their proposal, they trained forty psychometric testers, drawn partly from the student body at Hebrew University and partly from government agencies and public institutions.[121]

In addition to providing vocational guidance and training psychometric testers, the bureau also responded to the increasing awareness of vocational guidance and research. Through publications, lectures, and seminars addressed to students,

[117] Ibid. 15. [118] Hadassah Annual Report, 1950, 2. [119] Hadassah Annual Report, 1948/9, 19.
[120] Hadassah Annual Report, 1952, 25. [121] Ernstein, *Research in Vocational Guidance* (Heb.), 8.

school principals, social workers, and the general public, Dr Ernstein and the Vocational Guidance Bureau spread the idea that a proper education system should provide guidance to its teenage students and those beginning their careers, and that psychometric examinations and vocational guidance were important means to this end.[122]

After the establishment of the state, the Brandeis Vocational Centre developed a fourth project, namely, post-secondary training institutes. In 1949 Hadassah set up the first of these: the Fashion and Design Institute, followed in February 1950 by the Hadassah Hotel Management School. Both were founded with the aim of supporting industrial development in Israel by training professionals for managerial positions. They were headed by Helen Kittner, who considered their development of tremendous importance, and supervised by advisory committees.[123] Other activists on the Hadassah Council in Israel also worked hard to develop the two institutes in order to promote Israeli industry, which in their view desperately needed professionals in the fields of fashion and hotel management.

The Fashion and Design Institute offered a two-year post-secondary training course. Its aim was to bring state-of-the-art production methods to Israel, to promote the sector's development, even 'to change the fashion industry in Israel'.[124] Helen Kittner believed that the job of the institute was to 'help correct the [current] inefficient production methods in the fashion industry'.[125] In its first year, the institute taught thirty-four students in two programmes, one in fashion drawing and one in drawing on textiles and pattern-making. In the second year the students were given a concentrated course in a small factory adjacent to the school; also, among other activities, they prepared fashion shows for the Hadassah annual convention 'with the aim of arousing the enthusiasm of its members'.[126]

The institute was not, however, without its problems. A year after its establishment Helen Kittner began hunting for an expert in fashion to help set up a workshop for teaching new methods of manufacturing clothing and to contribute significantly to constructing an efficient industrial system. This was the only way, she claimed, to fulfil the purpose of the institute, which was intended not to be just another sewing school, but to improve the methods of Israel's inefficient fashion industry. She turned, among others, to Ralph Harris, production manager of Ata (one of the largest textile factories in Israel), but together they reached the conclusion that there was no suitable expert in Israel, and that one would have to be

[122] Ernstein, *Research in Vocational Guidance* (Heb.), 8. [123] Hadassah Annual Report, 1950, 43.
[124] Ibid. 3–5; For the quotation, see memorandum of the meeting of the Supervisory Committee held on 20 Dec. 1950, ISA, RG71, box 1719, file 5. [125] For the quotation, see ibid. [126] Ibid.

recruited from the United States. She applied to the Hadassah National Board, but her request was turned down, the board taking the view that the small number of students at the institute did not justify sending such an expert to Israel. At this point, a conflict emerged between Kittner and her colleagues in Israel on the one hand, and the National Board on the other. The board, she claimed, was seeing the project through 'American' eyes (that is, quantitatively), and neglecting its original purpose, in which, she believed, 'the number of students was not a factor'.[127]

The Hadassah Hotel Management School, which was set up in early February 1950, was the first post-secondary school in this field in Israel. It was established with the aim of promoting tourism, which was perceived as important for the development of the economy and a crucial source of hard currency. Convinced that Israelis lacked the necessary skills and training in hotel management, Hadassah recruited Jewish experts and academics from the United States to help set up the school. Samuel B. Iseman, head of the Institute of Applied Arts and Sciences at the State University of New York in Brooklyn, was seconded to Hadassah to launch the project, with the aim of establishing a school modelled on the institute's Hotel Department.[128]

Iseman arrived in Israel, equipped with a curriculum based on the 'most innovative American approach', to direct the school for the first six months. He was joined by Daweta Waldman, a graduate of the Hotel Department at his institute, who came to supervise the course in home economics, bringing with her a heavy load of modern equipment for the school. The report to Hadassah's Thirty-Sixth Annual Convention in 1950 noted the innovative American methods and the modern equipment that had been taken to the school, and expressed the hope that it would serve as a model for similar schools. Another partner in the school was the Israel Hotel Association, which appointed an advisory board to assist in its establishment.[129]

In its first year, twenty-two high-school graduates registered for the school. The first course trained workers in hotel administration and economic management, and its graduates found work in Israel's finest hotels, such as the King David in Jerusalem, and the Sharon and the Accadia in Herzliya, where there was a shortage of employees trained in hotel skills.[130] However, applicants for further courses were few. Helen Kittner and Myriam Granott, vice-chair of Hadassah Youth Services, made efforts to recruit more students for the course, and even applied to the Prime Minister's Office to find candidates from among the newly demobilized soldiers

[127] Ibid. [128] Hadassah Annual Report, 1950, 4. [129] Ibid. 4–5. [130] Ibid. 5.

and the leading high schools in the three major cities. In 1952 the school moved from Jerusalem to the Ramat Aviv Hotel in Tel Aviv, but even here it could attract no more than thirty-five students. In the light of these and other difficulties, Hadassah decided to transfer management of the school to the state. This was done in 1957, without any agreement having been reached on the school's future. It was closed the same year.[131]

Notwithstanding the problems encountered in these two ventures, Hadassah continued its efforts to establish new vocational education projects. In 1954 it set up a course for dental assistants, and in 1955 the National Board proposed a project to train teachers of vocational education, together with the Hebrew University, in response to the national shortage of such teachers. However, this initiative was never implemented.[132]

CO-ORDINATION AND
RESEARCH: THE SZOLD INSTITUTE

In 1941 the Vaad Le'umi committed itself to setting up the Henrietta Szold Institute for Child and Youth Welfare to co-ordinate the activities of the various agencies working in this field. The need for such a body had been apparent since the 1930s.[133] It was eventually established at the initiative of Henrietta Szold, then head of the Social Welfare Department of the Va'ad Leumi, who asked Hadassah to use the foundation it had established in 1936, in honour of her seventy-fifth birthday, for this purpose. Hadassah not only agreed but added to the funds available, thus enabling the institute to be set up.

The Szold Institute set itself three goals: first, to organize and co-ordinate the activities carried out for the benefit of children and teenagers, and to improve the social condition of young people in the country; second, to collect information on developments and innovations in various fields relating to the care and promotion of young people throughout the world; and third, to initiate and conduct research to promote activities to benefit young people.[134]

The idea in its original form was not implemented, and the Szold Institute did not become a co-ordinating body for the different organizations that dealt with children and teenagers, even after the establishment of the state. Nevertheless,

[131] Hadassah Annual Reports, 1955/6, 1957; Hadassah Progress Report: Projects and Activities, 1957/8, 37. [132] Minutes of Hadassah National Board meeting, 23 Mar. 1955, 3.

[133] Deutsch, 'The Development of Social Work' (Heb.), 214.

[134] 'The Institute for Children and Youth', 7 (Regulations of Association), 3, 5 (Heb.).

prior to that point the institute did initiate several projects for the benefit of teenagers. Particularly noteworthy was the establishment in 1942 of a network of boarding schools, institutions that could provide children with a holistic residential and educational environment.[135]

After Israel's independence, the Szold Institute focused on applied research and on the dissemination of information among professionals in fields related to children and teenagers, according to the pressing needs of the time.[136] For this purpose, in 1950 the institute founded the quarterly journal *Megamot* (Trends), subtitled *Child Welfare Research Quarterly*. The topical relevance of this publication should be viewed against the background of the difficult situation during that period, in which large-scale immigration was bringing great numbers of children and youngsters with emotional disorders into the country at a time when professionals qualified to deal with them, such as social workers, psychologists, and psychiatrists, were in short supply. The founder and first editor of the quarterly was the Berlin-born psychologist and professor of education Dr Karl Frankenstein (1905–90), one of the first theoreticians and researchers into the influence of a poor cultural background and mental neglect on cognitive development. Under Frankenstein's leadership, the journal held an overall view that the different professionals working with young people (teachers, dietitians, social workers, and others) should make themselves aware of developments in the various fields of education and therapy, with the aim of 'seeing the problem in its entirety and freeing [themselves] from narrow professional work'.[137] *Megamot* published diverse articles on methods of teaching and diagnosis, services for children and teenagers in Israel and abroad, and educational patterns in different ethnic communities (*edot*) within Israeli society.[138] It also included reviews of professional literature on issues related to children and teenagers.

[135] The failure to realize the original concept of the Szold Institute is the author's conclusion; see also Frankenstein, 'The Path of the Szold Institute' (Heb.). On the early activity of the Szold Institute and the establishment of closed boarding schools, see Deutsch, 'The Development of Social Work' (Heb.), 215.

[136] The author's conclusion. See also Frankenstein, 'The Path of the Szold Institute' (Heb.).

[137] Opening page (untitled, Heb.), *Megamot*, 7/1 (Jan. 1956), n.p.

[138] For examples of articles dealing with teaching and diagnosis, see Shor, 'Methods of Teaching' (Heb.); Shubert, 'The Sandy Test' (Heb.); Ortar, 'An Intelligence Test' (Heb.); Frankenstein, 'Anxiety among Children' (Heb.). On information about services for children and teenagers in Israel and abroad, and their evaluation, see e.g. Etron, 'Impressions of Education' (Heb.); Gross, 'High School and Education' (Heb.). On the education patterns of different communities, see e.g. Feitelson, 'Education of Young Children' (Heb.); see also the memorandum of the meeting of the Executive Committee of the Szold Foundation for Children and Teenagers, 14 Nov. 1950, 1, CZA, S75/5430; 'Publications to be Issued by the Szold Foundation in 5711 [1950–1]', n.d., CZA, S75/5430.

The Szold Institute published books and popular guides on child care, as well as professional literature in the fields of teaching and social work with children. Some of these were translated from English and adapted to the conditions in Israel.[139] The institute also undertook research on a wide range of subjects, particularly problems consequent on mass immigration, for example, the care of mothers and infants, teaching problems, learning problems among children of the oriental communities, and services for children in the temporary immigrant settlements (*ma'abarot*).[140]

PERSONAL WELFARE AND THERAPY: PSYCHIATRIC COUNSELLING OF CHILDREN

Another innovation that Hadassah introduced in Israel was psychiatric counselling of children and teenagers. In 1949 the Lasker Mental Hygiene and Child Guidance Clinic (today part of the Hadassah Medical Organization Department of Psychiatry) was established with the assistance of funding obtained through Dr Haim Yassky's efforts to promote the field of psychiatry in the country.[141] Thanks to these efforts, the philanthropist and financier Albert Lasker, who was the brother of Etta Rosensohn (then chair of the National Board Hadassah Medical Organization Committee), was persuaded to donate $50,000 for this purpose.[142]

The agreement between Yassky and Lasker stipulated that the funds be used to finance a project encompassing both the study of mental health problems and practical work, with particular attention to the needs of new immigrants. It further specified that Lasker's funds would be used to support the operation for three years, during which time additional contributions would be secured to ensure the continuation of the project. The Hadassah Medical Organization was required to submit a plan setting out how the money would be used.

In March 1948 the regulations of the Lasker Foundation for Promotion of Mental Health in Palestine defined its purpose as being 'to promote research and

[139] Report on the Care of Mothers and Infants in Israel (Heb. and Eng.), CZA, J113II/232/2; Szold Institute, Information Brochure 3, CZA, J113II/232/2.

[140] See e.g. Ortar and Frankenstein, 'Proposal of a Method' (Heb.); on the review of services for teenagers in temporary immigrant settlements, see e.g. Smilansky, 'Review of Services in the Temporary Immigrant Settlements' (Heb.), 153–70.

[141] Letter from Dr Haim Yassky to Dr M. Brachyahu, Dr Theodore Gruskah, and Ms A. Druckman, 8 Mar. 1948, CZA, J113II/121/3.

[142] Letter from Dr Haim Yassky to Dr Israel (Lipman) Halprin (Department of Neurology, Rothschild-Hadassah University Hospital), 18 Feb. 1948, CZA, J113II/121/3.

practice with the aim of improving the mental health of the Yishuv in Palestine'. It was determined that the foundation would be managed by the Hadassah Medical Organization, which would set up a staff of professionals, led by Dr Yassky, for this purpose.[143] According to the foundation's regulations, its activities, research, and therapy would be carried out at the Hadassah-Hebrew University Medical Center, in other Hadassah institutions, and in public institutions, such as the Histadrut Health Fund.[144]

The foundation's money was used to purchase a villa in the Katamon neighbour- hood of Jerusalem, along with advanced diagnostic and therapeutic equipment. The centre's first director was Dr Gerald Caplan, a respected psychiatrist who emigrated to Israel from England in 1948 and took up his position in September 1949. Prior to his emigration, Caplan had held a senior post at the Tavistock Clinic in London, a public mental health clinic with a worldwide reputation; he had specialized in psychoanalysis and acquired experience in mental health therapy for children. An experienced social worker from a training clinic in England with a psychoanalytic approach stayed in Israel for six months in order to supervise the establishment of the centre. Most of the staff members—social workers, psych- ologists, and teachers—were recently qualified professionals who had emigrated from England and the United States. The Lasker Clinic opened its doors to the public on 1 November 1949.[145]

The primary aim of the clinic was to guide key figures in education and the teaching staffs of educational institutions in Jerusalem in providing the children under their care with an emotional environment that would support the develop- ment of a healthy personality. Another aim was, so far as possible, to diagnose and treat children suffering from mental disorders before they reached a pathological stage; thus it restricted its activity in this area to the treatment of infants and pre- school children. It also provided services to pregnant women, families, and young children at Hadassah's health welfare stations, and to children in kindergartens in Jerusalem, and advised and trained teachers in the methods suitable for treating children with behavioural disorders.[146]

In January 1950 Youth Aliyah and the Lasker Clinic reached an agreement whereby the clinic would undertake responsibility for research, diagnosis, and

[143] Preliminary Progress Report of the Lasker Mental Hygiene and Child Guidance Center of Hadassah Covering the First Three Months, 1.1.49–31.1.50 [sic],The Henrietta Szold Documentation Center of Youth Aliyah, CZA, 621.42, p. 3.; Rothblat, 'Lasker Mental Hygiene Clinic', 5; HMO Interim Progress Report, 5714 (1953–4), 6; letter from Dr Haim Yassky to Dr Israel (Lipman) Halprin, 18 Feb. 1948, CZA, J113II/121/3 (Heb.). [144] Lasker Fund, General Regulations, app. A, 4 Mar. 1948, CZA, J113II/121/3 (Heb.).
 [145] Ibid. [146] HMO Interim Progress Report, 5714 (1953–4), 6–7.

recommendations for treatment in respect of children suffering behavioural disorders in Youth Aliyah institutions throughout the country; train Youth Aliyah teachers and youth leaders in how to deal with children suffering from behavioural disorders; and advise on problems related to children in special institutions and foster families.[147] Another important aspect of the clinic's work was giving lectures on psychology to the staff of Hadassah, paediatricians, nurses, employees in the field of child welfare from other authorities outside Hadassah, and Youth Aliyah staff.[148] In this way the Lasker Clinic gave Youth Aliyah a professional therapeutic aspect that it had lacked.

Dr Caplan sent the clinic's staff for in-service training in the United States and England, as he believed that this was the only way to create a centre with 'the fitting scientific standard for a centre of mental [health] work in Israel'.[149] Caplan preferred to send his staff to study abroad rather than import an expert from the United States who was not familiar with the special conditions of the country, a view shared by Dr Kalman Mann, director of the Rothschild-Hadassah University Hospital. It was decided that Dr Caplan would be the first to travel for in-service training, and would be followed by other staff members.

Over time, the centre concentrated increasingly on research, as Caplan strove to establish its international scientific reputation and accordingly made efforts to involve it in international research projects.[150]

Hadassah's projects for children and teenagers involved a wide range of activities. As well as supporting Youth Aliyah (as described in the next chapter), it established health and welfare projects, as well as institutions for vocational education and training, vocational guidance, and child psychiatry. A considerable proportion of these were actually cultural imports: that is, they represented the introduction of new methods and fields by Hadassah representatives and their development to suit the needs of the country. Some were the outcome of initiatives by Henrietta Szold, who played a central role in shaping the activities of Hadassah in the Yishuv. In introducing and developing these projects, Hadassah drew inspiration from the

[147] Lasker Foundation, General Regulations, app. A, 4 Mar 1948, CZA, J113II/121/3, p. 3.

[148] HMO Interim Progress Report, 5714 (1953–4), 5.

[149] For the quotation, see the memorandum of a conversation with Dr Gerald Caplan, 28 Oct. 1951, CZA, J113II/122/3 (Heb.).

[150] Lasker Mental Hygiene and Child Guidance Center of Hadassah, Annual Report, June 1952–June 1953 (Jerusalem, June 1953), CZA J113II/122/4, n.p.

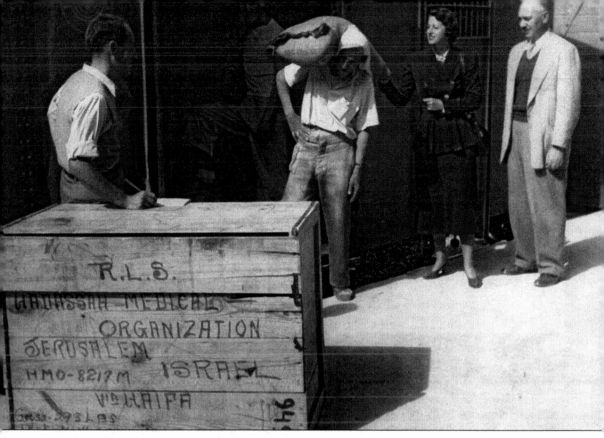

Plate 31. Supplies sent from the United States by Hadassah arriving in Israel, 1951. Mrs Ben Cooper speaks to one of the workers unloading sacks from the train with an Israeli customs inspector looking on

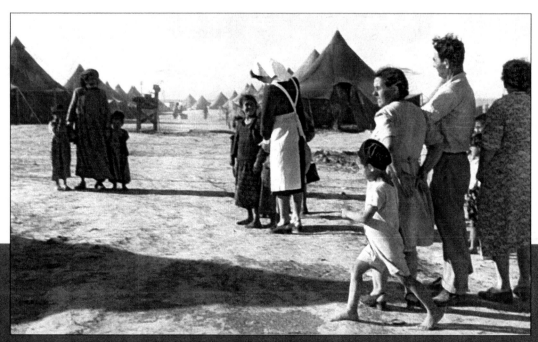

Plate 32. Nurse in new immigrant camp, Beersheba, 1951

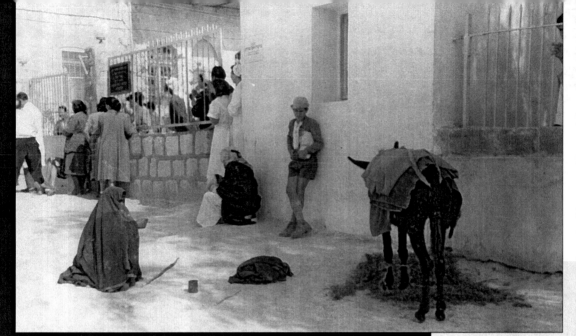

Plate 33. In front of the Hadassah-Yassky Memorial Hospital, Beersheba, 1954

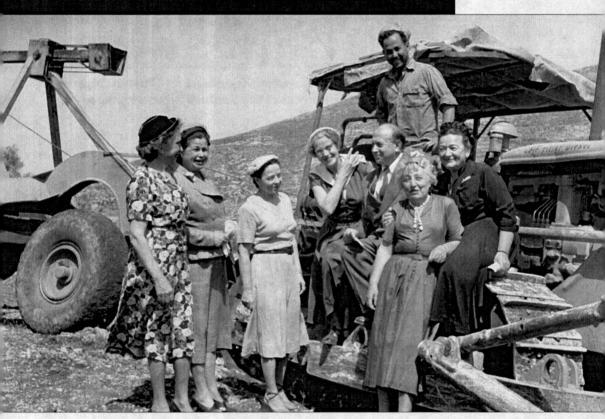

Plate 34. Hadassah leaders visiting the site of the new Hadassah-Hebrew University Medical Center in Ein Karem, 1952, around the day of the groundbreaking. *Left to right*: Ethel Agron, Bertha Schoolman, Rose Halprin, Marian Greenberg, the physician Dr Kalman Mann (director general of the Hadassah Medical Organization), Judith Epstein, Rebecca Shulman

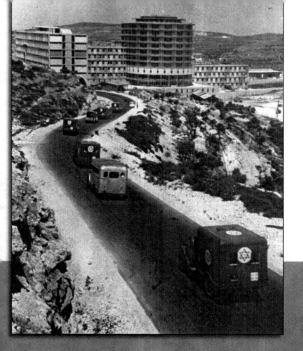

Plate 35. Moving day: ambulances transport patients to the new Medical Center in Ein Karem, 1961

Plate 36. Members of the Hadassah National Board in front of the Hadassah-Hebrew University Medical Center in 1964, three years after its opening

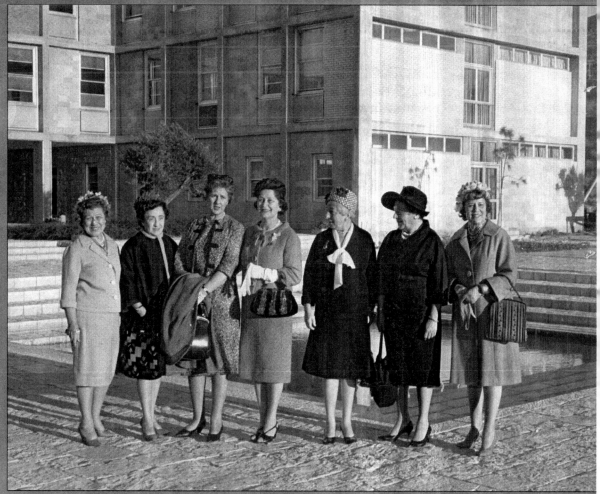

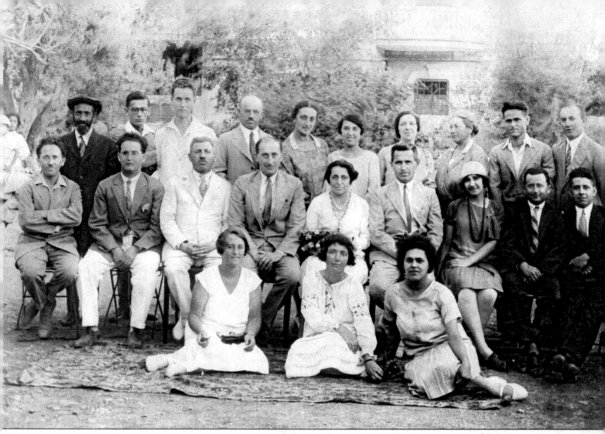

Plate 37. Staff of the Hadassah management office in Palestine, 1928. *Standing, back row, fourth from left*: Dr Mordecai Brachyahu (Borochov). *Seated, second row, fourth from left*: Dr Haim Yassky

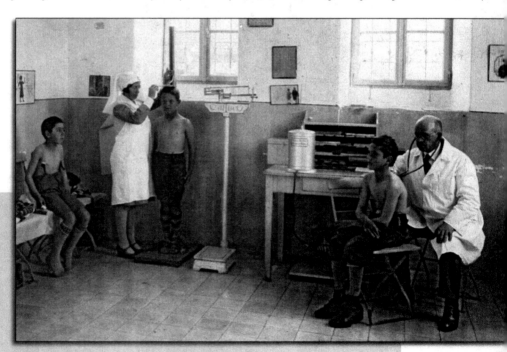

Plate 38. Dr Mordecai Brachyahu (*far right*) carries out tests on a child in a Jerusalem clinic, 1930

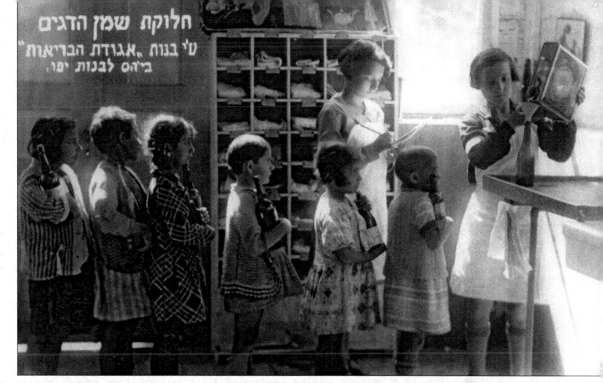

חלוקת שמן הדגים
ע״י בנות „אגודת הבריאות"
ביה״ס לבנות יפו.

Plate 39. Distribution of fish oil at a girls' school in Jaffa by older girls belonging to a health society, 1920s

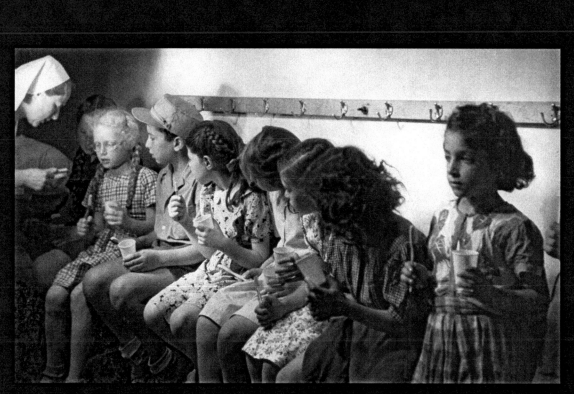

Plate 40. Girls with toothbrushes given to them as part of the School Hygiene Service, late 1940s/early 1950s

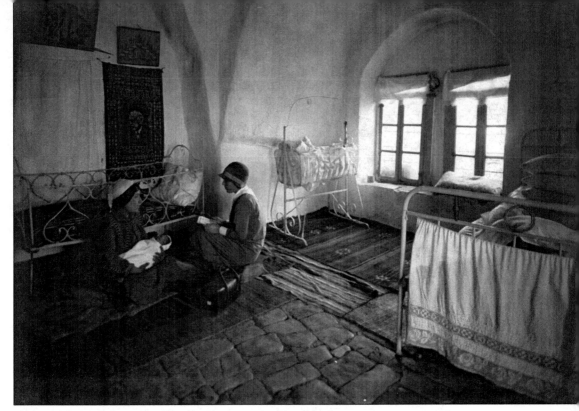

Plate 41. A Hadassah public health nurse visiting a home in the Old City of Jerusalem, late 1920s or 1930s. The nurse's uniform is modelled on that worn by New York City visiting nurses at the time

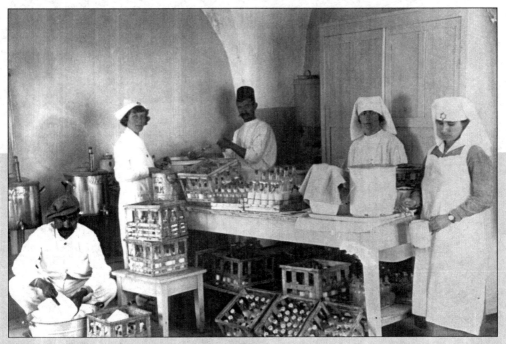

Plate 42. Pasteurized milk being prepared for distribution at a mother and child welfare station in the Old City of Jerusalem, 1925. *Left, standing:* Bertha Landsman (1882–1962), one of the pioneers of public health in the Yishuv and the founder of Hadassah's infant health welfare stations

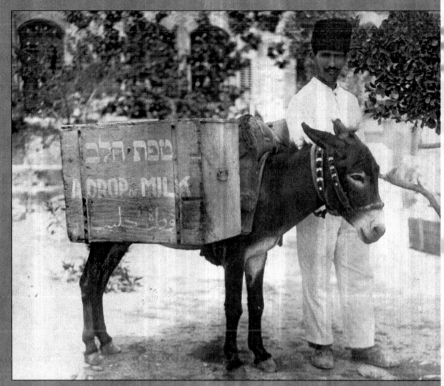

Plate 43. Bottles of milk prepared daily at the welfare station in David Street in the Old City of Jerusalem were delivered to the Rothschild Hospital by donkey, 1925. From there they were distributed to mothers by the Council of Hebrew Women

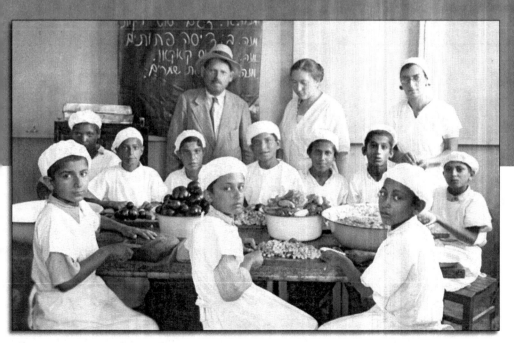

Plate 44. Boys preparing luncheons in a religious school for boys in which most pupils were Jews of Yemeni origin, Tel Aviv, mid- to late 1930s

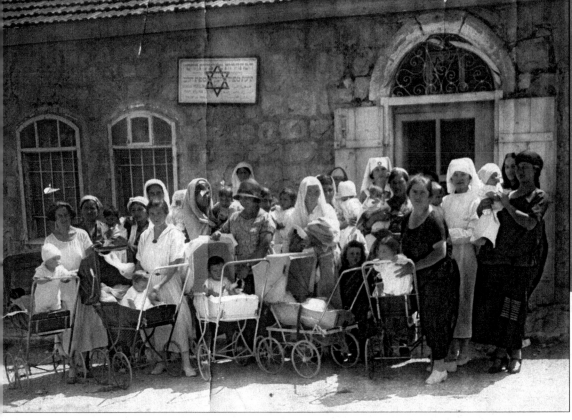

Plate 45. Mothers with their babies outside an infant health welfare station run by Hadassah in Jerusalem, 1928

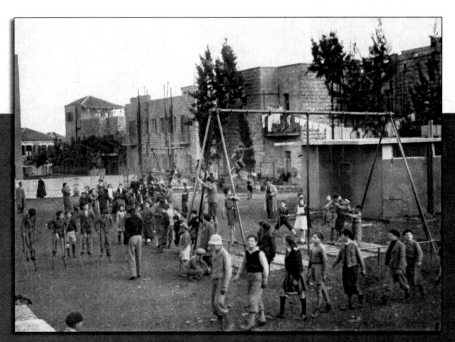

Plate 46. Children playing at the Hadassah playground in the Mekor Baruch neighbourhood of Jerusalem, 1928

Plate 47. Helen Kittner (1910–78), the first headmistress of the Alice L. Seligsberg Trade School for Girls (1942–77), 1947

Plate 48. A young patient at the Albert and Mary Lasker Mental Hygiene and Child Guidance Clinic, 1955

Plate 49. Gisela Wyzanski (*centre*) and Lola Kramarsky (*right*) were very active in support of Youth Aliyah during the 1940s and 1950s. Here they are representing Hadassah at the Youth Aliyah conference, 17 April 1950

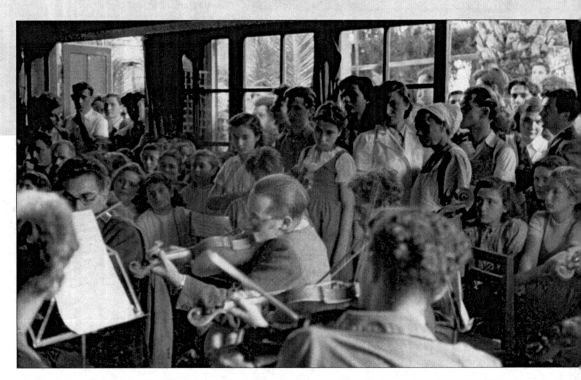

Plate 50. Wards of Youth Aliyah at a musical performance given at the celebrations in honour of Henrietta Szold's eightieth birthday, Ben Shemen, 24 December 1940

Plate 51. Henrietta Szold interviewing one of the Tehran Children, 1943

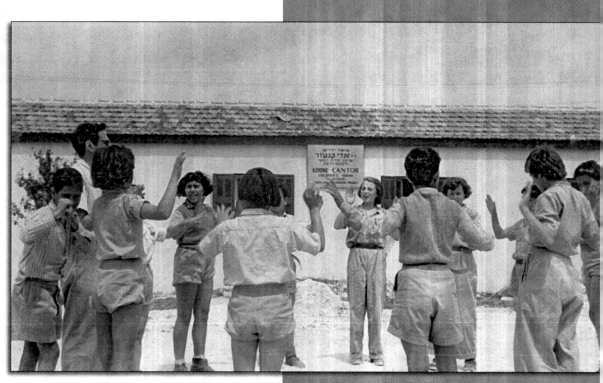

Plate 52. Children in the care of Youth Aliyah playing at a children's home named after Eddie Cantor, 1951. The Jewish actor and entertainer helped to raise funds for Hadassah's Youth Aliyah for more than thirty years

Plate 53. Judith Steiner Freud, director of the Henrietta Szold Hadassah-Hebrew University School of Nursing (1968–83), and a leading figure in the establishment of nursing as an academic discipline in Israel

Plate 54. The physician Dr Kalman Mann, director general of the Hadassah Medical Organization (1949–81), 1950s

Plate 55. The four-generation life member pin. Each medallion represents a generation— grandmother, mother, daughter and granddaughter

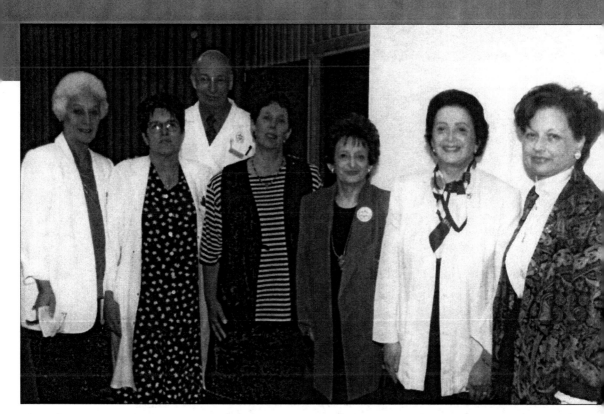

Plate 56. Organizers of and participants in the Women's Heart Disease Symposium held by Hadassah Israel in Jerusalem, 1990s

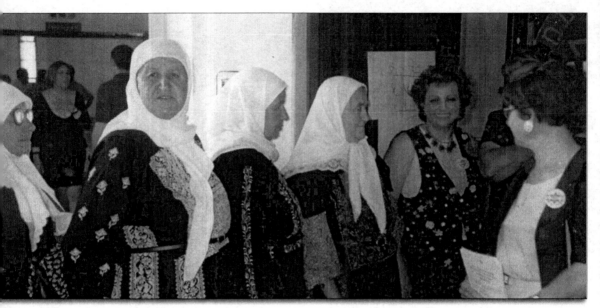

Plate 57. Arab women waiting in the Jerusalem Mall for heart examinations organized by Hadassah Israel, 1990s

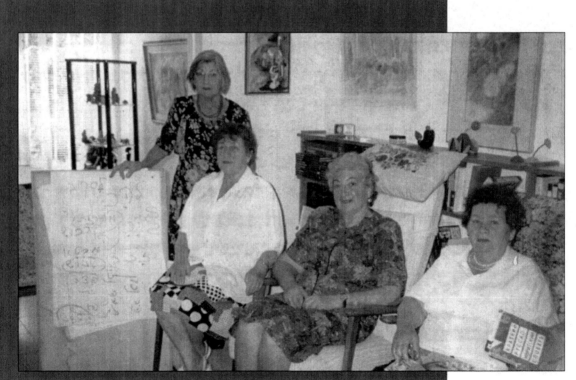

Plate 58. A member of Hadassah Israel gives tuition in Hebrew at her home to new immigrants from the former Soviet Union, 1990s

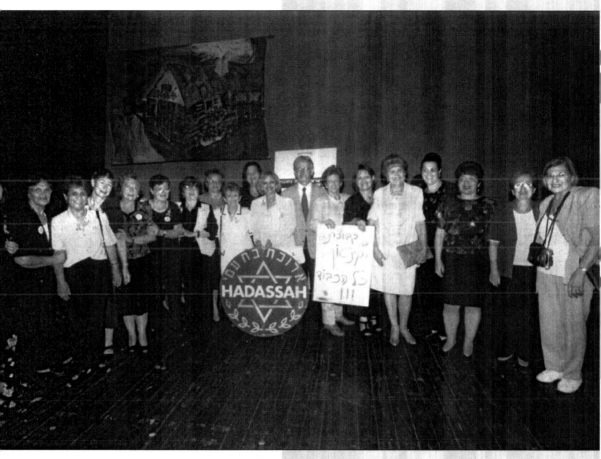

Plate 59. Hadassah Israel fundraising organizers, Jerusalem, July 1994

American women's movements, as well as from the wider ethos of the Progressive era in the United States.

Hadassah's aim of bringing modernity and progress to the Yishuv and Israel, the ideal of service, and the priority attached to a scientific orientation and professionalism were expressed in all its enterprises involving children and young people. Several of those in the field of vocational education were also aimed at promoting the development of industry and tourism in Israel. Many of them were the first of their kind to operate in the country, thus expressing the pioneering ideal that served as the ideological basis for many of Hadassah's projects.

In working to benefit children and teenagers, Hadassah implemented ideas drawn from work with distressed populations—mainly immigrants—in the United States in the early twentieth century, and adapted them to what they perceived as the needs of the Yishuv. This is an interesting aspect of Hadassah, which seems to have held a distinctively patronizing view of the Yishuv, and later of the young Israel, as an underprivileged community, albeit one with promise. This approach is reflected in Hadassah's concentration on the development of vocational education and different aspects of welfare, and not on academic education, which was the focus of its activity in the United States.

The study of Hadassah's projects in the area of child and adolescent welfare reveals patterns of activity that are characteristic of all its projects in the country: training or in-service training at the managerial level in the United States; emphasis on the most modern methods and equipment; creation of projects that would serve as models for others; and the recruitment of American experts for training, supervision, and evaluation, while local teams were charged with project implementation.

Projects for Immigrant Children and Teenagers

HADASSAH'S WORK in caring for children and teenagers in Israel's early years laid a particular emphasis on the care of young immigrants, who in the early 1950s constituted some 71 per cent of all children and teenagers within the Jewish population of Israel. The proportion of youngsters (from birth to age 17) in the Jewish population grew from 34 per cent in 1947 to 37 per cent in 1953.[1] Tens of thousands of youngsters arrived in these years, and the education they had received, if any, in the countries from which they came differed from that of their contemporaries in the Yishuv. As a result of the mass immigration, new social classes developed; these came to be known as 'the second Israel' (new immigrants from among the Holocaust survivors) and 'the third Israel' (new immigrants from Islamic countries). The widespread social and economic hardship in these groups presented a serious challenge to the young nation, and a large number of the children and teenagers among them would years later be recognized as 'underprivileged'.[2] At the same time there was a 'frightening lack of professional workers [for children and youngsters] of all types': teachers, educational counsellors, psychologists, psychiatrists, and social workers.[3]

Hadassah's projects for immigrant children and teenagers are distinct from all its other projects, in that they had scarcely any American roots. In these enterprises Hadassah was a partner with other Zionist organizations. Some of them were long-term endeavours; others were ad hoc projects that Hadassah supported for a brief period only. The most important, from Hadassah's perspective, was Youth Aliyah, to which Hadassah allocated more funding than to any other area of its activity apart from health services (30 per cent of all funds raised went to Youth Aliyah, 38 per cent to health services).[4]

[1] For the statistics, see Sikron, 'The Demographic Structure of Israel's Population' (Heb.), 93.

[2] Tsameret, *A Narrow Bridge* (Heb.), 54, 245; Sikron, 'The Demographic Structure of Israel's Population' (Heb.), 103. [3] For the quotation see *Megamot*, 3/1 (Oct. 1951), 3.

[4] For the statistics, see Hadassah Annual Report, 1953/4.

HADASSAH AND YOUTH ALIYAH

Youth Aliyah was founded in the early 1930s, on the eve of the Nazis' rise to power in Germany, for the purpose of encouraging young people to emigrate from that country to Palestine. Later it was expanded to include young people from other countries, and started to take care of children from the age of 6. Thus it became one of the major organizations dealing with children and teenagers in the Yishuv and in the early days of statehood. Under the auspices of Youth Aliyah, orphans, sick children, and those whose parents, unable to emigrate, agreed to send them to Palestine for refuge and education were absorbed in kibbutzim, moshavim, and educational institutions including yeshivas and youth villages. Its aims were always rescue, absorption, rehabilitation, education, and training a cadre for future agricultural settlement, primarily through the kibbutz movement.[5]

The Funding of Youth Aliyah

As noted in Chapter 2, in 1935 Hadassah undertook to be the US patron of Youth Aliyah.[6] Thereafter it became the organization's second greatest source of funding, second only to the Jewish Agency.[7] In the years 1935–53 Hadassah contributed sums equivalent to $21 million today to the Youth Aliyah budget: over 27 per cent of Youth Aliyah's total income. In addition to this substantial sum, Hadassah also contributed some $2 million a year outside the regular Youth Aliyah budget.[8] The great advantage of these funds was that they could be used for activities not covered by the current budget, such as art, enrichment programmes, training group leaders and child carers, and vocational education. Thus Hadassah provided a 'flexible budget' that could be used as current needs required.[9]

In 1936 Hadassah recruited the American Jewish entertainer Eddie Cantor to help raise funds for Youth Aliyah, impelled by the particular urgency of this project to depart from its custom of not using professional fundraisers. Cantor, an expert in persuading people to 'put something in the pot', raised half a million dollars for Youth Aliyah in 1938 alone, and helped Hadassah to finance the organization for the following twenty years. Half the money he raised in 1936 and 1937 was divided between Zionist organizations (the United Israel Appeal and the Jewish National Fund) for the purpose of purchasing land for homes, schools, and farms, and for

[5] Gelber, *A New Homeland* (Heb.), 186; Bar-Gil, *Search for a Home* (Heb.), 9, 11, 12.

[6] Levin, *Balm in Gilead*, 124; Miller, 'A History of Hadassah', 318; Berman, *Nazism*, 35.

[7] *Report on Activities 5707–5711 [1946–51]* (Heb.), CZA, 259 (review of supporters of the Youth Aliyah project). [8] Bar-Gil, *Search for a Home* (Heb.), 25.

[9] Ibid.; author's interview with Dr Shlomo Bar-Gil, researcher into Youth Aliyah, Modi'in, 26 Mar. 2001.

absorbing refugee children in Palestine; the remainder was donated directly to Hadassah, which transferred it in full to the Youth Aliyah office in Jerusalem. On the outbreak of the Second World War, Hadassah funded about 50 per cent of the overall Youth Aliyah budget in Palestine; in 1940 this rose to about 80 per cent.[10]

Although Hadassah was Youth Aliyah's sponsor in the United States, Zionist women's organizations in other parts of the world also played a significant role in fundraising. While Hadassah, as the official agency in the United States for raising funds for Youth Aliyah, contributed to the organization as a whole, the other organizations made specific donations to individual projects, such as particular youth villages. Chief among these other contributors was the Women's International Zionist Organization, especially its two strongest elements, Hadassah–WIZO Canada and WIZO Israel. Hadassah–WIZO Canada, for example, set up the Hadassim youth village in the northern Sharon region and the agricultural school on Moshav Nahalal in the Jezreel Valley.[11] In Canada, South America, and South Africa there was an agreement between WIZO and Youth Aliyah for the collection and distribution of funds. With the exception of Hadassah and WIZO, the women's organizations had particular religious or political affiliations and contributed to Youth Aliyah on that basis. Thus the Mizrachi Women's Organization of America worked for Youth Aliyah mainly with the purpose of finding homes for children who came to Israel where they would be able to pursue the religious lifestyle that their parents would have wanted to give them. The Chicago-based Pioneer Women, a group affiliated to the Zionist labour movement, helped establish several educational institutions, including the Talpiyot Study Farm (1933) and the Ein Karem Youth Village (1948), both in Jerusalem, and Kanot, near Gedera (1952).[12] Contribu-tions to Youth Aliyah were also made by the United Jewish Appeal in Britain and other organizations in the Diaspora.[13]

Youth Aliyah before the Second World War

As we have seen, Youth Aliyah was established in Germany, shortly before Hitler came to power, against a background of economic crisis and growing antisemitism. Recha Freier, the wife of a Zionist rabbi in Berlin and herself a social worker and Zionist activist, conceived the idea of arranging a programme to enable young Jews to emigrate to Palestine (their parents possibly following later). The intention was

[10] Greenberg, *There Is Hope*, 96. [11] Bar-Gil, *Search for a Home* (Heb.), 29.
[12] Ibid. 28–9. Carmel-Hakim's research deals with Hadassah–WIZO Canada. See Carmel-Hakim, 'Agricultural–Vocational Training' (Heb.).
[13] Author's interview with Dr Shlomo Bar-Gil, Modi'in, 26 Mar. 2001.

that they would not only escape the grim future that awaited them in Germany, but also study in a pioneering environment and receive practical training in collective workers' settlements. This, Freier thought, would serve both the material and the spiritual needs of working-class Jewish adolescents who found themselves jobless as a result of the economic crisis in Germany, as well as assisting the Jewish people in rebuilding their home in Palestine.[14]

Despite some initial resistance from the Zionist establishment in Germany, which feared difficulties arising from the attempt to absorb the young people in Palestine, Youth Aliyah soon gained substantial support both there and in the Yishuv. As Youth Aliyah developed, the immigration of young people from Germany played a significant role in the Zionist plans. It was acknowledged that it would be difficult to meet the needs of adult Jews emigrating to Palestine from Germany; young people, on the other hand, could be educated together with children and teenagers raised in Palestine and trained for a life of pioneering, in particular for establishing new settlements and working the land. In this way, their integration into the country as adults would be ensured.[15] The first group of children emigrated from Germany to Palestine in February 1934 and settled at Kibbutz Ein Harod in the Jezreel Valley, near the town of Afula. This group served as a model for its successors.[16]

Until 1939 Youth Aliyah was based on an elitist model. Candidates were carefully selected from among all the streams of Zionist youth organizations in Germany, primarily on the basis of mental and physical adaptability, health, and temperament.[17] The preferred way of operating was to absorb young people into the Yishuv on kibbutzim, in the framework of the *hevrat noar* (literally: 'youth society'), the educational unit of Youth Aliyah, and it focused on teenagers rather than young children. However, as the Nazi violence intensified, Youth Aliyah expanded its activity to include children from Austria, Czechoslovakia, Poland, and Romania, and also began to accept younger children, from age 6 upwards.[18]

Education in Youth Aliyah did not involve vocational training; rather, the curriculum concentrated on the Hebrew language and culture, Zionist values, and the history and principles of the Zionist labour movement. Particular emphasis was placed on the value of personal labour, that is, the notion that every person should earn his or her living from his or her own labour—mainly in agriculture—and not rely on hired workers.[19] Between the movement's foundation and the outbreak of

[14] Amkraut, 'Zionist Attitudes towards Youth Aliyah', 67—8; Reinhold, *Youth Builds its Home* (Heb.), 15.

[15] Gelber, *A New Homeland* (Heb.), 188. [16] Ibid.; Bar-Gil, *Search for a Home* (Heb.), 11.

[17] Gelber, *A New Homeland* (Heb.), 199. [18] Bar-Gil, *Search for a Home* (Heb.), 11. [19] Ibid., 12.

the Second World War, 5,010 children and young people emigrated to Palestine in the framework of Youth Aliyah, most of their parents remaining in their countries of origin. The great majority of the young immigrants were absorbed in kibbutzim, which under the conditions of the time were the only places in the country equipped for the task.[20]

The Key Figures in Hadassah's Work with Youth Aliyah, 1940–1953

In late 1935 Henrietta Szold took on the management of Youth Aliyah. She headed the organization until her death in February 1945, and contributed considerably to its development and character. She believed firmly that Youth Aliyah should 'be a movement, that is, an educational movement whose pedagogical nature was determined by the needs of Palestine, the land of absorption'.[21] She recruited Hadassah as its major patron in the United States, and worked to involve as many organizations as possible in its financing.[22]

When Henrietta Szold died her place was taken by Hans Beyth, who had been her deputy since 1935. He had managed Youth Aliyah during the critical years of the Second World War and its immediate aftermath, bringing young Holocaust survivors to Palestine. In December 1947, on returning from a reception held for a group of youngsters who had just arrived in Palestine, he was murdered by an Arab.[23]

In contrast to all Hadassah's other activities between 1940 and 1953, the period in which Youth Aliyah arranged the emigration and absorption of child and teenage survivors of the Holocaust, the National Board Youth Aliyah Committee was headed by women who had emigrated to the United States from Germany, and not native Americans. Each of these women had a fascinating life story.

From 1941 until the end of the Second World War the Youth Aliyah Committee was headed by Gisela Warburg, later Wyzanski (1912–91). Born in Hamburg into the Warburg family of bankers and philanthropists, which had branches in both Germany and the United States, she was recruited by Henrietta Szold to work with Youth Aliyah during a visit to Palestine. After a short time in the country Warburg returned to Germany, where she worked in the Berlin office of Youth Aliyah from 1935 to 1938.[24]

In her commitment and zeal for the welfare of others, and for Zionism, Gisela was continuing a Warburg family tradition. Felix M. Warburg was chairman of the

[20] Bar-Gil, *Search for a Home* (Heb.), 11.

[21] For the quotation, see Reinhold, *Youth Builds its Home* (Heb.), 17.

[22] Ibid. 20. [23] Dash, *Summoned to Jerusalem*, 319.

[24] All the details on Gisela Wyzanski from here are based on 'Judith Epstein Interviews Gisela Wyzanski', HA, RG20, Oral History/Transcriptions, 1–8; *Who's Who in World Jewry*, 931.

American Joint Distribution Committee from 1914 to 1932 and Otto Warburg was president of the World Zionist Organization in 1911. Gisela's father, Max Warburg (1867–1946), a banker and a prominent figure in the German economy before the Nazis came to power, was from 1933 a leading force in the German Jewish organizations established in the wake of the Nazis' rise to power and in response to the deteriorating conditions for German Jews. During this period he focused on helping Jewish emigrants to get their money out of Germany via PALTREU— Palästina Treuhandstelle zur Beratung deutscher Juden. His bank was one of two through which funds belonging to German Jews were transferred out of the country. Warburg had close links with the German banker and financier Hjalmar Schacht, minister of economics in Hitler's government from 1934 to 1937. Hoping that he could use this connection to the benefit of his fellow Jews, he remained in Germany with his family right up to 1938, taking a great risk by doing so.[25]

Gisela came to the United States with her parents in late 1938, but not with the intention of staying there: she wanted to return to Germany in order to continue her activity on behalf of Youth Aliyah. In the end, relatives persuaded her that she should stay in America. She immediately joined Hadassah, with the aim of continuing her work for Youth Aliyah within the organization. In 1943 she married Judge Charles Wyzanski and moved to Cambridge, Massachusetts. She headed the Hadassah National Board Committee for Youth Aliyah from 1941 to 1945.

Gisela Wyzanski recruited Lola Kramarsky (1896–1991), who succeeded her as chair of the committee in 1945. Kramarsky, who eventually became president of Hadassah, serving from 1960 to 1964—one of only a very few women born outside the United States to hold that office—was an extremely impressive woman, artistic and musical, with somewhat elitist views and a distinctive European style.[26] Born Lola Popper into an assimilated Jewish family in Hamburg, she married a wealthy banker, Siegfried Kramarsky, an act that dramatically changed her life, for her husband had a profound commitment to his Jewish identity, and wanted to keep a kosher home. The couple continued to live in Hamburg until 1923. That year, when Lola was pregnant with her daughter, she was harassed by German thugs. She demanded an apology from the mayor of Hamburg, only to be told that the time was not right for apologies. The couple left Germany on that very day. They settled in Amsterdam, where they lived for about twenty years before fleeing just a few

[25] Barkai, 'Max Warburg'; Pinner, 'Ha'avarah'.

[26] All the details on Lola Kramarsky from here are based on Levin, 'Kramarsky'; author's interviews with Sonia Kramarsky, Lola Kramarsky's daughter, New York, 13 July 1991, Mendelle Woodley, Washington, DC, 30 June 1991, and Florence Perlman, Jerusalem, 30 July 1991; 'Mrs. Moses Epstein Interviews Mrs. Siegfried Kramarsky', HA, RG20, Oral History/Transcriptions, folder 3, p. 1.

days before Hitler invaded The Netherlands, thanks to a warning received from the British embassy. They reached Canada via Lisbon, and a year later settled in New York. They had managed to bring much of their substantial wealth with them from Europe and became well known for, among other things, their collection of extremely valuable Impressionist paintings.

When she arrived in the United States, Lola Kramarsky knew neither English nor Yiddish, the two languages most commonly spoken at that time among American Jews. For many years, in fact, she did not develop the art of public speaking, one of the important qualities required of a Hadassah leader. Her poor command of English and her heavy German accent were a stumbling block, and many of her speeches had to be written for her.

The third chair of the National Board Committee for Youth Aliyah, serving from 1950 to 1953, was Anna Tulin (1903–2001), a charismatic and business-minded woman. She had been born Anna von Lepel in Berlin; her aristocratic, Lutheran German family owned vast assets and property in Paramonia, eastern Prussia (now part of Poland). When Anna was 14 years old her mother died, and from this point she was brought up by her grandmother. When she was about 23, in 1926, she travelled to the United States and began working in a company owned by a relative.[27]

In 1936 Anna met Abraham Tulin, a Jewish lawyer (a graduate of Harvard Law School) from Hartford, Connecticut, who was an active member of the Zionist Organization of America. The two decided to marry, but Tulin made the marriage conditional on Anna's going to Germany and telling her family that she intended to marry a Jew. However, on arriving in Germany Anna found antisemitism so rife, and her family's attitude so unpromising, that she avoided telling them the truth. She returned to New York and married Tulin two days later, having rapidly converted to Judaism under the Zionist Reform rabbi Stephen Wise, then the president of the Zionist Organization of America.

At the age of 93, by which time she had been a widow for many years, Anna Tulin recalled in an interview: 'I informed my family, and especially my grandmother [who had brought her up] of my marriage immediately after the [wedding] ceremony, and I never heard from them again. I wrote and called, but there was no answer. At that time, it was simply impossible for a German woman to marry a

[27] All the information on Anna Tulin from here is based on author's interviews with Anna Tulin Elyachar, New York, 20 June 1991 and 14 July 1991, and Jerusalem, 30 July 1991, and with Mendelle Woodley, daughter of Denise Tourover, Washington, 30 June 1991; for biographical details, see *Who's Who in World Jewry*, 782–3.

Jew.' Before I left her home, she showed me a Bible, written in Gothic script and bound in parchment. 'This is the Bible that I brought with me from Germany', she told me.[28]

Abraham Tulin was a close associate of Samuel Rosensohn, husband of Etta Rosensohn, and Etta recruited Anna to Hadassah shortly after her marriage. The Tulins lived on the West Side of Manhattan in an apartment overlooking Central Park, but made numerous visits to Israel. The couple had no children, and when Anna died, at the age of 98, she bequeathed her works of art to the Israel Museum in Jerusalem.

The Tehran Children

In September 1943 the Tehran Children, the first group of child and teenage Holocaust survivors to make their way to Palestine, arrived at their destination. Hadassah had played a central role in getting them there.

The episode of the Tehran Children had begun over a year earlier, when in summer 1942 rumours began to reach Palestine that thousands of refugees from occupied Poland had made their way south, through Russia. They would shortly arrive in Tehran, where their status would be dubious, and the conditions in which they would be kept unsatisfactory. The refugees included Jewish civilians and soldiers, as well as 800 teenagers, children, and infants. The majority of these (80 per cent) were without their parents, and many were orphans. Upon the Nazi invasion of Poland in September 1939, these children had fled with their parents to Russia from various parts of Poland. Some had been imprisoned in camps in Siberia. Since then, they had made their way south through Russia to Uzbekistan, from where they were sent on to Iran.[29]

The Iranian authorities, however, refused to allow the children to pass through their territory, so they were kept in a camp in Tehran for five months, waiting for a way to get to Palestine. In order to obtain consent for their passage, it was necessary to persuade the Americans to act, and in the resulting negotiations Hadassah's role was crucial. The Hadassah representative in Washington, Denise Tourover (of whom much has been said in Chapters 3 and 5), directed an intensive lobbying campaign in the White House and the State Department, on Capitol Hill, and among foreign diplomats. These efforts ultimately led to permission being granted

[28] Author's interview with Anna Tulin Elyachar, New York, 20 June 1991.

[29] Rosenblith, *Youth Aliyah* (Heb.), 25; Kadosh, 'Ideology vs Reality', 329; Greenberg, *There Is Hope*, 55–7; Bar-Gil, *Search for a Home* (Heb.), 13.

for 712 children to travel by train to Basra in Iraq, from where, after another long journey, they finally reached Palestine.[30]

Hadassah's involvement in this matter influenced its position in Youth Aliyah. As early as 1937 Hadassah had asked for a policy-making role, which would give it at least partial control over Youth Aliyah finances. It reiterated this request several times, but was repeatedly rejected, partly because of Henrietta Szold's objection to the inclusion of a Hadassah representative on the Youth Aliyah executive board. Only in 1943, after the success of its energetic diplomatic efforts on behalf of the Tehran Children, was Hadassah invited to send a representative as a full member of the Youth Aliyah executive.[31]

After the Second World War: The Child Holocaust Survivors

Approximately 150,000 Jewish children under the age of 17 survived the Holocaust in Nazi-occupied Europe. Of these, about 40,000 were orphans. Some had been in concentration camps; others had survived in the forests with groups of partisans. Now on their own, the children had to find food, a place to sleep, and clothing for themselves. They ate from rubbish bins, stole in the open markets, slept in ruins and abandoned buildings, and wandered from one country to another. Thousands more children had been hidden by Christian families and in monasteries and convents. Some of them were unwilling to return to the Jewish world, no longer feeling safe there; many remained in remote villages, and nobody knew where they were, especially if their parents had perished. Somehow, these children—now suffering not only from hunger and disease, but from continuing antisemitism in many places—had to be found and given a future.[32]

Among the first to come to the aid of the child survivors were those leaders of Zionist youth movements in Europe who had also survived the war. They began organizing the children and formed groups called 'children's kibbutzim' (*kibutsei yeladim*), which wandered together in search of somewhere to live.[33] Then, in early 1946, various Jewish organizations, both Zionist and non-Zionist, and including especially many Orthodox groups, began working on behalf of the Jewish children dispersed throughout Europe. The Zionist pioneering-oriented youth movements—Hashomer Hatzair, Dror, Gordonia, Bnei Akiva, and others—began to gather up homeless children and provide their basic needs: a roof over their heads, food, and clothing; they also spearheaded the efforts to move endangered children

[30] Rosenblith, *Youth Aliyah* (Heb.), 25; Kadosh, 'Ideology vs Reality', 329; Greenberg, *There Is Hope*, 55–7; Bar-Gil, *Search for a Home* (Heb.), 13. [31] Kadosh, 'Ideology vs Reality', 154.
[32] Bar-Gil, *Search for a Home* (Heb.), 48. [33] Ibid.

to other countries. Other Yishuv organizations, including the kibbutz movements (Hakibbutz Hame'uhad, Hakibbutz Ha'artzi, and Hakibbutz Hadati), the religious parties (Mizrachi and Hapo'el Hamizrachi), US Jewish organizations (mainly the Joint Distribution Committee and Hadassah) and Hadassah–WIZO Canada, participated in taking over the care of Jewish children from monasteries and Christian families.[34]

Youth Aliyah joined the efforts to help the child survivors at a relatively late stage. It participated only as a junior partner in the initial gathering up of the children in the operation known in Hebrew as *haberihah* ('the escape')—the spontaneous, illegal mass migration of Holocaust survivors from eastern Europe to western and southern Europe between 1944 and 1948.[35] Nevertheless, at the Twenty-Second Zionist Congress in 1946, the first after the Holocaust, it was Youth Aliyah that was authorized as the organization empowered to rescue children and teenagers who had survived the Holocaust.[36] As a result, Youth Aliyah increased its activity in Europe in late 1946, and worked for the transfer of children from eastern Europe to Palestine. Between 1945 and late 1952, some 29,449 child survivors of the Holocaust emigrated to the Jewish homeland.[37]

Bertha Schoolman and Youth Aliyah

On 27 November 1947, two days before the UN resolution on the partition of Palestine into a Jewish state and an Arab state, Bertha Schoolman (1897–1973), a member of the Hadassah National Board since 1935, arrived in Palestine to serve as Hadassah's representative on Youth Aliyah's management committee (and one of its two chairpersons). This was the result of prolonged negotiations over Hadassah's demand that two chairpersons be appointed to this committee, one of whom would be a Hadassah representative. The proposal was finally accepted, but on condition that the Hadassah representative live in Palestine during her term in office.[38]

Bertha Schoolman was a teacher by profession. She was born in New York, where she lived as a child and teenager, and studied at Hunter College and at the Teachers' Institute of the Jewish Theological Seminary of America, training as a teacher and taking a master's degree. Later she married another educator, Albert P. Schoolman, with whom she directed the Cejwin Camps (Jewish summer camps run by the Central Jewish Institute) in Port Davis, New York.[39] A good-natured

[34] Ibid. 50–1; discussion with Dr Shlomo Bar-Gil, Modi'in, 26 Mar. 2001.
[35] Bar-Gil, *Search for a Home* (Heb.), 48–9. [36] Ibid. 23. [37] Ibid. 17. [38] Ibid. 26.
[39] 'The Israel Information', Hadassah Archives, RG7, Special Collections, Bertha Schoolman folder.

woman, she was involved in extensive voluntary work. She was very active in the Reconstructionist movement, being a member of the Society for the Advancement of Judaism and sitting on the board of directors of the Jewish Reconstructionist Foundation. She published articles in the *Hadassah Newsletter*, the *Jewish Social Service Quarterly*, and *The Reconstructionist*.[40] She spoke Hebrew fluently and visited the Jewish homeland twenty-nine times between 1939 and 1960, both on public business and on family visits, sometimes staying for long periods. She had two daughters, one of whom (Judith) emigrated to Israel with her husband in May 1948 and settled at Kibbutz Sasa in Galilee, where they brought up their three children, and where they still live today.[41]

Bertha Schoolman's early days in post were anything but calm. A few days after arriving in Palestine in November 1947, she accompanied Hans Beyth on his last journey, when, as noted above, he was murdered on his way home from a welcome ceremony for the children rescued by Youth Aliyah.[42] The organization's employees welcomed her warmly, but were at the same time concerned that she would try to dictate policy. However, throughout her time in office, which lasted until April 1954, she rose to the challenge: she succeeded in being both an emissary of Youth Aliyah to Hadassah in America, on the one hand, and a representative of Hadassah to Youth Aliyah in Israel on the other, simultaneously taking care of Youth Aliyah's needs and promoting Hadassah's principles. During this period she spent six to eight months of each year in Israel, including six months during the War of Independence.[43]

The influence of Hadassah on Youth Aliyah prior to the founding of Israel also included energetic and critical involvement in the election of Moshe Kol, a member of the General Zionists Israeli party, as head of the organization in spring 1948.[44]

Youth Aliyah after Israel's Independence: The Expansion of Youth Aliyah Facilities

With Israel's independence, the scope of Youth Aliyah's work grew and the composition and background of the population with which it was dealing changed. In 1949, as the rate of immigration of Holocaust survivors from the displaced persons camps in Europe slackened, the focus of Youth Aliyah's work shifted to the immigration of teenagers, first from eastern Europe and the Balkan states, and later from Arab and north African countries. In the period of non-selective mass immigration

[40] 'The Israel Information', Hadassah Archives, RG7, Special Collections, Bertha Schoolman folder.
[41] Ibid. [42] Ibid.
[43] Bar-Gil, *Search for a Home* (Heb.), 26; 'The Israel Information', HA, RG7, Special Collections, Bertha Schoolman folder. [44] Bar-Gil, *Search for a Home* (Heb.), 26.

from 1948 to 1951, Youth Aliyah took in 23,000 children and teenagers from eastern and southern Europe (Romania, Poland, Bulgaria, Yugoslavia, and the USSR), Asia (Yemen, Iraq, and Iran), and northern Africa (including Egypt).[45] From 1951 to 1956 it absorbed slightly fewer than this number—21,000—mainly from northern Africa and the Middle East (Morocco, Tunis, Iraq, and Yemen) and Romania, as well as taking into its care vulnerable children within Israel.[46]

Throughout 1948 Hadassah worked to set up a screening and classification centre for Youth Aliyah wards, almost entirely on its own, in addition to financing a considerable portion of the Youth Aliyah budget. The centre, which was named Ramat Hadassah Szold after its founder, had been planned as a youth village by Henrietta Szold; she also chose its location, in the hilly region near Haifa, adjacent to Kibbutz Alonim (which was founded by graduates of Youth Aliyah). However, in response to the particular need arising from the closure of the transit camps in Europe and the large-scale immigration of children to Palestine the intended character and purpose of the settlement were changed, and it was established in February 1949 as a temporary camp for the screening and classification of young immigrants.[47]

Hadassah did, however, set up five new youth villages to address the shortage of places for the young people brought to Israel by Youth Aliyah. These were the Magdiel Institute for Agricultural Education (and later, vocational training) in Hod Hasharon in the southern Hasharon region; Alonei Yitzhak, near Kibbutz Kfar Glickson in the Hadera area; Neve Hadassah, near Kibbutz Tel Yitzhak in the Sharon region; the Israel Goldstein Zionist Youth Farm in Jerusalem; and the Nitzanim youth village in the northern Negev, named after the members of Kibbutz Nitzanim who fell in the War of Independence. Hadassah also helped fund the Ben-Shemen youth village, located east of the town of Lod, in particular the work to expand it when its members returned to the permanent location which they had been forced to abandon during the War of Independence.[48]

Education, Personal Development, and Vocational Training

At the time of Israel's independence there were only eight institutions for training teachers and pre-school teachers in the country, and, despite the great surge in the number of students in the education system, only a small number of additional teacher training institutes opened between 1948 and 1950. With immigrants mak-

[45] For the figures, see *Report on Activities 5707–5711 [1946–51]* (Heb.), CZA, 226; *Report on Activities 5711–5716 [1951–5]* (Heb.), CZA, 83. [46] *Report on Activities 5711–5716 [1951–5]* (Heb.), CZA, 83.
[47] Kahanoff, *Ramat-Hadassah-Szold*, 21, 23. [48] Bar-Gil, *Search for a Home* (Heb.), 168.

ing up nearly half of all school pupils, the Ministry of Education had to provide thousands of new teachers, and in order to cope with the severe shortage turned to various sources of unqualified teachers, such as youngsters about to embark on army service and new immigrants. It introduced various forms of short training courses, including seminaries in the IDF, night-school courses over a year and short full-time courses of five months, but genuine improvement in the training of teachers was slow to come about. Most of the professionals involved in child care were unacquainted with the cultures and mindsets of the young immigrants, who came from seventy-two different countries, about half of them (53 per cent of those aged 6–17 and 47 per cent of those aged 0–5) being of Asian or African origin.[49]

Large numbers of children and teenagers—most of them new immigrants— were placed within agricultural frameworks of one kind or another: mainly in kibbutzim, but also in moshavim and agricultural schools (both boarding and day).[50] This practice was based on the vision motivating the leaders of the Israeli labour movement: convinced that building the new country depended on the settlement of the land, and consequently that agricultural labour was the most valuable work a person could do, they sought to cultivate a 'new Jew' who had a visceral bond with nature and the land. Agricultural education also constituted a practical solution to the problem of absorbing such great numbers. The kibbutzim and the boarding schools offered a welcoming home and an education to thousands of children and young people who arrived in Israel without any family, or whose families had difficulty supporting them at home.[51]

Youth Aliyah's educational approach was inspired by the kibbutz way of life. Henrietta Szold supported the educators within the labour movement in Palestine in their insistence on 'the authority of the labour settlements to educate immigrant youth within their settlements according to their pioneering ideas'.[52] The leaders of Youth Aliyah had a clear inclination towards the ideology of the labour settlements, and the educational ideal of the organization was 'a life of pioneering'. For example, Moshe Kol, the head of Youth Aliyah from the spring of 1948, defined its main aim as education in the light of the image of the 'rural pioneer'. On another occasion, Kol said that the main work of Youth Aliyah was 'to educate youth for the "Hebrew village" and to prepare a future cadre for pioneer settlement in Israel'.[53]

According to the research of Tsvi Tsameret on education in Israel's first decade, Youth Aliyah was the framework within which immigrant children, and the child-

[49] Tsameret, *A Narrow Bridge* (Heb.), 54–5: Tadmor-Shimoni, 'Immigrant Teachers as an Agent of the State' (Heb.), 100–1. [50] Ibid. 132. [51] Ibid. 133.
[52] For the quotation, see Reinhold, *Youth Builds its Home* (Heb.), 19.
[53] Tsameret, *A Narrow Bridge* (Heb.), 134.

ren of immigrants, were absorbed into society and 're-educated' in the labour settlements and boarding schools. In Tsameret's view, the kibbutzim ascribed great importance to taking in immigrant teenagers as it gave them an opportunity to inculcate their values and thereby expand the ranks of their members.[54] Youth Aliyah, then, saw itself not only as a rescue movement but also, and equally, as 'an educational framework based on group living and aimed at equipping the immigrant youth with life values and tools that will prepare them mentally for fulfilling pioneering roles and overcoming the hardships of life in Israel'.[55] These collectivist views were not consistent with cultivation of the individual. Consequently, Youth Aliyah did not emphasize the provision of personal development individual therapy, or social and educational services for children or their families.[56]

This inattention to the individual's needs was in total contradiction to the fundamental beliefs and conceptions of Hadassah, which, inspired by American social movements as previously described, placed the individual and especially the child at the centre. The quite different set of priorities that predominated in Youth Aliyah evinced a disregard for Hadassah's devotion to professionalism (see Chapter 5), and precisely in the sphere in which Hadassah's leadership regarded themselves as experts—children, young people, and education. This situation began to change with the appointment of Hadassah's representative Bertha Schoolman to Youth Aliyah's board of directors. From that time Hadassah's leaders acted to change the educational and therapeutic conception of the Youth Aliyah enterprise.

The collectivist vision underlying Youth Aliyah was embodied in its unique central educational figure, the youth leader (*madrikh*). This role, which was created in the context of kibbutz education and adopted by Youth Aliyah, combined the functions of a teacher with those of a social leader.[57] However, the youth leader—who could be male or female—was selected not as a professional educator but as a model member of the kibbutz community, someone who exemplified the kibbutz way of life. Thus the criteria for selection focused mainly on the individual's personality and ability to represent kibbutz values. He or she had to have a well-developed world-view, be a good worker, and be willing to serve the national

[54] Ibid. 133–7.
[55] On its being a rescue movement, see *Report on Activities 5711–5716 [1951–5]* (Heb.), CZA, 4; author's interview with Miriam Freund-Rosenthal, Jerusalem, 28 Aug. 1995; Meeting of the Zionist Executive in Jerusalem, 9–17 Kislev, 5713 (20–27 Nov. 1952) (Heb.), Organization Department of the World Zionist Organization, CZA, 68.
[56] Reinhold, *Youth Builds its Home* (Heb.), 116; Katz, *Shulamit Kalivnov's Perception of Education* (Heb.), 25; Glanz, 'Social Services in Youth Aliyah' (Heb.), 29. [57] Bar-Gil, *Search for a Home* (Heb.), 122–4.

mission. In practice, since the kibbutzim suffered a constant shortage of labour, many youth leaders were taken from their farming jobs irrespective of whether they had received any formal education, and without any training for the demanding job they were about to take on. In small, geographically remote settlements especially they were sometimes chosen hastily, under various local constraints.[58]

The youth leader was supposed to be a guide, an older sibling, and a parent to children who had no family and most of whom had a traumatic past; and yet most leaders had no professional educational or therapeutic training. Thus the youth leader, who spent most of the hours of both day and night with the children, had to rely on intuition and instinct to understand their problems.[59] He or she also had to cultivate a family atmosphere and an educational and study environment which would allow the children normal development and instil in them proper habits of study.[60]

Youth Aliyah, like all the educational frameworks of the time, was subject to pressure from the various Israeli political parties, each of which hoped to win over a greater proportion of the youngsters than the others and all of which were engaged in constant struggle, which was especially acute between the religious and non-religious groups.[61] Such a situation did not leave much time for the cultivation of the individual, or for responding to personal, emotional, or developmental needs. However, given the circumstances in which Youth Aliyah functioned, it inevitably had to deal with personal and social as well as educational problems. As early as 1943 its boarding schools had begun accepting teenagers from within the Yishuv, particularly those from communities of Asian or African origin. That year had brought a particularly large number of children without parents to Palestine: first the Tehran Children, then others from Lebanon, Syria, Turkey, and Yemen—and all this before the child Holocaust survivors, who came after the war. Youth Aliyah had to act as a substitute parent to these children; consequently, by the middle of the Second World War it had become an educational and social endeavour caring for teenagers who needed social aid in the broad sense. In recognition of this additional responsibility an educational social worker, Dora Strauss-Weigrat, was appointed to the staff.[62]

In 1947 Youth Aliyah had two divisions that dealt with personal care: an Educational Therapy Division (later called the Unit for Personal Therapy and Rehabilitation); and a Social Work Division, which worked together with the Medical

[58] Bar-Gil, *Search for a Home* (Heb.), 123. [59] Ibid.
[60] Reinhold, *Youth Builds its Home* (Heb.), 117; Bar-Gil, *Search for a Home* (Heb.), 123.
[61] Tsameret, *A Narrow Bridge* (Heb.), 135. [62] Deutsch, 'The Development of Social Work' (Heb.), 213.

Services and Training Division.[63] The Educational Therapy Division dealt initially with difficult cases, mainly child Holocaust survivors, with serious behavioural disorders. At a later stage it treated children prevented by what was called at the time 'environmental retardation' from engaging in agricultural work and social life, and above all from realizing their cognitive potential.[64] The Social Work Division dealt with three fields: first, finding appropriate placements for children whose poor health rendered them unsuitable for agricultural training; second, providing study scholarships to graduates and in-service training scholarships to wards; and third, arranging for adoption.[65] However, despite the existence of these two divisions, the educational approach of Youth Aliyah, based as it was on communalist principles, did not emphasize the treatment of children as individuals.

The approach of Youth Aliyah to vocational training was based on the same principles. Most of the wards did not study a vocational subject, as agricultural work was given priority.[66] However, a small proportion of the children did receive training in vocational institutions: the L. Teich School at Kibbutz Yagur, near Haifa; the Max Fein Vocational School of the Histadrut; the WIZO schools (of which there were three by 1954); and the Mizrachi Young Girls' Homes (Beit Tse'irot Mizrahi).[67] In addition, approximately 30 per cent of the students were trained as apprentices in workshops in the settlements where they lived. Many of the young Holocaust survivors expressed a strong wish to train for an occupation, rather than building their lives on a kibbutz or moshav, and the parents of children of Asian and north African origin similarly wanted to obtain vocational training for them.[68]

Against this background, Hadassah tried to inject into Youth Aliyah a different perception of care in the fields of education, vocational training, and personal care of children and teenagers. In the years 1947–56 Hadassah sent several American experts in education and social work to present suggestions for improving the work of Youth Aliyah. The first to arrive in Palestine, in summer 1947, was Dr Alexander M. Dushkin, Hadassah's educational adviser (formerly head of the Board of Jewish

[63] Reinhold, *Youth Builds its Home* (Heb.), 18.

[64] Meeting of the Zionist Executive in Jerusalem, May 1952, Organization Department of the World Zionist Organization (Heb.), CZA, 29.

[65] S. Adiel (ed.), '15 Years of Work of the Medical Pedagogical Division', bound documents (stencils), 26 June 1955, CZA, S119, 621.431.539 h 37; 'Activities of the Department for the Immigration of Children and Youngsters 1950', 19–20; Report to the Zionist Executive, 1 May 1949–28 Feb. 1950, Jerusalem, 21 Mar. 1950, CZA, 9.

[66] Reinhold, *Youth Builds its Home* (Heb.), 76. See also Tsameret, *A Narrow Bridge* (Heb.), 134–5.

[67] Reinhold, *Youth Builds its Home* (Heb.), 75.

[68] Yablonka, *Foreign Brothers* (Heb.), 207; Grossbard, 'Report to the National Board', 4–5.

Education in New York and Chicago, the first supervisor of the Jewish schools in Palestine during the Mandate period, and the founder of the Department of Education at the Hebrew University in 1934). Dushkin spent a few months visiting the Youth Aliyah institutions, and discussed the organization's problems with its leaders.[69] He summarized his visit in a comprehensive report which he submitted to Hadassah. Later he was invited to serve as chair of the Youth Aliyah Pedagogical Council.[70]

Dushkin's conclusions focused on vocational training and education. In his view, the non-professional youth leaders lacked proper training in the humanities and the hard sciences, and used faulty methods of instruction, especially for young people over the age of 15. He also drew attention to the lack of basic equipment, from science laboratories down to chalk and pencils. His recommendations concentrated on expanding training for youth leaders, improving work conditions, and providing equipment.[71]

As a result of Dushkin's report, in 1948 Hadassah established the Hadassah Educational Equipment Fund. The fund supported schools, youth clubs, laboratories, and libraries in many absorption centres and equipped them with books, writing supplies, instruments, sports equipment, and more.[72] In the 1948/9 and 1949/50 budgetary years, Hadassah transferred $100,000 to the fund. From its inception up to the end of the 1950s it allocated in total approximately $300,000 for this purpose.[73] Given the lack of other sources of finance to meet these needs, the fund constituted a substantial contribution to improving the facilities available in the Youth Aliyah absorption centres and institutions.[74]

In July 1950 Dushkin presented Hadassah with a re-evaluation of Youth Aliyah. He noted some improvement in terms of educational equipment, thanks to the activity of the Hadassah Educational Equipment Fund, but criticized the inadequate attention to the personal needs and desires of the individual children and teenagers. He further argued that the approach used by Youth Aliyah worked

[69] Deutsch, 'The Development of Social Work' (Heb.), 213; Dushkin, 'Hadassah's Child Welfare Program in Erets Yisra'el', 1. [70] Reinhold, *Youth Builds its Home* (Heb.), 24.

[71] Dushkin, 'Educational Achievements and Problems', 2, 5–6, 10–14; Reinhold, *Youth Builds its Home* (Heb.), 5–6, 10–15.

[72] Minutes of Hadassah National Board meeting, 20 Mar. 1952, 3 (Dushkin's speech); 'List of Places Approved for Allocations from the Hadassah Fund in 5709 [1948–9]', CZA, S119, 627.51 8.

[73] *Report on Activities 5707–5711 [1946–51]* (Heb.), CZA, 259; Report to the Zionist Executive, 1 May 1949–28 Feb. 1950, Jerusalem, 21 Mar. 1950, 9.

[74] Excerpts of letter to Mrs S. Kramarsky of Hadassah, USA, from Dr Alexander Dushkin, Jerusalem, 30 July 1950, 1, CZA, S119, 620.1 b 8.

simultaneously in conflicting directions, preparing the children for collective life on the one hand, while also strengthening their mental abilities and cultivating their personal inclinations on the other, thereby creating emotional difficulties in the youngsters 'in all its institutions'.[75]

In response to Dushkin's second report, Hadassah sent the director of research of the Council of Jewish Federations and Welfare Funds, Dr Harold Glasser, to Israel. During a five-week stay he visited all the vocational training institutions in the country. Reporting to the National Board on what he had seen, Glasser severely criticized the low standard of technical training in Israel.[76] One of the roles of vocational training in the country, he said, was to contribute to the development of its industry; and yet this training was being carried out according to old-fashioned east European methods—he called it 'vocational training of the period of Tsar Alexander'—which lagged decades behind contemporary US standards and was not at all suitable for the needs of the young state. According to Glasser, the young people graduating from these institutions contributed nothing to raising the standard of the technical professions in Israel. Moreover, he argued, the number of institutions for vocational training in Israel was far from adequate to meet the demand.[77]

Glasser took the view that among the organizations raising funds in the United States for this purpose (the Histadrut and ORT,[78] in addition to Hadassah), Hadassah was the best suited to developing vocational training institutions in Israel, because of its direct involvement in its own vocational training projects and its ability to apply the modern, American methods of training that were so sorely needed, in his view, if these institutions were to attain the requisite standards.[79]

In 1953 Hadassah sent yet another educational expert to Israel, this time in response to criticism that had been voiced both in the United States and in Israel of Youth Aliyah's management of its financial as well as educational affairs. Since Youth Aliyah was no longer involved in rescue operations, it was said, the money allocated for this purpose should be used to meet other needs. It was also claimed that Youth Aliyah separated children from their families and created tension between parents and their children. The National Board appointed an investigation committee, which recommended that Louis H. Sobel, a well-known New York social worker who served as general manager of the Jewish Child Care Association

[75] Ibid. [76] Mr Glasser's Report, 19 Sept. 1950, CZA, S119, 1332, 620.8 h 37.
[77] For the quotation, see ibid. 2; for the information, see ibid. 4.
[78] Mr Glasser's Report, 2–3. [79] Ibid.

and a member of the Hadassah National Board Youth Aliyah Committee, be sent to Israel to investigate the situation.[80]

During his five weeks in Israel, Sobel systematically examined the Youth Aliyah institutions. His recommendations were presented to the National Board in August 1953, and adopted. They concentrated on the leadership of Youth Aliyah, and centred on the appointment as director of the organization of a psychologist or psychiatrist, who would introduce professional and systematic individual psychological therapy. He also suggested that Avraham Yaari, director of the Youth Aliyah Absorption Department, be sent immediately to one of the schools of social work in the United States on a fellowship for a special systematic training programme, and that the diagnostic services at the Ramat Hadassah Szold Reception Centre be improved and reinforced.[81]

In response to this last recommendation Hadassah sent Hyman Grossbard, of the Columbia University School of Social Work, to Israel for fifteen months. In the report that Grossbard submitted to the National Board at the end of his visit, he noted that the psychological services in Youth Aliyah were centred on screening and diagnosis alone, while a considerable proportion of the youngsters who came to Youth Aliyah suffered emotional difficulties arising from their poor social and cultural background.[82] He recommended adding consultation frameworks to the existing services, with the aim of helping children and their parents to judge by objective criteria whether they wanted to be included in Youth Aliyah.[83]

Grossbard further recommended that candidates for Youth Aliyah should be screened near their homes and not in distant absorption centres;[84] that regional absorption and screening centres be set up; and that the reception and classification centre at Ramat Hadassah Szold be given over exclusively to the care of those individuals who required a prolonged period of adjustment or who suffered mental disorders and educational deficits. In pursuit of this last aim, he recommended that Ramat Hadassah Szold take fewer children and keep them in the centre for longer periods, and that it appoint more experts in education and diagnosis to its staff.[85]

Grossbard made similar comments regarding the work done at the 'Swedish Village' in the Beit Mazmil (today Kiryat Hayovel) neighbourhood of Jerusalem, which had been established in 1950 to rehabilitate children with disabilities and

[80] Report by Louis Sobel on a Visit to Israel in Connection with Youth Aliyah, July 1953, CZA, S119, 620.8 h 37; see also Report of Mr Louis Sobel to the National Board of Hadassah, 20 Aug. 1953.

[81] Report of Mr Louis Sobel to the National Board of Hadassah, 20 Aug. 1953, 14–25.

[82] Grossbard, 'Report to the National Board', 8.　　　[83] Ibid. 8, 10, 11.　　　[84] Ibid. 12.　　　[85] Ibid.

those recovering from serious diseases. He praised the fine physical treatment that the residents enjoyed, but criticized the meagre education offered and the lack of psychological treatment for the emotional problems that accompany prolonged illness. He suggested changing the approach to care in the institution from the existing focus on physical problems to a broader attention to all the children's problems and needs.[86]

In response to Grossbard's proposals, Ramat Hadassah Szold changed its main purpose, and by the end of 1954 it was reserved exclusively for wards who could not be absorbed immediately in the Youth Aliyah educational institutions because they required medical care, a period of adjustment, or some other special consideration. In 1956, 677 children from the temporary immigrant settlements and 1,130 children who had just arrived from other countries were accepted at Ramat Hadassah Szold.[87] The census conducted in October 1957 reveals that a large proportion of the children at Ramat Hadassah Szold did not live a normal family life, either abroad or in Israel; only some of their parents worked on a regular basis, and in many families the mother was the sole earner.[88]

Hadassah thus reinforced Youth Aliyah's efforts to give greater attention to the treatment of wards as individuals, to provide both enrichment studies beyond the core practical and educational elements and vocational studies, and to place a greater emphasis on personal well-being. As well as helping to introduce organized social and psychological therapy into the framework for the first time in the history of Youth Aliyah, Hadassah's work also contributed to the professionalization of the organization's leaders and workers, including a deepening of their professional understanding of the personal problems of their wards. At the same time, according to Shlomo Bar-Gil, Hadassah confined its attention to these areas without interfering in the overall aims of Youth Aliyah, which it accepted and supported unreservedly.[89]

PROJECTS FOR IMMIGRANT YOUTH IN THE PERIOD OF MASS IMMIGRATION

The discussion of Hadassah projects for children and teenagers would be incomplete without a description of two additional projects to help immigrant youngsters in which the organization was involved during this period. These enterprises reflected not only Hadassah's dedication to the Zionist duty of 'ingathering the exiles', as presented in the resolution accepted at its Thirty-Fifth Annual

[86] Ibid. 13–14. [87] Kahanoff, *Ramat-Hadassah-Szold*, 31.
[88] Ibid. [89] For Bar-Gil's arguments, see id., *Search for a Home* (Heb.), 28.

Convention in 1949, but also another continuing aspect of its work in Israel, namely, ad hoc, short-term assistance that responded to urgent needs as they arose. Thus, in addition to continuing its earlier activities in Youth Aliyah and adapting them to current needs, in 1951–2 Hadassah set up two projects, one of which became a permanent institution, while the other fulfilled its intended temporary purpose. Both were aimed at helping teenage immigrants: one was designed to assist those in the immigrant moshavim (*moshavei olim*) and the other focused on those in the temporary settlements for new immigrants.

The Hadassah–Neurim Rural Vocational Centre

A small proportion of the immigrants who arrived in Israel in the first few years of the state settled in co-operative agricultural moshavim. Immigrant moshavim differed from the veteran workers' moshavim in that their members came to them not necessarily out of any ideological orientation but as a result of absorption difficulties in Israel, and they generally lacked any agricultural training. Many of these immigrant moshavim were established with insufficient planning or attention to economic considerations, primarily from a desire to settle outlying areas and improve the population distribution. The national Moshav Movement (Tenuat Hamoshavim), which sponsored this settlement for national, social, and political reasons, tried to generate cultural and social change among the immigrants to incorporate them into their communities; however, it was difficult for the new immigrants to adjust to the organizational structure and principles of the moshavim, and they needed extensive social and financial support. [90]

In 1952, Hadassah and Youth Aliyah responded to the problems of the immigrant moshavim by setting up the Hadassah–Neurim Rural Vocational Centre. Hadassah contributed an initial sum of $150,000 towards the foundation of the centre and continued to support it with a set annual sum. [91] Its executive management was divided equally between representatives of Youth Aliyah and of Hadassah, one of whose representatives, Julia Dushkin, also chaired the board of directors. [92]

Hadassah–Neurim was located in the heart of the Hefer Valley. The idea behind the enterprise was, first, that these young people needed training in order to help their parents, who had emigrated to Israel without any experience in agriculture, to maintain and improve their farms; and, second, that the trainees would become a new cadre of leaders, who would raise the cultural and social standards of the

[90] Hacohen, *Immigrants in Turmoil*, 143–4.
[91] Pincus, *Neurim*, 50, 53. [92] Yishay, 'Neurim' (Heb.), 25.

immigrant moshavim.[93] The founders of Hadassah–Neurim considered it an experimental undertaking, part of the search for new ways to educate the children of the immigrant moshavim in farming and rural life.[94] The educational approach of the centre emphasized the importance of showing the immigrant youngsters that agriculture was a profession that they should study and advance in, and equipping them with the basic tools for doing so.[95]

The training centre had two sections: an in-service training centre for young immigrants, opened in 1952, and a three-year agricultural boarding school for nearly 120 Youth Aliyah students from the immigrant moshavim, aged 12–16, opened the following year.[96] One of the main problems that the first staff faced was how to enable the pupils to return to their homes after their education at the centre without creating rifts in their families. The founders believed that, after their time in the boarding school, the students should return to their homes to assimilate into the life of the village and encourage their parents in their work, before leaving home again when the time came for their army service. During their time back in their moshavim, the young people would also attend regional in-service training courses in agriculture and home economics.[97]

In 1952 Hadassah–Neurim ran its first intensive, six-week in-service training course for about 100 students in various fields of agriculture and related areas in which they worked on their home moshavim. These included types of cultivation (vegetable growing, fodder, field crops) as well as technological subjects (for example, metalwork, mechanics, and farming equipment) and related subjects such as farm maintenance and plumbing.[98] There were different programmes for girls and boys. The girls were seen as future settlers' wives, and accordingly given short courses in domestic skills (sewing, embroidery, weaving, cooking, child care, and home economics) that would allow them to run their households effectively and efficiently. Every girl at the training centre took intensive courses in sewing, cooking, and other domestic functions.[99]

[93] Pincus, *Neurim*, 53.
[94] Letter from Akiva Yishay to Yaakov Niv, 18 Mar. 1956 (Heb.), ISA, RG71, box 2919, folder 3.
[95] Hadassah Annual Report, 1953/4, 13. [96] Yishay, 'Neurim' (Heb.), 25.
[97] A. Yishay, 'Agricultural Education for Children of Immigrant Moshavim' (Heb.), memorandum, 2 Feb. 1956, ISA, RG71, box 2919, folder 3.
[98] Yishay, 'Neurim' (Heb.), 25; Annual Report of Hadassah–Youth Aliyah Rural Training Centre, 1955/6, 26 June 1956, ISA, RG71, box 2919, folder 3, 1–4.
[99] Letter from Akiva Yishay to Yaakov Niv (Heb.), 18 Mar. 1956; Annual Report of Hadassah–Youth Aliyah Rural Training Centre, 1955/6, 26 June 1956, ISA, RG71, box 2919, folder 3; 'A Year of Activity at Neurim', *Dapim*, Sept. 1956, 21–2.

By 1 October 1953, 523 young boys and girls had studied at the training centre; in 1954/5 the number rose to 600, spread across thirty-one courses. The instructors were also involved, on a voluntary basis, in the social care of the students, young people from the immigrant moshavim and the temporary immigrant settlements in the Hefer Valley.[100] In 1955 and 1956 additional courses were added, including one in home economics for girls from Kurdistan, Yemen, Tunis, and Morocco who lived in immigrant moshavim.[101]

Youth Centres in the Temporary Immigrant Settlements

The other project developed by Hadassah specifically for young immigrants was a network of youth centres in the temporary settlements for new immigrants (ma'abarot). These settlements continued to be set up throughout Israel from mid-1950 to provide an immediate housing solution for the large numbers of new immigrants. As their name suggests, the idea was that the immigrants would stay in these settlements for only short periods, until they were absorbed into Israeli society.[102] The accommodation was constructed very rapidly, from temporary structures and light building materials: initially tents, after that canvas huts and, at a later stage, tin shanties and wooden cabins.[103]

The inhabitants of the temporary settlements constituted a cross-section of all the groups of immigrants that came to Israel after the establishment of the state. However, the most numerous were members of the two largest waves of immigration—from Romania and Iraq—who arrived in Israel in mid-1950 after the temporary immigrant settlements had become part of the Israeli landscape, and accounted for some two-thirds of the inhabitants of these settlements and hostels. In 1951, when the immigrants began to leave the temporary settlements for more permanent accommodation, almost 80 per cent of those left in the temporary settlements were of Asian and African origin; in the remainder, the demographic composition varied, with Romanians predominating among the Europeans.[104]

The education of the immigrant children in general, and of those in the temporary immigrant settlements in particular, was one of the most pressing and

[100] Yishay, 'Neurim' (Heb.), 30–2.

[101] Letter from Akiva Yishay to Yaakov Niv (Heb.), 18 Mar. 1956, ISA, RG71, box 2919, folder 3; Annual Report of Hadassah–Youth Aliyah Rural Training Centre, 1955/6, 26 June 1956, ISA, RG71, box 2919, folder 3, 67; Kachinsky, 'The Temporary Immigrant Settlements' (Heb.), 78–9.

[102] On the temporary nature of the settlements and conditions in them, see Hacohen, *Immigrants in Turmoil*, 160–1.

[103] Hacohen, *Immigrants in Turmoil*, 230–1. [104] For the data on 1951, see ibid.

painful problems that the fledgling state faced. The tremendous increase in the number of pupils—which doubled in the first two years of the state's existence—created both a financial burden and a serious shortage of teachers. The compulsory education law, which obliged parents to send their children to school from age 5 to age 12, was not always enforced. Some parents, impelled by economic hardship, did not send their children to school regularly, but sent them to work instead. Getting girls into the education system was also difficult because of the widespread traditional view that girls should not study but rather help their mothers in the home.[105]

These problems were particularly severe in the temporary immigrant settlements. In 80 per cent of them the children studied in the settlement itself, where schools, kindergartens, continuing education projects, vocational training for youngsters, enrichment classes, and youth movements were set up and run by various educational and voluntary organizations, such as the Histadrut, WIZO, and ORT.[106] These organizations provided guidance for mothers, care for babies and toddlers, and advice and assistance in health and education, as well as disseminating information and setting up youth movements, thus fulfilling an important role in helping the immigrants.[107]

Youth Aliyah was among the organizations operating in the temporary immigrant settlements, and in 1953/4 it set up a series of youth centres in some of them. These were day schools of the kind also established in development areas and poor neighbourhoods to serve children and teenagers who were not absorbed into the formal education system.[108] Their aim was to give pupils both a general education and some vocational training (carpentry and metalwork for boys, home economics and sewing for girls).[109] The first of these youth centres was set up in Beersheba, where there were hundreds of children who received no formal education whatsoever. Plans were made together with the municipality to set up a day centre that would offer youngsters vocational training and general education, as well cultural and social activities.[110]

Four of these centres were set up by Hadassah in collaboration with Youth Aliyah, in temporary immigrant settlements in Jerusalem and the Jerusalem Corridor, at Talpiyot, Kiryat Hayovel (Beit Mazmil), Maoz Zion (Castel), and Beit Shemesh (Hartuv). Hadassah allocated funds for this project, which it saw from the

[105] Kachinsky, 'The Temporary Immigrant Settlements' (Heb.), 78–9.
[106] Ibid. 80. [107] Hacohen, Immigrants in Turmoil, 191.
[108] Kol, The Youth Aliyah Tractate (Heb.), 264; see also Bar-Gil, Search for a Home (Heb.), 26.
[109] Hadassah Annual Report, 1954/5, 13.
[110] Printout from the report to the meeting of the Zionist Executive, Tevet 5713 (Dec. 1952–Jan. 1953) to Kislev 5714 (Jan.–Feb. 1954), CZA, S119, 620h, 37, 74.

outset as a short-term commitment. The sum of $300,000 was contributed from the reserve funds of Hadassah's vocational education projects, and the intention was to sponsor the scheme until this amount was exhausted.[111] The youth centres were set up by Youth Aliyah together with the Hadassah Medical Organization: Youth Aliyah organized and ran the educational activity and held seminars for the teachers who taught in the centres, while the Hadassah Medical Organization took on the provision of health services.[112]

At each of these youth centres, the mornings were devoted to studying a vocational subject, and the afternoons to educational, cultural, and social activities, which were open to all children of the region.[113] In accordance with its view of this project as a temporary endeavour to meet a particular need, Hadassah did not attempt to direct its content, but confined its involvement to providing funding. The aims and goals of the education programme were set by the education staff at the centre, without Hadassah's intervention. Efforts were also made to help graduates of the centres, who had completed their training in vocational subjects such as shoemaking, tailoring, metalwork, hairdressing, carpentry, and stone-cutting, to get work outside the centres.[114]

As in the case of other temporary projects, the Hadassah activists in Israel tried to persuade the National Board to extend its support beyond the amount initially allocated. However, they were unsuccessful, and after discussion it was decided that the project would continue until 1958, and then be transferred to other authorities.[115] In April 1958 it was accordingly taken over in its entirety by the Ministry of Labour.[116]

[111] Kol, *The Youth Aliyah Tractate* (Heb.), 290.
[112] Ma'abarot Project for the Year 1956/7, Annual Report, ISA, RG71, box 1184, file 13, 13.
[113] Draft resolutions on Transferring the Ma'abarot Youth Centres, ISA, RG71, box 1184, file 1, p. 4.
[114] Hadassah Annual Report, 1956/7, 13.
[115] Minutes of meeting on Transfer of the Ma'abaroth Youth Centres, 30 June 1957, ISA, RG71, box 1184, file 19. [116] Hadassah Projects Report, 1958, 21.

PART V

HADASSAH IN CONTEXT

Comparative and Feminist Perspectives

O UR UNDERSTANDING of Hadassah and its sources of strength can be enriched by comparing it to other American Zionist organizations, in particular the Zionist Organization of America (ZOA), Pioneer Women, and the Mizrachi Women's Organization of America, and also with WIZO, the Women's International Zionist Organization.

HADASSAH AND
THE ZIONIST ORGANIZATION OF AMERICA

The ZOA led the American Zionist movement's struggle for the establishment of the State of Israel. Its contribution to this cause, in the political and public campaigns alike, was tremendous; however, after independence was achieved, the ZOA lost both its political leverage and its popular support while Hadassah continued to thrive. The reasons for this development and the conclusions that may be drawn from it are relevant not only to the study of the period immediately after Israel's independence but also to a broader understanding of the two leading American Zionist organizations, and of American Zionism as a whole.

The ZOA's Search for a New Purpose

From late 1948 the ZOA was in a state of deep crisis, evident in two major phenomena: first, a steep decline in membership, which by 1953 had dwindled from its 1948 level of 225,000 to 95,000; and second, in its search for significant new fields of activity.[1] The most likely cause of both was that with the creation of a Jewish state, its main purpose—the political efforts to assure that objective—had ceased to exist.

[1] For the 1948 membership figure, see Halperin, *The Political World of American Zionism*, 327; for the 1953 figure, see Proceedings of the 56th Annual Convention of the Zionist Organization of America, New York, 26–30 Aug. 1953, CZA, F38/348, 35.

Many of the ZOA's members were businessmen, who were very much engrossed in their private enterprises. It takes a great challenge to draw such time-pressed people into public affairs. The three years preceding the foundation of the State of Israel provided just such a challenge, unparalleled in the history of Zionism, perhaps in all of Jewish history. However, after the establishment of Israel—and despite the new state's need for massive political and financial support—the ZOA lacked objectives challenging enough to attract new active members or sustain activity among its existing ones.

The establishment of Israel also stripped the ZOA of its two central roles: political–diplomatic lobbying and fundraising. Political and diplomatic activity was now the responsibility of the new state, while the need for funds to support the absorption of the masses of new immigrants stimulated other American Jewish organizations into action, diminishing the role of the ZOA. One new fundraising organization in particular, the United Jewish Appeal, raised enormous sums for Israel in the period immediately after 1948.[2]

The ZOA's sudden loss of a sense of purpose reflects the profound difference between that organization and Hadassah. The ZOA was totally divorced from the daily life of the Yishuv and had no base from which to work in Israel. Hadassah, in contrast, had become firmly established in the life of the Yishuv through its health and welfare projects, and in these areas it played a key role in the daily life of the newly formed state—to the extent, indeed, that it was impossible to imagine the establishment of a health system in Israel without Hadassah's involvement. Although the Histadrut Health Fund ultimately became the dominant organization in the development of the Israeli health-care system, in the early years of the state Hadassah was bombarded with requests for assistance in the various fields of health care, requests rendered urgent by the extraordinary needs of the time.

Consequently, while the ZOA was facing the loss of its central challenge and relinquishing key activities, Hadassah was encountering so many new challenges that, as noted in earlier chapters, it found itself forced to choose between those fields in which it would continue to act and those in which it would hand responsibility over to the government of the new state. The combination of its established work and the emergence of new demands ensured that the organization continued to be active in Israel and, as a result, in the United States as well. Its institutions and projects in the Yishuv, and then in Israel, were the central pillar sustaining the organization in the United States. The ZOA, by contrast, had no such pillar; and so,

[2] Urofsky, *We Are One*, 299–301.

rendered obsolescent by the political changes it had fought so hard to bring about, the ZOA almost vanished from the Zionist arena.

The key figures in the ZOA, looking for ways to overcome the crisis the organization was experiencing, sought new fields of activity in both the United States and Israel. As early as 1949 Emanuel Neumann proposed to the ZOA convention various activities and projects for implementation in Israel.[3] In the end, only two were actually put into practice. One was ZOA House in Tel Aviv, which it was hoped would bridge the gap between Israel and the American Zionists. Founded in 1953, it was based on the American concept of a community centre, and was intended to enrich cultural life in Tel Aviv. The other was the Kfar Silver Agricultural School near Ashkelon, established in 1955.[4]

Other attempts to create new realms of activity for the ZOA focused on three areas: economic enterprises, public relations, and education. The ZOA's 1953 convention decided to establish an economics department, to develop private initiatives and investments in Israel. A year later, the 1954 convention adopted resolutions to intensify public relations and fundraising for Israel.[5]

There was widespread recognition in the ZOA that it should increase its efforts to promote Jewish education in the United States, an area which it had neglected in favour of more urgent needs in the years immediately preceding the establishment of the State of Israel. Now it had become apparent that most Jewish teenagers in the United States lacked any knowledge of Jewish tradition and culture or of the Hebrew language, and that measures so far taken by American Jews to remedy this situation had failed.[6] In 1949 Daniel Frisch, president of the ZOA, proposed that Hebrew should become the second language of Jewish teenagers in the United States as a means towards the broader goal of strengthening ties with Israel, and presented this as a major objective of the organization.[7]

[3] On Neumann's suggestion, see 'The Convention in Review: A Day-by-Day Summary', *The New Palestine*, 14 June 1949, 2.

[4] On ZOA House in Tel Aviv, see 'Monosson in Israel for Cornerstone Laying of ZOA House in Tel Aviv', *The New Palestine*, 27 Oct. 1949, 2. On Kfar Silver, see 'Kfar Silver to Include College of Agriculture', *The American Zionist*, 20 Feb. 1953, 2; 'Opening of Kfar Silver', *The American Zionist*, Oct. 1955, 15; 'Kfar Silver Gets New Water System, Dorms', *The American Zionist*, Dec. 1954, 13; 'Kfar Silver Now Has 100 Students', *The American Zionist*, Dec. 1956, 17.

[5] On the decision to set up an economics department (1953) and other efforts in the field of economics, see *Proceedings of the 56th Annual Convention of the Zionist Organization of America*, New York, 26–30 Aug. 1953, CZA, F38/348, 36; on the ZOA convention, see 'ZOA Convention Sets New Standards for Israel [sic] Work', *The American Zionist*, July 1954, 1.

[6] 'The ZOA Program for Action', *The New Palestine*, 30 Aug. 1949, 5.

[7] 'Education for Jewish Living', address delivered by Daniel Frisch, President, Zionist Organization of

As a result of this heart-searching, the 1952 convention of the ZOA adopted a series of resolutions for action in the field of Jewish education.[8] A department of Hebrew language and culture was set up to offer 'every Zionist' the means to learn Hebrew. It offered correspondence courses for busy professionals and business-men, plans were made for Hebrew study clubs and social events, and a committee of Hebrew teachers and scholars was set up.[9] The department organized frame-works for studying Hebrew and Jewish culture, and from 1956 it supported a weekly radio programme broadcast on one of the New York radio networks, which made it possible to reach local stations throughout the United States. The program-ming included a Hebrew course for beginners, popular discussions on topics related to Hebrew culture, and Hebrew songs.[10]

Notwithstanding the effort put into them, the projects that Emanuel Neumann proposed did not get the ZOA back on its feet. This was because they were not consonant with the established character of the organization, which had developed to respond to immediate political challenges, not to engage in mundane, day-to-day activity. Thus, despite the many initiatives taken in both the cultural and the econ-omic realms, the ZOA in the late 1950s was 'nearly impotent, a pale shadow of its once powerful self, with few members, little status, and no purpose'.[11]

Hadassah's Sources of Strength: Gender and Culture

The answer to the question why the ZOA deteriorated to the point of dissolution, while Hadassah continued to gain in strength, lies in the implications of the differ-ent gender bases of the two organizations, which led the ZOA to become almost totally politically orientated and Hadassah to be much more socially involved. This,

America, at the first meeting of the National Commission on Culture and Education of the Zionist Organi-zation of America, 26 Sept. 1949, CZA, F38/488; Editorial, 'Program for Action', *The New Palestine*, 30 Aug. 1949, 5; 'The State of the Organization', address delivered by Daniel Frisch, President of the Zionist Organi-zation of America, at the National Administrative Council of the ZOA, Waldorf Astoria Hotel, New York, 13 Nov. 1949, CZA, F38/488, 10–11.

[8] Resolutions 3–12: 'Zionist Educational Seminaries', 'Yiddish Circles', 'Hebrew Terminology', 'Hebrew Publications', 'Jewish Culture', 'The American Zionist', 'Dos Yiddishe Folk', 'Zionist Book of the Month Club', 'Anthology of Jewish Philosophy', 'Radio and Television': Proceedings, Convention of the Zionist Organization of America, New York, 12–16 June 1952, CZA, F38/348, 422–8.

[9] On the committee of teachers and Hebrew scholars, see 'Discuss Plan for Revision of Hebrew Educa-tion', *The New Palestine*, 27 Oct. 1949, 15.

[10] 'Tenenbaum Heads ZOA Hebrew Committee', *The American Zionist*, Oct. 1955, 15; 'ZOA to Sponsor Hebrew Broadcasts', *The American Zionist*, Feb. 1956, 20.

[11] For the quotation, see Urofsky, *We Are One*, 279.

in turn, suggests a more general conclusion: that the difference between the two leading American Zionist organizations lay fundamentally in the 'masculine' nature of the ZOA and the 'feminine' character of Hadassah.

Leisure time was one of the major sources of power for Hadassah, and one of the factors that enabled it to engage in continuous activity. The continuity and stability in activity and membership that characterized the organization were intrinsically related to its engagement in long-term activities that needed consistent and un-broken attention. Such activities suited the social structure of Hadassah's member-ship, which at both the leadership level and among the rank and file comprised mostly married women who did not hold jobs outside the home. Up to the 1970s it was the norm that a Jewish woman in America did not work outside her home unless required to do so to meet family needs; thus many had considerable leisure time at their disposal, and this, coupled with the high level of education that some of them acquired and the financial security of their families, brought talented and well-educated women to the top echelons of Hadassah. The majority had trained as teachers or (a smaller number) as social workers, both considered distinctly 'feminine' professions. Thus, until such time as it became more generally accept-able for women to develop their own careers, Hadassah served as a channel for the skill and energy of women who could not fulfil themselves in the workplace. For its leaders, activity in Hadassah was a worthy substitute for a career and a source of satisfaction, power, and influence, as well as an arena in which they could apply the professional knowledge they had acquired in college. These leaders were supported by an 'army of housewives', who were also volunteers, and whose activity served them too as a source of personal satisfaction, social life, Jewish and feminist iden-tity, and influence. Just as Hadassah provided its leaders with a socially acceptable avenue for their talents and energies, so it provided the membership at large with the opportunity to engage in activities deemed not only legitimate but, perhaps even more importantly, respectable for women in American society prior to the second wave of feminism in the 1970s. This type of activity gave Hadassah's mem-bers an opportunity, without breaking the social consensus, to combine family life with fulfilling activity that gave expression to their identities both as Jews and as women.

By virtue of their nature, Hadassah's activities in the Yishuv and in Israel re-quired constant daily work. There was always something to do, regardless of the specific political circumstances. The comparison with the ZOA underscores this aspect of Hadassah's work: while the former restricted its activity to distinctly 'masculine' fields, and could flourish only when inspired by a major political

challenge, Hadassah was able to sustain constant activity over the long term. Moreover, its involvement in health and welfare made it not only an integral part of the local landscape but also a crucial participant in the continuous development of Jewish society in the Jewish homeland, and its choice of these areas of activity derived, directly and indirectly, from its character as a women's organization. This orientation, together with the restriction of its political engagement to intra-Zionist politics (as opposed to social politics or questions of public policy), freed Hadassah from dependence on political vicissitudes and allowed it to flourish steadily. As shown in earlier chapters, Hadassah's activities in the Yishuv and in Israel have been, and remain today, the pillar that supports the organization in the United States; thus we can conclude that Hadassah's choice of 'women's' areas of concern and its modus operandi have been among the main reasons for its longevity.

Another substantial source of the organization's strength was the broad scope and diversity of Hadassah's fields of activity, encompassing education (both in the United States and in the Yishuv and Israel), medicine and the paramedical professions, child welfare projects, and vocational training. This range of projects made it possible for women from many different fields of interest and expertise to find their place in Hadassah—as reflected in the composition of the Hadassah leadership in the late 1940s and 1950s. Some of the key figures (such as Rose Halprin and Judith Epstein) focused on politics, others (Tamar de Sola Pool and Miriam Freund) were interested mainly in education, and yet others (Etta Rosensohn, for example) took a particular interest in health services. This diversity enabled Hadassah to appeal to a wide spectrum of Jewish women, on both the leadership and the rank-and-file levels. It also contributed to the success of the organization's public relations, which presented a rich programme and the promise that any Jewish woman in America could find a suitable activity within its framework.

Here another source of Hadassah's strength emerges: its deep roots in the philanthropic tradition of American Jewry. As discussed in Chapter 4, Hadassah's activities were firmly rooted in the Jewish tradition, in general, and in the American Jewish philanthropic tradition in particular. It is no surprise, therefore, to find that Hadassah received widespread support, not only among American Zionist Jewish women, but among American Jews more broadly.

Thus the study of the role gender played in both Hadassah and the ZOA, the leading Zionist organizations in the United States, illuminates the enormous differences between them in character, development, and many other respects. It suggests that gender had a crucial role in the formation of their respective characters, spheres of activity, ways of working, and relationships with the Jewish com-

munity in Palestine and in Israel, as well as in their ability to survive and thrive. Gender differences can explain why the Zionist Organization of America almost vanished from the Zionist scene after it fulfilled its major contribution to the Zionist enterprise—helping to establish the State of Israel—while Hadassah continues, albeit in a much more modest way, to contribute to the Zionist cause to this day.

The comparison also suggests that gender has been an important element in the American Zionist movement, which essentially imported contemporary American perceptions of gender roles, gender differences, and gender divisions in spheres of activity within the family and society. Thus within the American Zionist movement politics was deemed the province of men, welfare and education that of women. Following this pattern, the ZOA made its contribution in the political and diplomatic sphere, while Hadassah focused its efforts in the fields of welfare and education and imported various American 'women's occupations' to the Yishuv and Israel. The contribution of American Zionists to the Zionist enterprise was therefore, to some extent at least, shaped by assumptions about gender prevailing in American society in the first half of the twentieth century.

HADASSAH AND OTHER ZIONIST WOMEN'S ORGANIZATIONS

Since Hadassah's outstanding success on the American Zionist scene was a result of its being a women's organization, a comparison with its sister Zionist movements in the United States—Pioneer Women and the Mizrachi Women's Organization of America—as well as WIZO, which operated internationally, is warranted. What gave Hadassah the advantage over the others?

Similarities and Differences

There were certainly similarities among the three American organizations. Pioneer Women and Mizrachi Women also devoted considerable effort to the care of children and teenagers, and supported the Youth Aliyah movement.[12] Like Hadassah, they operated in two arenas—in the Yishuv and Israel, and in the United States—emphasizing philanthropic activity for pragmatic causes in the Yishuv and Israel, and spiritual activity in the United States. However, alongside these resemblances there were also significant differences.

[12] *Report on Activities 5707–5711 [1946–51]* (Heb.), CZA, 259 (Financial Report); *Report on Activities 5711–5716 [1951–5]* (Heb.), CZA, iii–12.

One factor is that the other organizations concentrated specifically on fostering the welfare and interests of *women* in Israel, whereas Hadassah established projects intended to benefit the entire population. Pioneer Women set itself the main goal of fundraising and support for the Women's Labour Council (Mo'etset Hapo'alot). Its undertakings included providing day nurseries and pre-school groups, so that women could go to work; training courses for girls and women in vocations traditional for women, such as sewing, cooking, housekeeping, and home economics; help and advice on family budgeting and hygiene; cultural activity and the establishment of educational and cultural frameworks exclusively for women.[13] It can be considered, then, a feminist organization that fought for the welfare of women and promoted their interests. Mizrachi Women's Organization of America (later known as Amit) also supported day-care centres, social services, vocational training projects, and schools for teenage girls.[14]

Likewise, WIZO, the Women's International Zionist Organization, defined itself as a union of Jewish women that aimed at 'taking an active part in building and consolidating the state of Israel' by means of supporting institutions and services in Israel related to the education and training of girls and women in agriculture, home economics, and other skills; the welfare of teenage girls; and the provision of aid and training to immigrant women so that they could integrate into the life of the state of Israel.[15] Thus Hadassah was distinct from WIZO, too, in directing its activities towards the benefit of the population as a whole rather than women alone.

This wider focus on providing services to the entire population of the Yishuv, and later Israel, and not women alone, had a considerable impact on the support for Hadassah's projects, and this in turn contributed substantially to increasing the organization's overall strength. Declaring work on behalf of one part of the population alone as central to an organization is likely to limit its support. In comparison, activity in pursuit of general humanitarian aims, addressing every person, and based on the American and American Jewish sense of mission and tradition of philanthropy, enhanced Hadassah's attraction. This was the core of Hadassah's advantage over other Zionist women's organizations, both within the United States and outside it

Another advantage of Hadassah over the other American Zionist women's

[13] C. B. Sherman, s.v. 'Na'amat', *Encyclopaedia of Zionism and Israel*, ii. 973–4.

[14] Shargel, 'American Jewish Women'; Y. Goldshlag and B. Mindel, s.v. 'Na'amat', *Encyclopaedia of Zionism*, ii. 945; see also Hyman and Moore, *Jewish Women*, i. 48–9.

[15] For the quotation and arguments, see Greenberg and Herzog, 'A Voluntary Women's Organisation', 52.

organizations was its ability to appeal to a very wide cross-section of Jewish women in the United States, while the other organizations addressed specific sectors only. In 1952 the Mizrachi Women's Organization of America defined its objectives as being to 'maintain schools and nurseries in Israel in an environment of traditional Judaism; conduct cultural activities for the purpose of disseminating Zionist ideals and strengthening traditional Judaism in America'.[16] In other words, while Hadassah supported general Zionist ideals, shared by the majority of American Jews, and aspired to be a broad, popular Zionist movement, Mizrachi Women supported and adhered to ideals and concepts accepted only by Orthodox Jews, and therefore did not appeal to so large a proportion of American Jewry. Furthermore, Mizrachi Women was part of the worldwide Mizrachi movement, associated with the Mizrachi party in Israel, which narrowed its potential membership even further.

Pioneer Women also limited itself to a narrow target membership, again because of its connection with a political party in Israel (Mapai) and because of its goals, which appealed only to a small portion of American Jewry. By its own definition, its major objective was 'to build the state of Israel along cooperative lines'.[17] Although there was a similarity between Hadassah and Pioneer Women in that both worked in the field of health, only those with a socialist Zionist outlook would be likely to support Pioneer Women. Hadassah, then, appealed to a wider audience than any other nationwide Zionist women's organization in the United States.

Hadassah and the National Council of Jewish Women

Perhaps the most interesting finding emerges from a comparison of Hadassah with the National Council of Jewish Women (NCJW). As a non-Zionist organization, the NCJW could potentially attract all American Jewish women. However, as early as the late 1930s Hadassah's membership matched that of the NCJW, and thereafter surpassed it. After the Second World War, Hadassah's membership was over double that of the NCJW (143,000, compared with 60,000 in the NCJW), and in 1950 Hadassah had 270,000 members, compared with only 90,000 in the NCJW.[18]

The explanation for this apparent anomaly lies in the social composition of the National Council of Jewish Women, which was totally different from that of Hadassah. The NCJW drew its membership primarily from Jewish women of

[16] For the quotation, see *The American Jewish Yearbook*, 53 (1952), 525.
[17] For the quotation, see *The American Jewish Yearbook*, 52 (1951), 465–6.
[18] For the data on Hadassah, see Hadassah National Office; for the data on the National Council of Jewish Women, see Rogow, *Gone to Another Meeting*, 241.

German descent. The majority of its members were married to successful men, and a high proportion belonged to the upper echelons of their Jewish communities, taking part in elite social and cultural events. They were well educated for the time, usually having attended private schools and about 80 per cent having graduated from college, and most belonged to the Reform stream of Judaism.[19] The NCJW was, then, an elitist organization, and its members tended to stress the high intellectual level of its activities.[20] This social profile did not include most of the Jewish women in the United States in the late 1940s and 1950s: the majority came from families of east European immigrants, were adherents of Conservative Judaism, and—with few exceptions—had not had the opportunity to study at prestigious educational institutions.

For various reasons, then, Hadassah was able to attract a broader spectrum of women than any other Jewish women's organization in the United States, Zionist or non-Zionist. This was true not only at the level of the rank-and-file membership, but also in terms of the leadership: most of the leaders of Hadassah were daughters of immigrants from eastern Europe and Conservative or Reconstructionist Jewish women, who would have been debarred from NCJW activities both by their social background and by their religious affiliation.

However, despite the differences between them, the two organizations also shared some common traits. Both the NCJW and Hadassah were operated and led, for the most part, by married women with leisure time. Both organizations were also careful not to breach the gender-based division of occupations that was accepted at the time. The NCJW, like Hadassah, also engaged in both practical and spiritual projects. A considerable part of its activity was devoted to helping new Jewish immigrants in the United States. It worked according to the scientific standards of the time and some of its endeavours, like those of Hadassah, were inspired by the settlement house movement, many years after that movement itself had ceased to exist.[21] In these respects, Hadassah resembled the National Council of Jewish Women, but with a Zionist orientation.

Nevertheless, the two organizations diverged again at the level of project implementation. For the most part, it was the volunteer women themselves who carried out the work of the NCJW, while, as noted, the Hadassah projects in the Yishuv, and later in Israel, were executed by local professionals, who became a crucial factor in the organization's activity. We shall return to this topic in the next chapter.

[19] Rogow, *Gone to Another Meeting*, 206, 207, 210. [20] Ibid. 268. [21] Ibid. 131.

HADASSAH AS A WOMEN'S ORGANIZATION

Paradoxically, Hadassah owes its success largely to being a women's organization whose main interest has not been, either ideologically or practically, the betterment of women's conditions or social status. The history of Hadassah reveals that for most of the years of its existence it did not strive directly to change or promote the status or the welfare of women alone, either in the United States or in Israel. Feminist aims and objectives are not listed in any of the major documents presenting Hadassah's ideology, nor in any of the organization's constitutions (of which there have been at least twenty-eight), which are the central documents expressing its ideology. Even the *Hadassah Handbook*, a primary document for understanding the organization, hardly mentions the advancement of women or women's issues.

Hadassah's leadership did not view the members as agents of social change. Instead, it presented them with challenges related directly to Hadassah's objectives: fundraising, recruitment of new members, and efforts in the field of Jewish education. Thus the main instruments used by the leaders to inspire the members to action, such as the bulletins *Hadassah Newsletter* (which was sent to the entire membership) and *Hadassah Headlines* (whose original purpose was to inform chapter leaders about current and forthcoming projects), did not try to cultivate a feminist identity that would encourage members to struggle for equality with men, a sense of feminist elitism, or any other feminist ideals that extended beyond the bounds of the existing social consensus. This represented a deliberate avoidance of any ideological element that might undermine Hadassah's main objective of reaching every Jewish woman in America.[22]

In the late 1940s and 1950s two additional factors pushed women's issues off Hadassah's agenda: first, feminism was dormant in America at the time, as discussed below; and second, special circumstances pertained in Israel in the early years of statehood.

The American feminist movement advanced in two waves, the first beginning in the late nineteenth century and culminating in the 1920s, and the second beginning in the 1960s. The intervening period, from approximately 1920 to 1960, was characterized by general hostility towards feminist movements, and was therefore largely a dormant period for feminism. Moreover, in the fifteen years after the

[22] 1947 Constitution, 1956 Constitution, HA, RG17, Printed Material/Pamphlets/Constitutions; *Hadassah Handbook*; *Hadassah Newsletter* and *Hadassah Headlines* for the years discussed. See also the definition of objectives in the *American Jewish Year Book*, 51 (1950), 468, 53 (1952), 487, and 54 (1953), 503.

Second World War the thoughts of white, middle-class American women were focused on their homes and families. The feminist scholar and author Betty Friedan describes the typical view of women's advancement in these years in her book *The Feminine Mystique*: no one argued whether women were inferior or superior to men, and concepts such as the 'liberation' of women would have sounded very odd and out of place.[23]

The other factor was the overriding importance in these years of the affairs of Israel and their implications for Hadassah's status and activities. Throughout the period discussed in this volume, Hadassah was occupied above all with helping Israel, reorganizing in the wake of statehood and the consequent changes in its role there. Dwelling on the advancement of women, which had never been among its objectives in any case, would have diverted much-needed organizational energy away from its central purpose of promoting Zionist objectives.

This brings us to an interesting finding: Hadassah began its activity as a women's movement, working for the welfare of women and children, but over the years it moved away from this goal, both ideologically and practically, in favour of other objectives.

Hadassah's original idea as it developed in the 1920s and 1930s stressed the need for action on behalf of women and children, and emphasized the unique contribution women could make to the Zionist cause, as the result of three critical impulses. These were: first, the desire to establish an organization that would be consistent with women's inclinations, as understood then, namely, involvement more in practical matters than in ideological issues; second, the aspiration to acquire a defined and central role for Hadassah in American Zionism and in the world Zionist movement as a whole; and third, the pressing need for health and welfare institutions in the Yishuv.[24]

However, over time the role of Hadassah in the American and world Zionist movements became firmly established, and the assumption underlying the initial concept—that men and women should take unique and different roles—was put aside. Thus by the late 1940s and 1950s no trace either of the idea of separate spheres or of feminist, gender-based ideas could be found in Hadassah's ideology. They had been replaced by ideas regarding other needs and goals, primarily the need to be a broad, popular Zionist movement.

[23] On the two waves of feminism, see Buechler, *Women's Movements*, 12–35; Hannam, 'Women, History and Protest', 77–94. The classic description of the concentration on the home among American women in the fifteen years following the Second World War can be found in Friedan, *The Feminine Mystique*, 199; Buechler, *Women's Movements*, 36.

[24] On the three factors, see McCune, 'Social Workers in the Muskeljudentum', 137.

The gradual diminution in activities on behalf of women was not limited to the ideological realm, but was strongly reflected in Hadassah's projects in the Yishuv and Israel. Hadassah's first project in the Yishuv, in 1913, was aimed at establishing a network of regional welfare stations that would operate according to the visiting district nursing method. It was intended mainly for the benefit of women and children, and was directly, albeit not exclusively, related to women's welfare. However, it did not last long, being terminated at the beginning of the First World War. When Hadassah became involved in actual medical activities in 1918, through the American Zionist Medical Unit, it began developing health services for the general public in the Yishuv. Since then, the original direction of the work, which focused on the benefit of women and children, has changed completely. Later, Hadassah did work for the benefit of women, but not as its central activity.

In the 1930s Hadassah centred its activity in Jerusalem and concentrated on 'scientific' and academic medical work, rather than the social medicine it had championed in the 1920s. This change, again, represented a turn away from activity on behalf of women. However, until the early 1950s Hadassah continued to run the health welfare stations, which can also be perceived as a project designed to benefit women, although not only women. When most of the health welfare stations were transferred to the authority of the state this activity on behalf of women was again pushed to the bottom of Hadassah's list of priorities.

Hadassah, then, is not a feminist organization aimed at the betterment of women, but, both ideologically and practically, an organization that brings women together for Zionist activity.

HADASSAH AS AN APOLITICAL ORGANIZATION

In addition to the factors discussed above, Hadassah drew strength from its apolitical character. The avoidance in principle of any affiliation with any political party, either in the United States or in Israel, was based on the central objective of Hadassah to be a popular, mass-based Zionist movement of Jewish women. This motive was coupled with the accepted view at the time of its establishment that political involvement was not appropriate for women. Indeed, to this day the largest women's organizations, Jewish and non-Jewish alike, are mainly involved in humanitarian work, and declare themselves non-partisan.[25]

Hadassah, then, portrayed itself as an apolitical organization—with one exception: the context of the world Zionist movement. As an organization unaffiliated

[25] On women's organizations involved in humanitarian activity, see As, 'On Female Culture'.

with any political party in the Diaspora, Hadassah risked being left powerless within the world Zionist movement, which was based entirely upon political affiliations. In order to avoid this, it joined the World Confederation of General Zionists. This political move enabled it to gain substantial power within the World Zionist Organization. Here too a comparison with WIZO is informative: WIZO, which adopted a purely apolitical stand in all arenas of activity, was totally powerless in the World Zionist Organization for many years.

Finally, though Hadassah was by no means a feminist group, its political path within the World Zionist Organization was characterized by a firm stand against the 'masculine establishment', both on behalf of its own interests and positions and on behalf of American Jewry in general. This took the form of direct argument and a willingness to take uncompromising positions, as well as shrewd use of political tactics.

Hadassah's Partners

Hadassah's enterprise in Palestine was the largest collective project of women in the Diaspora on behalf of the Yishuv and, later, Israel, and remains so today. It depended for its success, however, on its partners in this enterprise: professionals in the Yishuv and Israel. These doctors, nurses, teachers, and others, most of them European migrants to Israel, gave of the energy, talent, and knowledge they had acquired in the countries in which they had been educated. They were the executors, and sometimes the visionaries, of Hadassah's various projects in the Yishuv and Israel. These people played a critical role in Hadassah's work for the Yishuv and Israel, and in its existence as a Zionist organization in the United States.

Henrietta Szold understood that only people who were part of the Yishuv could implement Hadassah's work in their community. On the basis of this view, she took one of the most significant steps in the history of Hadassah when, in 1929, she placed the administration of the Rothschild Hospital in the hands of Russian-born Dr Haim Yassky, who had come to Palestine as a pioneer. The first physicians employed by Hadassah in Palestine, including Dr Yassky's four predecessors as head of the Rothschild Hospital, were Americans. They made a significant contribution to shaping the medical services of the Yishuv in the 1920s, but they were considered outsiders and became embroiled in countless conflicts with Yishuv residents. Hadassah became an integral part of the Yishuv only after Dr Yassky took over as head of the hospital and director of the Hadassah Medical Organization. From then on, it was locally recruited people who directed the organization's projects. This was a critical factor in the success of these endeavours, and the key also to the success of Hadassah as a Zionist organization in the United States.

A review of the history of the Rothschild-Hadassah University Hospital confirms the thesis that key decisions regarding its medical character were taken by the 'partners'. Most of the physicians at the hospital in the 1930s (slightly more than a decade after Hadassah started its medical activity in the Yishuv) had acquired their medical education and training in Germany. It was these doctors, and not the

women of Hadassah, who changed the medical practices of the Hadassah Medical Organization in Palestine, imbuing it with a scientific and expert character, in the spirit of the German medical tradition that they brought with them to the country.

Similarly, a decade later, when the Hebrew University-Hadassah Medical School was established in 1949, in fulfilment of a Zionist vision outlined as early as the Thirteenth Zionist Congress in 1913, Hadassah women played an important role in its establishment, but several organizations in Israel were involved in the campaign to bring it into being, and the final push to open its doors came from the local professionals. It was also the local professionals who determined that the teaching method, a central issue in defining the character and direction of the school, would follow the American school of thought in teaching medicine, believing as they did that 'the future of medicine [lay] in the United States'.[1] Hadassah recruited a group of eminent Jewish physicians to serve (in a voluntary capacity) on its Medical Reference Board, and this group made a significant contribution to the institution, for example in presenting the American school of thought on teaching medicine to its planners and forming ties with leading medical institutions in the United States. However, its role was purely advisory; it was not a decision-making body. A good example of the independent drive of the 'partners' is furnished by the dental school: the school planners announced its establishment to the Hadassah National Board members only after it was a fait accompli.

The establishment of the medical school, and the choice of the American system of teaching, led to the field of medicine in Israel developing in a new and radically different direction. As noted above, from the 1930s medical practice at the Rothschild-Hadassah University Hospital had been characterized by a strongly German medical orientation (for many years the patients at the hospital complained that the doctors attending them spoke German among themselves).[2] Integral to the German—and, more broadly, central European—tradition was a method of teaching medicine based on lectures and demonstrations delivered by a single eminent expert to large classes of students. The American method, by contrast, which was implemented immediately after the medical school was established, involved small study groups, bedside teaching, and an emphasis on medicine as an experimental science. This required a large number of teachers, both full-time staff and guest lecturers, who were recruited from medical institutions throughout Israel, and some of whom rose to professorial rank. A review of the career histories of 106 teachers at the medical school in 1960 reveals that the

[1] Fact Sheet on the Hebrew University-Hadassah Medical School, 5 May 1947, HA, RG2, ser. 52, box 90, p. 260. [2] Niederland, 'The History of the Medical School' (Heb.), 28.

majority had studied medicine in various places in Europe, and most were consequently unfamiliar with the American methods of teaching. Nevertheless, a change in orientation, reflecting the American approach, was already evident in the early 1950s, both at the medical school and at the Rothschild-Hadassah University Hospital, where its students received their practical training.

In the 1950s the Rothschild-Hadassah University Hospital and the Hebrew University-Hadassah Medical School sent a large number of young doctors on the teaching staff abroad for in-service training, some through Hadassah's Fellowship Programme and some with grants from other foundations. The main purpose of this undertaking was to bring new methods from the United States to Israel, and accordingly almost all of the overseas in-service training was conducted at leading universities, medical centres, and hospitals in the United States, such as Harvard, Johns Hopkins, and Columbia universities, and Jewish hospitals in New York, especially Mount Sinai, the Jewish Hospital of Brooklyn, and the Jewish Sanatorium for Incurables.[3] There were also a few exceptions: in 1951–2 one doctor attended in-service training in Johannesburg, and another studied from 1946 to 1950 in Toulouse. Further evidence of the American orientation of Hadassah's Fellowship Programme is its rejection of a proposal to set up a European advisory board that would arrange for those doctors who for one reason or another could not study in the United States to go instead to Europe. Hadassah declared that the orientation of the medical school was Anglo-American, and that therefore such a committee, and indeed provision for in-service training in Europe, was unnecessary.

A similar American orientation was prevalent in this period throughout the Hebrew University in Jerusalem, the only university in Israel in the early years of the state, and developed rapidly through these years. The university had been founded in 1925 in fulfilment of a Zionist vision, and with the purpose of serving as a world centre of Jewish science and research. It was originally based on the model of the universities in the German-speaking countries (including Austria, Switzerland, and Czechoslovakia), and the overwhelming majority of its first teachers had studied at German universities.[4] However, after the Second World War, exposure to the United States increased, even among the older generation, and the university looked to American universities as models in the exact sciences (especially mathematics) and natural sciences (especially biochemistry), as well as the social sciences (primarily economics, sociology, and education).[5]

 [3] Hebrew University of Jerusalem, *The Hebrew University of Jerusalem.*
 [4] Ben-David, 'Universities in Israel' (Heb.), 527–8.
 [5] See Troen, 'The Discovery of America'.

This turn towards America came about as a result of a number of factors to do with both the international situation and Jewish considerations. Ties between the Yishuv and the German-speaking universities, which had been among the best in Europe for medical education before the war, had been severed in the 1930s by the rise of Nazism; in any case, in the aftermath of the Holocaust the idea of forging links with European institutions was unattractive. Moreover, across almost the whole of Europe universities and their medical schools had been destroyed by the conflict.[6] In contrast, their counterparts in England and the United States came out of the war in a better state, thanks to their achievements in war-related research. Academic ties with scientific and medical institutions in the United States were also fostered by the support these institutions gave to advanced students and academic researchers from throughout the world, and their willingness to finance large-scale research outside the United States. Countries that gained independence after the war benefited particularly from US support, and Israel was one of the first to enjoy such aid.[7] Finally, the United States was home to the largest and wealthiest Jewish community in the world.[8]

In time, the Hebrew University-Hadassah Medical School spread the American orientation, both in research and in teaching, to all the other medical schools that were established in Israel. In 1965 Tel Aviv University established its medical school, which eventually became Israel's largest. Seven years later, in 1972, a medical school was opened in Beersheba at Ben-Gurion University of the Negev, and another followed at the Technion in Haifa. The founders of all these schools were graduates of the Hebrew University-Hadassah Medical School, people who had worked there for many years and also trained in the United States as part of Hadassah's Fellowship Programme.[9] Andre De Vries, founder of the Tel Aviv University Faculty of Medicine, was a high-ranking physician at the Rothschild-Hadassah University Hospital. He studied in the United States as part of the Fellowship Programme in the late 1940s, and taught at the Hebrew University-Hadassah Medical School upon his return. Moshe Prywes, who served for many years as assistant dean at the Hadassah-Hebrew University Medical School, was one of the founders of the Medical School at Ben-Gurion University of the Negev. The founder of the Technion's Faculty of Medicine in Haifa, Yaakov Ehrlik, and

[6] See Troen, 'The Discovery of America', 165. [7] Ben-David, 'Universities in Israel' (Heb.), 535.
[8] Troen, 'The Discovery of America', 169–74.
[9] Niederland, 'The History of the Medical School' (Heb.), 28; author's interview with Prof. Shaul Feldman, Jerusalem, 28 Feb. 2001.

other physicians who worked with him, also came from the Hebrew University-Hadassah Medical School.[10]

The adoption of the American approach to medicine as an experimental science had far-reaching implications for the character of the medical profession in Israel. In making their diagnoses American doctors used a range of different tests, some of them very complex, employing advanced laboratory equipment and clinical instruments. This school of thought also gave priority to pure research, based on sophisticated technology, over general, community, and preventative medicine.[11] The application of this approach in teaching, first at the Hebrew University-Hadassah Medical School, and later, as a result of the model of medicine it reflected, in other medical schools in Israel, had a profound impact on the perspective and methods of Israeli doctors. Among the agents of the American orientation in medicine were the many physicians who left the Rothschild-Hadassah University Hospital (where the physicians were—and still are—also teachers at the medical school) from the 1950s onwards, moving to other hospitals and taking with them the American approach, methods, and priorities, which they then applied in their new capacities as heads of wards and in other senior positions.[12]

The Rothschild-Hadassah University Hospital also contributed to the development of other hospitals. In the early years of the state a system of affiliation was established involving, among other things, secondment of clinical students from the new Hebrew University-Hadassah Medical School to other hospitals to raise standards there. As a condition for this support, the hospitals were required to meet criteria set by Hadassah and the Hebrew University: a minimum requirement for affiliation of the hospitals was the maintenance of an X-ray institute, clinical laboratories, and an atomic pathological laboratory. During the 1960s these links became widespread, and all the major hospitals in Israel—Tel Hashomer, Beilinson, Rambam, and Hadassah in Tel Aviv—became affiliated with the Rothschild-Hadassah University Hospital in Jerusalem. Later, the hospital in Afula, the main hospital in the Jezreel Valley region (now the Emek Medical Centre) and the Kaplan Hospital in Rehovot were also affiliated.[13]

Finally, Hadassah's partners also contributed to the promotion of family medicine in Israel. In 1962 the medical school and the Histadrut Health Fund signed an agreement to create a framework to provide in-service training for the fund's

[10] Niederland and Kaplan, 'The Medical School' (Heb.), 29; author's interview with Prof. Shaul Feldman, Jerusalem, 28 Feb. 2001.
[11] Niederland and Kaplan, 'The Medical School' (Heb.), 13, 29. [12] Ibid. 29. [13] Ibid.

physicians, with the purpose of raising the professional standards of the health fund, which provided 70 per cent of the health care in Israel. An institute was set up which offered courses lasting between one and two months; the emphasis was on clinical practice, accompanied by lectures and group discussions. This training was especially valuable for new-immigrant doctors, whose period of study was extended to three months.[14]

A more complex picture arises with regard to the role of the 'partner' professionals in establishing the nursing and paramedical professions. All of these, with the exception of the work of X-ray technicians, were based on the American model. A fixed pattern is evident: the training curriculum was based on the programme at the leading institutions in the United States; the first instructors of the profession were brought in from the United States; and leading local teachers were sent to the United States for further training.

The nursing profession was introduced to the Yishuv by the American Zionist Medical Unit when there were hardly any nurses in the country. The first teachers were Americans who came with the unit. The American orientation of the Hadassah Nurses' Training School was reflected in its curriculum and the professional values imparted to the students. Most of the key figures in the school during the Mandate period were sent to or attended in-service training at the leading nursing institutions in the United States. Thus the part played by the partners in importing the profession was not great, as it was brought to the Yishuv by American nurses; however, their role in inculcating professional nursing methods throughout the country was considerable.

There were five schools of nursing in the Yishuv during the Mandate period. Three were established and initially directed by graduates of the Hadassah Nurses' Training School: those at the Beilinson Hospital (established in 1936), at the Hadassah Hospital in Tel Aviv (later the Ichilov Medical Centre), established in 1943, and at the Haifa Municipal Hospital.[15] After independence, additional schools were founded, all by graduates of the Hadassah Nurses' Training School. Thus the American orientation in nursing was spread throughout the Yishuv and Israel.[16]

From the early 1920s Hadassah also introduced the study and practice of nutrition to the Yishuv. Julia Dushkin, who was trained at Cornell University and came to Palestine under the influence of Henrietta Szold, was the first dietitian in the Yishuv. She was followed by Sara Bavly, who established the nutrition studies

[14] Niederland and Kaplan, 'The Medical School' (Heb.), 29.

[15] See the table in Zwanger, 'Preparation of Graduate Nurses', 128–9; interview with Leah Zwanger, Ashkelon, 28 Mar. 2001. [16] Ibid.

programme in the Yishuv and later in Israel, after being sent to the United States to study nutrition at Columbia University. Bavly was strongly influenced by what she saw in the United States and implemented what she had learned there in the Yishuv, adapting it to local needs. Other nutritionists also attended in-service training in the United States, later returning to become key figures in the practice and teaching of their profession, in the Yishuv and later in Israel.

Occupational therapy was the first in a series of paramedical professions that Hadassah introduced in Israel in the early years of the state, along with audiology and the training of X-ray technicians. Training in occupational therapy was planned by American professionals, according to teaching methods accepted in the United States, and the first instructors in Israel were Americans trained in the United States especially for the purpose. Thus the partners were not instrumental in introducing this profession or in laying the foundations for training; however, they did play a considerable role in establishing it, in respect of both practice and training.

Thus nursing and the paramedical professions, which were distinctly regarded as 'women's professions' in the United States, were introduced into the Yishuv and Israel as the result of American Jewish initiative, and in some cases by American Jewish professionals. Moreover, most of the key figures in the Hadassah nursing school in Palestine during the Mandate period underwent in-service training in nursing centres in the United States. However, it was people from the Yishuv and, later, Israel, who developed and established these professions in the country. The partners played a central role in adapting American methods and ideas to local needs, especially in applying them in Hadassah's projects for children and teenagers. Over time, too, their influence increased. In the 1920s and 1930s, at the beginning of its involvement in the Yishuv, Hadassah played a crucial role in both initiating projects and establishing them. Gradually, however, the projects that Hadassah brought to Palestine in the 1920s took on a local character. Conditions in the Yishuv were quite different from those in the American cities where the projects had first been conceptualized, and most of the people charged with implementing them had never been to the United States. These women and men introduced changes to the American models and added new elements to suit the Yishuv's needs, circumstances, and values. For example, Rachel Schwartz, who directed the playground project, was a nursery-school teacher who had seen how playgrounds were run in England, and Moshe Schwabe, who was responsible for the educational programme at the Hadassah playgrounds, was of central European origin. Neither was familiar with the American playground model, which for them

was no more than a general concept. Thus they imbued the playground project with their own ideas and moulded its content according to their educational and Zionist views. In this way, as in the field of medicine, from the 1930s onwards the weight of the partners in the various Hadassah projects grew.

In the 1940s and 1950s Hadassah also developed projects that had no explicit American model and were not connected to any parallel American projects or institutions. These included the Alice L. Seligsberg Trade School for Girls, the Szold Institute, and the short-term projects such as the youth centres set up with Hadassah's funding in the early years of the state. These were designed from the very beginning by local residents.

Research for this book revealed only one example of an attempt to 'import' an American model that was unsuccessful: the field of hotel management. In 1950 Hadassah sent two American chefs from the State University of New York to Israel to set up a school of hotel management. Although the first graduates were successful in obtaining jobs, applicants to the school were few and it was closed down within a few years.

In view of the differences in mentality and ideology between the residents of the young State of Israel and the American Jews of Hadassah, one must ask how American approaches and methods were accepted in the Hadassah projects. In medicine, American methods were usually welcomed in Hadassah's institutions; indeed, they were brought in with the agreement of the doctors at the Rothschild-Hadassah University Hospital, for reasons discussed in earlier chapters. The same is true regarding the paramedical professions: for example, as noted above, occupational therapy was brought into Israel in replication of the American model, and was welcomed throughout the Hadassah institutions (with the exception of the nurses at the Rothschild-Hadassah University Hospital, who feared encroachment on their functions). Moreover, 'in the health projects of Hadassah, the American methods were accepted without question'.[17]

In other fields, too, American methods were readily embraced. Even the European Helen Kittner, who directed the Seligsberg School, asked Hadassah in 1949 to bring an expert in fashion to Israel from the United States, rather than from Europe. Similarly, when Hadassah tried to establish a school of hotel management in Israel, in co-operation with the Israel Hotel Association, the Israeli group agreed to the introduction of an American model, straight from the State University of New York.[18]

[17] Interviews with Yehudit Steiner Freud, Jerusalem, 16 Jan. 2001, and Nira Sussman, Tel Aviv, 18 Feb. 2001. [18] Hadassah Annual Report, 1952, 25.

On further reflection, this readiness to absorb American ideas and expertise is less surprising than it may at first appear. As noted in earlier chapters, David Ben-Gurion and other Zionist leaders believed strongly in the value of American scientific methods and technology in developing the fledgling state. This was not a desire for the Americanization of Israeli lifestyle, ideology, or politics, nor was it seen as conflicting with the Zionist ideal. It was, however, consistent with the admiration and respect for American achievements and models that prevailed almost everywhere in the Western world following the Second World War.

Hadassah's partners, then, were central to the process of establishing American ideas and methods in the Yishuv and Israel and adapting them to the country's needs. As this book has shown, the role of local people increased steadily over time, and it was they who made Hadassah's unique contribution possible. Moreover, Hadassah's projects in the Yishuv and Israel were from its inception, and remain to this day, the pillar of the organization's existence in the United States. This mutual support could be achieved only through partnership. This partnership was, and still is, a vital condition for Hadassah's existence.

Epilogue

HADASSAH HAS BEEN ACTIVE in the United States and in Israel (the two largest concentrations of the Jewish people today) for a century now. Amazingly, despite the changing times and circumstances, much of what has been said of it over those years was still true when I was collecting the material for this epilogue in 2005 (terms such as 'currently' and 'today' used here relate to that year).

Hadassah's organizational identity and its fundamental objectives and goals, as they were worded in the 1956 constitution (see Appendix C), remained unchanged until 1999. At that time a small amendment was made, but it entailed no substantial change either to its objectives and goals or to its organizational identity.[1] According to three central figures in Hadassah in the past thirty years, Bernice Tannenbaum (president from 1976 to 1980), Ruth Popkin (president from 1984 to 1988), and Marlene Edith Post (president from 1995 to 1999), 'the ideology has not changed, the basic goals have not changed—it is the practice which has changed.'[2]

And so today, as in the 1940s and 1950s, Hadassah's ideology is aimed at responding to the needs of American Jews in accordance with their fundamental values. It encompasses American ideals, including the fundamental notions of American democracy, as almost sacrosanct values, and reflects the desire to ensure that the next generation will continue to live as Jews. Because Hadassah's Zionism combines elements of American ideology and American patriotism, traditional Jewish ideas, and ideas considered by very many American Jews as common to both Judaism and Americanism, it appeals to Jews with varying Jewish perspectives and of varying political affiliations.

The precipitous rise in the last three decades of the twentieth century in the rate of mixed marriage in the American Jewish community—which had been a marginal phenomenon (3–5 per cent) until the end of the 1950s—has wrought a change in Hadassah's financial priorities, particularly with regard to its educational activity among Jewish youth in the United States.[3] Currently, Hadassah allocates the

[1] Hadassah Constitutions 1956–98, HA, RG17, Printed Material/Pamphlets/Constitutions.

[2] Interviews with Bernice Tannenbaum, New York, 19 Dec. 2004; Ruth W. Popkin, New York, 19 Dec. 2004; Marlene Post, New York, 19 Dec. 2004. The quotation is from Post's remarks at that interview.

[3] The rate of mixed marriage among Jews in America was 2% among those who married in the first quarter of the twentieth century and 3–5% among those who married in the 1930s, 1940s, and 1950s

second-largest segment of its budget, after its health enterprises in Israel, to the
Young Judaea youth movement, which aims to reach all streams of Judaism
(Reform, Conservative, Orthodox, and Reconstructionist) as well as Jews who are
not affiliated with any stream, and regards its principal role as developing a deep-
seated Jewish identity and a strong identification with Judaism and Israel.[4]
Hadassah regards Young Judaea as a source for the future generation of Jewish
leaders in America in general and for itself specifically (indeed, many of Hadas-
sah's present-day leaders are graduates of Young Judaea).[5] As part of its collabora-
tion with Young Judaea, Hadassah invests a great deal of effort, far beyond that of
the 1950s, in arrangements for young American Jews to visit Israel, including
summer programmes, one-year programmes, and programmes in conjunction
with the Hebrew University.[6]

The character of Hadassah as an organization operating in Israel out of solid-
arity towards Jews in distress outside the United States, in particular new immig-
rants, which found unmistakable expression in the first years after the founding of
the state, manifested itself in various guises in later periods. Thus it committed
itself to helping immigrants from the former Soviet Union integrate into Israel
when they arrived in the 1990s.[7] Significant funds were invested in training doc-
tors, dentists, nurses, and other health workers from among the immigrants, many
of whom were employed at its hospitals. Also participating in the efforts to aid

(Rebhun and DellaPergola, 'Socio-Demographic and Identity Aspects of Intermarriage' (Heb.), 376). In the
first half of the 1960s the rate of mixed marriage was 10%; in the second half of that decade it rose to 22%,
and then in the 1970s to 28%, in the first half of the 1980s to 38%, and to 43% between 1985 and 1995
('Rates of Intermarriage', United Jewish Communities, The Federations of North America, www.ujc.org/
content_display.html?ArticleID=83911 NJPS). According to the second National Jewish Population Survey,
held in summer 1990, and the third National Jewish Population Survey, held in 2000 and 2001, nearly half
of the marriages in 1984–9 were mixed marriages. The question who is considered Jewish for the purpose
of the surveys is the primary reason for the disagreement among social science researchers on whether the
rate of mixed marriage in those years (1984–9) was 42% or 52%. On the other hand, there is agreement
among scholars that the rate of mixed marriages rose sharply from 1970 to 1990 (Fishman, *Double or Noth-
ing*, 7). According to the most recent assessment, the rate of mixed marriages was 54% in 2006 (*Annual
Assessment 2006. Major Shifts: Threats and Opportunities*, 11).

[4] Young Judaea, *Tomorrow's Leaders Today*.

[5] 'Building Jewish Identity', HA; Carmela Efros Kalmanson, Hadassah Biographical Material, 1991;
Debora Kaplan, Friday afternoon acceptance speech, 26 July 1991, HA, RG2, box 86, folder 8.

[6] See e.g. the following pamphlets (all published by the Hadassah National Office in New York): *Young
Judaea Israel Summer Programs 2003*; *Young Judaea Year Courses in Israel 2003–2004*; *Shalem: A More Complete
Religious Israel Program, 2003–2004*.

[7] At the declarative level, see e.g. 'Soviet Jewry', statement adopted at the 76th Hadassah National Con-
vention, July 1990, New York, HA, RG3, box 83, folder: 'Policy Statements, Treasurer's Report 1990'.

immigrants were Hadassah's institutions in Israel that deal with counselling and vocational training, the Hadassah Career Counselling Institute (see Chapter 10) and the Hadassah College Jerusalem (see below). Hadassah also contributed to the absorption of the two waves of immigrants from Ethiopia in the 1980s and 1990s: in this case its efforts were mainly concentrated in health education programmes and in programmes for increasing the integration of immigrants into Israeli society, which were developed in conjunction with other bodies.[8]

The Hadassah-Hebrew University Medical Center in Jerusalem is to this day the principal object of investment for Hadassah. It should be seen not only as a focus of medical practice and research, but also as the central pillar of the organization in the United States and the principal expression of its Zionism. A financial contribution to the medical centre is the most common practical expression of Zionism by Hadassah women and their families.

In 1967, after the Six Day War, the hospital building on Mount Scopus was returned to Hadassah and a general hospital was established in it serving the residents of north Jerusalem, Jews and Arabs alike. Thus, the Hadassah Medical Center is today a tertiary care facility (for specialist medicine) that consists of two university hospitals (in Ein Karem and on Mount Scopus) and incorporates within it all of the medical sub-specialties. Within the framework of this centre, which is renowned throughout the world, there are also five schools of the health professions common to Hadassah and the Hebrew University (medicine, dentistry, nursing, occupational therapy, and public health), and various health services in Jerusalem and Tel Aviv. In addition, the medical centre operates in conjunction with other health service providers in operating community clinics.[9] Over the years many medical and technological innovations have taken place for the first time in Israel at the medical centre, such as the first open heart surgery (1958), the first successful kidney transplant (1967), the first use of computers for medical purposes (1970), the first bone marrow transplant (1977), the first heart transplant (1986), and the establishment of the first brain research laboratory.[10]

[8] Katzburg-Yungman, 'Hadassah: *Yishuv* to the Present Day'. On the aid provided by the Hadassah Career Counseling Institute: interview with and information provided by Dr Yitzhak Garty, director of the Hadassah Institute for Personal and Organizational Development, Jerusalem, 23 Sept. 2004. On aid to immigrants from Ethiopia: interview with Ora Sela, Jerusalem, 20 Feb. 2004; 'The Long and Narrow Bridge' by E. Chigier et al., report sponsored by Hadassah. [9] <www.hadassah.org.il>.

[10] Katzburg-Yungman, 'Hadassah, *Yishuv* to the Present Day'. On the first use in Israel of computers for medical purposes, see Hadassah Annual Projects Report, 1971/2, Proceedings of 58th Annual Convention, New York City, 20–3 Aug. 1972, HA, RG3, 25c.

The paramedical professions that Hadassah brought to Israel began to undergo a process of transformation into academic fields of study in the 1970s. In 1975 the Hebrew University and Hadassah opened their joint school of nursing, which offered, for the first time in Israel, a generic degree in nursing (BS.N.), that is, an academic curriculum leading to a bachelor's degree as well as a nursing degree, and in 1978 Hadassah, the Hebrew University, the Joint Distribution Committee, and the Ministry of Health inaugurated the Hadassah and Hebrew University School of Occupational Therapy. Later, advanced degree programmes began to be developed at these schools. When they were being established, these schools were aided by American models provided by similar schools in the United States and also by American professionals.[11]

Another sphere in which Hadassah has been involved since the days of the British Mandate is that of vocational education. In both new initiatives and continued activity within older projects it is possible to identify the same trends, ideas, and lines of action that characterized Hadassah's involvement in this field from its inception in the 1940s: establishment according to an American model (with the exception of the Seligsberg School), employment of external professionals in shaping the image of the enterprise and local professionals to operate it, a contribution to the advancement of industry and technology, and a desire to increase individual welfare by these means. A clear example of this is the Hadassah College Jerusalem, which was established in 1970 to provide higher education for young Israelis from a disadvantaged background—primarily those of Asian and north African origin, who were unable get into university through lack of money or inadequate preparation. Initially the intention was to train young people to work in the field of computing or as lab technicians or medical registrars. The model adopted was that of the American community college, one of the most popular ways of acquiring higher education in the United States, which was aimed at students who lacked either time or money to attend a regular college.[12] Over time the college gradually expanded its sphere of teaching and became more academic. In 1999 Professor Nava Ben-Zvi was appointed college president, and since then emphasis has been placed on professional academic training. Since 2005 the college has awarded a B.Sc. degree (at the School of Health Sciences and at the School of

[11] The Hadassah-Hebrew University Faculty of Medicine School of Occupational Therapy also bestows master's degrees (since 1991) and doctoral degrees (since 1996): see <http://ot.huji.ac.il/mivne_frames.html>. Since 2001 the nursing school has offered a master's degree in advanced clinical nursing: see www.hadassah.org.il.

[12] Hadassah Annual Projects Report, 1969/70, Proceedings of 56th National Convention, Washington, DC, 16–19 Aug. 1970, HA, RG3, 42.

Computer and Information Sciences) and a technician degree (at the School of Technicians and at the School of Visual Arts).[13]

Following the period discussed in this book, Jewish life in both the United States and Israel has undergone enormous changes in the economic sphere, in social structure, and in the way each community regards the other. An extremely important change from Hadassah's perspective was the second wave of the feminist revolution, whose influence has been substantial since the 1970s. It changed the *modus operandi* of American Jewish women in the professional and religious spheres, and the norms of family structure, as well as Jewish American women's approach to volunteering; by the end of the 1980s many Jewish women worked for a salary outside the home and lived in an environment that promoted the development of a career. In addition to this, there was an enormous increase in the rate of mixed marriages, which was intertwined with a weakening of Jewish bonds and of willingness to volunteer for Jewish causes.[14] All of these trends are self-evidently unfavourable to a fundamentally volunteer organization such as Hadassah.

From its establishment in 1912 up to the 1980s, Hadassah was an organization of leisured women. Both the leadership of the organization and its rank-and-file membership put a great deal of work into achieving the organization's Zionist objectives. The leadership formulated the vision, and guided and maintained contact with its projects in the Yishuv and later in Israel; the ordinary members, the great majority of them married women who did not work in paid positions outside the home, undertook the practical role of fundraising, upon which the existence of the organization depended. Professional fundraisers were used only seldom, and although Hadassah did have additional sources of funding as well as the efforts of its membership, its achievements were founded on the fact that it had at its disposal a veritable army of housewives, with time on their hands and the willingness to devote that time, and a great deal of effort, to achieving the organization's objectives.

The founders of Hadassah who devised this system believed—in accordance with the accepted wisdom of the time—that women, in contrast to men, are not designed to deal with politics and ideology, and function best in implementing

[13] See Kroyanker, *The Terra Sancta Compound* (Heb.), 66. Information on the courses of study and the various degrees from Prof. Nava Ben-Zvi.

[14] Fishman, *A Breath of Life*, 77, 82–3. For research on changes in the family sphere and personal circumstances, see pp. 298–9 below. For changes in the sphere of religious life, see Fishman, *A Breath of Life*, chs 6 and 7; Dinner, *The Jews of the United States*, 350–7; ead., 'Negotiating Egalitarianism and Judaism'; Hyman, 'Bat Mitzva' and 'Jewish Feminism in the United States'.

practical tasks. It was for this reason, among others, that they planned the organiza-
tion as one centred on projects in Palestine. These were (and still are) primarily
health-related projects, augmented in what may be referred to as the 'historical
Hadassah' by welfare projects for children and teenagers. Indeed, in the lives of
leisured women the concrete task of fundraising had an extraordinary importance,
not only for the functioning of the organization but also for the rank-and-file mem-
bers themselves, who were constantly faced with the practical challenge of daily
work for Hadassah upon which the success of the organization was dependent.
They met this challenge by putting on rummage sales, dinner-dances, and other
types of fundraising events, all of which entailed a vast amount of effort.

The changes that took place in the lives of American Jewish women in the 1970s
and, especially, the 1980s, resulting in many of these women taking paid work
outside the home, forced the Hadassah leadership to take cognizance of a new type
of Jewish woman with whom the 'traditional' organization was not accustomed to
dealing. This was a woman who worked for a living, or to provide for her family, or
to develop a career—a woman who did not have time on her hands, and who, even if
she did offer to volunteer, was not enthused by the 'traditional' methods by which
Hadassah had raised money to fund its projects since its inception.

Later still, in the early 1990s, it became clear to the Hadassah top leadership that
their organization, as a Jewish and Zionist organization, faced an even more
complex problem, including not only the factors associated with a membership of
working women deeply involved in their careers, but also those associated with the
distance between these women and the Jewish world and Israel. This discovery
emerged from a survey of Hadassah members in 1993 which generated important
findings regarding the composition of the organization's membership and the
relationship between this and the social, age, and denominational structure of
American Jewry, as well as the strength of Jewish and Zionist identity. According to
the results of the survey, the social and age structure of Hadassah membership in
the 1990s was different from the 'traditional' structure which had characterized it
from its inception until the results of the second wave of the feminist revolution
began to appear at the end of the 1970s and during the 1980s. The survey showed
that the average Hadassah member was over 54 years old, and that 45 per cent of the
older members and over 71 per cent of the younger members were working
women, with full- or part-time jobs. A further important finding showed that the
characteristics of Hadassah members are not identical to those of the general
American Jewish female population in the United States. Hadassah members have
a stronger Jewish identity, are part of the more Zionist portion of the Jewish popu-

lation, and by denominational affiliation are more likely to be Conservative than Reform, the stream with which most religiously affiliated Jews were identified at the end of the twentieth century (and with which most still identify today). As for intermarriage, only 5.5 per cent of Hadassah members had married non-Jews, as opposed to 28 per cent of all American Jewish women; among the younger members the figure was 10 per cent, compared to 40 per cent in the general American Jewish population at the time the survey was undertaken.[15]

At the end of the 1980s the Hadassah leadership came to recognize that changes in various aspects of the lives of Jewish women in America and in American Jewish society in general necessitated a change in the organization. In consequence of this recognition, in 1987 Carmela Kalmanson, then the national president of Hadassah, appointed Jane Zolot from Hadassah's National Board to head a team to develop a strategic programme. As time went by the team turned into a committee and the committee became an entire department. In 1989 Hadassah's Department of Education published the book *Marital Status*, which attempted to confront the changes that had occurred in the family life of Jewish women in America.

Two prominent conclusions became apparent to the Hadassah top leadership almost immediately these issues came under consideration: first, the interest of women at the rank-and-file level must be attracted, otherwise they will not join; second, the 'old' model of the leader working in the organization all her life is not practicable in the new reality, and therefore the organization's method of working must be adapted to one that is led by volunteers and directed by professionals, through close co-operation.

The initial attempt to confront these issues at the end of the 1980s was impressive in its ambition to tackle the problem in both depth and breadth, covering all of its practical and spiritual aspects. One of its first steps was a comprehensive effort to understand the 'new species of Jewish woman' at the end of the twentieth century, and to respond to the full spectrum of her needs. Beyond this came four more steps: first, an extensive use of professionals, far beyond what had been accepted until then in Hadassah, among other things to provide assistance to the volunteers; second, a change in the style of meetings for rank-and-file members, with a comprehensive reorientation towards working women; third, an attempt to attract young women; and fourth, attempts to recruit a good and well-educated leadership from new sources not traditionally associated with the organization and adapted to the new reality of Jewish women in America, including an effort to

[15] Report on the 1993 Hadassah National Membership Survey, Hadassah National Office, New York, 7.

appeal in new and creative ways to women far removed from Zionism and from Judaism. Additionally, the Department of Education adapted itself in various ways to the new mindset of the contemporary American Jewish woman, in both personal and religious aspects. All of these attempts were accelerated or reached maturity around 1995.

A key challenge was how Hadassah could function best as a volunteer organization when most of its members had little leisure time. One response was to increase the number of paid staff in the national office in New York. By 2008 several hundred people were employed there, including accountants, financial specialists, IT specialists, lawyers, and administrators, as well as experts in specific subjects: for example, educators dealing with Jewish education and a certified health education specialist as director of the health department. An even more significant transformation was the appointment of paid staff (nearly ninety in all by 2008) throughout the United States at the local level, where—apart from a few paid local executive directors and administrative staff—volunteers had done almost all of the work since the very beginnings of the organization. Both centrally and locally, then, the idea was to support the volunteers by means of professionals.[16]

In a separate development, the organization's Jewish Education Department adapted itself to the new mood that pervaded the American Jewish woman's arena in its personal and religious aspects, issuing publications that reflected the changes that had taken place in the American Jewish family (a large growth in the proportion of single and divorced people, smaller families than those of the 1950s and 1960s) and in the functions of American Jewish woman in the religious sphere (greater participation in synagogue rituals and in ceremonies related to the life cycle, as well as in certain aspects of theological thought).[17]

These initiatives gathered pace during the second half of the 1990s. From 1995 to 1998 Hadassah launched a number of projects related to women's welfare in an attempt to understand the contemporary Jewish American woman, to recruit

[16] Information given to the author by Susan Woodland, Hadassah archivist, 23 June 2010. See also e.g. 'Hadassah Leadership Academy' (undated pamphlet, n.p.), Hadassah National Office.

[17] On attempts to deal with the changes in personal life, see e.g. the book published by Hadassah's Jewish Education Department: Diament, *Jewish Marital Status*, p. xxii; for various activities undertaken in this sphere, see ibid. On the changes that took place in family and personal circumstances within the American Jewish community, see Fishman, 'The Changing American Jewish Family' (contains information about previous periods and especially about the 1980s); ead., 'Choosing Life'. For publications relating to other changes in the American Jewish arena, including the religious sphere, see e.g. the trilogy published by the Education Department between 1997 and 2003: Diament, *Jewish Women Living the Challenge*; Tanenbaum, *Moonbeams*; Harlow and Cohen, *Pray Tell*.

women for leadership positions, and to attract new members to the organization. Among these were the establishment of a Women's Health Department at Hadassah's national office in New York (1995); the establishment of an institute for Jewish women's research in conjunction with Brandeis University (in 1997; in 2006 it was renamed the Hadassah Brandeis Institute); the establishment of the Hadassah Leadership Academy (in 1998), a two-year programme for developing leadership capabilities, primarily among women who were not previously connected to Hadassah; and the establishment of the Hadassah Foundation (also in 1998).[18]

The Hadassah Foundation was set up to meet social and spiritual needs in Israel and the United States, beyond Hadassah's traditional projects. It supports institutions in both countries dealing with different aspects of women's empowerment. For example, in Israel it has supported the non-profit-making organization Advancing Economic Empowerment for Women, which trains women to establish small businesses and provides loans enabling them to do this), as well as the feminist multicultural centre Kol Ha-Isha in Jerusalem, which deals with many facets of women's empowerment, from helping women on low incomes to cope financially, in projects related to women and poverty, to fostering dialogues between women of different cultural backgrounds (religious and secular, Jewish and Arab citizens of Israel, heterosexuals and lesbians).[19]

Another response to the changes in the nature and circumstances of the membership, and one that has had extremely significant repercussions, as discussed below, was to change the way fundraising was handled in the organization. With most women going out to work, Hadassah could no longer rely on the traditional fundraising methods—rummage sales and social events, almost entirely without the use of professional fundraisers—that had been effective during the years when women did not commonly work outside the home and so had the time and energy for this demanding work. Other factors militating against continuance of the old methods included changes in the world of Jewish philanthropy in general, with increased competition for the 'Jewish dollar'. As a result of this combination of pressures, in 2003/4 only 20 per cent of the money raised by Hadassah was collected in the 'traditional' manner.

In consequence of this shift, the principal role of the rank-and-file members as it

[18] 'Hadassah Leadership Academy'.

[19] Information on Advancing Economic Empowerment for Women: interview with Ayelet Ilani, Haifa, 18 Nov. 2003; general information about the foundation: *The Hadassah Foundation in Action*, 1; information on the grant to the NPO for economic empowerment: ibid. 3; on the grant to Kol Ha-Isha, ibid. 4.

existed in the 'historical Hadassah' has almost vanished. The leadership has trans-
ferred the members' traditional role of fundraising to professional fundraisers and
senior medical centre staff. For example, the director general of the Hadassah-
Hebrew University Medical Center in Jerusalem—a physician symbolizing a com-
bination of Judaism and humanity—is considered by the organization's leadership
to be a figure whom a donor cannot refuse, and so frequently visits the United
States to meet 'major donors'.

The scale and characteristics of donors have also changed as a result. In 2003/4,
for example, 'major gifts' (over $5,000 in a single donation) totalled $31 million and
bequests $41 million. In previous years bequests have made up 70 per cent of total
major donations and 5 per cent of all donations. Some of those leaving bequests—
men and women alike—had never had any contact with Hadassah. Sometimes not
even the name of the person leaving the bequest is known, and research must be
carried out in order to discover where the money has come from.[20]

As a result of these developments, Hadassah has lost its character as an org-
anization of women with leisure time raising money to fund its projects, which was
one of the foundations on which it was built, providing the principal and traditional
role earmarked for rank-and-file members. Today the key functions of devising the
organization's vision, formulating policy, fundraising, and realizing the vision in
Hadassah's health projects in Israel lie in the hands of the few hundred volunteers
heading the organization, along with professional teams in the United States and
Israel. Together they deal with the great majority of the work of planning and imple-
mentation, so that the organization is run like a large and well-managed business.

The continuance of Hadassah's traditional involvement in health projects in
Israel, which focused for the majority of its history on its hospital, then hospitals, in
Jerusalem, and to which a significant proportion of its resources is dedicated,
requires the raising of enormous sums of money. Today the organization also has
additional projects in Israel, the most important of which is the Hadassah College
Jerusalem, which has grown and developed significantly in recent years. To these
one must add the entire range of operations in the United States. Even so brief a
summary of the organization's commitments makes it clear that at the leadership
level the challenge is very great and demands a great deal of work.

However, as a result of the processes described above, the rank-and-file mem-
bers have lost their old role, which was rendered obsolete by the new reality of
working women on the one hand and the growing need for money on the other. By

[20] Information given to the author at the Hadassah National Office.

placing the role of fundraising in professional hands and increasing concentration on 'major' donors, the leadership may have solved the concrete problem of fundraising, but the rank-and-file members have been left without a real practical task, for the first time in the entire history of the organization.

At this point a number of questions arise that remain open for study. Are the rank-and-file members, once deprived of their traditional role, left without *any* genuine role? Has a replacement role been found which is more suitable for the new reality of the end of the twentieth century and the beginning of the twenty-first? Or is there no need for such a role, involving a practical challenge, in an organization the majority of whose members have an extremely deep Jewish and Zionist identity on the one hand, and no leisure time at their disposal on the other? For in the new reality the requirements of such Jewish women are actually being met by Jewish and Zionist elements not connected to the practical work that characterized the organization from its inception and still continues to exemplify it: the aspiration to continue to educate Jewish women in the United States in Zionism, to strengthen their connection with Israel and Judaism, and to foster activity among young people by means of the Young Judaea youth movement, which in 2003/4 enjoyed the second largest part of Hadassah's budget after the part invested in its health projects in Israel.

A further change in the organization was the establishment of International Hadassah, consisting of volunteers, women and men, 'of all religions', in more than thirty countries (in North and South America, in Europe, in the Middle East, in Asia, and in Australia).[21] The principal aim in creating this body was to raise funds for the Hadassah Medical Organization;[22] to this was later added the objective of cultivating a positive image for Israel in the world through medicine,[23] as an element considered capable of appealing to everyone regardless of political and cultural differences and national conflicts, consistent with Hadassah's existing philosophy. International Hadassah took its first steps in 1983, after Bernice Tannenbaum, one of Hadassah's veteran leaders (president from 1976 to 1980 and at this point chairman of the HMO), realized the potential inherent in Hadassah's breaking into

[21] <www.hadassahinternational.org.il>.

[22] 'Proposal to Create Hadassah International', Hadassah National Convention, 15 Aug. 1983, presented by Bernice S. Tannenbaum, Hadassah National Office, New York.

[23] Hadassah International, 'Frequently Asked Questions'; Tannenbaum, *Hadassah International 20th Anniversary Commemorative Book*, 7.

the international arena, beyond the borders of the United States.[24] She was prompted by, among other things, the model of WIZO, whose branches are spread throughout the world, an influence given weight by her close acquaintance with Raya Jaglom, president of WIZO International from 1970 to 1996.[25]

The attempt to establish Hadassah groups outside the United States began with the creation of Hadassah Israel groups in several cities in Israel, involving new immigrants from the United States who wished to continue their past activity, as well as some new immigrants from the UK. A short time later a number of groups composed of Israeli women were set up. In the early stages these new groups ran several fundraising programmes on behalf of Hadassah's enterprises in Israel. Later, Hadassah Israel developed differently from both the mother organization in the United States and International Hadassah. It is different from the mother organization in that, including as it does Jewish women who are not American, it does not confine itself to fundraising but also deals with community matters, primarily for the benefit of women, and is integrated into the Israeli women's lobby. Thus, for example, Hadassah Israel is involved with projects for absorbing immigrants (such as a programme supporting immigrant children of Ethiopian origin and their parents), a support and enrichment programme for children at risk, a programme for awareness of early detection of breast cancer, various activities for prevention of violence against women, and a programme to empower women who have experienced violence.[26]

Notwithstanding the developments and changing circumstances described in this epilogue, the objectives, goals, and organizational identity of Hadassah as a Zionist organization have remained constant over the years, as has the focus of its work and investment—the medical projects in Israel. Up to now, too, the fact of Hadassah's being fundamentally an organization bringing women together for Zionist activity, and not a women's organization operating for the welfare and advancement of women, has not changed. The proposal often arises that men should be admitted as

[24] Pre-Convention National Board Meeting, 15 Aug. 1985, Miami Beach, Florida, HA, RG3, box 79, folder 1, p. 8. On International Hadassah's conception as a non-Zionist body: interview with Marlene Post, Jerusalem, 27 Feb. 2005; on recognizing the international potential, the proposal to establish International Hadassah, and its being understood as a friend of the Hadassah Medical Organization: interview with June Walker (Hadassah president 2003–7), New York, 19 Dec. 2004.

[25] On Tannenbaum and her relationship with WIZO: interview with Marlene Post, Jerusalem, 22 Feb. 2005.

[26] Pre-Convention National Board Meeting, 24 July 1999, p. 2; Hadassah Biennial Report, 1984–6, p. 8.

members of the organization, and time and again ways have been found to reject it. Hadassah's future appears conditional upon a blend of its ability to face up to the future requirements of American Jewry and its ability to respond to the changing needs of Jewish American women, at all levels, but first and foremost at the leadership level. Success at this level will depend on its ability to create a challenge for talented women, so that they will find interest and satisfaction in a Zionist volunteer organization even in a period in which attractive opportunities for self-fulfilment outside volunteer organizations on the one hand, and in the non-Jewish volunteer organizations on the other, are numerous and great.

APPENDICES

APPENDIX A

■

HADASSAH MEMBERSHIP RELATIVE TO THE JEWISH COMMUNITY IN THE UNITED STATES, 1917–1957 (SELECTED YEARS)

Year	Hadassah membership[a]	Size of Jewish community in US[b]	Hadassah membership as % of US Jewish community
1917/18	5,500	3,012,141	0.18
1921/2	11,259	3,300,000	0.34
1931/2	27,342	4,228,029	0.65
1934/5	32,496	4,228,029	0.77
1939/40	73,835	4,770,647	1.55
1945/6	176,973	4,770,647	3.71
1947/8	242,962	5,000,000	4.86
1952/3	271,747	5,000,000	5.44
1956/7	287,854	5,200,000	5.54

[a] For the data on Hadassah members, see printed list in Hadassah Archives (unsorted collection).
[b] For the data on the number of Jews in the United States, see *American Jewish Yearbook*, 19 (1917/18), 410; 22 (1921/2), 280; 32 (1930/1), 417; 34 (1933/4), 420; 40 (1939/40), 400; 47 (1945/6), 308; 49 (1947/8), 737; 54 (1953), 197; 58 (1957), 224.

APPENDIX B

■

ARTICLES OF THE 1947 CONSTITUTION RELATING TO DEFINITION OF OBJECTIVES

Article I

Name

Sec. 1 The name of this federation of Women's Zionist societies is Hadassah, The Women's Zionist Organization of America, Inc.

Article II

Objects and Purposes
Sec. 1 The objects and purposes of Hadassah are as follows:

1. To promote the establishment of a legally assured, publicly secured home for the Jewish people in Palestine.

2. To provide and promote in Palestine a broad program of health activities, social services and youth welfare work.

3. To foster Zionist ideals and education in America.[1]

[1] Hadassah Constitution, as adopted by the annual convention, Oct. 1947, Hadassah Archives, RG17, Printed Material/Pamphlets/Constitutions. By permission of Hadassah, The Women's Zionist Organization of America, Inc.

APPENDIX C

■

ARTICLES OF THE 1956 CONSTITUTION RELATING TO DEFINITION OF OBJECTIVES

Article I

Name
The name of this organization is Hadassah, The Women's Zionist Organization of America, Inc.

Article II

Objects and Purposes
Hadassah is an organization dedicated to the ideals of Judaism, Zionism, and American Democracy.

Sec. 1 The objects and purposes of the organization are as follows:

a. To provide medical relief and to minister to the physical and spiritual well-being of needy persons in the state of Israel; to support and maintain voluntary non-profit hospitals, community health services in immigrant camps, schools and agricultural settlements; to support and maintain a program of preventive, diagnostic and curative medical work; to distribute food, clothing and other necessities; to establish and maintain, and to assist in the establishment and

maintenance of, voluntary facilities to render guidance and assistance to persons in need and to establish and maintain and to assist in the establishment and maintenance of a public health program and facilities for the education and spiritual guidance of young immigrants and to provide for and assist in their vocational training as well as for that of Israeli youth generally.

b. To encourage and support medical education in the State of Israel through the establishment and support of physicians, dentists, nurses, pharmacists, medical dental and laboratory technicians and related personnel; by granting fellowships and other assistance to medical personnel for advanced study and research and to further by clinical study, laboratory research, publication of material and other suitable methods, knowledge helpful in the prevention, control, diagnosis and treatment of all physical and psychical ailments and diseases.

c. To assist in the rescue and immigration to the State of Israel, of Jewish children and youth from areas where Jewish life and institutions are threatened and to provide in the State of Israel for such children and youth, as well as for orphans and other Israeli children and youth, facilities for their maintenance, rehabilitation, education and vocational training. To assist in the settlement of youthful immigrants in need of assistance and to provide for their rehabilitation and education; and to support a program of land reclamation and afforestation in the State of Israel.

d. To foster the ethics and ideals of Judaism among its members and among Jewish youth through a program of Jewish education designed to encourage, and to provide material and facilities for, the study of the Bible, Jewish history, traditions and culture, the Hebrew language and literature, Zionism; to strengthen the concept of a Jewish renaissance through the rebirth of Israel as a nation, in its ancient homeland; and to stimulate Jewish learning and study through the publication and dissemination of literature relating to Jews and Judaism.

e. To help strengthen American democracy through a program of information and study designed to awaken its members to their civic responsibilities and an awareness of the issues of the day.[1]

[1] Hadassah Constitution, as adopted by the annual convention, Oct. 1956, Hadassah Archives, RG17, Printed Material/Pamphlets/Constitutions. By permission of Hadassah, The Women's Zionist Organization of America, Inc.

APPENDIX D

A SELECTION OF THE PAMPHLETS RECOMMENDED TO MEMBERS BY THE HADASSAH EDUCATION DEPARTMENT, 1951

Ahad Ha-Am, Prophet of Cultural Zionism
Chapters on Modern Hebrew Literature
Come, Let's Sing
Democracy's Hebrew Roots
Education Institutes
Glimpses of Arts and Handicrafts in Israel
Glossary of Useful Hebrew Words and Phrases
Government of Israel
Great Jewish Women throughout History
Guide to Jewish History
Hadassah Education Forum
Hadassah Handbook
Hadassah Honors Course
Hadassah's Role in the American Jewish Community
Introducing Music in Israel
Leader's Guide to Jeremiah Ben-Jacob's 'The Rise of Israel'
Leader's Guide to Milton Steinberg's 'Basic Judaism'
Leader's Guide to Milton Steinberg's 'The Making of the Modern Jew'
Need for a New Emphasis in Education
Recommended Books of Jewish and Zionist Interest
Recommended Courses for Study and Discussion Groups
Syllabus for 'The American Jew'
Theodor Herzl—Prophet of Classical Zionism
What's Left to Say about Purim?
Women in Israel
Zion's Founding Fathers
Hebrew University-Hadassah Medical School[1]

[1] *What to Read—Where to Find It—A Survey of Pamphlets of Jewish and Zionist Interest Recommended by the Education Department of Haddassah* [sic] (New York: Hadassah Education Department, June 1951), 24–5. By permission of Hadassah, The Women's Zionist Organization of America, Inc.

Bibliography

ARCHIVES

Hadassah Archives, New York (The Archives of Hadassah, the Women's Zionist Organization of America, Inc.) (HA)

Annual Reports of the National Board to the Convention, 1947–2003 (RG3)

Biennial Report, 1949–51

Minutes of National Board, 1947–58

National Office Records

Progress Reports: Projects and Activities, 1954/5, 1957/8

Archived Material in Record Groups

RG2 The Records of the Hadassah Medical Organization

RG3 Conventions/Annual Conventions

RG4 Zionist Political History

RG5 Hadassah in Israel

RG6 Hadassah Education in Israel

RG7 Special Collections, Hadassah Leaders Series

RG13 Presidents

RG17 Printed Material/Pamphlets/Constitutions

RG20 Oral History/Transcriptions

Central Zionist Archives, Jerusalem (CZA)

A365 Israel Goldstein

A580 Sara Bavly

F25 Collection of Material on Zionism in America

F38 Zionist Organization of America

J17 The Education Department of the Va'ad Leumi

J113 Hadassah Medical Organization

LK12 Office of the Twenty-Third Zionist Congress, Jerusalem, 1951

LK13 Office of the Twenty-Fourth Zionist Congress, Jerusalem, 1956

S5 The Department of Organization

S75 Youth Aliyah

S100 Minutes of the Jewish Agency Executive

S119 The Henrietta Szold Documentation Center of Youth Aliyah, 1950–3

Z5 Offices of the Jewish Agency Executive in the United States, New York

Israel State Archives, Jerusalem (ISA)

RG43 Prime Minister's Office

RG57 Ministry of Health

RG71 Ministry of Education

RG129 Ministry of Social Welfare

Abraham Harman Institute of Contemporary Jewry, Hebrew University of Jerusalem, Oral
 History Division

Ben-Gurion Heritage Institute Archives, Sede Boqer (Ben-Gurion Diary, 1950–1)

Hebrew University Archives, Mount Scopus, Jerusalem

Israel Defence Forces Archives (IDFA), Tel Hashomer Base

Jerusalem City Archives, Hadassah file

Jewish National and University Library, Hebrew University of Jerusalem

REPORTS

'Building Jewish Identity: A Study of Young Judaea Alumni, Fall 1998', study conducted for
 Hadassah, The Women's Zionist Organization of America, Inc., by Professor Steven
 M. Cohen, Hebrew University, Jerusalem, Israel and Alan Ganapol, Marketquest, Inc.
 Mohegan Lake, NY

'The Institute for Children and Youth: Founded by the National Committee of the Commu-
 nity of Israel—Goal, Regulations, and Decree of Trusteeship' [Hamosad lema'an
 hayeled vehano'ar: miyesodo shel hava'ad hale umi lekeneset yisra'el: hamaterah,
 hatakanon, ketav hane'emanut] (Jerusalem, 1942)

Meeting of the Zionist Executive in Jerusalem, 5–15 May 1949 [Moshav hava'ad hapoel
 hatsiyoni biyerushalayim, 6–16 Iyar 5709]: Discussion and Accounts of Lectures,
 Debates, Resolutions, Zionist Executive, Jerusalem (n.d.)

Meeting of the Zionist Executive in Jerusalem, 19–28 April 1950: Decisions Taken [Moshav
 hava ad hapoel hatsiyoni biyerushalayim, 2–11 Iyar 5710: haḥlatot shenitkabelu]: Zion-
 ist Executive, Jerusalem (n.d.)

Meeting of the Zionist General Council in Jerusalem, 2–9 Kislev, 5713 (20–7 Nov. 1952),
 Organization Department of the World Zionist Organization

'The Long and Narrow Bridge: A Special Report on Health Education for Ethiopian Adoles-
 cent Immigrants in Youth Aliyah in Israel, 1986–1996', by E. Chigier, A. Nudelman,
 and E. Cohen, sponsored by Hadassah, Youth Aliyah, and The Jewish Agency for Israel
 (n.d.)

Report on Activities 5707–5711 [1946–51], Presented to the Twenty-third Zionist Congress,
 Jerusalem, Av 5711 [1951] [Din veheshbon al hape'ulot beshanim 5707–5711]
 (Jerusalem: The Jewish Agency Publisher, Av 5711 [Aug.–Sept. 1951])

Report on Activities 5711–5716 [1951–5], Presented to the Twenty-fourth Zionist Congress,
 Jerusalem, Av 5711 [Din veheshbon al hape'ulot bashanim 5711–5716] (Jerusalem: The
 Jewish Agency Publisher, Nissan 5716 [April 1955])

Report on the 1993 Hadassah National Membership Survey, by Professor Barry A. Kosmin,
 City University of New York Graduate School

'Report to the National Board [of Hadassah] on my Experience with Youth Aliyah in Israel,
 August 1954–September 1955', by H. Grossbard, March 1956, Henrietta Szold Docu-
 mentation Center of Youth Aliyah, 8: 620.8

Twenty-Third Zionist Congress 1951, Stenographic Account [Hakongres hatsiyoni ha-23, 1951]
 (Jerusalem: World Zionist Organization, 5716/17 [1956/7])

Twenty-Fourth Zionist Congress 1956, Stenographic Account [Protokol hakongres hatsiyoni ha-
 24, 24 April–7 May 1956] (Jerusalem: World Zionist Organization Management,
 5717/18 [1957/8])

Twenty Years of Medical Service in Palestine, 1918–1938 [Esrim shenot sherut refu'i be'erets
 yisra'el, 1918–1938], report of the Hadassah Medical Organization in honour of the
 opening of the Hadassah Medical Center and the University, 9 May 1939

INTERVIEWS

Abusol, Selma D. (member of the Vicksburg, Va., chapter of Hadassah in the 1950s),
 Bethesda, Md., 30 June 1991

Bartal, Nira (telephone), 24 Oct. 2001

Bavly, Miriam (daughter of Sarah Bavly), Jerusalem, 17 Dec. 2000

Bucksbaum, Dorothy (member of National Board, 1991), Jerusalem, 29 July 1991

Cohen, Fanny S. (member of Hadassah since 1930s; member of National Board since 1952;
 close friend of Judith Epstein; chair, National Board Committee for Construction of the
 Medical Center), New York, 31 May 1991, 2, 9, 10, 17, 20 June, 6, 10 July 1991;
 Jerusalem, 27 July 1991

Cohen, Naomi (daughter of Judith Epstein), 8 Jan. 2007 (by telephone)

Davis, Professor Eli (director, Hadassah Medical Organization, 1948–51), Jerusalem, 11 Apr. 1992

De Vries, Andre (member of staff, Rothschild–Hadassah University Hospital, 1948–53), Tel Aviv, 28 Mar. 1992

Diesendruk, Yehudit, Raanana, 20 June 1991

Dorfman, Rose (member of Hadassah since 1932; member of National Board, 1991), New York, 2, 7, 10, 22 June 1991

Freund-Rosenthal, Dr Miriam (president of Hadassah, 1956–60), New York, 27 May, 4 June 6, 8, 12, 15 July 1991; Jerusalem, 2 Aug. 1991

Garty, Yitzhak (director of the Hadassah Career Counseling Institute), Jerusalem, 23 Sept. 2004

Gottesman, Esther (member of National Board since 1939; chair, National Board Committee for Education, 1950–54), New York, 3 July 1991

Gurin, Naomi (member of National Board, 1991), New York, 12 July 1991

Ilani, Ayelet, Haifa, 18 Nov. 2003

Jacobson, Charlotte (president of Hadassah, 1972–6), New York, 27 May, 17 June 1991

Kain, Frima (daughter of Bertha Schoolman), Modi'in, 11 Jan. 2007

Kalb, Shirley (professional member of Hadassah management; from 1956 director of Young Judaea youth camps), New York, 9 July 1991; Camp Tel Yehudah, 14 July 1991

Kalmanson, Carmela E. (president of Hadassah, 1992–5), New York, 12 June 1991

Karpa, Helen (member of National Board since 1972), Washington, DC, 30 June 1991; Jerusalem, 14 Aug. 1995

Kaslove, Ruth (daughter of Rose Halprin), Jerusalem, 2 Aug. 1991

Katzburg, Avraham (student at the Talmud Tora Mizrachi elementary school, 1934–8), Jerusalem, 12 May 2005

Kimball, Tova (member of National Board, 1991), New York, 20 June 1991

Kramarsky, Sonia (daughter of Lola Kramarsky), New York, 14 July 1991

Lapin, Ada (member of Habonim, 1945–50) and Hechalutz (1946–9) and a founder of the Intercollegiate Zionist Federation of America (IZFA)

Lifson, Helen (president of Baltimore chapter, 1991), Baltimore, Md., 24 June 1991

Lombard, Avima (daughter of Julia Dushkin), Jerusalem, 18 Dec. 2000

Lozabnick, Ethel (president of Beverly Hills chapter, 1991), Jerusalem, 1 Aug. 1991

Mann, Professor Kalman Yaakov (director, Hadassah Medical Organization, 1951–81), Jerusalem, 19 July 1992

Maztkin, Rose E. (president of Hadassah, 1972–6), Jerusalem, 28 July 1991

Miskin, Sara (member of Hadassah since 1950), New York, 21 June 1991

Popkin, Ruth W. (president of Hadassah, 1988–92), New York, 15 June 1991, 19 Dec. 2004

Post, Marlin (president of Hadassah, 1996–2000), New York, 19 Dec. 2004, 22 Feb. 2005

Rosenbaum, Sara (executive director, Philadelphia chapter, 1943–76), Philadelphia, 16 July 1991

Sela, Ora, Jerusalem, 20 Feb. 2004

Shapiro, Louella (member of National Board, 1991), Jerusalem, 1 Aug. 1991

Simon, Belle (member of National Board, 1991), New York, 4, 17 June 1991

Slott, Lois (one of the typists of the Emergency Council; member of Hadassah since 1950), Jerusalem, 2 Aug. 1991

Tamir, Varda (daughter of Ethel Agron), Ramat Hasharon, 18 Dec. 2000

Tannenbaum, Bernice (president of Hadassah, 1976–80), New York, 16 June 1991, 19 Dec. 2004

Teller, Judith (daughter of Bertha Schoolman), 28 Sept. 2000

Tigay, Elan E. (editor of *Hadassah Magazine* since 1985), New York, 6 June 1991

Tulin Elyachar, Anna (chair, National Board Committee for Medical School Affairs, 1950; chair, Hadassah Medical Organization, 1953–7; chair, National Board Youth Aliyah Committee, 1950–3), New York, 20 June, 14, July 1991; Jerusalem, 30 July 1991

Walker, June (Hadassah president from 2003), New York, 19 Dec. 2003

Weiner, Laurel (member of National Board, 1991), Jerusalem, 2 Aug. 1991

Woodley (formerly Berenson), Mendelle (daughter of Denise Tourover), Washington, DC, 6 June 1991

Zolot, Jane (member of National Board, 1991), New York, 10 June 1991

PUBLICATIONS SPONSORED BY HADASSAH

Ben-Asher, N., *Democracy's Hebrew Roots* (New York: Hadassah Education Department, 1951, 1953).

Diament, C. (ed.), *Jewish Marital Status, A Hadassah Study* (Northvale, NJ, and London: Jason Aronson, 1989).

——(ed.), *Jewish Women Living the Challenge: A Hadassah Compendium* (New York: Hadassah, 1997).

Goldberg, Hannah L., *Hadassah Handbook* (New York: National Education Committee of Hadassah, 1950).

Goldberg, Hannah L., *The Making of the Modern Jew: A Leader's Guide to the Book by Milton Steinberg* (New York: Hadassah Education Department, 1948; rev. 1952, 1964, 1976, 1987).

Hadassah, *The Hadassah Foundation in Action: Shaping a Better World for Women and Girls* (New York: Hadassah, 2003).

—— *Integrated Kit* (New York: Hadassah, various years)

Hadassah Education Department, *Leader's Guide to the Book 'Great Ages and Ideas of the Jewish People'* (New York: Hadassah, 1956).

Harlow, J., and T. Cohen, *Pray Tell: A Hadassah Guide to Jewish Prayer* (Woodstock, Vt.: Jewish Lights Publishing, 2003).

Hirsh, J. (ed.), *The Hadassah Medical Organization: An American Contribution to Medical Pioneering and Progress in Israel* (New York: Hadassah, 1956).

Levin, S. R., *Basic Judaism: A Leader's Guide to the Book by Milton Steinberg* (New York: Hadassah Education Department, 1948; rev. 1950, 1964, 1976).

Sarlin, N., *Leader's Guide to the Book of Deuteronomy* (New York: Hadassah Education Department, 1951).

Schwarz, L. W. (ed.), *Great Ages and Ideas of the Jewish People* (New York: Random House, 1956).

Tanenbaum, L., *Moonbeams: A Hadassah Rosh Hodesh Guide* (New York: Hadassah, 2000).

Tannenbaum, B. S. (ed.), *Hadassah International 20th Anniversary Commemorative Book* (New York: Hadassah, 2003).

What to Read—Where to Find It—A Survey of Pamphlets of Jewish and Zionist Interests Recommended by the Education Department of Haddassah [sic] (New York: Hadassah Education Department, June 1951).

'The Women's Zionist Organization of America, Inc.' by Professor Steven M. Cohen, Hebrew University, Jerusalem, Israel, and Alan Ganapol, Marketquest, Inc., Mohegan Lake, NY, 1999.

Young Judaea, Israel Summer Programs 2003.

—— 'Shalem, a More Complete Religious Israel Program', 2003–4.

—— *Tomorrow's Leaders Today*, pamphlet (New York: Hadassah National Office, n.d.).

—— Year Courses in Israel 2003–4.

NEWSPAPERS, PERIODICALS, AND YEARBOOKS

The American Jewish Yearbook (New York and Philadelphia: The American Jewish Committee and the Jewish Publication Society of America)

The American Zionist (New York: Zionist Organization of America)

Commentary (New York: American Jewish Committee)

Davar (Tel Aviv)

Ha'aretz (Tel Aviv)

Hadassah Headlines (New York: Hadassah)

Hadassah Newsletter (New York: Hadassah)

Israel Government Statistical Yearbook (Heb.), no. 9: *5718* (1957/9) (Jerusalem: Government Publishing Co., n.d.).

Israel Government Yearbook 5709–5717 [1947/8–1956/7] (Heb.), (Tel Aviv: Government Printing Office)

Jewish Frontier (New York: Labor Zionist Organization of America)

Korot: Quarterly of the History of Medicine and Natural Sciences (Academy of Medicine, Jerusalem), vols. 1–6

Megamot: Child Welfare Research Quarterly (Jerusalem: Henrietta Szold Institute for Child and Youth Welfare)

The New Palestine (Washington, DC: Zionist Organization of America)

Niv Harofeh (Tel Aviv: Journal of the Union of Physicians in the General Federation of Labor)

Pioneer Woman (New York: Women's Labor Zionist Organization of America)

REFERENCE WORKS

Encyclopedia Hebraica (Heb.), 34 vols. plus 4 supp. vols. (Jerusalem: Company for Publishing Encyclopedias, 1953–85).

Encyclopedia of the Holocaust [Entsiklopediyah shel hasho'ah], ed. Abraham Barkai and Israel Gutman, 5 vols. (Tel Aviv: Sifriat Hapoalim; New York: Macmillan, 1990).

Encyclopedia Judaica, ed. Cecil Roth and Geoffrey Wigoder, 16 vols. (Jerusalem: Keter; New York, Macmillan, 1971–2).

Encyclopedia Judaica, 2nd edn., ed. Fred Skolnik and Michael Berenbaum, 22 vols. (Detroit: Thomson Gale Macmillan Reference USA, 2006).

Encyclopedia of Zionism and Israel, ed. Raphael Patai (New York: Herzl Press/McGraw-Hill, 1971).

New Encyclopedia of Zionism and Israel, editor-in-chief Geoffrey Wigoder, 2 vols. (New York, London, and Toronto: Herzl Press, 1994).

Talmudic Encylopedia on Matters of Halakhah [Entsiklopediyah talmudit be'inyanei halakhah] ed. Rabbi Shlomo Yosef Zevin, 25 vols. (Jerusalem: World Center of Mizrachi, Talmudic Encyclopaedia Publishers/Harav Kook Institute/World Mizrachi, 1952–2004).

Who's Who in World Jewry: Biographical Dictionary of Outstanding Jews, ed. Yitzhak Schneiderman and J. Carmin, 4 vols. (New York: Monde, New York, 1955–87).

WEBSITES

www.Hadassah.org.il/Hadassa (Heb.)

www.hadassahinternational.org

www.hadassah.org

www.hadassah.ac.il (Heb.)

http://ot.huji.ac.il/mivne_frames.html (Heb.)

SECONDARY WORKS

Adams, R., 'The Creation of Community Nursing in the Jewish Population in Palestine' (Heb.), in R. Adams-Stockler and R. Sharon (eds.), *Landmarks in Nursing: A Collection of Historical Research on Nursing Written in Israel* [Tsiyunei derekh bahitpathut hasiyud: kovets mehkarim historiyim besiyud shenikhtavu beyisra'el] (Tel Aviv: Tel Aviv University, 1995–6).

Alcalay, L., 'The Origins and Development of the World Confederation of General Zionists', master's thesis, Hebrew University of Jerusalem, 1978.

Alon, H., *Be Prepared: Fifty Years of Scouting in Palestine, 1919–1969* [Heye nakhon: hamishim shenot tsofiyut be'erets yisra'el, 1919–1969] (Tel Aviv: Am Hasefer, 1977).

Amkraut, B., 'Zionist Attitudes towards Youth Aliya from Germany, 1932–1939', *Journal of Israeli History, Politics, Society, Culture*, 20/1 (Spring 2001), 67–86.

Annual Assessment 2006. Major Shifts: Threats and Opportunities (Jerusalem: Jewish People Policy Making Institute, 2006).

Antler, J. *The Journey Home: Jewish Women and the American Century* (New York and London: Free Press, 1997).

Arieli, Y., *Individualism and Nationalism in American Ideology* (Cambridge, Mass.: Harvard University Press, 1964).

—— *Political Thought in the United States* [Hamahshavah hamedinit be'artsot haberit], 2 vols. (Jerusalem: Bialik Institute, 1969), vol. ii.

As, B., 'On Female Culture: An Attempt to Formulate a Theory on Women's Solidarity and Action', *Acta Sociologica*, 8/2–4 (1975), 142–61.

Ashbal, R., *All That We Could: The Contribution of the Hebrew University and the Doctors of Palestine in the Second World War and Afterwards* [Kol asher yakholnu: terumat ha'universitah ha'ivrit verofei erets yisra'el bamilḥemet ha'olam hasheniyah vele'aḥareiḥa] (Jerusalem: Magnes, 1985/6).

Assaf, M., 'The Population' (Heb.), *Encyclopedia Hebraica*, vol. vi.

Atzmon, E., 'Jewish Education for Adults in the United States' (Heb.), in M. Zohari, A. Tarkover, and H. Ormiyan (eds.), *Hebrew Thought in America* [Hagut ivrit be'amerikah] (Tel Aviv: Brit Ivrit Olamit/Yavne, 1981).

Avigad, M., 'Technological Vocational Education' (Heb.), in H. Ormiyan (ed.), *Education in Israel* [Haḥinukh beyisra'el] (Jerusalem: Ministry of Education and Culture, 1973).

Avizohar, M., *In a Cracked Mirror: Social and National Ideals and their Reflection in the World of Mapai* [Bire'i saduk: ideyalim ḥevratiyim uele'umiyim vehishtakfutam be'olamah shel mapai] (Tel Aviv: Sifryat Ofakim of Am Oved/Ben-Gurion Heritage Institute and Research Center/Ben-Gurion University of the Negev, 1990).

Baader, G., 'The Impact of German Jewish Physicians and German Medicine on the Origin and Development of the Medical Faculty of the Hebrew University', *Korot*, 30 (2001), 9–45.

Bar-Gil, S., *Search for a Home, Find a Homeland—Aliyat Hanoar in Education and Rehabilitation of Holocaust Survivors 1945–1955* [Meḥapsim bayit motsiyim moledet: aliyat hano'ar beḥinukh ubeshikum she'eirit hapeleitah 1945–1955] (Jerusalem: Yad Ben-Zvi/Ben-Gurion University of the Negev, 1999).

Bar-Zohar, M., *Ben-Gurion: A Political Biography* [Ben-guriyon: biografiyah politit], 3 vols. (Tel Aviv, 1976–7).

Barkai, A., 'Max Warburg', *Encyclopedia of the Holocaust* [Entsiklopediyah hasho'ah], ed. Israel Gutman, 5 vols. (Tel Aviv: Sifriat Hapoalim; New York: Macmillan, 1990), ii. 446.

Barshai, B., 'Hebrew University in Jerusalem, 1925–1935' (Heb.), *Cathedra*, no. 53 (Sept. 1989), 107–22.

——'Preparations for the Opening of the Hebrew University and its First Years' (Heb.), *Cathedra*, no. 25 (Sept. 1982), 65–78.

Bartal, N., *Compassion and Competence: Nursing in Mandatory Palestine 1918–1948* [Ḥemlah veyeda: reshit miktsoa hasi'ud be'erets yisra'el, 1918–1948] (Jerusalem: Yad Izhak Ben-Zvi, 2005).

——'Establishment of a Nursing School in Jerusalem by the American Zionist Medical Unit, 1918: Continuation or Revolution?' (Heb.), in M. Shilo, R. Kark, and G. H. Hazan

Rokem (eds.), *The New Hebrew Women: Women in the Yishuv and in Zionism from a Gender Perspective* [Ha'ivriyot haḥadashot: nashim bayishuv uvatsiyonut bere'i hamigdar] (Jerusalem: Yad Ben-Zvi, 2001).

Bartal, N., 'Landsman, Bertha', in P. E. Hyman and D. Ofer (eds.), *Jewish Women: A Comprehensive Historical Encyclopedia*, CD-ROM (Jerusalem: Shalvi, 2006).

—— 'The Theoretical and Practical Training of Jewish Nurses in Palestine in the Mandate Period, 1918–1948, in the Perspective of the Development of the Henrietta Szold Hadassah Nurses' Training School, Jerusalem' [Hahakhsharah hate'oretit vehama'asit shel aḥayot yehudiyot be'erets yisra'el bitekufat hamandat, 1918–1948, bire'i hitpatḥuto shel beit hasefer le'aḥayot al shem henri'eta sold hadasah], Ph.D. diss., Hebrew University of Jerusalem, 2000.

—— and J. Steiner-Freud, 'Cantor, Shulamit', in P. E. Hyman and D. Ofer (eds.), *Jewish Women: A Comprehensive Historical Encyclopedia*, CD-ROM (Jerusalem: Shalvi, 2006).

———— *The First Graduating Class, Hadassah School of Nursing, 1921*, pamphlet (New York: Hadassah, n.d.).

———— 'Nursing Education Moves into the University: The Story of the Hadassah School of Nursing in Jerusalem, 1918–1984', *Nursing History Review*, 13 (2005), 121–45.

Bavly, S., *Our Nutrition* [Tezunatenu], 2nd edn. (Jerusalem: Ever, 1939).

Beiger, G., 'Jerusalem: The Capital of the British Administration in Palestine, 1917–1948' (Heb.), in Y. Ben-Arieh (ed.), *Jerusalem in the Mandate Period: Practice and Legacy* [Yerushalayim bitekufat hamandat haberiti: ha'asiyah vehamoreshet] (Jerusalem: Yad Ben-Zvi/Mishkenot She'ananim, 2003).

Ben-Arieh, Y., *A City in the Context of the Period: The New Jerusalem in the Nineteenth Century* [Ir beri'i tekufah: yerushalayim bame'ah hatesha-esreh] (Jerusalem: Yad Ben-Zvi, 1977).

Ben-David, J., 'Professionals and Unions in Israel', in S. N. Eisenstadt, R. Bar-Joseph, R. Kahane, and A. Shelah (eds.), *Social Classes in Israel: A Reader* [Revadim beyisra'el] (Jerusalem: Academon, 1968), 255–77.

—— 'Socialization and Career Patterns as Determinators of Productivity of Medical Researchers', in J. Ben-David, *Scientific Growth* (Berkeley: University of California Press, 1991).

—— 'Universities in Israel: Dilemmas of Growth, Diversity, and Management' (Heb.), in W. Ackerman, A. Carmon, and D. Zucker (eds.), *Education in a Society in the Making: The Israeli System* [Ḥinukh beḥevrah mithavah: hama'arekhet hayisra'elit], 2 vols. (Jerusalem and Tel Aviv: Hakibbutz Hameuchad and the Van Leer Institute, 1985), i. 527–62.

Ben-Gurion, D. *The War Diary, The War of Independence 5708–5709* [Yoman hamilḥamah, milḥemet ha'atsma'ut, 5708–5709], ed. G. Rivlin and E. Orren, 3 vols. (Tel Aviv: Society for Dissemination of the Teachings of David Ben-Gurion, Ministry of Defense, 1984).

Bergman, R., 'Research and Studies on Nursing in Israel', *Israel Journal of Medical Sciences*, 7 (1971), 601–7.

Berkowitz, M., 'Transcending "Tzimmes and Sweetness"', in Maurice Sacks (ed.), *Active Voices: Women in Jewish Culture* (Champaign: University of Illinois Press, 1995), 41–62.

Berman, A., *Nazism, the Jews and American Zionism 1933–1948* (Detroit: Wayne State University Press, 1990).

Berrol, Selma, 'Richman, Julia', in P. E. Hyman and D. Ofer (eds.), *Jewish Women: A Comprehensive Historical Encyclopedia*, CD-ROM (Jerusalem: Shalvi, 2006).

Bierbier, D., 'The American Zionist Emergency Council: An Analysis of a Pressure Group', *American Jewish Historical Quarterly*, 60/1 (1970), 82–105.

Black, N., *Social Feminism* (Ithaca and London: Cornell University Press, 1989).

Bonner, T. N., *Becoming a Physician: Medical Education in Britain, France, Germany, and the United States, 1750–1945* (New York and Oxford: Oxford University Press, 1995).

Brachyahu, M., *The School and the Student in Palestine: Review of 18 Years of Work of the Hadassah Department for School Hygiene* [Beit hasefer vehatalmid be'erets yisra'el: sekirah al 18 shenot avodah shel maḥleket hadasah lehegiyenah shel beit hasefer] (Jerusalem: Kalanter and Mizrachi, 5698 [1937/8]).

Brown, M., 'Henrietta Szold's Progressive American Vision of the Yishuv', in A. Gal (ed.), *Envisioning Israel: The Changing Ideals and Images of North American Jews* (Jerusalem: Magnes Press/Hebrew University; Detroit: Wayne State University Press, 1996), 60–80.

——— *The Israeli–American Connection: Its Roots in the Yishuv, 1914–1945* (Detroit: Wayne State University Press, 1996).

Buechler, S. M., *Women's Movements in the United States: Woman Suffrage, Equal Rights, and Beyond* (New Brunswick, NJ, and London: Rutgers University Press, 1990).

Burns, E. M., *The American Idea of Mission: Concepts of National Purpose and the American Idea of Mission Destiny* (New Brunswick, NJ: Rutgers University Press, 1957).

Carmel-Hakim, E., 'Agricultural–Vocational Training for Women in the Yishuv with the Assistance of Jewish Women's Organizations 1911–1929' [Mifal hahakhsharah hamiktsoit–ḥaklait shel nashim bayishuv ve'ezratam shel irgunei nashim yehudiyot, 1911–1929], Ph.D. diss., University of Haifa, 2003.

Chafe, W. H., *The American Woman: Her Changing Social, Economic, and Political Roles 1920–1970* (New York: Oxford University Press, 1972).

Cohen, N. W., *American Jews and the Zionist Idea* (Garden City, NY: Ktav, 1975).

—— Hanns G. Reissner, and Ruth Beloff, 'Straus', *Encyclopaedia Judaica*, 2nd edn., ed. Fred Skolnik and Michael Berenbaum (Detroit: Macmillan Reference USA, 2007), xix. 248.

Cott, N. F., *The Grounding of Modern Feminism* (New Haven: Yale University Press, 1987).

Curti, M., 'American Philanthropy and National Character', *American Quarterly*, 10/4 (1958), 421–7.

Dash, J., *Summoned to Jerusalem: The Life of Henrietta Szold* (New York, Hagerstown, San Francisco, and London: Harper & Row, 1979).

Davis, E., *Saga of a Siege: A Medical Historical Novel of Jerusalem 1948* (Jerusalem: Rubin Mass, 1981).

Dayan, M., *Diary of the Sinai Campaign* [Yoman ma'arekhet sinai] (Tel Aviv: Maariv, 1956).

Degen, M. L., *The History of the Women's Peace Party* (New York and London: Garland, 1972).

Dehn, M., 'HMO Treats Arabs and Jews in Protestant Leprosarium', *Hadassah Newsletter*, 30/11 (July–Aug.) 1950.

Deutsch, A., 'The Development of Social Work as a Profession in the Yishuv' [Hitpathut ha'avodah hasotsiyalit kemiktso'a bayishuv ha'ivri be'erets yisra'el], Ph.D. diss., Hebrew University of Jerusalem, 1970.

Dinner, H. R., *The Jews of the United States, 1654 to 2000* (Berkeley and Los Angeles: University of California Press, 2004).

—— 'Negotiating Egalitarianism and Judaism: American Jewish Feminism and its Implications for Jewish Life', in Roberta Rosenberg Farber and Chaim I. Waxman (eds.), *Jews in America: A Contemporary Reader* (Hanover, NH, and London: Brandeis University Press, 1995), 163–90.

Dolev, D., 'The Hebrew University's Master Plans, 1918–1948' (Heb.), in S. Katz and M. Heyd (eds.), *The History of the Hebrew University of Jerusalem: Origins and Beginnings* [Toledot ha'universitah ha'ivrit biyerushalayim: shorashim vehathalot] (Jerusalem: Magnes Press/Hebrew University, 1997), 257–80.

Don-Yehiya, E., '"Galut" in Zionist Ideology and in Israeli Society', in E. Don-Yehiya (ed.), *Israel and Diaspora Jewry: Ideological and Political Perspectives* (Ramat Gan: Bar Ilan University Press, 1991).

Dushkin, A. M., *Living Bridges: Memories of an Educator* (Jerusalem: Keter, 1975).

Dushkin, J. A., 'Hadassah's Child Welfare Program in Palestine', memorandum, Hadassah, New York, 1942.

Eastabrooks, C. A., 'Larina Lloyd: The Henry Street Years', in E. D. Baer and C. A. Eastabrooks (eds.), *Enduring Issues in American Nursing* (New York: Springer, 2001).

Eisen, A. M., *The Chosen People in America: A Study in Jewish Religious Ideology* (Bloomington: Indiana University Press, 1983).

—— *Galut: Modern Jewish Reflections on Homelessness and Homecoming* (Bloomington and Indianapolis: Indiana University Press, 1986).

Elath, E., *The Struggle over the State: Washington 1945–1958* [Hama'avak al hamedinah: vashington 1945–1958], 2 vols. (Tel Aviv: Am Oved/Hasifriya Hatsiyonit, 1979), i: *1945–1948*.

Eliav, B., *The Jewish Community in Palestine in the Time of the National Home* [Hayishuv biyemei habayit hale'umi] (Jerusalem: Keter, 1976).

—— 'Palestine' (Heb.), *Encylopedia Hebraica*, vi.

Elwell, E. S. E., 'The Founding and Early Programs of the National Council of Jewish Women: Study and Practice as Jewish Women's Religious Expression', Ph.D. diss., Indiana University, 1982.

Endevelt, R., 'Sara Bavly', in P. E. Hyman and D. Ofer (eds.), *Jewish Women: A Comprehensive Historical Encyclopedia*, CD-ROM (Jerusalem: Shalvi, 2006).

Engle, A., 'Hadassah Serves Arab Children', *Hadassah Newsletter*, 30/3 (Nov. 1949), 3.

Epstein, L., 'The Hebrew University, Hadassah Braun School of Public Health and Community Medicine: Its International Role and Experience', *Public Health Review*, 30 (2002), 1–4, 35–47.

Ernstein, E., *Research in Vocational Guidance* [Meḥkarim bahadrakhah miktso'it] (Jerusalem: Hadassah Vocational Education Projects, 1960).

Etron, R., 'Impressions of Education in the United States' (Heb.), *Megamot*, 3/3 (April 1951), 13–28.

Feingold, H. L., 'The American Component of the American Jewish Identity', in D. M. Gordis and Y. Ben-Horin (eds.), *Jewish Identity in America* (Jersey City, NJ: Ktav, 1991), 69–80.

—— 'Rescuing and the Secular Perception: American Jews and the Holocaust' (Heb.), in B. Pinkus, and I. Troen (eds.), *National Jewish Solidarity in the Modern Period* [Solidariyut yehudit le'umit be'et haḥadashah] (Kiryat Sede Boqer: Ben-Gurion Research Center, Ben-Gurion University of the Negev, 1988), 160–72.

Feitelson, D., 'Education of Young Children Among the Kurdish Ethnic Group' (Heb.), *Megamot*, 8/2 (Jan. 1954), 95–109.

Feldstein, A. L., 'David Ben-Gurion, the World Zionist Organization and US Jewry' [David ben-gurion, hahistadrut hatsiyonit, veyahadut artsot haberit], Ph.D. diss., Hebrew University of Jerusalem, 2000.

—— *Gordian Knot: David Ben-Gurion, the World Zionist Organization and American Jewry, 1948–1963* [Kesher gordi: david ben-gurion, hahistadrut hatsiyonit veyahadut artsot

haberit] (Sede Boqer: Ben-Gurion Institute, Sapir Academic College, Avraham Harman Institute of Contemporary Jewry, Hebrew University of Jerusalem, and Ben-Gurion University of the Negev Press, 2003).

Fineman, I., *Woman of Valor: The Life of Henrietta Szold, 1860–1945* (New York: Simon & Schuster, 1961).

Fishman, Sylvia Barack, *A Breath of Life: Feminism in the American Jewish Community* (Hanover, NH, and London: Brandeis University Press, 1995).

—— 'The Changing American Jewish Family Facing the 1990s', in Roberta Rosenberg Farber and Chaim I. Waxman (eds.), *Jews in America: A Contemporary Reader* (Hanover, NH, and London: Brandeis University Press, 1995), 51–88.

—— 'Choosing Life: Evolving Gender Roles in American Jewish Families', in Dana Evans Kaplan (ed.), *American Judaism* (Cambridge: Cambridge University Press, 2005), 237–52.

—— *Double or Nothing: Jewish Families and Mixed Marriage* (Hanover, NH, and London: Brandeis University Press, 2004).

Frankenstein, C., 'Anxiety among Children' (Heb.), *Megamot*, 3/4 (July 1952), 380–401.

—— 'The Path of the Szold Institute' (Heb.), Editorial Board Forum, *Megamot*, 2/2 (Jan. 1952), n.p.

Freund-Rosenthal, M., *In My Lifetime: Family, Community, Zion* (New York: Chestnut Ridge, 1989).

Friedan, B. *The Feminine Mystique* (New York: Norton, 1963).

Friedman, M., 'Point Four and Hadassah', *Hadassah Newsletter*, 33/3 (Oct. 1952).

Friesel, E., 'Brandeis' Role in American Zionism Historically Reconsidered', *American Jewish History*, 69 (Sept. 1979), 34–57.

—— *The Zionist Movement in the United States, 1897–1914* [Hatenuah hatsiyonit be'artsot haberit bashanim 1897–1914] (Tel Aviv: Tel Aviv University/Hakibbutz Hameuchad, 1969/70).

—— *The Zionist Policy after the Balfour Declaration, 1917–1922* [Hamediniyut hatsiyonit le'ahar hats'harat balfur, 1917–1922] (Tel Aviv: Tel Aviv University/Hakibbutz Hameuchad, 1976/7).

Gal, A., 'American Zionism between the Two World Wars: Ideological Characteristics' (Heb.), *Yahadut Zemanenu*, 5 (1988–9), 79–90.

—— *Brandeis of Boston* (Cambridge, Mass.: Harvard University Press, 1980).

—— 'Brandeis' View on the Upbuilding of Palestine', *Studies in Zionism*, 6 (Autumn 1982).

—— *David Ben-Gurion and the American Alignment for a Jewish State* (Bloomington and Indianapolis: Indiana University Press; Jerusalem: Magnes, 1991).

—— David Ben-Gurion: Preparing for a Jewish State. Political Alignment to the White Paper and the Outbreak of World War II, 1938–1941 [Likrat medinah yehudit: hahe'arkhut ha-medinit nokhaḥ hasefer halavan uferots milḥemet ha'olam hasheniyah, 1938–1941] (Sede Boqer: Ben-Gurion University of the Negev, 1985)

—— 'Hadassah and the American Jewish Political Tradition', in J. S. Gurock and M. L. Raphael (eds.), An Inventory of Promises: Essays on American Jewish History in Honor of Moses Richin (Brooklyn, NY: Carlson, 1995), 89–114.

—— 'Hadassah's Ideal Image of the State of Israel' (Heb.), Yahadut zemaneinu, 4 (1998), 157–70.

—— 'The Historic Continuum Version of the Perception of Israel among the Constructivists', in P. Ginnosar (ed.), Studies in Zionism: The Yishuv and the State of Israel [Iyunim bitekumat yisra'el: ma'asaf leba'ayot hatsiyonut, hayishuv, umedinat yisra'el], 3 (1993), 270–91.

—— 'Independence and Universal Mission in Modern Jewish Nationalism: A Comparative Analysis of European and American Zionism (1897–1948)', Studies in Contemporary Jewry, 5 (1989), 242–55.

—— 'The Mission Motif in American Zionism', American Jewish History, 75/4 (June 1986), 363–85.

—— 'The Sources of Ben-Gurion's American Orientation, 1938–1941', in R. W. Zweig (ed.), David Ben-Gurion: Politics and Leadership in Israel (Jerusalem: Yad Ben-Zvi, 1991).

Ganin, Z., Truman, American Jewry and Israel, 1945–1948 (New York: Holmes & Meier, 1979).

Gassman-Sherr, R. G., The Story of the Federation of Women Zionists of Great Britain and Ireland 1918–1968 (London: Federation of Women Zionists, 1968).

Gat, B., 'The First Medical Institutions in Palestine' (Heb.), in M. Ish Shalom (ed.), Jerusalem: Palestine Research [Yerushalayim: meḥkarei erets yisra'el] (Jerusalem, 1952/3).

Gelber, N. M., The History of the Zionist Movement in Galicia 1875–1918 [Toledot hatenuah hatsiyonit begalitsiyah], 2 vols. (Jerusalem: Zionist Library, 1968).

Gelber, Y., A New Homeland: The Immigration and Absorption of the Jews of Central Europe, 1933–1948 [Moledet ḥadashah: aliyat yehudei merkaz eiropah vekelitatam, 1933–1948] (Jerusalem: Yad Ben-Zvi/Leo Baeck Institute, 1990).

Ginnton, S., 'Twenty Years of Health in Israel' (Heb.), in Twenty Years of Independence in Israel [Esrim shenot atsma'ut leyisra'el] (Jerusalem: Information Services of the Prime Minister's Office, Publication Services, 1969).

Glanz, M., 'Social Services in Youth Aliyah' (Heb.), Dapim, 18 (Spring 1968).

Glazer, N., American Judaism, 2nd edn. (Chicago: University of Chicago Press, 1972 [first pub. 1957]).

Golan, M., *Doctor Moshe Rahmilevitz* [Rofeh, moshe raḥmilevits] (Tel Aviv: Zmora Beitan, 1989).

Goldberg, H., 'Draft Constitution is Great Document', *Hadassah Newsletter*, 29/5 (Jan.–Feb. 1949), 8.

Goldstein, E., 'The Practical as Spiritual: Henrietta Szold's American Zionist Ideology, 1878–1920', in B. Kessler (ed.), *Daughter of Zion: Henrietta Szold and American Jewish Womanhood* (Baltimore: Jewish Historical Society of Maryland, 1995).

Goldstein, I., *My World as a Jew: The Memories of Israel Goldstein*, 2 vols. (New York, Herzl, 1984), vol. i.

Goren, A., 'A "Golden Decade" for American Jews: 1945–1955', *Studies in Contemporary Jewry*, 8 (1992), 3–20.

——'Zionism and its Opponents in American Jewry' (Heb.), in *Zionism and its Jewish Opponents* [Hatsiyonut umitnagdeihah ba'am hayehudi] (Jerusalem: Bialik Institute, 1990).

Gorny, Y., 'From Zionist Ideology to the Zionist Vision: On David Ben-Gurion's Attitude to Zionism in the Years 1906–1963'(Heb.), in S. Almog (ed.), *Transition and Change in the New Jewish History: Essays Presented in Honor of Shmuel Ettinger* [Temurot bahistoriyah hayehudit haḥadashah] (Jerusalem: Zalman Shazar Center and the Israel Historical Society, 1987).

——*The Quest for National Identity: The Role of the State of Israel in Jewish Public Thought in the United States, 1945–1987* [Haḥipus aḥar hazehut hale'umit: mekomah shel medinat yisra'el bemaḥshavah hayehudit hatsiburit be'artsot haberit bashanim 1945–1987] (Tel Aviv: Am Oved, 1990).

Gottesman, M., '25 Years out of the 40 Years of Youth Aliya' (Heb.), in H. Ormiyan (ed.), *Education in Israel* [Haḥinukh beyisra'el] (Jerusalem: Israel Ministry of Education and Culture, 1973).

Graham, P. A., 'Expansion and Exclusion: A History of Women in American Higher Education', *Signs*, 3 (Summer 1978), 759–73.

Grand, S., 'A History of Zionist Youth Organizations in the United States from their Inception to 1940', Ph.D. diss., Columbia University, 1958.

Greenberg, M. G., *There Is Hope for your Children: Youth Aliyah, Henrietta Szold and Hadassah* (New York: Hadassah, 1986).

Greenberg, O., 'WIZO: Women's International Zionist Organization (1920–1970)', in P. E. Hyman and D. Ofer (eds.), *Jewish Women: A Comprehensive Historical Encyclopedia*, CD-ROM (Jerusalem: Shalvi, 2006).

——and H. Herzog, *A Voluntary Women's Organisation in a Society in the Making: WIZO's Contribution to Israeli Society* (Tel Aviv: Institute of Social Research, Faculty of Sociology and Anthropology, Tel Aviv University, 1981).

Gross, N., 'The Economic Policy of the British Mandate Government in Palestine' (Heb.),*Cathedra*, no. 25 (Sept. 1982), 135–68.

——'High School and Education of the Citizen in Israel' (Heb.), *Megamot*, 4/3 (April 1953), 287–91.

Grunfeld, Katharina Kroo, 'Hunter College', in P. E. Hyman and D. Ofer (eds.), *Jewish Women: A Comprehensive Historical Encyclopedia*, CD-ROM (Jerusalem: Shalvi, 2006).

Guttman, E., 'Israel: Democracy without a Constitution', in V. Bogdanor (ed.), *Constitutions in Democratic Politics* (Aldershot: Policy Studies Institute, 1988), 290–308.

Hacohen, D., *Immigrants in Turmoil: The Great Wave of Immigration to Israel and its Absorption, 1948–1953* [Olim besa'arah: ha'aliyah hagedolah vikelitatah beyisra'el, 1948–1953] (Jerusalem: Yad Izhak Ben-Zvi, 1994).

—— *Immigrants in Turmoil: Mass Immigration to Israel and its Repercussions in the 1950s and After* (Syracuse, NY: Syracuse University Press, 2003).

Hadassah International, 'Frequently Asked Questions' (New York: Hadassah National Office, n.d., n.p.).

'The Hadassah School of Medicine and the Hebrew University', unpublished booklet (Jerusalem: Department of the History of Medicine, Hebrew University, 1985).

Halevi, H. S., 'The Health System from the Mid-Nineteenth Century' (Heb.), *Encyclopedia Hebraica*, vi. 716–27.

——and A. Brzezinski, *Under Double Siege: Besieged Mount Scopus in Besieged Jerusalem, Passover 5708 [1948]* [Bematsor kaful: har hatsofim hanatsur biyerushalayim ha-netsurah, pesah 5708] (Tel Aviv: Hadar, 1982).

Halperin, S., *The Political World of American Zionism* (Detroit: Wayne State University Press, 1961).

Halpern, B., *The American Jew: A Zionist Analysis* (New York: Theodor Herzl Foundation, 1956).

Hannam, J., 'Women, History and Protest', in V. Robinson and D. Richardson (eds.), *Introducing Women's Studies*, 2nd edn. (Basingstoke: Palgrave Macmillan, 1997).

Hebrew University of Jerusalem, *The Hebrew University of Jerusalem* (Jerusalem: Hebrew University, 1960).

—— *The Hebrew University-Hadassah Medical School* (Jerusalem: Azriel, 1954).

Hirsch, Dafna, '"We Are Here to Bring the West": Hygiene Education in the Jewish Community of Mandatory Palestine' (Heb.), *Zmanim*, no. 78 (Spring 2002), 107–20.

Hofstadter, R., *The Age of Reform: From Bryan to F.D.R.* (New York: Knopf, 1956).

Hurwitz, A. (ed.), *Against the Stream: The Seven Decades of Hashomer Hatzair in North America* (Givat Haviva: Yad Ya'ari, 1994).

Hyman, P. E., 'Bat Mitzva', in P. E. Hyman and D. Ofer (eds.), *Jewish Women: A Comprehen-sive Historical Encyclopedia*, CD-ROM (Jerusalem: Shalvi, 2006).

——'Jewish Feminism in the United States', in P. E. Hyman and D. Ofer (eds.), *Jewish Women: A Comprehensive Historical Encyclopedia*, CD-ROM (Jerusalem: Shalvi, 2006).

——and D. D. Moore (eds.), *Jewish Women in America: An Historical Encyclopedia*, 2 vols. (New York and London: Routledge, 1997).

——and D. Ofer (eds.), *Jewish Women: A Comprehensive Historical Encyclopedia*, CD-ROM (Jerusalem: Shalvi, 2006).

Ilan, A., 'The Prophecy of the Jewish State and its Realization, 1941–1949' (Heb.), *Hatsiy-onut*, 10 (1985), 280–99.

Israel Ministry of Health, 'Health in Israel 1948–1978', draft (Jerusalem: Ministry of Health, 1979).

——*Israel Health Services* (Jerusalem: Ministry of Health, 1955).

Jacobs, R. G., 'Beginnings of Hadassah', in I. S. Meyer (ed.), *Early History of Zionism in America* (New York: American Jewish Historical Society/Theodor Herzl Foundation, 1958), 228–44.

Jacobs, S., 'Twenty-Five Years of Hadassah' (Heb.), *Harofeh ha'ivri*, 1 (1937), 37–52.

Jaquette, J. S. (ed.), *Women in Politics* (New York and London: Wiley, 1974).

Kachinsky, M., 'The Temporary Immigrant Settlements' (Heb.), in M. Naor (ed.), *Immi-grants and Temporary Transit Settlements: Sources, Summaries, Selected Interpretations and Supplementary Material* [Olim uma'abarot: mekorot, sikumim, parshiyot nivḥarot veḥomerei ezer] (Jerusalem: Yad Ben-Zvi, 5747/1987).

Kadosh, S. B., 'Ideology vs Reality: Youth Aliya and the Rescue of Jewish Children During the Holocaust Era, 1933–45', Ph.D. diss., Columbia University, New York, 1995.

Kahanoff, J., *Ramat-Hadassah-Szold: Youth Aliyah Screening and Classification Center* (Jeru-salem: Fédération Internationale des Communautés d'Enfants, 1960).

Kallen, H. M., *Culture and Democracy in the United States* (New York: Arno, 1924).

——'Democracy versus the Melting Pot', *The Nation*, 100, 18 Feb. 1915, 190–4, 25 Feb. 1915, 217–20.

Kanivsky (Kanav), Y., *Social Insurance in Palestine: Achievements and Problems* [Habitu'aḥ hasotsiyali be'erets yisra'el: heisegav uba'ayotav] (Tel Aviv: Briut Ha'oved, 1942), vol. ii.

Kaplan, M. A., *The Making of the Jewish Middle Class: Women, Family and Identity in Imperial Germany* (Oxford: Oxford University Press, 1991).

Kaplan, M. M., *The Greater Judaism in the Making: A Study of the Modern Evolution of Judaism* (New York: Reconstructionist Press, 1960).

——*Judaism as a Civilization: Toward a Reconstruction of American Jewish Life* (New York: Reconstructionist Press, 1934).

—— *A New Zionism* (New York: Theodor Herzl Foundation, 1955).

——'A Program for the Reconstruction of Judaism', *Menorah Journal*, 6/4 (Aug. 1920), 115–59.

Karp, A. Y., *The Spiritual Life of the Jews of America* [Ḥayei haru'aḥ shel yahadut amerikah] (Jerusalem and Tel Aviv: Shocken, 1984).

Katz, Y., 'Religion as a Unifying and Dividing Force in Modern Jewish History', in id., *Jewish Nationalism: Theses and Research* (Jerusalem: Hasifriya Hatsiyonit, 1979).

——*Shulamit Kalivnov's Perception of Education* [Teḥushatah haḥinukhit shel shulamit kalivnov: kovets lezikhrah], memorial volume (Department of Child and Youth Immigration, The Jewish Agency, 5729/1968–9).

Katzburg-Yungman, M., 'Hadassah: *Yishuv* to the Present Day', in P. E. Hyman and D. Ofer (eds.), *Jewish Women: A Comprehensive Historical Encyclopedia*, CD-ROM (Jerusalem: Shalvi, 2006).

——'The Impact of Gender on the Leading American Zionist Organizations', in Judith Tydor Baumel and Tova Cohen (eds.), *Gender, Place and Memory in the Modern Jewish Experience: Replacing Ourselves* (London: Vallentine Mitchell, 2003), 165–86.

——'Women and Zionist Activity in *Eretz Israel*: The Case of Hadassah, 1912–1958,' in S. Reinharz and M. A. Raider (eds.), *American Jewish Women and the Zionist Enterprise* (Waltham, Mass.: Brandeis University Press, 2005), 160–83.

Kaufman, D., 'Jewish Education as a Civilization: A History of the Teachers' Institute', in Jack Wertheimer (ed.), *Tradition Renewed: A History of the Jewish Theological Seminary*, i (New York: Jewish Theological Seminary of America, 1997), 567–653.

Kaufmann, M., 'The Other Zionism in the New World' (Heb.), *Gesher*, 123 (Summer 1991), 92–109.

Kehillah of New York City, *The Jewish Communal Register of New York City, 1917–1918* (New York: Kehillah of New York City, 1918).

Kerem, M., Y. A. Hazan, S. Derech, M. Unna, M. Rosner, S. Gilboa, et al., 'Kibbutz Movement', *Encyclopaedia Judaica*, xii. 121–32.

Khleif, B. B., 'The Arab Citizens of Israel', *Hadassah Newsletter*, 35/9 (May 1955), 5.

Kohn, H., *American Nationalism: An Interpretative Essay* (New York: Macmillan, 1957).

Kol, M., *The Youth Aliyah Tractate* (Heb.) (Jerusalem and Tel Aviv: Neumann, 1965).

Kotek, S., 'The Pasteur Institute in Palestine' (Heb.), *Korot*, 9/7–8 (1988), 205–19.

Kroo Grunfeld, K., 'Hunter College', in P. E. Hyman and D. Ofer (eds.), *Jewish Women: A Comprehensive Historical Encyclopedia*, CD-ROM (Jerusalem: Shalvi, 2006).

Kroyanker, D., *The Terra Sancta Compound, Jerusalem: Biography of a Place—Profile of a Period, 1926–1999* [Sipur mitḥam rotshild: yerushalayim, reḥov haneviyim—biyografiyah refuit veḥinukhit] (Jerusalem: Hebrew University, Jerusalem, 2001).

Kussy, S., 'When Hadassah Was Born', *Hadassah Newsletter*, 10/3 (1930), 4.

Kutscher, C., 'The Early Years of Hadassah, 1912–1921', Ph.D. diss., Brandeis University, 1976.

Kutzik, A. J., 'The Social Basis of American Jewish Philanthropy', Ph.D. diss., Brandeis University, 1967.

Kuzmack, L. G., *Woman's Cause: The Jewish Woman's Movement in England and the United States 1881–1933* (Columbus, Ohio: Ohio State University Press, 1990).

Lerner, G., *The Majority Finds its Past: Placing Women in History* (New York, Toronto, and Melbourne: Oxford University Press, 1982).

——*The Woman in American History* (Menlo Park, Calif., and London: Addison Wesley, 1971).

Levin, M., *Balm in Gilead: The Story of Hadassah* (New York: Schocken, 1973).

——*It Takes a Dream: The Story of Hadassah* (Jerusalem: Gefen, 1997).

——'Kramarsky, Lola Popper', *Encyclopedia of Zionism and Israel*, ii. 826.

Levitse, Y., *Jerusalem in the War of Independence* [Tisha kabin: yerushalayim bikravot milḥemet ha'atsma'ut] (Tel Aviv: Maarkhot, 1986).

Levy, N., *Chapters in the History of Medicine in Palestine, 1799–1948* [Perakim betoledot harefu'ah be'erets yisra'el 1799–1948] (Haifa: Hakibbutz Hameuchad/Baruch Rapoport Faculty of Medicine, The Technion, 1998).

Liebman, Y., 'Reconstructionism in the Lives of American Jewry' (Heb.), *Tefutsot yisra'el*, 9/3 (May–June 1971).

Lipset, S. M., *Continental Divide: The Values and Institutions of the United States and Canada* (New York: Routledge, 1990).

Lisak, M., 'Jerusalem as a Mirror of Israeli Society' (Heb.), in A. Bareli (ed.), *Divided Jerusalem 1948–1956: Selected Sources, Summaries, Selected Episodes and Supplementary Material* [Mekorot, sikumim, parshiyot nivḥarot veḥomerei ezer] (Jerusalem: Yad Yitzhak Ben-Zvi, 1990/1).

——*The Mass Immigration in the 1950s: The Failure of a Melting Pot* [Ha'aliyah hagedolah bishenot haḥamishim: kishelono shel kur hitukh] (Jerusalem, Bialik Institute, 1999).

Lotan (Lubinsky), G., 'Henrietta Szold as a Guide of Social Work' (Heb.), *Megamot*, 3/3 (1951), 207–8.

McCune, Mary, 'Formulating the "Women's Interpretation of Zionism": Hadassah Recruitment of non-Zionist American Women, 1914–1930', in S. Reinharz and M. A. Raider

(eds.), *American Jewish Women and the Zionist Enterprise* (Waltham, Mass.: Brandeis University Press, 2005), 89–112.

—— 'Social Workers in the Muskeljudentum: "Hadassah Ladies", "Mainly Men" and the Significance of Gender in the American Zionist Movement 1912–1928', *American Jewish History*, 86/2 (June 1998), 135–65.

—— '*The Whole Wide World, without Limits': International Relief, Gender Politics, and American Jewish Women, 1893–1930* (Detroit: Wayne State University Press, 2005).

Mann, K. J., 'The Hadassah Medical Organization Program', in J. Hirsch (ed.), *The Hadassah Medical Organization: An American Contribution to Medical Pioneering and Progress in Israel* (New York: Hadassah, 1960).

Margalit, D., *Israel's Path in Medicine: Its Ethical Uniqueness* [Derekh yisra'el birefu'ah] (Jerusalem: Academy of Medicine, 1970).

Markowitz, R. J., *My Daughter, the Teacher: Jewish Teachers in New York City Schools* (New Brunswick, NJ: Rutgers University Press, 1993).

Masterman, E. W. G., *Hygiene and Disease in Palestine in Modern and in Biblical Times* (London: Palestine Exploration Fund, n.d. [*c*.1920?]).

Medding, P. Y., 'Towards a General Theory of Jewish Political Interests and Jewish Political Behavior' (Heb.), in Daniel Elazar (ed.), *National and Ethnic Group: The Jewish Political Tradition and its Implication for our Times* [Am ve'eidah: hamasoret hamedinit hayehudit vehashlakhoteihah leyameinu] (Jerusalem: Reuven Mass/Jerusalem Center for Public and State Affairs, 1990/1).

Miller, D., 'A History of Hadassah, 1912–1935', Ph.D. diss., New York University, 1968.

Moore, D. D., *At Home in America: Second Generation New York Jews* (New York: Columbia University Press, 1981).

Morawska, E., 'Assimilation of Nineteenth-Century Jewish Women', in P. E. Hyman and D. D. Moore (eds.), *Jewish Women in America: An Historical Encyclopedia*, 2 vols. (New York and London: Routledge, 1997), i. 82–90

Nadav, D., 'Hospital 5 (Tel Hashomer) until its Devolution to the Israeli Ministry of Health, 1953' (Heb.), in P. Ginnosar (ed.), *Studies of the Establishment of Israel: Collection of Issues of Zionism in Pre-State Jewish Palestine and the State of Israel* [Iyunim bitekumat yisra'el: ma'asaf leba'ayot hatsiyonut, hayishuv, vemedinat yisra'el], 7 (1997), 439–62.

—— Untitled research paper on rehabilitation in the IDF (n.d.).

Nadell, P. S., and J. D. Sarna, *Women and American Judaism: Historical Perspectives* (Hanover, NH, and London: Brandeis University Press, 2001).

Nahon, S. U. (ed.), *Fundamental Issues of Zionism at the 23rd Zionist Congress* (Jerusalem: Organization Department of the Zionist Executive, 1952).

Naor, M. (ed.), *Immigrants and Immigrant Settlements, 1948–1952: Sources, Summaries, Selected Episodes and Supplementary Material* [Olim uma'abarot 1948–1952: mekorot, sikumim, parshiyot nivḥarot veḥomerei ezer] (Jerusalem: Yad Ben-Zvi, 1987).

Navot, O., and A. Gross, 'The War against Trachoma: The Beginning of Public Health in Palestine' (Heb.), *Cathedra*, no. 94 (2000), 92–114.

Near, H., *Kibbutz and Society: The Kibbutz Me'uchad 1923–1933* [Hakibuts vehaḥevrah: Hakibuts hame'uḥad 1923–1933] (Jerusalem: Yad Ben-Zvi, 1993/4).

Neuberger, B., *The Issue of a Constitution in Israel: Government and Politics in the State of Israel* [Sugiyat haḥukah beyisra'el: mimshal upolitikah bemedinat yisra'el] (Tel Aviv: The Open University, 1990).

—— *The Parties in Israel: Their Development, Organization, and Status in the Political System* [Hamiflagot beyisra'el: hitpatḥutan, irgunan, vema'amadan bema'arekhet hapolitit] (Tel Aviv: The Open University, 1991).

Neumann, E., *In the Arena: An Autobiographical Memoir* (New York: Herzl, 1976).

Niederland, D., 'The History of the Medical School' [Toledot beit hasefer lirefu'ah] (Jerusalem: Dean's Office of the School of Medicine of the Hebrew University and Hadassah Division of the History of Medicine, 1985).

—— 'The Influence of the German Immigrant Doctors on the Development of Medicine in Palestine' [Hashpa'at harofim ha'olim migermaniyah al hitpatḥut harefu'ah be'erets yisra'el], master's thesis, Hebrew University Jerusalem, 1982.

—— 'The Influence of the German Immigrant Doctors on the Development of Medicine in Palestine, 1933–1939' (Heb.), *Cathedra*, no. 30 (1983), 111–60.

—— and Z. Kaplan, 'The Medical School of the Hebrew University and Hadassah in Jerusalem: Preparations and Early Years' (Heb.), *Cathedra*, no. 48 (June 1988), 145–63.

Nissan (Katznelson), S., 'The Development of Medical Services in Jerusalem in the British Mandate Period' (Heb.), in Y. Ben-Arieh (ed.), *Jerusalem in the Mandate Period: Practice and Tradition* [Yerushalyaim bitekufat hamandat haberiti: ha'asiyah vehamoreshet] (Jerusalem: Yad Ben-Zvi/Mishkenot She'ananim, 2003).

O'Neill, W. L., *Feminism in America: A History*, 2nd edn. (New Brunswick and Oxford: Transaction, 1988).

Ortar (Ostreicher), G., 'An Intelligence Test for Children at the Age of School Entry' (Heb.), *Megamot*, 1/3 (April 1950), 206–23.

—— and C. Frankenstein, 'Proposal of a Method for Strengthening the Ability of Abstraction among Children of Immigrants from the Eastern Countries' (Heb.), *Megamot*, 2/4 (July 1951).

Oryan (Herzog), N., 'The Leadership of Abba Hillel Silver in the Jewish-American Scene 1938–1949' [Manhiguto shel aba hilel silver bazirah hayehudit-amerikanit 1938–1949], Ph.D. diss., Tel Aviv University, 1982.

Ostfeld, Z., *An Army is Born: Main Stages in Building the Army under the Leadership of Ben-Gurion* [Tsava nolad: shelavim ikariyim biveniyat hatsava behanhagato shel david ben-guriyon], 2 vols. (Tel Aviv: Ministry of Defense, 1994), vol. i.

Pa'il, M., and A. Ronen, *A Rift in 5708* [Kera be-5708] (Ramat Efal: Israel Galili Centre, n.d. [1991?]).

Pilch, J., 'From the Early Forties to the Mid-Sixties', in J. Pilch (ed.), *A History of Jewish Education in America* (New York: National Curriculum Research Institute of the American Association for Jewish Education, 1969).

Pinkus, B., and I. Troen (eds.), *Jewish Solidarity in the New Era* [Solidariyut yehudit ba'eit haḥadashah] (Kiryat Sede Boqer: Ben-Gurion University of the Negev, 1989).

Pinkus, C., *Neurim: The Rural Vocational Training Center of Youth Aliyah and Hadassah*, FICE Document 8 (Jerusalem: Fédération Internationale des Communautés d'Enfants, 1962).

Pinner, L., 'Ha'avarah', *Encyclopaedia Judaica*, 2nd edn., ed. Fred Skolnik and Michael Berenbaum (Detroit: Macmillan Reference USA, 2007), viii. 171.

Porath, Z., *Letters from Jerusalem 1947–1948* [Mikhtavim miyerushalayim: milḥemet ha'-atsma'ut be'eineihah shel na'arah amerikayit] (Tel Aviv: Cherikover, 1998).

Powers, J. B., *The 'Girl Question' in Education: Vocational Education for Young Women in the Progressive Era* (Washington and London: Palmer, 1992).

Prywes, M., *Hopeful* [Asir tikva] (Tel Aviv: Zmora Beitan, 1992).

——'Medical Education in the State of Israel' (Heb.), *Niv Harofeh*, 5/3–4 (Aug. 1955).

Raider, M. A., *The Emergence of American Zionism* (New York and London: New York University Press, 1998).

——'Pioneer Women', in P. E. Hyman and D. D. Moore (eds.), *Jewish Women in America: An Historical Encyclopedia* (New York and London: Routledge, 1997), ii. 1071–7.

——'The Romance and *Realpolitik* of Zionist Pioneering: The Case of the Pioneer Women's Organization', in S. Reinharz and M. A. Raider (eds.), *American Jewish Women and the Zionist Enterprise* (Hanover, NH, and London: Brandeis University Press, 2005), 114–34.

Rainer, R., 'Amit', in P. E. Hyman and D. D. Moore (eds.), *Jewish Women in America: An Historical Encyclopedia*, 2 vols. (New York and London: Routledge, 1997), i. 48–9.

Rapaport, Y., 'Exploration of Youth Aliyah and its Place in Education in Israel' (Heb.), *Megamot*, 5/1 (Oct. 1953), 50–77.

Raphael, M. L., *Abba Hillel Silver: A Profile in American Judaism* (New York and London: Holmes & Meier, 1989).

Rebhun, U., and S. DellaPergola, 'Socio-Demographic and Identity Aspects of Intermarriage among the Jews of the United States' (Heb.), in Israel Bartal and Isaiah Gafni

(eds.), *Sexuality and the Family in History: Collected* Essays [Erus, eirusin, ve'isurim: miniyut umishpaḥah behistoriyah] (Jerusalem: The Zalman Shazar Center for Jewish History, 1998).

Reinhartz, J., 'Laying the Foundation of the Hebrew University of Jerusalem: The Role of Chaim Weizmann (1913–1914)' (Heb.), *Cathedra*, no. 46 (1988), 123–6.

Reinharz, S., 'Irma Lindheim: An American Zionist Woman's Search for Truth', *World Congress of Jewish Studies*, 12/E [Eng.] (2001), 53–61.

——'Irma "Rama" Lindheim: An Independent American Zionist Woman', *Nashim*, 1 (1998), 106–35.

——and M. A. Raider (eds.), *American Jewish Women and the Zionist Enterprise* (Waltham, Mass.: Brandeis University Press, 2005).

Reinhold, C., *Youth Builds its Home: Youth Aliyah as an Educational Movement* [No'ar boneh beito: aliyat hano'ar kitenua ḥinukhit] (Tel Aviv: Am Oved, 1952/3).

Reuveni, Y., *The Mandate Administration in Palestine, 1920–1948: Political-Historical Analysis* [Memshal hamandat be'erets yisra'el 1920–1948: nituaḥ histori medini] (Ramat Gan: Bar Ilan University, 1993).

Riemer, Y. 'Jewish Youth between Acculturation and Fulfilment: The English-Speaking Habonim Movements' (Heb.), *Gesher*, 124 (Winter 1992), 44–55.

Rinot, H., 'Boarding School Education in a Society in the Making: Schooling in Israel' (Heb.), in W. Ackerman, A. Carmon, and D. Zucker (eds.), *Education in a Society in the Making: The Israeli System* [Ḥinukh beḥevrah mithavah: hama'arekhet hayisra'elit], 2 vols. (Jerusalem and Tel Aviv: Hakibbutz Hameuchad/Van Leer Institute, 1985), vol. i.

Rogow, F., *Gone to Another Meeting: The National Council of Jewish Women 1893–1993* (Tuscaloosa and London: University of Alabama Press, 1993).

Rojanski, R., *Conflicting Identities: Poalei Zion in America, 1905–1931* [Zehuyot nifgashot: po'alei tsiyon be'amerikah] (Sede Boqer Campus: Ben-Gurion Research Institute for the Study of Israel and Zionism, Ben-Gurion University of the Negev Press, 2004).

Rosen, George, *A History of Public Health* (New York: MD Publications, 1958).

Rosen, Gladys, 'Bertha Schoolman', in P. E. Hyman and D. D. Moore (eds.), *Jewish Women in America: An Historical Encyclopedia*, 2 vols. (New York and London: Routledge, 1997), ii. 1212.

——'Judith Epstein', *Encyclopedia Judaica*, vi. 833.

——'Rose Halprin', *Encyclopedia Judaica*, vii. 1206–7.

Rosenberg, R., *Beyond Separate Spheres: Intellectual Roots of Modern Feminism* (New Haven and London: Yale University Press, 1982).

Rosenblith, P., *Youth Aliyah: History of the Project* [Aliyat hano'ar: korot hamifal] (Jerusalem: World Zionist Organization, 1968).

Rosenfield, G., 'Zionist Activities', *American Jewish Year Book*, 48 (1947).

Rothblat, S., 'Lasker Mental Hygiene Clinic Treats Children and Parents', *Hadassah Newsletter*, 30/9 (May 1950), 5.

Rothman, S. M., *Woman's Proper Place: A History of Changing Ideals and Practices, 1870 to the Present* (New York: Basic Books, 1978).

Round Shargel, B., 'American Jewish Women in Palestine: Bessie Gotsfeld, Henrietta Szold, and the Zionist Enterprise', *American Jewish History*, 90/2 (June 2002), 141–62.

Sardi, Z., *The First 45 Years: The Inception and Development of Hadassah Vocational Guidance Institute* (Jerusalem: Hadassah Vocational Guidance Institute, 1989).

Sarid, L. A., *Hehaluz and the Youth Movements in Poland, 1917–1939* [Heḥaluts vetenu'at hano'ar bepolin, 1917–1939] (Tel Aviv: Am Oved, 1979).

Sarna, J. D., *American Judaism: A New History* (New York and London: Yale University Press, 2004).

Scharfstein, Z., *History of Education in Israel: The Recent Generations*, iii: *The US, Canada, England, South Africa, Australia, New Zealand* [Toledot haḥinukh beyisra'el: bedorot aḥaronim] (Jerusalem: Reuven Mass, 1961/2; 2nd edn. 1972).

Schiff, Ofer, 'A Different View of the Americanization of Zionism' (Heb.) *Iyunim betkumat israel*, 10 (2000), 180–206.

Schmidt, S., 'Towards the Pittsburgh Program: Horace M. Kallen, Philosopher of an American Zionism', in M. I. Urofsky (ed.), *Herzl Year Book*, 8 (1978).

Schweid, E., *History of Jewish Thought in the Modern Era: The Nineteenth Century* [Toledot hahagut hayehudit ba'eit haḥadashah: hame'ah hatesha esrei] (Tel Aviv: Hakibbutz Hameuchad/Keter, 1977/8).

—— *A History of Jewish Thought in the Twentieth Century* [Toledot hahagut hayehudit bame'ah ha'esrim] (Tel Aviv: Dvir, 1990).

—— *Judaism and the Secular Culture* [Hayahadut vehatarbut haḥilonit] (Tel Aviv: Hakibbutz Hameuchad, 1980/1).

—— 'Yes to the Negation of the Diaspora' (Heb.), *Kivunim*, 12 (Aug. 1981), 23–41.

Scult, M., *Judaism Faces the Twentieth Century: A Biography of Mordecai M. Kaplan* (Detroit: Wayne State University Press, 1993).

Segev, Z., *From Ethnic Politicians to National Leaders: American Zionist Leadership, the Holocaust and the Establishment of Israel* [Mipolitikayim etniyim lemanhigim le'umiyim: hahanhagah hatsiyonit ha'amerikanit, hasho'ah, vehakamat medinat yisra'el] (Sede

Boqer: Ben-Gurion Research Institute for the Study of Israel and Zionism, Ben Gurion University of the Negev, 2007).

Selinger, M. 'Fundamental and Operative Ideology: The Two Principal Dimensions of Political Argumentation', *Policy Sciences*, 1 (1970), 325–38.

Shaham, D., *Israel: Forty Years* [Yisra'el arba'im hashanim] (Tel Aviv: Am Oved, 1991).

Shapiro, D. H., *From Philanthropy to Activism: The Political Transformation of American Zionism in the Holocaust Years 1933–1945* [Mifilantropiyah le'aktivism: hitgabshutam shel tsiyonei artsot haberit likevutsat hashpa'ah medinit vehihaletsutam lema'avak al atid erets-yisra'el (1933–1945)] (Jerusalem: Bialik Institute, 2001).

Shapiro, E. S., *A Time for Healing: American Jewry since World War II* (Baltimore and London: Johns Hopkins University Press, 1992).

Shapiro, Y., *Leadership of the American Zionist Organization, 1897–1930* (Detroit and Urbana, Ill.: University of Illinois Press, 1971).

Shargel, B. R., 'American Jewish Women in Palestine: Bessei Gotsfeld, Henrietta Szold, and the Zionist Enterprise', *American Jewish History*, 90/2 (June 2002), 141–62.

Shehory-Rubin, Z, 'Hadassah's Education and Health Projects in Palestine in the British Mandate Period' [Mifalim hinukhiyim-beriutiyim shel hadasah be'erets yisra'el bitekufat hamandat haberiti], Ph.D. diss., Ben-Gurion University of the Negev, 1998.

——and S. Shvarts, 'The Guggenheimer–Hadassah Playgrounds: The Community Centres of the Twenties' (Heb.), *Cathedra*, no. 86 (1998), 81.

——— *Hadassah for the Health of the People: Hadassah's Health and Education Activities in Palestine in the British Mandate Period* [Hadasah liberiut ha'am: pe'ilutah haberiutit hahinukhit shel hadasah be'erets yisra'el bitekufat hamandat haberiti] (Jerusalem: Hasifria Hazionit, 2003).

Shilo, M., *Princess or Prisoner? The Woman's Experience of the Old Yishuv in Jerusalem 1870–1914* [Nesikhah o shevuyah? Hahavayah hanashit shel hayishuv hayashan biyerushalayim 1870–1914] (Jerusalem: Haifa University Publishers/Zmora Beitan, 2001).

——R. Kark, and G. H. Rokem (eds.), *The New Hebrew Women: Women in the Yishuv and in Zionism from a Gender Perspective* [Ha'ivriyot hahadashot: nashim bayishuv uvatsiyonut bire'i hamigdar] (Jerusalem: Yad Ben-Zvi, 2001).

Shiloni, Z., 'The Medical Service and Hospitals in Jerusalem in the Period of the War' (Heb.), in M. Eliav (ed.), *In Siege and in Distress: Erets Yisrael in the First World War* [Bematsor uvematsok: erets yisra'el bamilhemet ha'olam harishonah] (Jerusalem: Yad Ben-Zvi, 1991).

Shimoni, G., 'Reformulations of Zionist Ideology since the Establishment of the State of Israel', *Studies in Contemporary Jewry*, 11 (1995), 11–36.

—— *The Zionist Ideology* (Hanover, NH, and London: Brandeis University Press, 1995).

Shmaltz, U., 'The Diminishing of the Population of Palestine in the First World War' (Heb.), in M. Eliav (ed.), *In Siege and in Distress: Erets Yisrael in the First World War* [Bematsor uvematsok: erets yisra'el bamilḥemet ha'olam harishonah] (Jerusalem: Yad Ben-Zvi, 1991).

Shor, D. F., 'Methods of Teaching a Class of Backward Children' (Heb.), *Megamot*, 3/3 (April 1952), 212–37.

Shub, L., 'Zionist and Pro-Israel Activities' in M. Fine (ed.), *American Jewish Year Book* (1951), 52.

Shubert, Y., 'The Sandy Test and its Theoretical Assumptions' (Heb.), *Megamot*, 1/1 (July 1950), 312–34.

Shulman, R., 'Hadassah Builds Again', *Hadassah Newsletter*, 31/3 (Nov. 1950).

—— 'US Nurses Welcomed to Israel', *Hadassah Newsletter*, 30/6 (Feb. 1950).

Shvarts, S., 'The Clalit Health Fund: Development as a Major Factor in the Health Services in Palestine 1911–1937' [Kupat ḥolim hakelalıt: ıtsuvah vehıtpatḥutah kegorem hamerkazi besherut haberiyut be'erets yisra'el], Ph.D. diss., Ben-Gurion University of the Negev, 1993.

—— *The Clalit Health Fund: Development as a Major Factor in the Health Services in Palestine 1911–1937* [Kupat ḥolim hakelalit: itsuvah vehitpatḥutah kegorem hamerkazi besherut haberiyut be'erets yisra'el] (Ben-Gurion Research Center, Ben-Gurion University of the Negev Press, 1997).

—— *Kupat Holim, the Histadrut and the Government: The Formative Years of the Health System in Israel, 1947–1960* [Kupat ḥolim, histadrut, memshalah: mehalakho be'itsuvah shel ma'arekhet haberiut beyisra'el] (Sede Boqer Campus: Ben-Gurion Research Center, Ben-Gurion University of the Negev, 2000).

—— 'Who Will Treat the People of Palestine? The Activity of the American Zionist Medical Unit in Setting up the Public Health System in the Early Mandate Period, 1918–1921' (Heb.), in P. Ginnosar (ed.), *Studies in Zionism, the Yishuv, and the State of Israel* [Iyunim bitekumat yisra'el: ma'asaf leba'ayot hatsiyonut bayishuv umedinat yisra'el], 8 (1988), 322–46.

—— 'The Women's Federation for Mothers in Palestine in 1918–1948' (Heb.), *Bitaḥon Sotsiali*, 51 (March 1988), 57–81.

—— and Z. Shehory-Rubin, 'Women's Federations for Mothers and Children in Palestine: The Efforts of Hadassah, the Federation of Hebrew Women, and WIZO to Establish Maternal and Infant Welfare Stations, 1913–1948' (Heb.), in M. Shilo, R. Kark, and G. H. Rokem (eds.), *The New Hebrew Women: Women in the Yishuv and in Zionism from a Gender Perspective* [Ha'ivriyot haḥadashot: nashim bayishuv uvatsiyonut bire'i hamigdar] (Jerusalem: Yad Ben-Zvi, 2001) 248–69.

Sikron, M., 'The Demographic Structure of Israel's Population and the Children and Youngsters within It' (Heb.), *Megamot*, 6/2 (April 1995), 91–112.

Simmons, E., *Hadassah and the Zionist Project* (Lanham: Rowman & Littlefield, 2005).

Simon, A., 'Youth Villages' (Heb.), in H. Ormiyan (ed.), *Education in Israel* [Haḥinukh be-yisra'el] (Jerusalem: Israel Ministry of Education and Culture, 1973).

Smilansky, M., 'Review of the Services in the Temporary Immigrant Settlements' (Heb.), *Megamot*, 6/2 (April 1955), 153–70.

Smith, C., and A. Freedman, *Voluntary Associations: Perspectives on the Literature* (Cambridge, Mass.: Harvard University Press, 1972).

Steinberg, M., *Basic Judaism* (New York: Harcourt, Brace, 1947).

——— *The Making of the Modern Jew* (New York: Behrman House, 1947 [first pub. 1934]).

Stock, E., *Chosen Instrument: The Jewish Agency in the First Decade of the State of Israel* (New York: Herzl Press, 1988).

——— *Partners and Pursestrings: A History of the United Israel Appeal* (New York: University Press of America, 1987).

Strum, P., *Brandeis: Beyond Progressivism* (Lawrence, Kan.: University Press of Kansas, 1993).

Sussman, N., 'The Development of Occupational Therapy in Israel, 1946–1956' (Heb.), *Israeli Journal of Occupational Therapy*, 2/4 (Nov. 1993), 146–56.

——— 'The History of Occupational Therapy in Israel: The First Decade, 1946 to 1956', master's thesis, New York University, 1989.

Tadmor-Shimoni, T., 'Immigrant Teachers as an Agent of the State' (Heb.), in *Dor Ledor: Studies in the History of Jewish Education in Israel and the Diaspora* [Dor ledor: kevatsim leḥeker uletiyud toledot haḥinukh hayehudi beyisra'el uvetefutsot], xxxi: *On the History of Education in Israel's First Decade* (2007), 97–115.

Teller, J. I., 'American Zionists Move toward Clarity', *Commentary*, 12/5 (Nov. 1951), 448.

Tevet, S., *David's Passion: The Burning Ground* [Kinat david: hakarka habo'er] (Jerusalem and Tel Aviv: Shocken, 1987).

Toll, W., 'Club Movement', in P. E. Hyman and D. D. Moore (eds.), *Jewish Women in America: An Historical Encyclopedia*, 2 vols. (New York and London: Routledge, 1997), i. 234–41.

——— *The Making of an Ethnic Middle Class: Portland Jewry over Four Generations* (Albany, NY: State University of New York Press, 1982).

——— 'A Quiet Revolution: Jewish Women's Clubs and the Widening Female Sphere', *American Jewish Archives*, 41/1 (Spring–Summer 1989), 7–26.

Troen, S. I., 'The Discovery of America in the Israeli University: Historical, Cultural and Methodological Perspectives', *Journal of American History*, 81 (June 1994), 164–98.

Tsameret, T., *On a Narrow Bridge: Shaping the Education System in the Days of the Great Wave of Immigration* [Alei gesher tsar: itsuv ma'arekhet haḥinukh beyemei ha'aliyah hagedolah] (Kiryat Sede Boqer: Ben-Gurion Heritage Institute, Ben-Gurion University of the Negev, 1997).

Tulchinsky, T. H., *Health in Israel 1948–1978* (Jerusalem: Ministry of Health, 1979).

Turk, D. B., 'College Students', in P. E. Hyman and D. D. Moore (eds.), *Jewish Women in America: An Historical Encyclopedia*, 2 vols. (New York and London: Routledge, 1997), i. 258–9.

United Jewish Communities, the Federations of North America, 'NJPS: Rates of Intermarriage', <www.ujc.org/content_display.html?ArticleID=83911>.

Urofsky, M. I., *American Zionism from Herzl to the Holocaust* (Garden City, NY: Anchor, 1995).

——*A Voice that Spoke for Justice: The Life and Times of Stephen S. Wise* (Albany, NY: State University of New York Press, 1982).

—— *We Are One: American Jewry and Israel* (Garden City, NY. Anchor, 1978).

——'Zionism: An American Experience', *American Jewish Historical Quarterly*, 63/3 (March 1974), 215–29.

Waserman, M., 'For Mother and Child: Hadassah in the Holy Land 1913–1993', *Bulletin of New York Academy of Medicine*, 70/3 (1993), 251–74.

Weigert, G., 'No Jim Crow in Israel', *Hadassah Newsletter*, 31/4 (Dec. 1950), 7.

Weiss, I., N. K. Langer, S. Shapiro, and M. Srer, 'The Development of the Social Work Profession in Israel' (Heb.), *Hevrah urevaḥah*, 22/2 (2002), 135–52.

Wenger, B. S., 'Jewish Women of the Club: The Changing Public Role of Atlanta's Jewish Women (1870–1930)', *American Jewish History*, 76/3 (March 1987), 311–33.

Williams, J. M., *Hunter College* (Charleston, SC: Arcadia Publishing, 2000).

Woloch, N., *Women and the American Experience* (New York: Knopf, 1984).

Woocher, J., *The Civil Religion of American Jews: Sacred Survival* (Bloomington and Indianapolis: Indiana University Press, 1986).

Yablonka, H., *Foreign Brothers: Holocaust Survivors in the State of Israel 1948–1952* [Aḥim zarim: nitsolei hasho'ah bimedinat yisra'el, 1948–1952] (Jerusalem: Yad Ben-Zvi/Ben-Gurion University of the Negev Press, 1994).

Yishay, A., 'Neurim: The Rural Training Center' (Heb.), repr. from *Dapim*, Department for Immigration of Children and Teenagers, Jerusalem, Dec. 1955.

Yungman, M. K., 2008, *American Women Zionists: Hadassah and the Rebirth of Israel* [Nashim tsiyoniot be'amerikah: hadassah utekumat yisra'el] (Sede Boqer: Ben-Gurion Research Institute for the Study of Israel and Zionism, Ben-Gurion University of the Negev, 2008).

Zalashik, R., 'The Development of Psychiatry in Palestine and Israel, 1892–1960', Ph.D. diss., Tel Aviv University, 2006.

Zald, M., and R. Ash, 'Social Movement Organizations: Growth, Decay and Change', *Social Forces*, 44 (1966), 327–40.

Zohar, Z., 'Hebrew Education as the Foundation of a Zionist Educational Institution' (Heb.), in Department for the Zionist Organization, *With the Change: Problems of Zionist Propaganda* (Jerusalem, 1954).

Zucker, D., 'Vocational Education: A System under Compounding Pressures' (Heb.), in W. Ackerman, A. Carmon, and D. Zucker (eds.), *Education in a Society in the Making: The Israeli System* [Ḥinukh beḥevrah mithavah: hama'arekhet hayisra'elit], 2 vols. (Jerusalem and Tel Aviv: Hakibbutz Hameuchad/Van Leer Institute, 1984/5), vol. i.

Zwanger, L., 'Foreign Prepared Jewish Nurses in Palestine and Israel 1900–1965', *Pflege*, 13 (2000).

——'Preparation of Graduate Nurses in Israel, 1918–1965', Ph.D. diss., Columbia University, 1968.

——'Striving for Higher Education in Israeli Nursing' (Heb.), in R. A. Stockler and R. Sharon (eds.), *Landmarks in Nursing: A Collection of Historical Research on Nursing Written in Israel* [Tsiyunei derekh behitpatḥut hasiyud: kovets meḥkarim historiyim besiyud shenikhtavu beyisra'el] (Tel Aviv: Tel Aviv University, 1995/6).

Plate Acknowledgements

The author and publisher are grateful to all those who have granted permission to use the photographs reproduced in this book. Every effort has been made to trace all copyright holders; if any error or omission has been made, we should be glad to learn of it so that it can be rectified in future impressions.

1, 3, 5, 6, 7, 8, 10, 17, 19, 20, 22, 23, 26, 28, 29, 33, 35, 37, 38, 41, 42, 43, 45, 46, 47, 49, 50, 52, 55 Courtesy of Hadassah, the Women's Zionist Organization of America, Inc.

2 Photo by Studio Ganan, courtesy of Hadassah, the Women's Zionist Organization of America, Inc.

4 Photo by Union Photo Co. NY, courtesy of Hadassah, the Women's Zionist Organization of America, Inc.

9, 39 Courtesy of Hadassah Medical Organization

11 Photo by Studio Huttman, Jerusalem, courtesy of Hadassah, The Women's Zionist Organization of America, Inc.

12 Courtesy of the Henrietta Szold Hadassah Hebrew University School of Nursing archives and Judith Steiner Freud, Dean Emeritus and chair of the alumni association of the school

13 Photo by J. M. Houlette, courtesy of Hadassah, the Women's Zionist Organization of America, Inc.

14 Photo: Herbert Sonnenfeld. Courtesy of Beth Hatefutsoth Photo Archive, Sonnenfeld collection

15 Photo by Alexander Archer, courtesy of Hadassah, the Women's Zionist Organization of America, Inc.

16 Photo by G. Maillard Kesslere, B.P., courtesy of Hadassah, the Women's Zionist Organization of America, Inc.

18 Photo by G. D. Hackett, courtesy of Hadassah, the Women's Zionist Organization of America, Inc.

21 Photo by Richards Photo Studio, courtesy of Hadassah, the Women's Zionist Organization of America, Inc.

24 Photo by Haas & Associates Photo, Roof Studio, courtesy of Hadassah, the Women's Zionist Organization of America, Inc.

25 Photo by Central Studios, Atlantic City, NJ, courtesy of Hadassah, the Women's Zionist Organization of America, Inc.

27 Photo by A. Malawsky, courtesy of Hadassah, the Women's Zionist Organization of America, Inc.

30 Photo by Z. Kluger for the Orient Press Photo Co., courtesy of Hadassah, the Women's Zionist Organization of America, Inc.

31 Photo by Studio M. Huttman, courtesy of Hadassah, the Women's Zionist Organization of America, Inc. (1951)

32, 40, 48 Photo by Hazel Greenwald, courtesy of Hadassah, the Women's Zionist Organization of America, Inc.

34 Photo by Fred Csasznik, courtesy of the Israel Defense Forces Archives and Hadassah, the Women's Zionist Organization of America, Inc.

36 Photo by R. Kneller. Courtesy of Annie Kneller and Hadassah, the Women's Zionist Organization of America, Inc.

44 Photo by Modern photo studio, courtesy of Hadassah, the Women's Zionist Organization of America, Inc.

51 Photo by Sonja Epstein, courtesy of Hadassah, the Women's Zionist Organization of America, Inc.

53 The Jewish Women's Archive (jwa.org)

54 Photo by A. Hazan, courtesy of Hadassah, the Women's Zionist Organization of America, Inc.

56, 57, 58, 59 Taken from a photo collection album of Vella Katzburg, the author's late mother, entitled 'Hadassah Israel'

All quotations from the Archives of Hadassah have been used in the book with the courteous permission of Hadassah, the Women's Zionist Organization of America Inc., New York.

Index

Lightning Source UK Ltd.
Milton Keynes UK
UKOW02f2009290514

232528UK00001BA/3/P